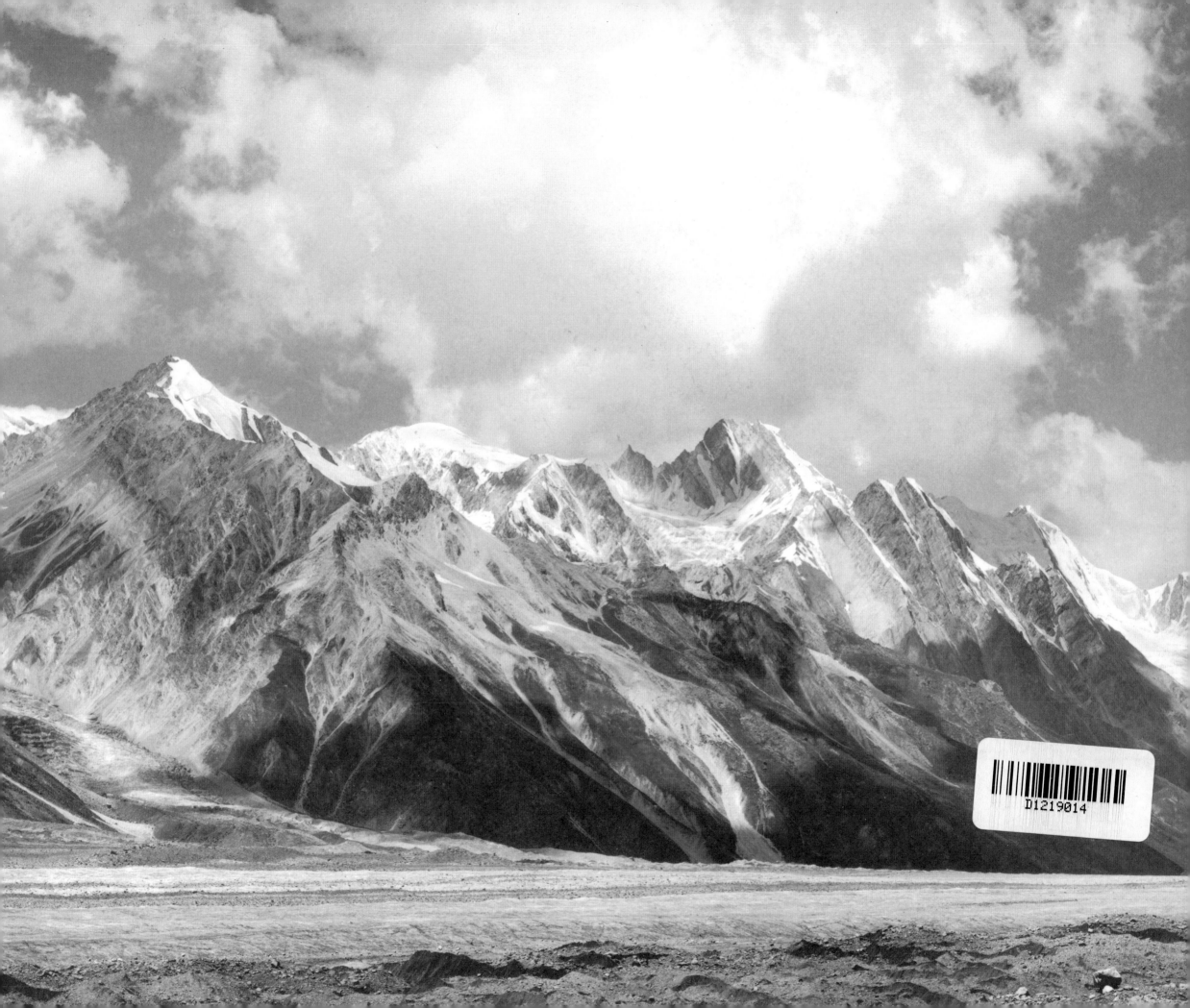

HIMALAYAN PORTFOLIOS

JOURNEYS OF THE IMAGINATION

KENNETH HANSON

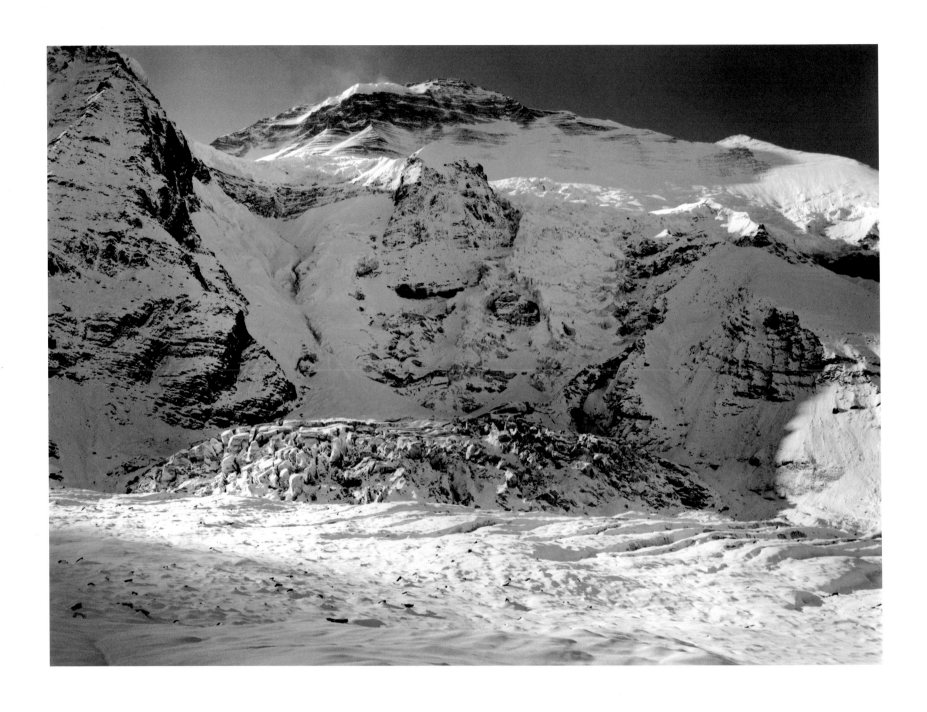

Dhaulagiri North Face from the Chhonbardan Glacier. Nepal 1992

CONTENTS

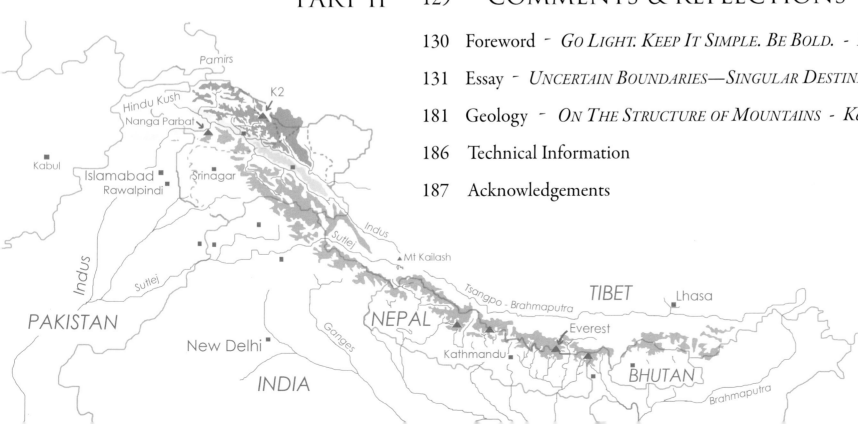

INTRODUCTION - CHARLES FIELDS

"... for the photographer the nature of the challenge is not immediately obvious. The photographer enters upon a symbolic journey in which all is uncertain. The subject matter is bafflingly different, the light is too intense, no clouds relieve the harshness of the sky, the equipment is heavy, the toes hurt, acclimatization is slow, the risks are significant and dust gets in the film holders. Once home, the further struggle begins to decide between the several claims of documentation, print quality and formal strength."

—*Kenneth Hanson*

Relentless, steady, authentic, passionate, and determined are five words that quickly come to mind to describe fellow photographer Ken Hanson. I first met Ken in the 1980s in our shared home state of Connecticut at one of his earlier Himalayan photography exhibitions. Immediately I understood and appreciated the intense commitment to the black and white image that he so modestly shared with admirers at that small gallery, continents away from the Himalayans and boxed in the safety and predictability of Connecticut.

While Ken's work is made to look completely natural and effortless, nothing could be further from the truth. His irreproachable hands-on photographic and printing techniques contrast with that of the faster, digital world most photographers embrace today. Similar to Ken, I too had spent many years traveling abroad, honing and exploring my manual craft across the globe, returning home to relive the experiences in the quiet solitude of my darkroom. Ken, though, has revisited the same region again and again— the mystical, illusive and dangerous Himalayas. They are a region of changing forms and shadows. Mountains never to be possessed, always to be admired and feared.

As his publisher, I feel privileged to have Ken as a client and as a cherished friend and admired colleague. Ken is a rare breed. He is an artist, scientist, scholar, adventurer and, of course, a master photographer—add to that his immersion in anthropology, poetry, and philosophy. His book is remarkable, not only because he has taken a bulky 4x5 camera up to altitudes of 21,000 feet and more, but also for the astonishing images he finds and captures despite the formidable physical hardship of reaching his subject. His ability to understand and evaluate the images from traditional negatives allows him a master license to recreate in his prints the mood and tone inherent in his experiences. The results are startling and spectacular.

For most, this artistic and physical exercise would be daunting and exhausting in and of itself. But that is just half of Ken's "method." He took his first trip to Nepal 21 years ago. In 1991, at age 60, he took a mountaineering course to open the way to more challenging routes and, perhaps, a few peaks. Now at 76, he has weathered a dozen trips to the Himalayas. On each trip, he's chronicled, day by day, the location of and technical information about his photographs and made notes about the native peoples and master climbers he has journeyed with and encountered along the way. The end portfolios reveal uncanny discipline and tenacity. For these reasons and the fine, meticulous body of work presented—only a portion of Ken's best prints—I am in awe.

Himalayan Portfolios, Journeys of the Imagination, has been in the making for over two decades, but for most of that time a book was not the goal. Ken's primary identity was that of scientist—photography was a vacation activity. He and I first seriously discussed the book in 1999. There was enough work, and yet he held back; it seemed the photographs were part of a larger quest that had yet to run its course. The structure of the work had to be explored by writing and rewriting, the Everest omission had to be addressed, a new identity had to be created. The result is the two-part book you have before you. Image and ideas interact.

As photographers, we often choose to (or feel we must) go to great lengths to "get the shot." To get there is a process—we have to want to be there and understand why we're going. We have to understand what we are shooting and what we're trying to convey, and then have the ability to present it. Ken has done that and more, transcending politics, religion and perhaps his former self while making many, many international friends. Through sheer endurance, he has achieved artistic clarity with keen concentration and exceptional will. And in this book he stands to gain thousands of new admirers, capturing their collective imagination and respect.

Congratulations Ken. You've made the journey. It's a thrill to call you friend.

—Charles Fields

FOREWORD - GREG MORTENSON

Ken Hanson's photographic portrait of the high Asian mountains is a compilation of two decades of passionate work. This masterpiece is a rare treasure for all mountain aficionados to cherish.

When I looked in Ken's first portfolio at the 1994 photograph of the turbulent Braldu Gorge, it had a special relevance. In September 1993 I had retreated from a climb of K2's west ridge and stumbled exhausted to the isolated Karakoram mountain village of Korphe situated on the south bank of the Braldu River opposite the village of Askole. A few remote Balti villages at the frontier of civilization have been the staging grounds for mountaineering expeditions for the last century. The compassionate Muslim villagers nursed me back to health with paiyu cha—salt tea laced with ten year old rancid yak butter. One crisp autumn morning, when I saw 84 shivering children in a dusty field writing with sticks in the sand, I made a rash promise to help the villagers build a school. When completed, the school would be a memorial to my sister, Christa, who had died of severe epilepsy a year earlier. It took me a year to raise the $12,000 needed, but only after I had sold everything I owned. When I returned in 1994 to begin to build the school, the villagers explained that first we must construct a bridge across the river.

Thanks to a generous Swiss benefactor, Dr. Jean Hoerni, I obtained the extra money needed. In 1995 the villagers built a 284 ft. cable bridge over the roaring Braldu River and we then laid the foundations to the school. But it was not until 1996 that I really began to learn about the world I had entered. One day the Korphe nurmadhar (chief), Haji Ali, forced me to sit down. I was handed a bowl of steaming paiyu cha. "The first time you share tea with a Balti you are a stranger." he said. "The second time an honored guest. The third time you share a cup of tea you become family and for our family we are prepared to do anything, even die. Dr. Greg, you must take time to share three cups of tea." Gradually I learned to listen to the villagers and accept their guidance. When the school was finally finished in 1996, it had been built for half the amount it would have cost the government. Meticulous accounts had been kept. From this humble start arose the *Central Asia Institute* (CAI).

With support from the mountaineering community, more schools were built. By 2007, the CAI had established 58 schools and educated 24,000 students, half of them girls, in remote villages of the Karakoram and Hindu Kush. After infinite cups of tea, and spending 65 months over 34 trips to Pakistan and Afghanistan, I am convinced that the essential task is to make sure that girls are educated. We can drop bombs, build roads or put in electricity, but until the girls are educated there will be little positive change. Women's education is the key to improve health care, reduce infant and childbirth mortality, and create local opportunities to bring peace to regions of turmoil.

In July of 2001 Ken Hanson was delighted to find the CAI-sponsored school in the village of Hushe. It proclaimed the commitment of those that had built it—scarlet painted wooden trim to every window and doorway, a neat gateway, and clipped grass within the courtyard. The residue of a miserable government school with a small blackboard still existed in a back alley. What very few understood that July was the full tragedy of the neglect of education by Pakistan's Government. Since 1980 burgeoning Wahhabi madrassas, funded by oil money, had filled the educational vacuum in Pakistan. An estimated 25,000 madrassas still help to spawn a militant ideology and hatred. The implications only became apparent later in the year: after 9/11/2001.

It might seem that in this destructive situation there would be no place for the beautiful photograph. But one of the unexpected privileges of my marriage in 1995 to Dr. Tara Bishop was access to the collection of mountaineering books and mountain photographs of her late father, Dr. Barry Bishop. The collection is now in the house of his widow Lila who lives a block away in Bozeman. He was the *National Geographic Society* (NGS) photographer on the first American Everest Expedition; he reached the summit on May 22, 1963. Later he spent two years with his wife and daughter in Jumla, on the edge of the Dolpo region of Nepal, studying trade routes for a PhD dissertation. He later became the NGS Chair of their Research and Exploration Committee. In September 1994, Barry was killed in a tragic car accident in Idaho on his way to speak at a San Francisco fund raiser for the *American Himalayan Foundation* (AHF). The AHF and the U.K *Himalayan Trust*, both created by Sir Edmund Hillary, have pioneered school and health projects in Nepal. A year after Barrie's death I met Tara at the AHF annual dinner. Our meeting was preordained—and we married six days later.

When life gets chaotic, I retreat to Barry's voluminous library. Among his books is a rare volume that contains the superb black-and-white photographs by Vittorio Sella taken on the 1909 Duke of Abruzzi expedition to K2. Ken's photographs, like those of Sella, provide a stabilizing perspective. They bring joy down from the mountains and remind me of the compassionate villagers whom it is our privilege to know. Thank you Ken for this magnificent tribute to the mountains we cherish. I hope many others will find this present volume to be a source of restoration and hope.

Greg Mortenson, is the founder of the nonprofit *Central Asia Institute*, www.ikat.org, and co-author, with David Oliver Relin, of the New York Times bestseller, *Three Cups of Tea: One Man's Mission To Promote Peace...One School At A Time* (Penguin 2007). The magnitude of the educational gap between men and women in Pakistan is indicated by the World Bank estimates for 2002. The Pakistan illiteracy rate for men was 43 %, but for women, 72%. The figures for Nepal were almost the same.

JOURNEYS OF THE IMAGINATION

Journeys beget journeys. As a child at the beginning of the Second World War I lived in Birmingham, England. There were identity cards and gas masks in cardboard boxes. The munitions factories of Birmingham were an inevitable target. On my way home from school I trekked past a searchlight emplacement and tarried by the barrage balloons waiting to be reeled skyward as nightfall approached. Before the serious bombing began my parents decided that my brother and I should be sent to live with my grandmother in the North. Such wartime journeys were endless: trains made long waits in sidings alongside the black tailings of coal mines, platforms were crowded with troops. My childhood journey was from a place of great uncertainty to a secure world of the imagination. My grandmother's house was on the edge of Morecambe Bay to the south of the English Lake District. The beach was only minutes away. Seasonal storms from the Irish Sea battered the coast, the Cumbrian Mountains were an ever-changing profile on the horizon, to the north were limestone escarpments and to the east were the Pennine Moors. In the following years the mountains inevitably became a defining presence. The Himalayas were the subject of local legend.

The post-war world was profoundly unstable and morally confused. Victory had required the acceptance of the unacceptable. Nuclear weapons had been used and as warheads accumulated their further use seemed inevitable. John Milton, writing after the chaos of the English Civil War and long after his passage through the Alps, incorporated into *Paradise Lost* a vision of destruction. As Satan approached the Gate of Hell, wandering fallen bands journeyed " O'er many a Frozen, many a Fiery Alp, / Rocks, Caves, Lakes, Fens, Bogs, Dens and shades of death, / A Universe of death which God by curse / Created evil." The vision seemed all too relevant. It was probably the uncertainty of the times that turned me to the pursuit of science and ultimately biochemistry. I entered a community in which an understanding of life's processes in terms of biochemistry and Darwinian natural selection was suddenly being realized. Progress was by imagination and experiment. A picture of how enzymes transform three-dimensional compounds one into another was emerging and the manner in which enzymes collaborate, as in photosynthetic metabolism, was being understood. My days were spent devising and performing experiments. I stress the nature of this quest because it has some bearing on my approach to photography.

When I first started using a camera for activities other than photographing my children, the impulse was to show the underlying order and symmetry of natural objects—to complement in art the beauty and order associated with the world of science and mathematics—the Enlightenment dream opposed to Miltonic chaos. The 4x5 Toyo view camera that I acquired in 1975, together with a sturdy wooden tripod, seemed an appropriate scientific instrument. Snapshots are not possible; the head is covered with a dark cloth and the image is viewed inverted and reversed on the ground glass screen; deliberate choice is necessary. But the process of photography is subversive. Whereas the scientific experiment deliberately restricts emotions, a photograph carries with it a complex iconography that can take the photographer by surprise. A photograph by its intensity may point to a subconscious image that the photographer only partially understands—a lone figure on an empty beach, for example. A portfolio may have a controlling image that is similarly mysterious. At the same time the individual image and the portfolio can incorporate layers of public iconography—a photograph of Everest cannot be separated from the history of its ascent. In short, the photographer proceeds by intuition that is more related to poetry and philosophy than to science. The carryover from science is the experimental spirit: the camera provides a means to examine afresh the emblems and tokens of the world. I like to think of my work as a Philosophical Enquiry in the eighteenth century sense. The strength of the Enquiry depends on the constraints imposed: the rejection of color, the choice of the large negative. An Enquiry is open to astonishment.

My Himalayan photography came about almost by accident. In 1986 my wife suddenly announced that she had been awarded a Fulbright grant to go to India and teach International Relations at the University of Puna. Furthermore, she declared, having hopped to India we should skip to the Himalayas. I was able to scrape together just enough vacation time to make a Himalayan trip possible and, being totally unrealistic about the travel complications, I decided to take the view camera. On returning home from the trek I concentrated on printing a few selected pictures. Carrying the camera, repeatedly setting up and taking down under adverse circumstances, the struggle to cross the high pass—all these were an essential part of the psychological process. The concept of 'the journey' became a controlling

image. As I struggled forward it seemed to me that I was exploring two imaginative realms: that of the Tibetan Buddhist culture represented by prayer flags and monasteries; that of the mountaineers and explorers who, in crossing the high passes and shattered ice falls and in ascending ice carved peaks, have traversed regions of great beauty and great danger. It is a land that cannot be possessed; no right of transit can be assumed. To cross the high pass requires a total concentration of the will: there is total clarity, total isolation and enveloping light.

The photographs in this book are linked to specific journeys and gathered into regional portfolios. With minor exceptions, the photographs are presented in the sequence in which they were taken. Each region has its own visual and iconographic character. I have provided introductions, notes and maps. The notes are more informative than anecdotal; the viewer may well prefer to allow the images to speak for themselves. The issue of iconography is addressed more fully in an essay at the end of this volume. There I consider not only the history of Himalayan mountaineering, that owes less to sport than to politics and science, but also the contributions of poetry and faith. The poetic range includes both the Miltonic image of "A Universe of death" and John Bunyan's image of unbounded light—the beauty and the glory of the heavenly Mount Zion. To a significant extent my guide has been Wordsworth. The Himalayas are emblems of the ultimate challenge and the final passage between life and death. As such they deserve our serious attention.

Kenneth Hanson
Connecticut, 2008

"I have a hatred of all photographs of the Himalaya. They degrade the mountains in the minds of all who have seen them."

Sir Francis Younghusband;
Explorer and Chair of the Everest Committee;
Foreword to *Everest the Challenge*, 1936.

Himalayan Geology

The visual diversity of the Himalayan mountains reflects the processes by which they were formed. In looking at the photographs, it is useful to have in mind the following distinct terrains. They were created by the Indian tectonic plate moving India away from Africa and Antarctica and pushing the subcontinent against Eurasia. This mountain building process is discussed more fully in Part II (*On The Structure of Mountains*).

—**The Kohistan-Ladakh Arc**: Long before India reached Eurasia an island arc, analogous to Japan, was created somewhere in the Sea of Tethys between India and Eurasia. These islands were added to the coast of Eurasia to form the regions later identified as Kohistan and the Ladakh Range.

—**The Great Himalaya**: Eventually the Indian continental mass fused with Eurasia. The line of contact more or less coincides with the Indus in Ladakh and the Tsangpo River in Tibet. The impact created to the south of this suture line the Great Himalaya that stretches from the mountains north of Islamabad, the site of the 2005 earthquake, to Arunachal Pradesh in the east. Long before India started its journey toward Eurasia, sediments were being deposited on the Indian continental shelf. These Tethyan sedimentary rocks became the region that extends from the suture line to the summit of many of the great peaks, including Everest, Annapurna and Dhaulagiri. A detachment fault separates these rocks from the underlying crystalline sequence that is encountered as the traveler climbs upwards from the south. Recent research indicates that these crystalline rocks, defined at their base by the Main Central Thrust Fault, have been extruded from beneath the Tibetan plateau.

—**The Karakoram**: The impact that formed the Great Himalaya thrust island-arc rocks beneath the region to the north. There pressure and heat generated the thee domains that together form the Karakoram: 1) upended metamorphic rocks in the south, 2) a band of granite spread across the middle, and 3) in the north a zone of metamorphic and sedimentary rocks that includes K2. As the mountain building process pushes the mountains ever upward they are being worn down by landslides, glaciers and monsoon rains.

In most of the maps in this volume the ground above 5,000 m (16,404 ft) is indicated by shading. By convention, heights are listed first in meters and then in feet: (1,000m/3,2808ft). The heights of major peaks cited are based on reliable sources. There is much inconsistency in the published heights of passes, camps and settlements.

THE MOUNTAINS OF KASHMIR

Kashmir is a jumbled region east of the North-West Frontier and southeast of the Pamirs. The Princely State of Kashmir came into being as an experiment in indirect rule. The Dogra, a Hindu tribal group of the Jammu region, helped the British East India Company fight the Sikhs. In return, in 1846, they were magnanimously granted permission to take what they could grab, backed by British power. A garrison was established in Gilgit and military roads were constructed. At the time of partition in 1947 Pakistan-supported tribesmen surged into Kashmir, Nehru sent in troops and Pakistan joined the fight. A ceasefire led to the Line of Control shown as a dashed line on the Map. Later the western border was nibbled by China (Aksai Chin). I have been close to the border on the Pakistan side in 1994 and 2001 and the Indian side in 1997, but then, as now, the Line could not be crossed.

The Line of Control divides the region, but the Indus ties it together. The Indus rises in Western Tibet, and follows a wide valley south of the Ladakh Range until it cuts through that range and crosses the Line of Control. It skirts the uninhabited Deosai Plateau, passes the junction with the Shyok River that drains the Siachen Glacier (the worlds highest and most stupid battlefield) and reaches Skardu at the junction with the Shigar River. Beyond Skardu the Indus has carved deep gorges through a bulge of the Great Himalaya. Thereafter it swings south past the junction with the Gigit River to flow through the Kashmir region known as Kohistan on its way to the Arabian Sea.

In approaching the mountains the traveler necessarily follows ancient trade routs. The Karakoram Highway, built jointly by Pakistan and China, departs from the Grand Trunk Road near Rawalpindi, passes the ancient Gandaharan city of Taxilla, then crosses the Black Mountains to reach the Indus. The main Highway continues along the Gigit and Hunza Rivers to the Khunjerab Pass on the Chinese border and then on to Kashgar, once a city on the Silk Road. The main Silk Road passed to the north but the Indus route led via the Grand Trunk Road to the great cities of India. Most trekkers and climbers follow the branch of the Highway that leads to Skardu, capital of the Baltistan region. This winding road, the only supply route for Pakistan's border defenses, is in places cut from the cliff face. Blind corners threaten to send the traveler hurling into the exploding waters far below.

Prior to partition, mountaineering expeditions usually departed from Srinagar in the Vale of Kashmir in time for the snow to clear on the Himalayan passes. Sir Martin Conway, for example, in 1892 crossed the Burzil Pass (about 3,960m/13,000ft) and followed the military road to Gilgit that runs through Astor, east of Nanga Parbat, to reach the Indus near the confluence with the Gilgit River. In 1938 the American K2 expedition led by Dr. Charles Huston and Robert Bates crossed the Soji La (3,536m/11,600ft) to reach Kargil on the road from Srinagar to Leh. The trail from Kargil to Skardu follows the Dras River and then the Indus. The Line of Control is just north of Kargil. In the Kargil Crisis of 1999 shelling and fighting took place and India and Pakistan nearly came to nuclear war.

THE KARAKORAM - Pakistan controlled Kashmir

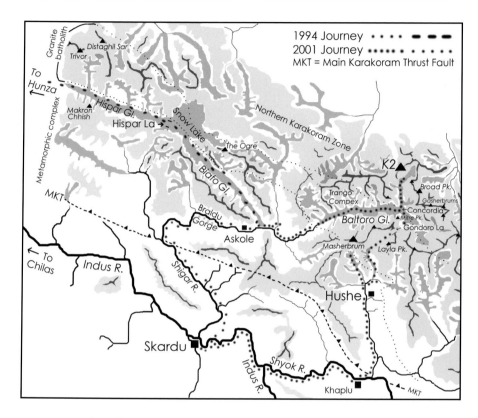

Biafo and Hispar Glaciers, 1994. Skardu is the jumping off place for most expeditions to the Karakoram. In 1994 we bounced our way by jeep up the Shigar valley to the Braldu Gorge. At this point we left the Kohistan-Ladakh island-arc region and entered the Karakoram. The road was washed out and from then on we walked. On reaching the Biafo Glacier we moved over open ice during the day and camped in ablation valleys at the moraine edge in the evening. On August 15 we reached the Hispar La (5,200m/17,000ft) which provided magnificent views of the near-level glacier called the Snow Lake and the granite peak of the Ogre (names given by Conway). After descending the Hispar Glacier, came a heart-stopping jeep ride to Karimabad in the Hunza valley—20 days after leaving Skardu.

Gondogoro and Baltoro Glaciers, 2001. In 2001 we followed the Shyok valley to Khaplu, once the center of a separate kingdom. The people of this area belong to the Nurbashi sect of Islam rather than the stricter Shia Islam of Skardu. A side valley led us to the village of Hushe (3,100m /10,171ft). After making an excursion to the Masherbrum base camp, we ascended the Gondogoro Glacier. The Gondoro La (5,585m/18,324ft) gave us our first view of K2, a pyramid towering over the neighboring peaks. From the pass, the Vigne Glacier led us to Concordia, the junction of the Godwin-Austen and Boltoro Glaciers. After visiting the K2 base camp, we returned to Concordia and descended the Baltoro Glacier that has cut a highway through the granite batholith that reaches across the width of the Karakoram. Finally, from beyond Askole, we returned by road to Skardu, 22 days after our departure.

Ladakh 1997. The visit of my wife and I to Ladakh happened to coincide with the fiftieth anniversary of Indian Independence. We flew to the military/civilian airport outside of Leh, the regional capital (3,505m/11,495ft), and spent a week visiting fortified palaces and towering Buddhist monasteries set in side valleys and promontories about the Indus plain. We then trekked through the Markha Valley to the high pastures where Pashmina goats are raised, crossed the Gong Maru La (5,197m/17,052ft) and descended to Hemis Gompa. The Himalaya Zanskar range was to the south. Ladakh was once closely linked to Tibet and that linkage extended to Skardu. Pilgrims and traders that followed the route from Leh to Skardu via Kargil came to Lamayuru Gompa before crossing the Fatu La (4,094m/13,431ft); for now the Line of Control has the last word.

LADAKH - Indian controlled Kashmir

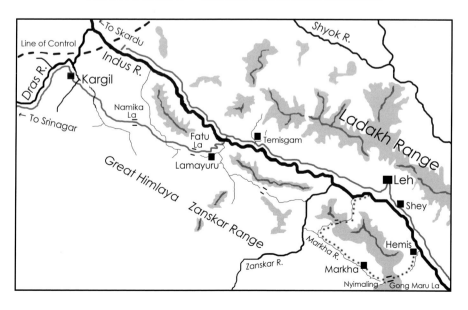

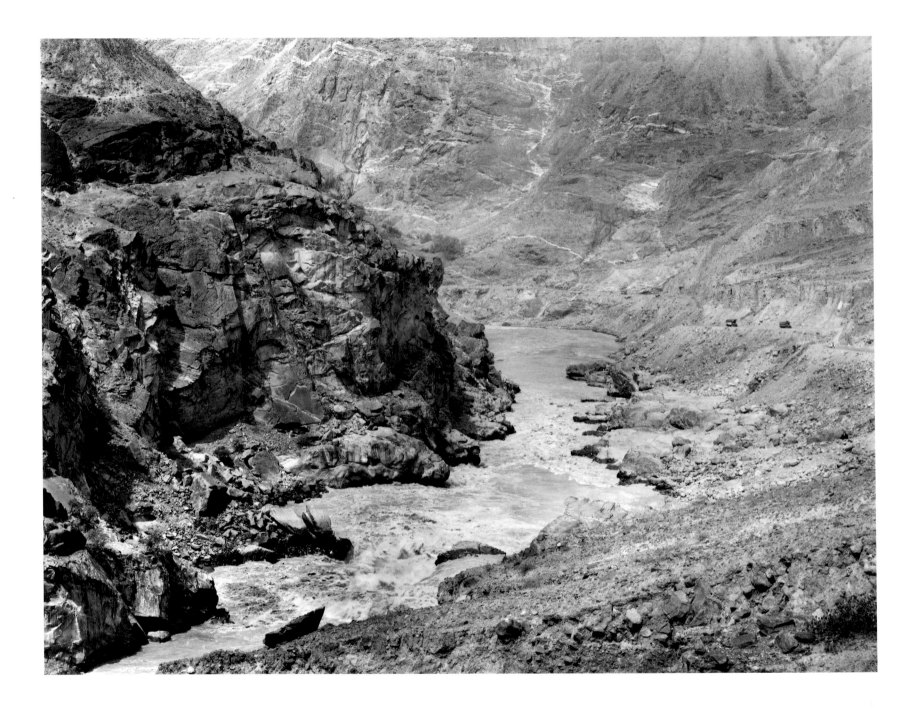

Indus Gorge and the Skardu Extension of the Karakoram Highway

The Indus in its long journey from Tibet to the Arabian Sea cuts through a northern promontory of the Himalayan chain shortly before its junction with the Gilgit River. At this most northerly point the river curves around the great block of Nanga Parbat. The highway in places follows ledges cut into the cliff face that feature blind corners customarily navigated by faith and a blaring horn. Before the construction of the highway by the military engineers of China and Pakistan, the gorge trail included ladders and rope bridges. (Photograph elevation about 1,500m/4,921ft.)

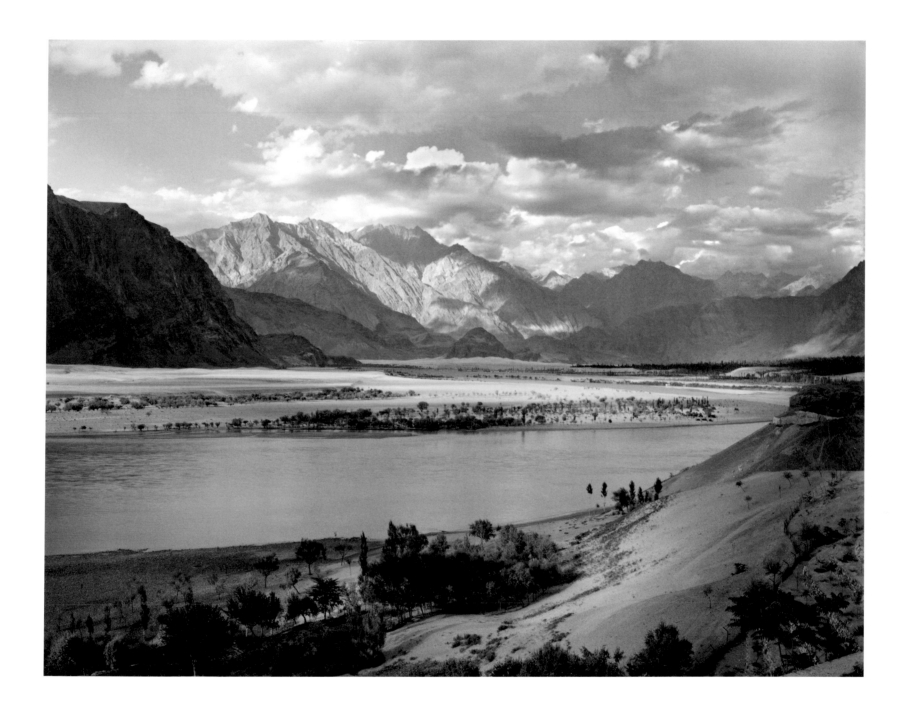

Indus River at Skardu; First View of the Karakoram

Skardu, at the confluence of the Shigar and the Indus Rivers, the administrative center of Baltistan, is the assembly point for most expeditions to the Karakoram. The photograph was taken from the government run K2 Motel (elevation about 2,300m/7,546ft). The hot dusty town, planted with apricot trees and irrigated by waterways, is overlooked by a dramatic fort, once the home of the Raja of Skardu, that is poised above the polo ground and a military camp. Most of the people of the Skardu area practice Shia Islam (porters tend to be called Ali or Hussein); the majority of Pakistanis are Sunni.

Petroglyph Rocks near Chilas; Indus Valley, Kohistan

Chilas is a small settlement, not far from the Indus-Gigit confluence, in the sun-baked high altitude desert known as Kohistan. The many petroglyphs record the cultural diversity of the pilgrims and traders that, from about 200 BCE onwards, traveled this part of the Silk Road. China was joined to the Grand Trunk Road that linked Rawalpindi to Lahore, Delhi and Calcutta. In addition to representations of animals, warriors and wheels, there are Buddhas and Buddhist chorten. Chilas is a useful stopping point on the 23-hour minibus journey from Rawalpindi to Skardu.

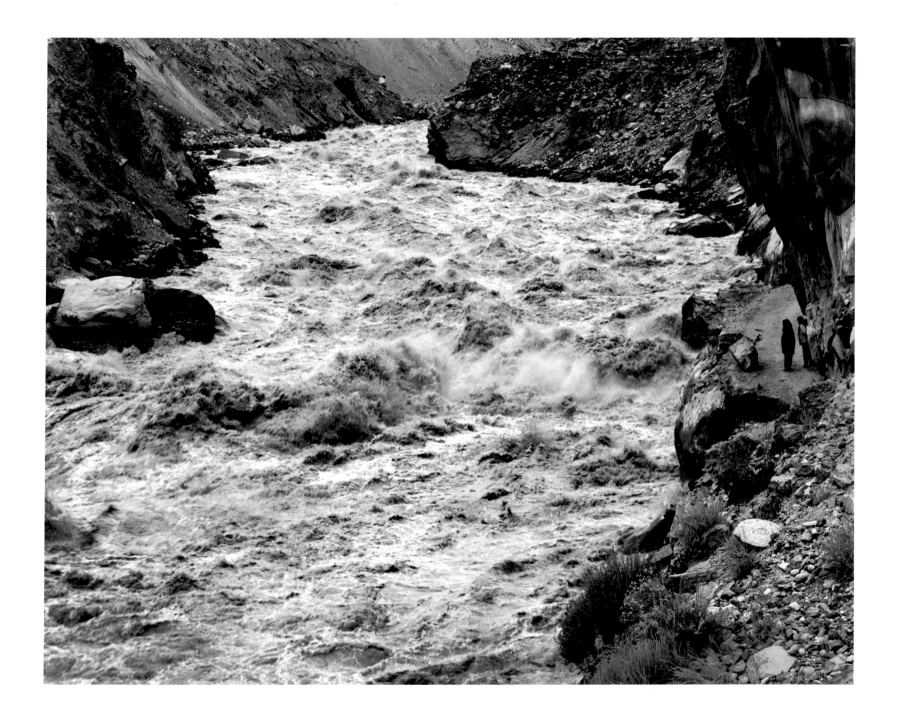

Road Washout in the Braldu Gorge

All the silt-laden melt water from the Biafo and Baltoro Glaciers flows through this narrow gorge on its way to the Indus. In 1994, after picking up Balti porters in the Shigar Valley, we reached the point photographed by late afternoon (Day 1, August 4). The explosive power of the water was destroying the road as we watched. By 4 am next morning the water was low enough for us to squirm past the blockage. From then on we walked. In 2001, traveling in the opposite direction, there were new washouts and a key bridge had been reduced to a few precarious timbers.

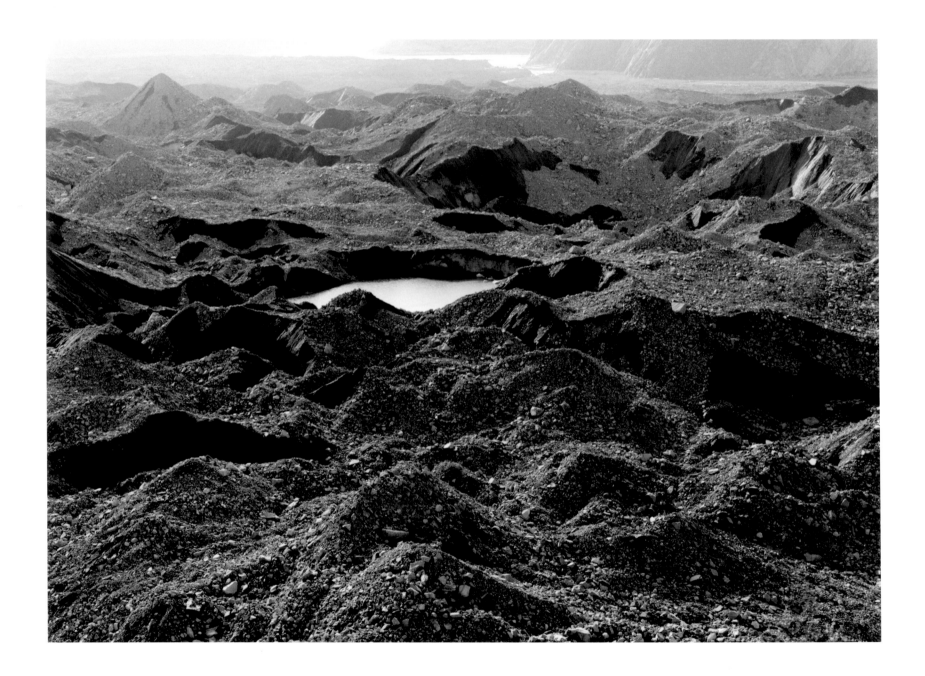

Moraine and Ice near the Terminus of the Biafo Glacier

In 1994 on Day 4 we passed the village of Askole and contoured round to join the Biafo Glacier at its dirtiest point (elevation about 3,100m/10,170ft). For two days the almost random trail wound hour after hour over mounds of black wet gravel embedded in invisible ice. Occasional stone piles marked the way. The weight of camera and tripod added to my instability on the slippery ice. Our camp areas were on level ablation terraces of ice-free edge-moraine above the level of the stone covered glacier.

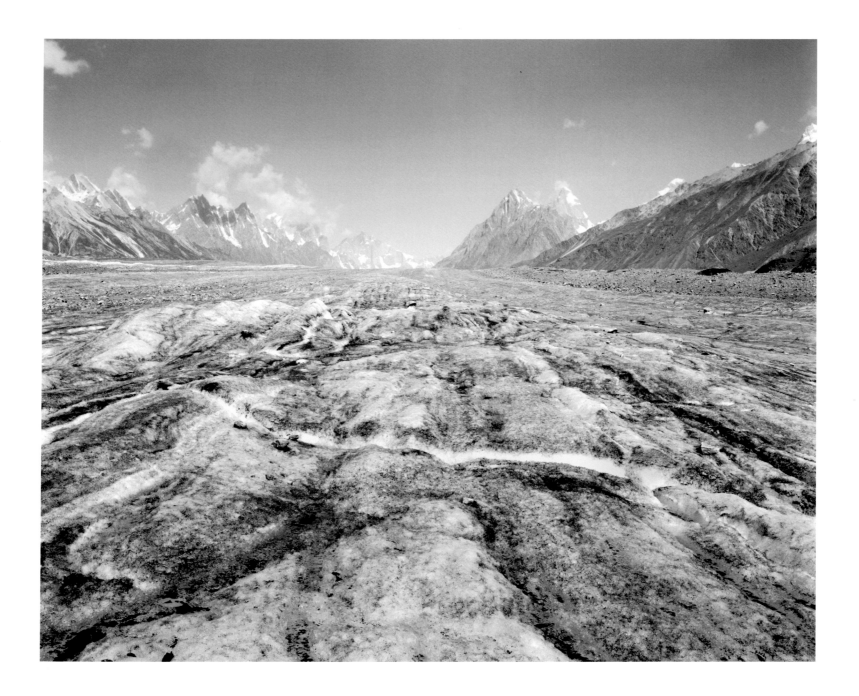

Ice Highway from before Baintha Camp, Biafo Glacier

By Day 6 ice dominated the glacial surface. Most of the crevasses were small enough that no detours were necessary. By afternoon the sun's heat created streams of melt water that flowed into holes in the ice and it was necessary to move to the moraine on the northeast side of the glacier (glacier elevation about 3,800m/12,467ft.).

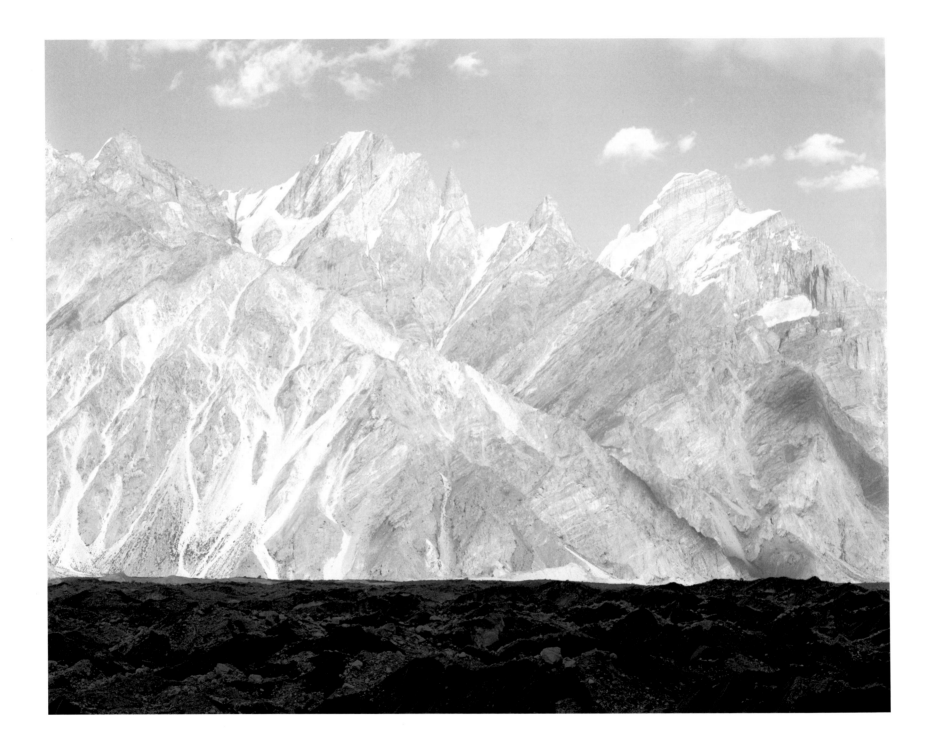

Evening Light on the Dongba-Bullah Ridge from Mango Camp, Biafo Glacier

The photograph was taken on the evening of Day 5 from an ablation terrace on the southwest side of the glacier. The mountains on the northeast side are carved from the same complex of upended metamorphic rock shown in the panorama on pp 19-22. The peaks are about 6,000 m (about 20,000 ft), i.e., the observed elevation above the glacier is about 7,500 ft.

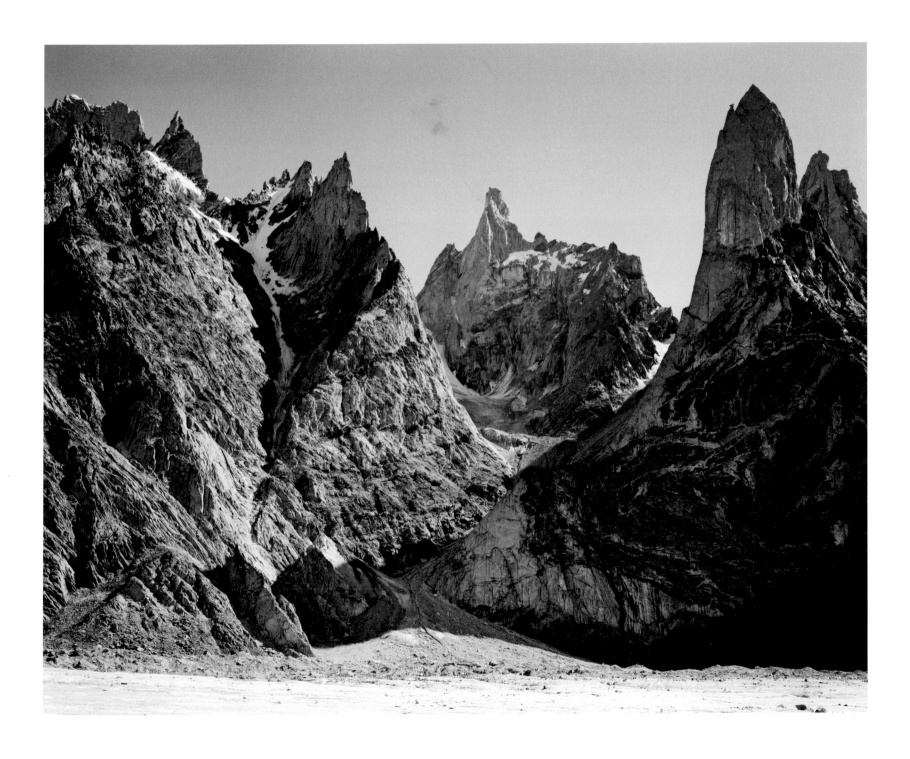

Ogre Thumb Formations near Nabrina Camp, Biafo Glacier

These pinnacles are part of the Karakoram granite batholith that here forms the northeastern edge of the glacier (Day 10, elevation 4,300m/14,108ft). The Ogre itself (p 23) is behind these peaks.

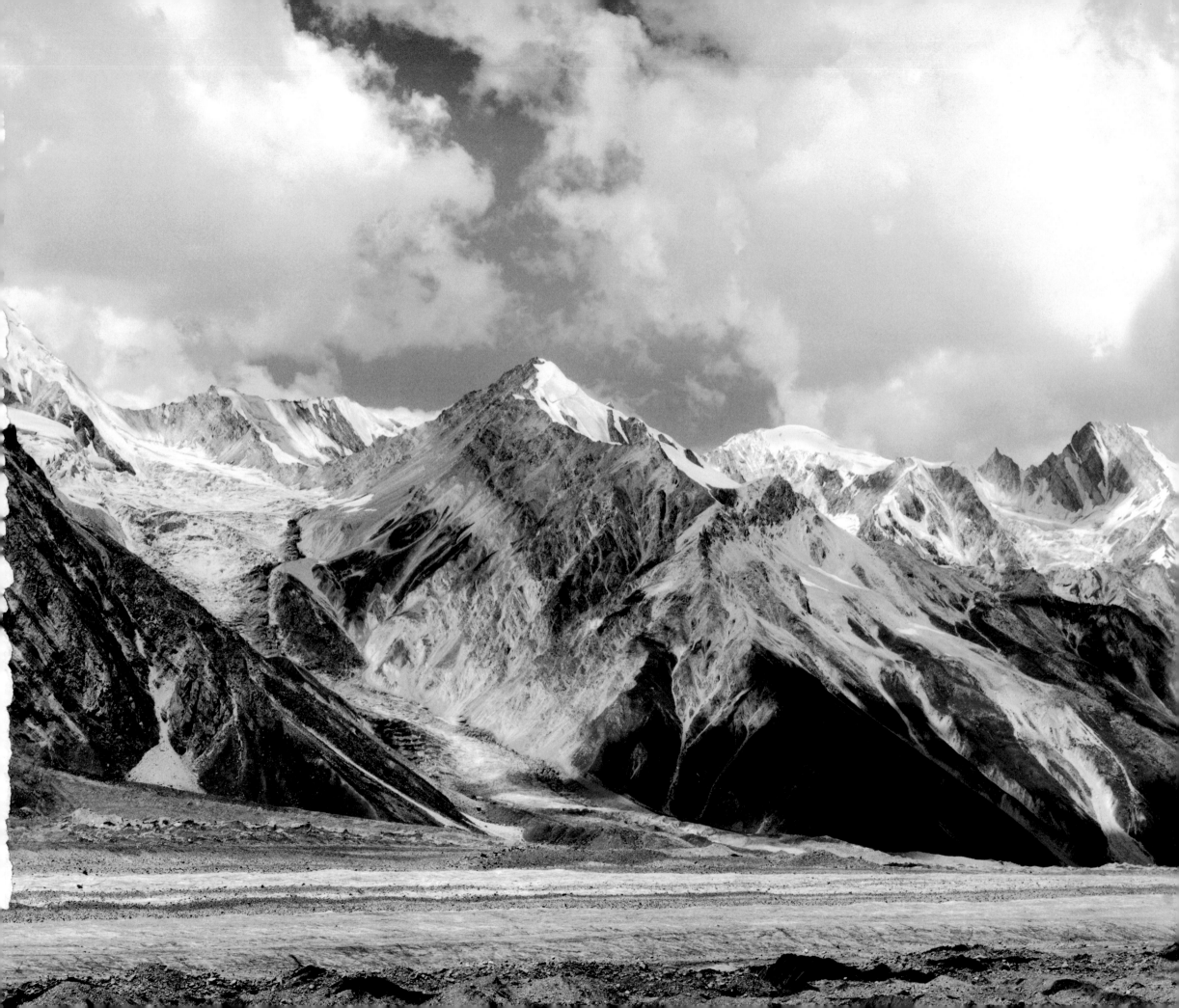

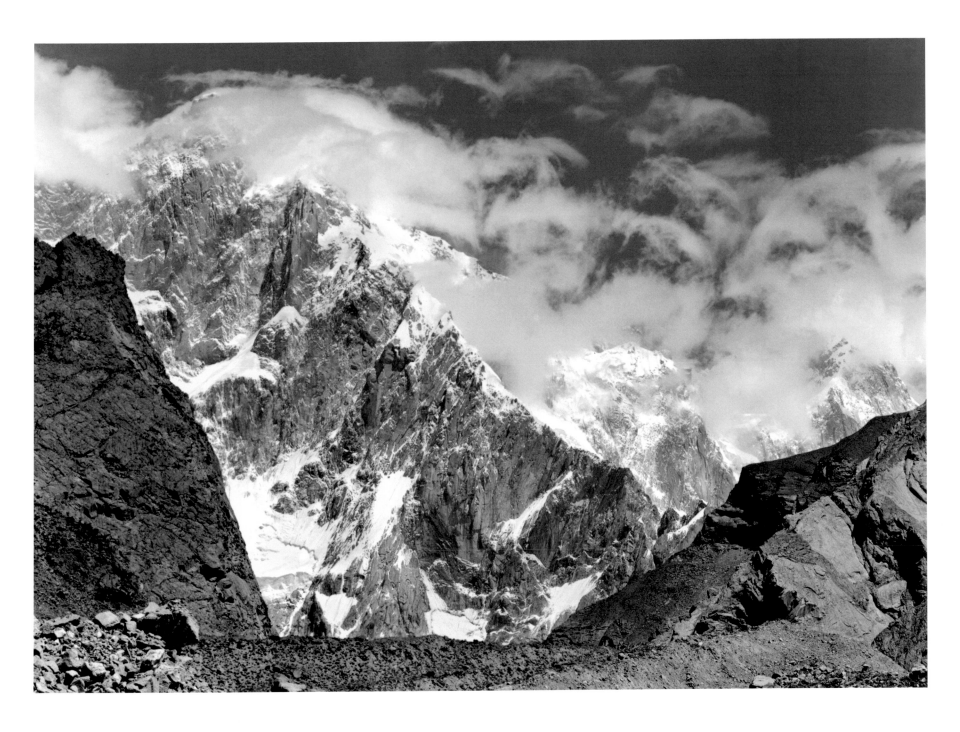

Trivor and Distaghil Sar, View North from the Junction of the Kunyang and Hispar Glaciers

For several days, as we descended the Hispar Glacier following the side moraine, the peaks were covered in cloud. Day 18 gave views of these major granite peaks to the north carved out of the Karakoram batholith: Trivor (7,728m/25,356ft) and Distaghil Sar (7,885m/25,871ft). The clouds formed and reformed as I photographed. Glacier elevation: about 3,900m/12,796ft.

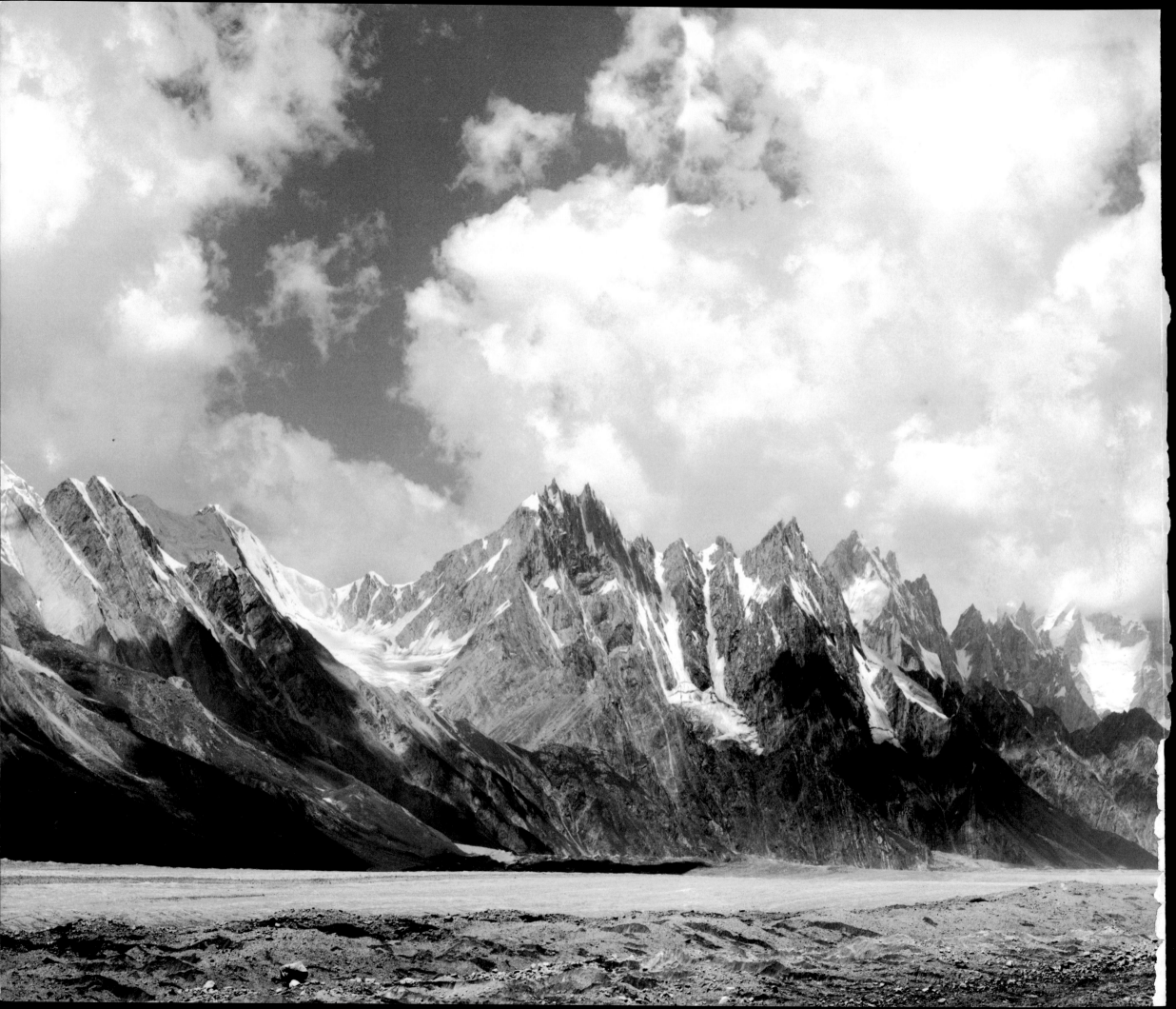

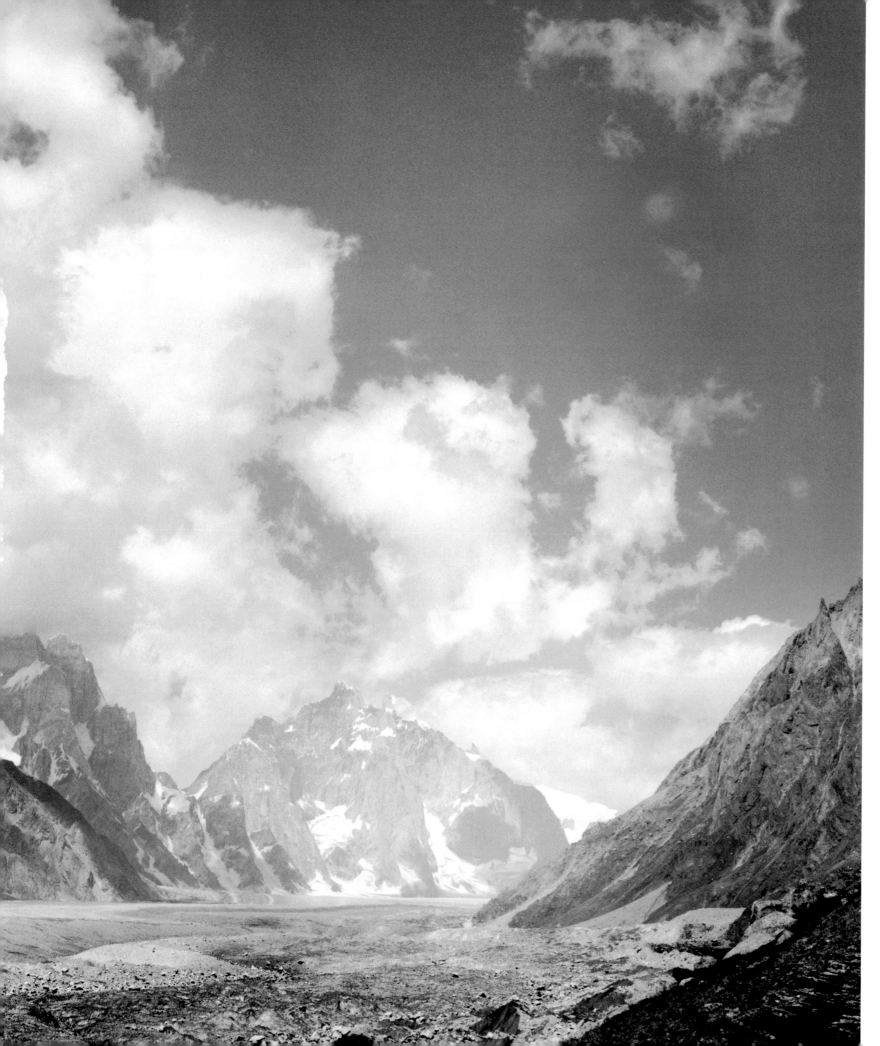

Panorama of the Biafo Glacier Taken from Before Baintha Camp

The panorama has been assembled from four negatives. The photographs were taken on Day 6 from the upper edge of the ablation zone on the northeast side of the glacier looking from southwest to northwest. The peak heights are between 5,500 and 6,500 m. Sosbun Brakk (6,413m/21,040ft), on the far right, is about 13 miles away. Glacier elevation: about 3,962m/13,000ft rising to 4,572m/15,000ft in the distant right.

19-22

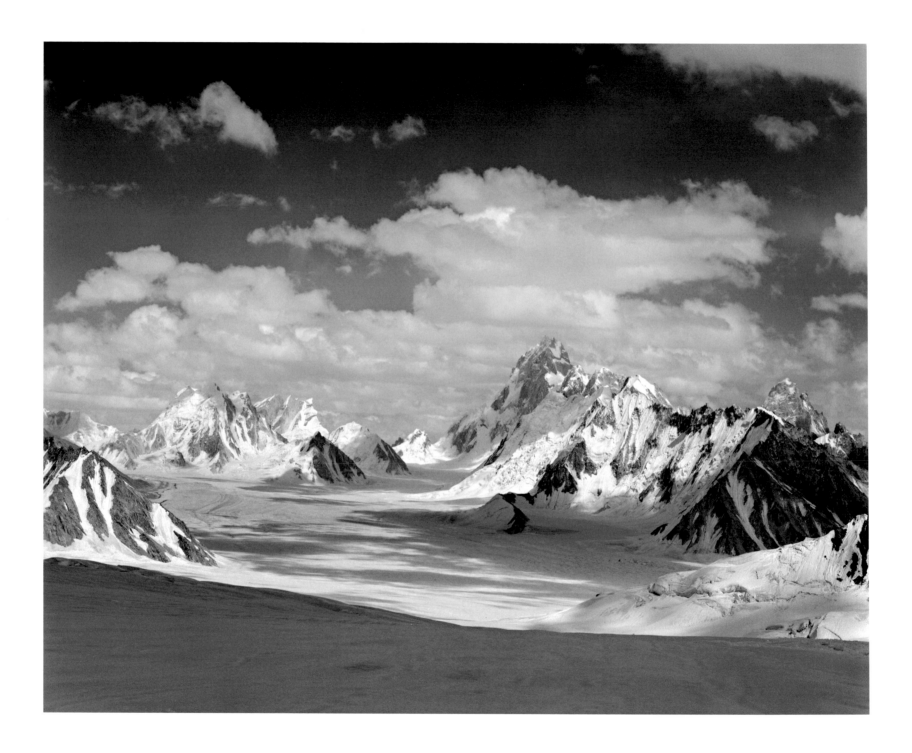

The Snow Lake, Sim-Gang Glacier and The Ogre from the Hispar La

The Biafo Glacier is fed by a large area of ice, the Snow Lake, that sweeps round to the left in the photograph (elevation about 5,000m/16,405ft). The Ogre (7,286m/23,905ft), the distant isolated granite peak, is about 10 miles away. The Snow Lake is connected to the Hispar Glacier be a broad pass, the Hispar La (5,120m/16,798ft). The photograph was taken in the early afternoon of Day 12 from near our Hispar La camp. The clouds were the advance of a monsoon storm and before long it was snowing. Next morning, in lightly falling snow that obliterated the trail, we descend to the Hispar Glacier past snow-covered crevasses.

23

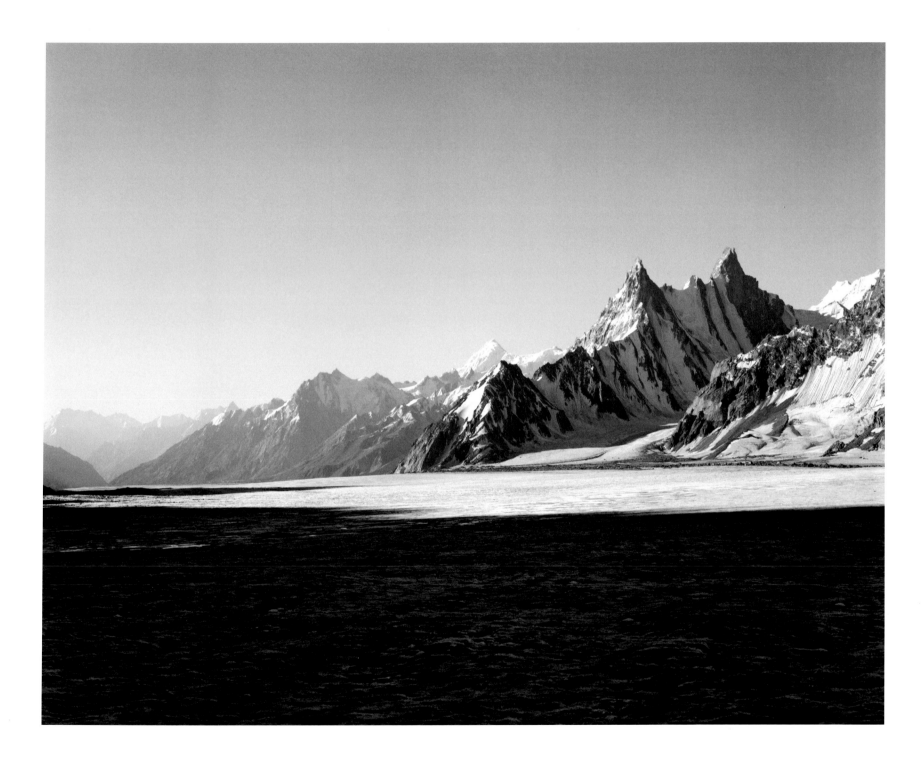

Looking Down the Biafo Glacier from the Sim-Gang Base Camp; Early Light

The photograph was taken at 6 am on Day 11; elevation about 4,600m/15,093ft. This was an acclimatization day in which we roped together and practiced glacial travel before crossing the Snow Lake (page 23) to reach the Hispar La. Roping together provides protection: should one member fall through the ice into a hidden crevasse the others can anchor the group using their ice axes. The Sim-Gang Glacier forms the southern edge of the Snow Lake.

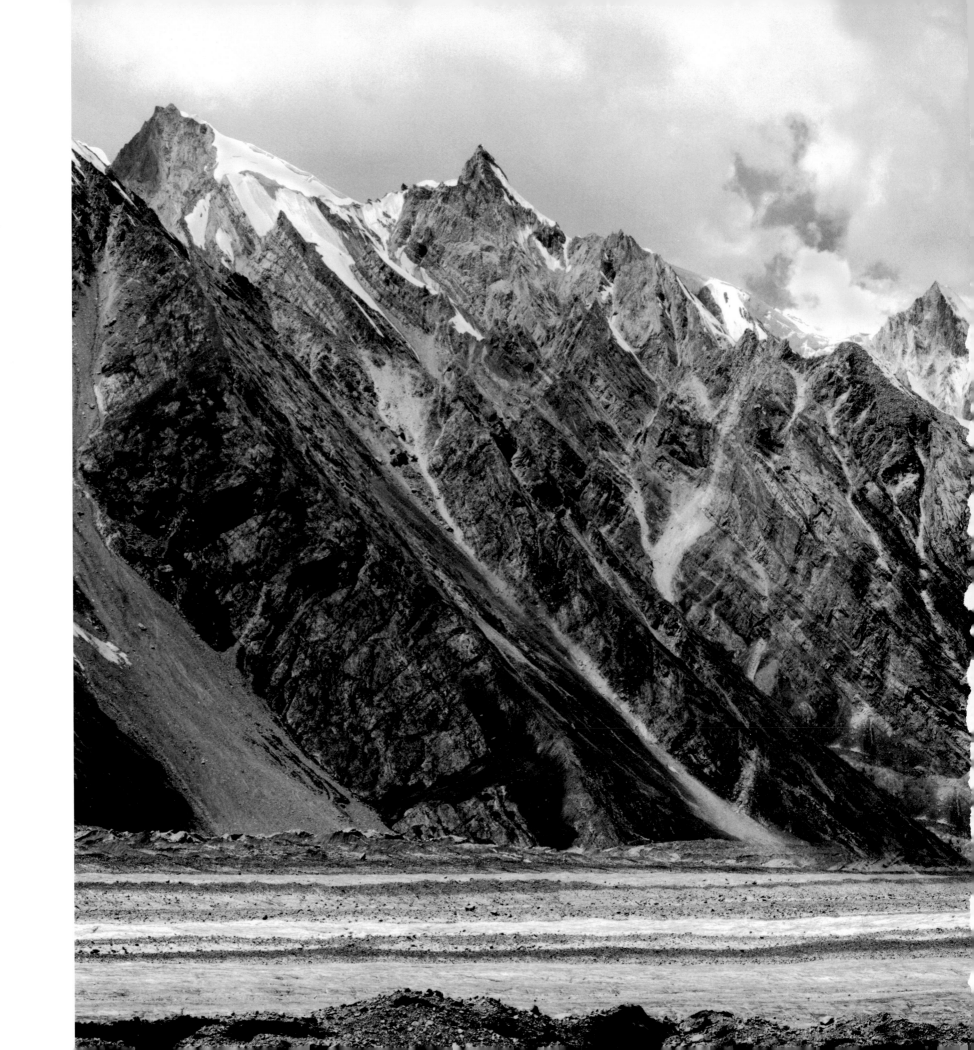

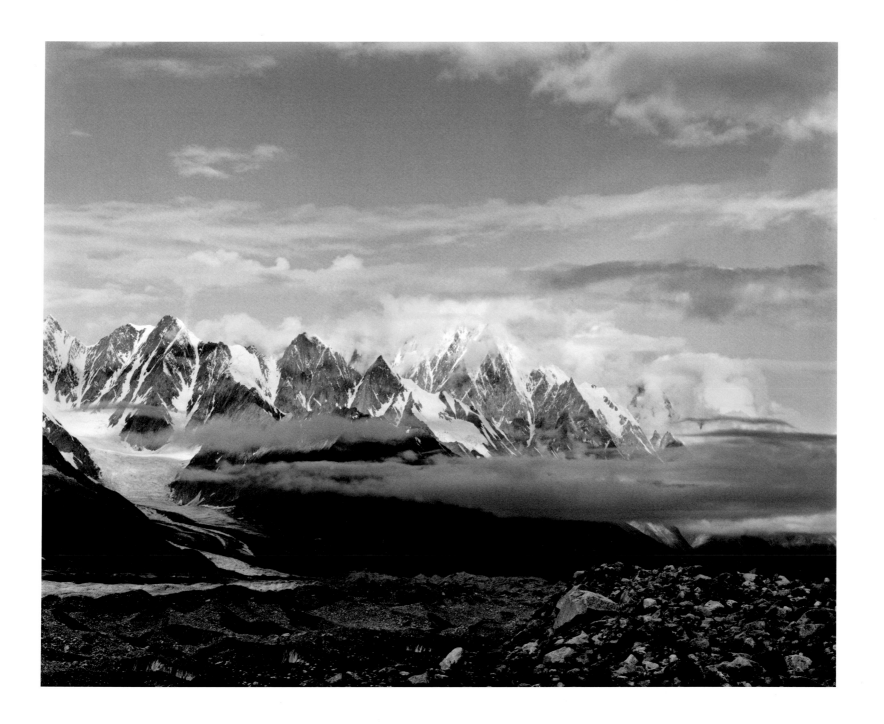

Makron Chhish Group and the Hispar Glacier from Jutmal Camp; Morning Light

Jutmal (4,420m/14,502ft) was the second stony camp after crossing the Hispar La (Day 15; Makron Chhish: 6,607m/21,677ft). We reached Hispar village just beyond the snout of the glacier on Day 19 and on Day 20 made a jeep ride down a perilous switchback road through arid gorges to reach the Hunza Valley. In the valley were long watercourses supporting poplars, apricot trees and abundant green fields. From the fortress town of Karimabad (2,500m/8,202ft) on the Karakoram Highway, we returned to Rawalpindi via Gilgit. The people of the Karimabad area are mostly of the Ismali sect of Islam.

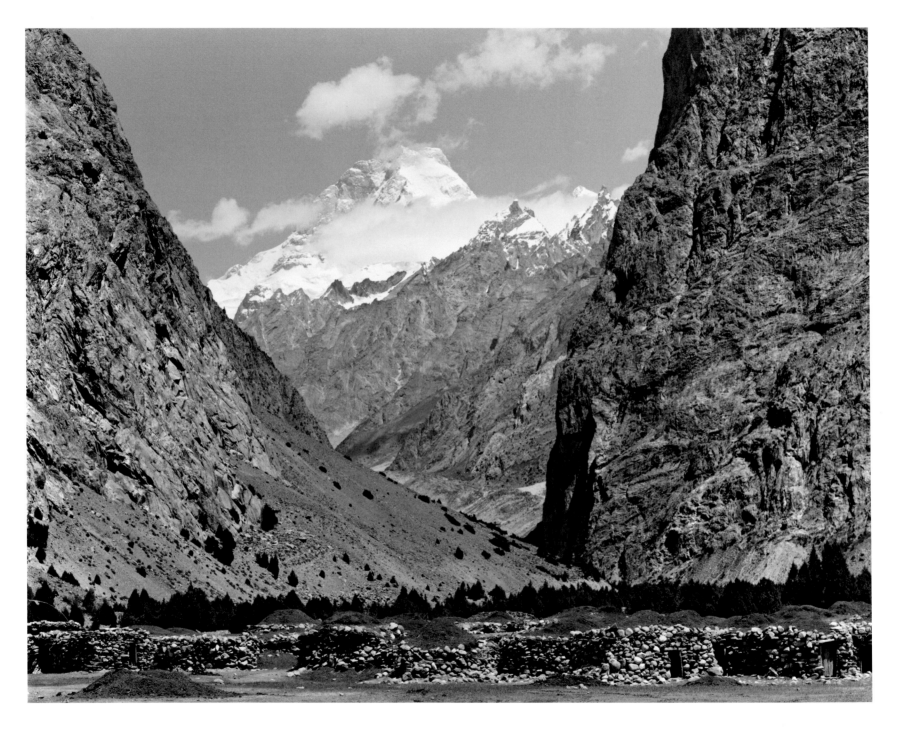

Masherbrum I from the Junction of the Masherbrum and Hushe Valleys; Huts and Goat Pens

Our 2001 approach to the Karakoram was from the south via Khaplu on the Shyok River. The Shyok rises in Tibet and collects all the melt water from the southern Karakoram before it joins the Indus to the southeast of Skardu. On July 6 (Day 1) we traveled by road from Skardu to Khaplu and then ascended north towards the village of Hushe (3,100m/10,170ft). The photograph was taken on our way to the Masherbrum Glacier and Base Camp (4,100m/13,452ft). This was a two day acclimatization trip. (Masherbrum I: 7,821m/25,661ft.)

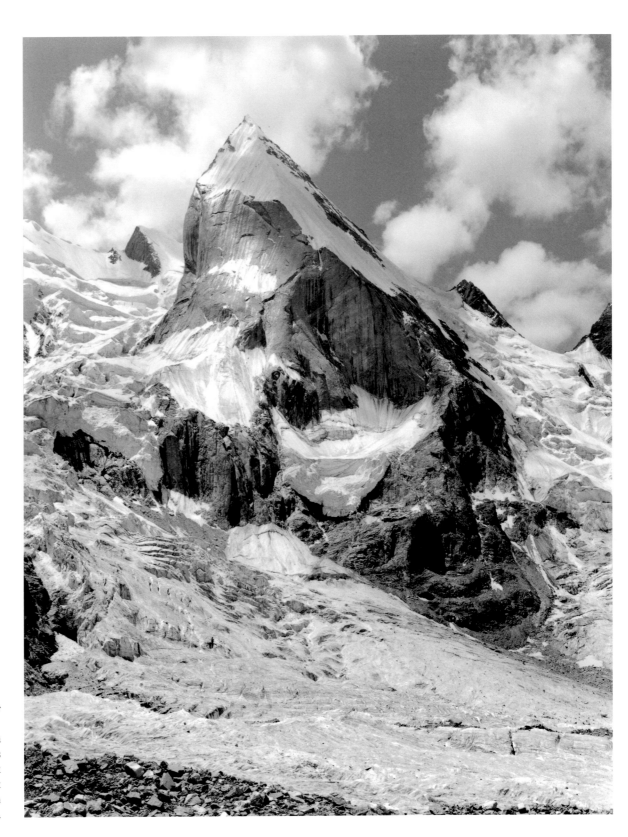

Layla Peak from the Gondokoro Glacier

The Hushe valley divides into the Gondokoro and Charakusa Glaciers. We turned north on the former. The photograph was taken on Day 11 shortly before reaching the Gondoro Peak Base Camp (4,800m/15,749ft). The Layla granite peak (6.200m/20,340ft) was ice carved from the Karakoram Batholith that formed about 21-25 million years ago.

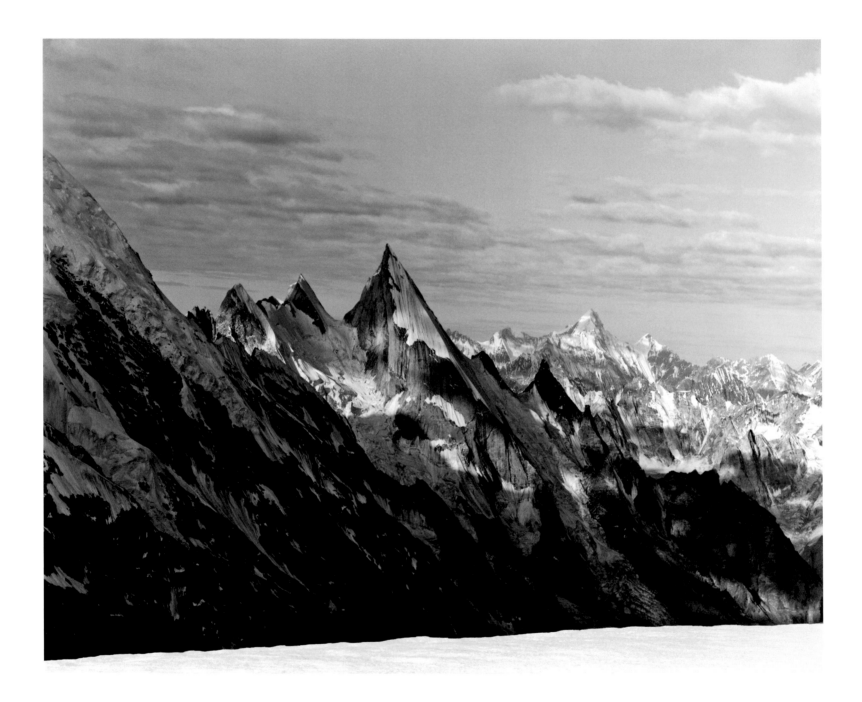

First Light on Layla Peak from the Gondoro La; View South

The snow covered summit of the Gondoro La (5,585m/18,323ft) was reached at 6 am of Day 12. We started the stony ascent from a high camp at 11:20 pm the night before. Layla Peak, first climbed in 1985 by Simon Yates, et. al. (alpine style; no permit, hence unofficial), is about 2000 ft higher than the pass.

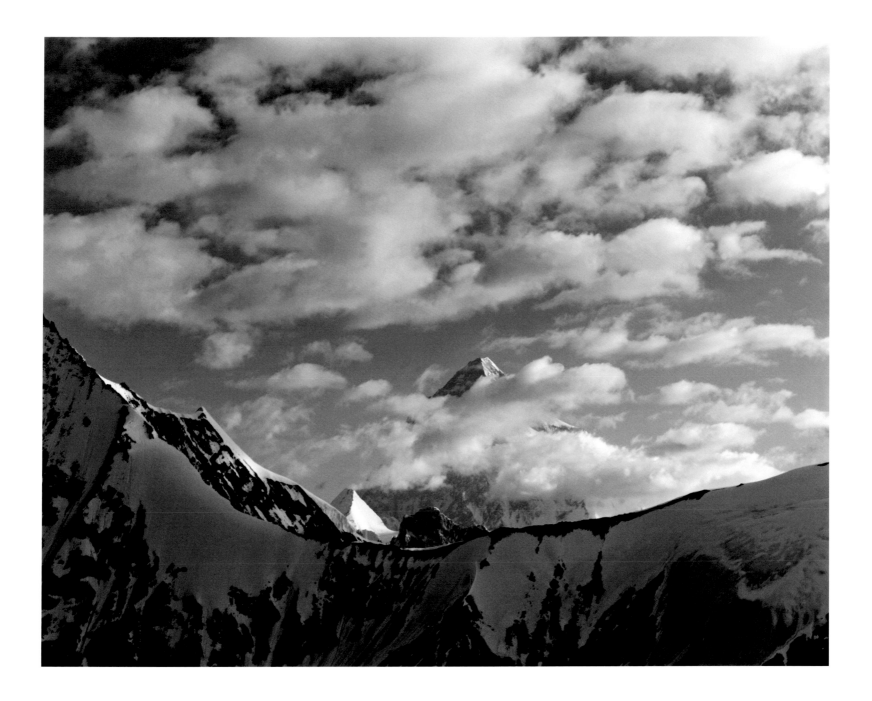

First Light on K2, Angel Peak and Mitre Peak from the Gondoro La; View North

Viewed from the pass K2 (8,611m/28,251ft) stands in splendid isolation—a pyramid of gneiss formed over 100 million years ago. Angel Peak, the white triangle, is a sub-sidiary peak on K2. Mitre Peak (5,770m/18,930ft), a black triangle of Carboniferous slate, is on the near side of Concordia. Concordia is a large area of moraine-covered glacier at the junction of the Godwin-Austen and Baltoro Glaciers. From the pass we made a steep descent past crevasses to the Vigne Glacier and continued to Concordia.

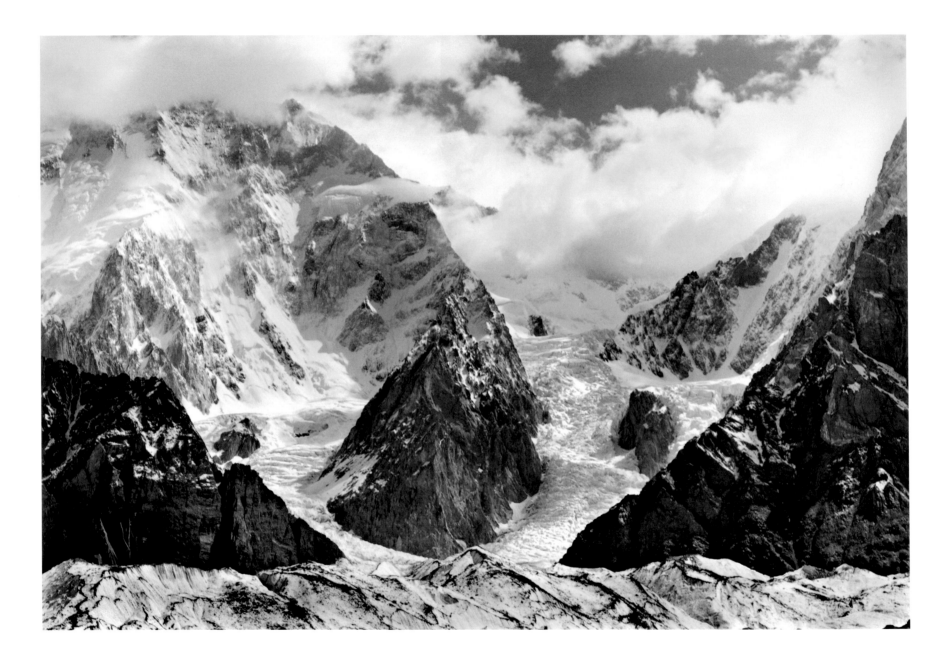

Broad Peak and the Gasherbrum Glacier from Concordia, View Northeast

A day of wet snow and cloud preceded our arrival at Concordia (4,650m/15,256ft). On the morning of Day 15 the clouds began to dissolve. Broad Peak (8,047m/26,400ft), the twelfth highest mountain, is to the right of the Godwin-Austen Glacier. The peaks about Concordia, other than K2, are composed of sedimentary and weakly metamorphic rocks.

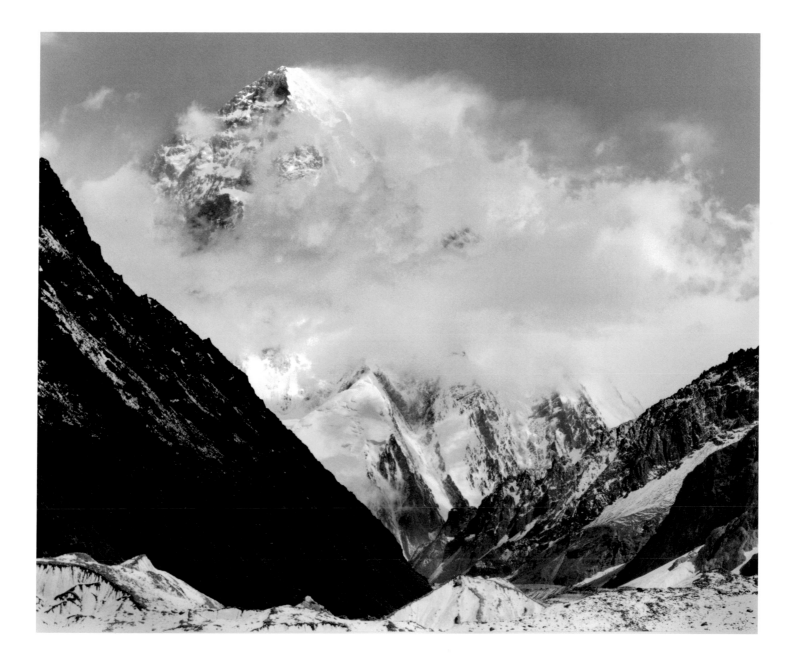

K2 and the Godwin-Austen Glacier from Concordia, View North

K2, the second highest mountain, rises abruptly beyond the junction of the Savoya and Godwin-Austen Glaciers. The junction is below the central shoulder in the photograph. The climbers' memorial set up after the death of Arthur Gilkey, a young geologist on the 1953 American expedition, is at the junction. The Base Camp is a little beyond the memorial to the right on the edge moraine of the Godwin-Austen Glacier. After visited the K2 Base Camp and the memorial, we returned to Concordia before descending the Baltoro Glacier.

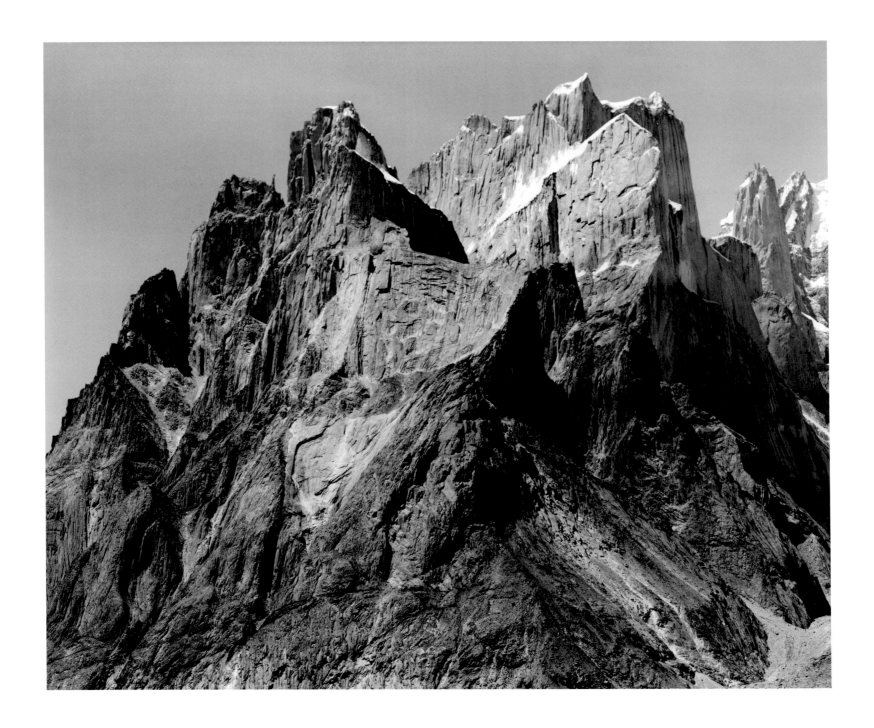

Trango Towers Complex from the Baltoro Glacier, View North

The Baltoro Glacier carved its way through the granite of the Karakoram batholith creating on the northern side of the glacier dramatic cathedral formations and the Trango Group. Most of the Trango peaks are over 6,000 m (Great Trango: 6,286m/20,610ft). The photograph was taken on the afternoon of Day 18 before reaching Horebose camp.

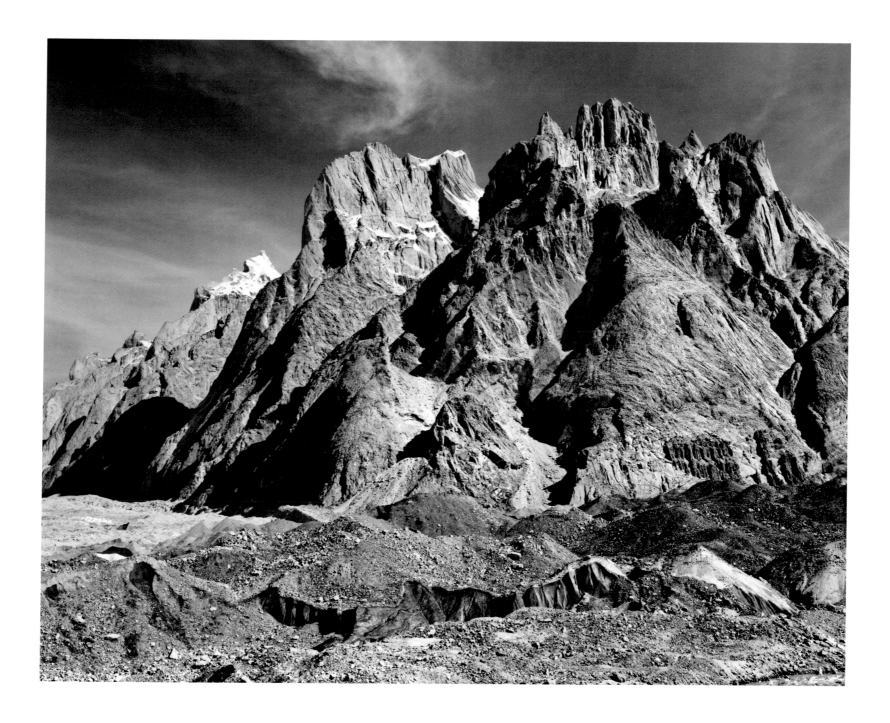

Trango Towers Complex from the Baltoro Glacier, View Northeast

This photograph was taken from the rocky edge of the moraine on the morning of Day 19 shortly before crossing to the northern side of the glacier. Glacier elevation about 3,900m/12,796ft.

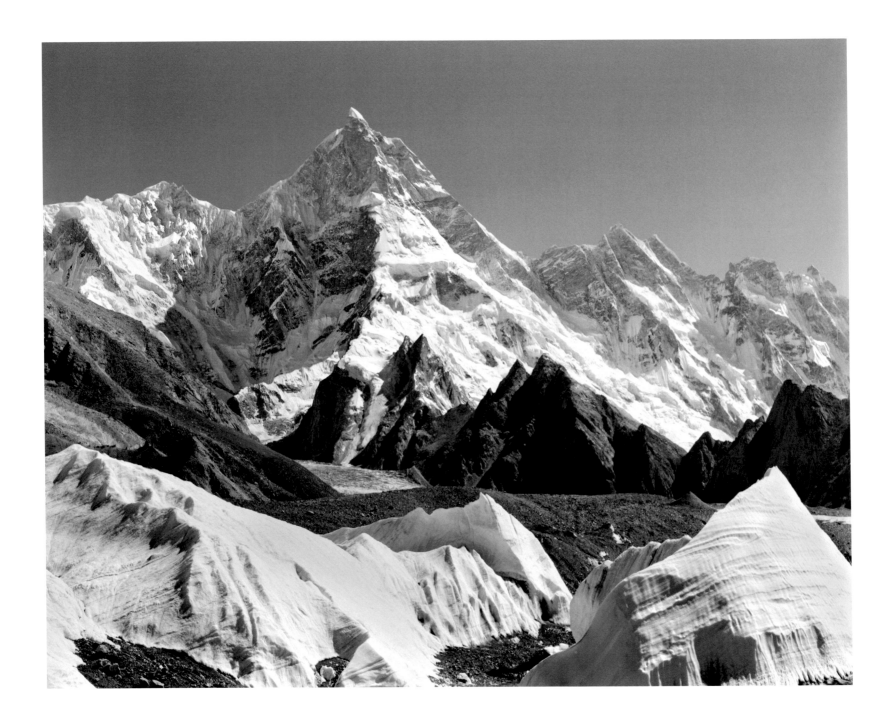

Masherbrum I from the Baltoro Glacier, View South

Masherbrum I (7,821m/25,659ft), seen earlier from the south (page 26) and also from the Southern Base Camp, presented a strikingly different appearance from the north.
Photograph Day 17; glacier elevation about 4,200m/13,780ft.

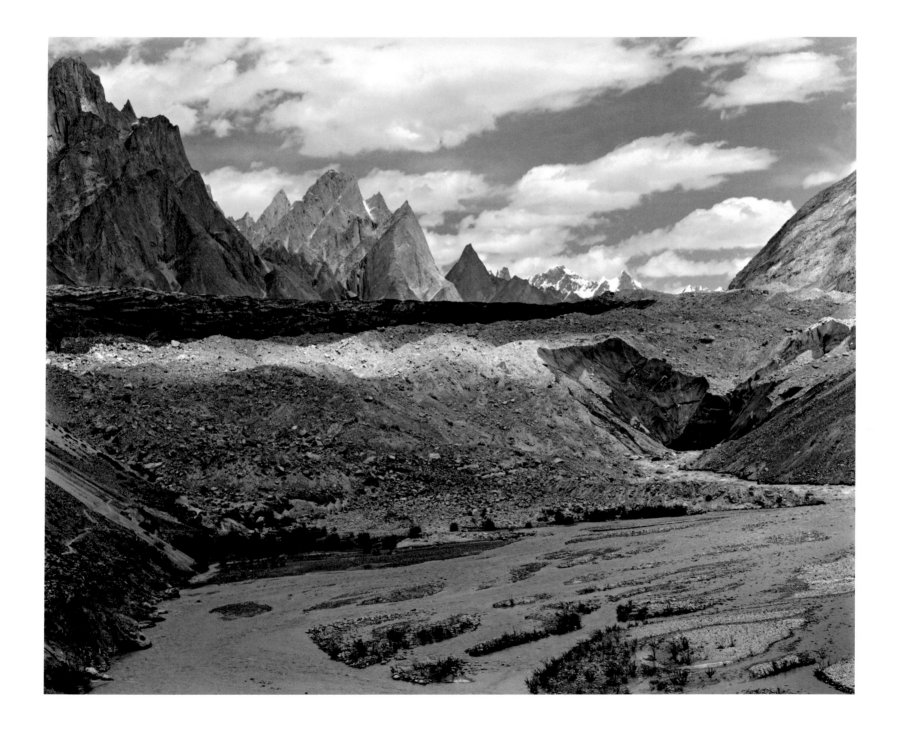

Terminus of the Baltoro Glacier

The photograph was taken on Day 19 before reaching the Paiju campground; glacier elevation about 3,500m/11,483ft. The Baltoro Glacier comes to an end a day's walk before the snout of the Biafo Glacier is encountered. We returned to Skardu from beyond Askole Village on Days 21 and 22 via the disrupted road through the Braldu Gorge.

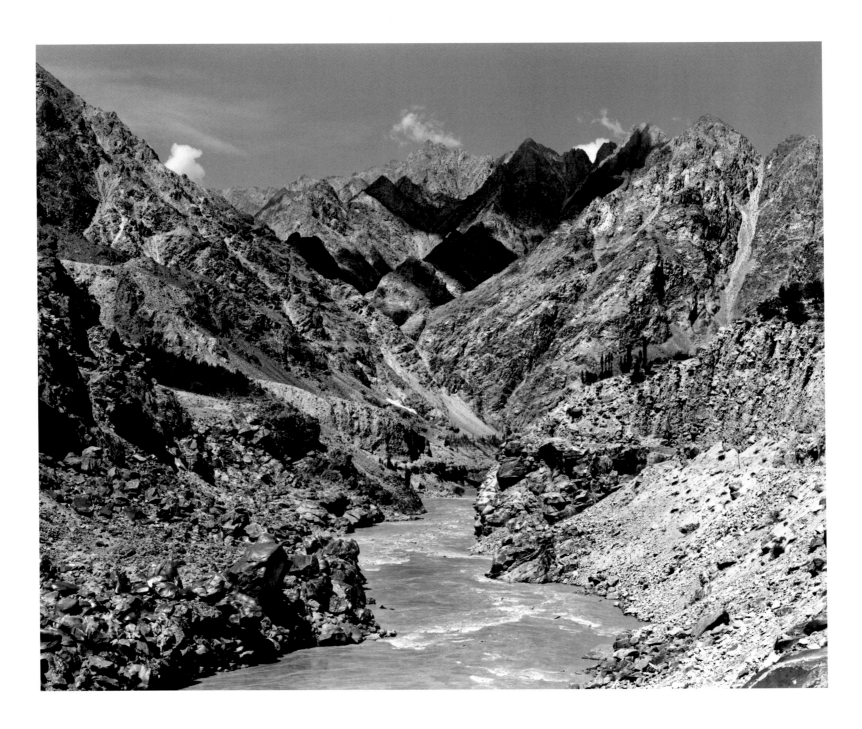

The Indus in Ladakh near the Line of Control; View Northwest

The Indus has created a broad valley in the sedimentary rocks to the south of the Ladakh Range and north of the Zanskar Himalaya. Leh (about 3,290m/10,794ft), the regional capital of Ladakh, is on the northern edge of this valley. The Indus cuts through the Ladakh Range on its way to Skardu, some 35 miles away, rather than through the Great Himalaya towards Srinagar. In August of 1997 we followed the irregular road almost to the de facto border. In 1999 the border became a battleground—the Kargil Crisis.

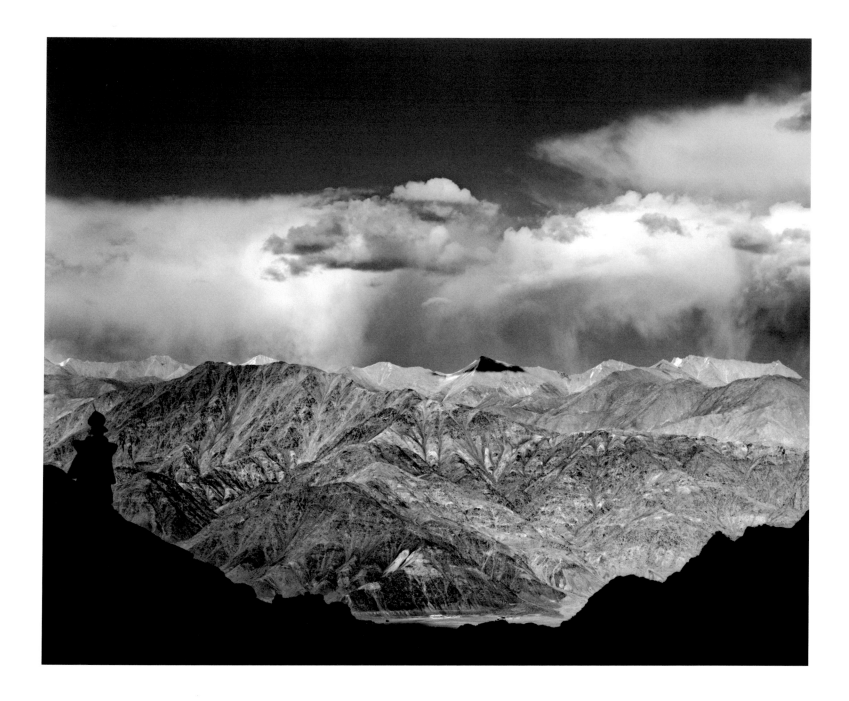

Storm over the Ladakh Range; Indus Valley from the Roof of Hemis Monastery; Afternoon Light, View North

The Ladakh Range, the greatly eroded remains of a volcanic island arc, separates the Indus from the Shyok River (peak heights about 5,800m/19,029ft). Hemis Gompa, that overlooks the Indus valley about 20 miles southeast of Leh, was built in the seventeenth century. It belongs to the Drug-pa branch of the Kagyu-pa (red hat sect), part of the older strata of Tibetan Buddhism. It is famous for a festival that features dances in homage to Padme-sambahva, the teacher honored for bringing Tantric Buddhism to Tibet around 760 CE.

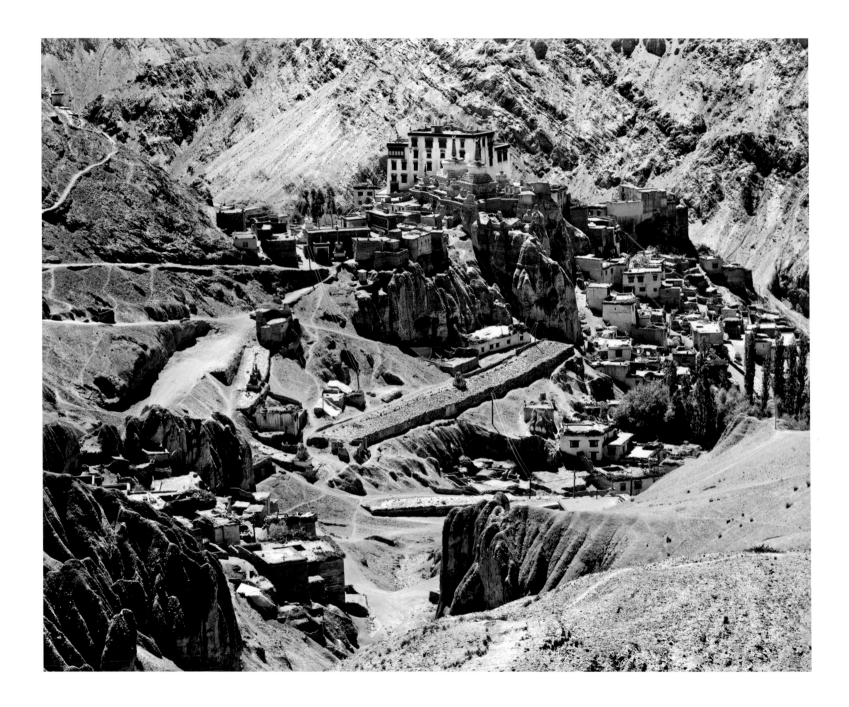

Lamayuru Gompa viewed from the Leh to Kargil Road (Highway 1A)

A Buddhist monastery (once Kagyu-pa, later Gelug-pa) has been present in the Lamayuru Valley since at least the tenth century CE. The site was probably a sacred place for centuries before that. It contains a cave where Naropa, one of the 80 great Buddhist Yogin and the subject of many fantastic legends, is said to have meditated. The monastery (3,444m/11,300ft) is only a few miles from the Fotu La (4,108m/13,479ft), the highest point on the ancient trade and pilgrim route linking Leh to Srinagar and also to Skardu and hence to the Silk Road.

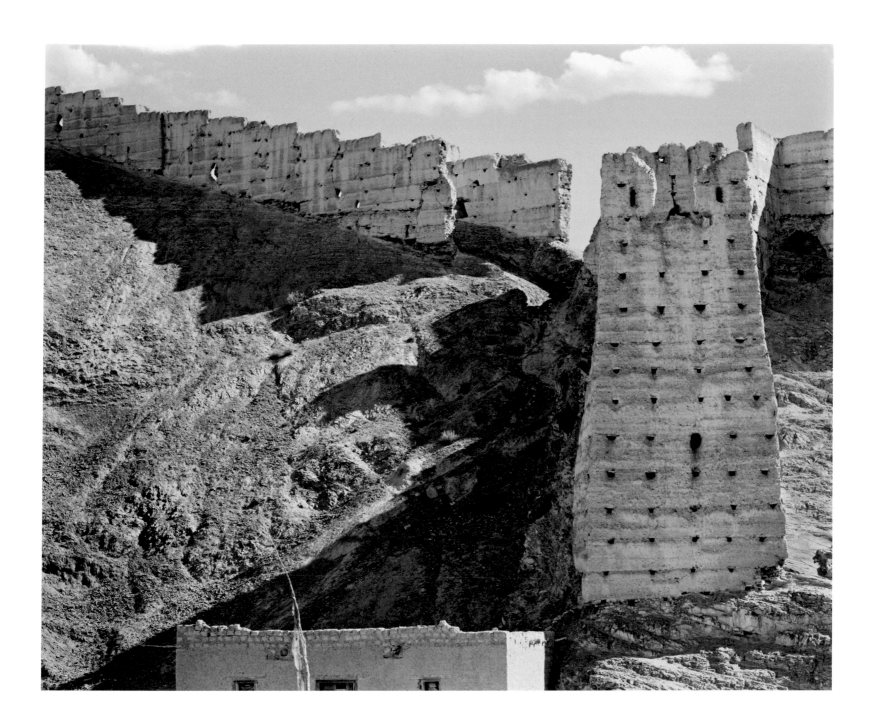

Palace Walls, Temisgam

The remains of this combination palace, fortress and monastery are located in a stony side valley to the north of the Indus about seven miles from the bridge on Highway 1A that leads to the south bank and continues towards Kargil. The palace may have prospered by controlling the Indus trade route that is now Highway 1A. The highway is a key part of India's border defenses. Beyond the bridge army trucks slowly ascends by at least 19 switchbacks to the Fotu La, a pass flanked by 5,500 m peaks.

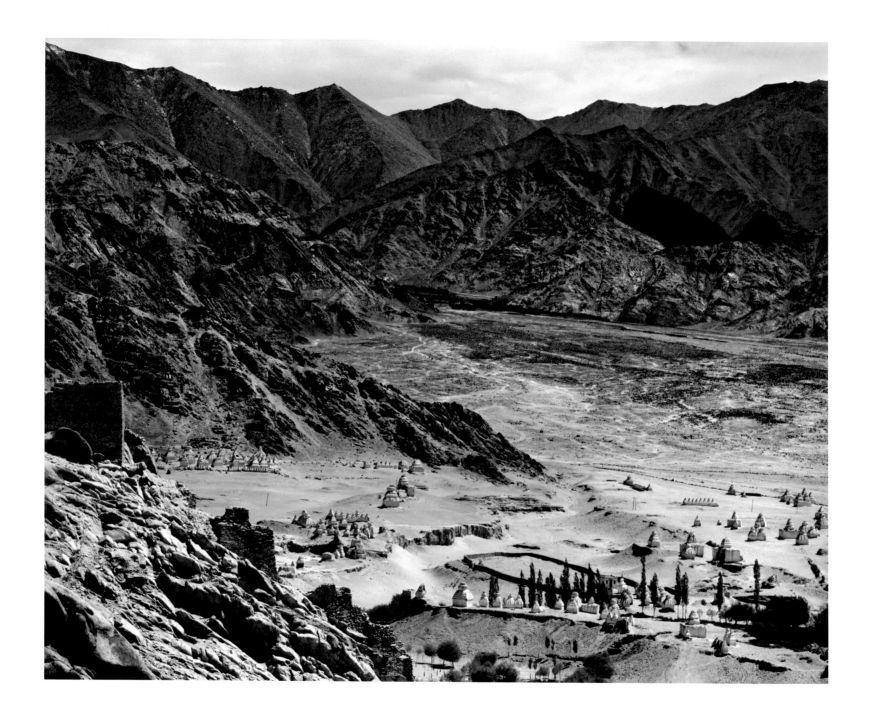

Buddhist Chorten on the Sandy Plain below Shey Palace and Gompa

Shey was built as a summer palace by the first king of Ladakh in about 1,450 CE. The ruined palace and the Monastery of Shey overlook the broad green valley of the Indus about 9 miles east of Leh. The monastery is noted for its wall paintings and large golden Buddha. The sandy field of chorten is to the east. The name 'Shey' has Buddhist associations and means crystal; see page 58.

Pashmina Goats at Nyimaling; Markha Valley

The Markha Valley is a region of sedimentary rocks (red and green slate) that lies parallel to the Indus south of Leh. Nyimaling is a large area of open moorland at 16,000 ft at the head of the valley. There Pashmina goats are raised for their fine cashmere wool. They must be herded into pens for the night and guarded to protect them from wolves. The photograph was taken from the roof of a herder's hut on Day 8 of our trek up the valley. The following day we crossed the Gong Maru La (5,200m/17,060ft) and descended towards Hemis.

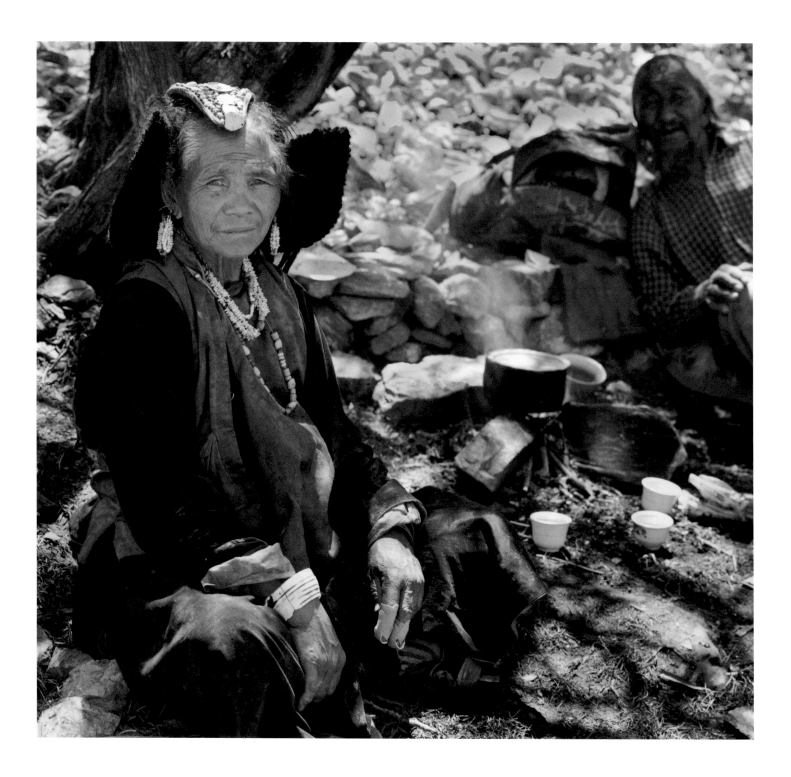

Woman From Markha Returning After Hearing the Dhali Lama Conduct a Kalachakra Ceremony in Leh

The woman and her husband had been walking for two days after taking a bus ride from Leh. In getting off the roof of the bus she had torn her hand. Seeing her bandaged hand, we provided band aids and this encounter led to the portrait. The headdress was probably worn especially for the ceremony in Leh. The photograph was taken on Day 4 of our 10 day walk up the Markha Valley.

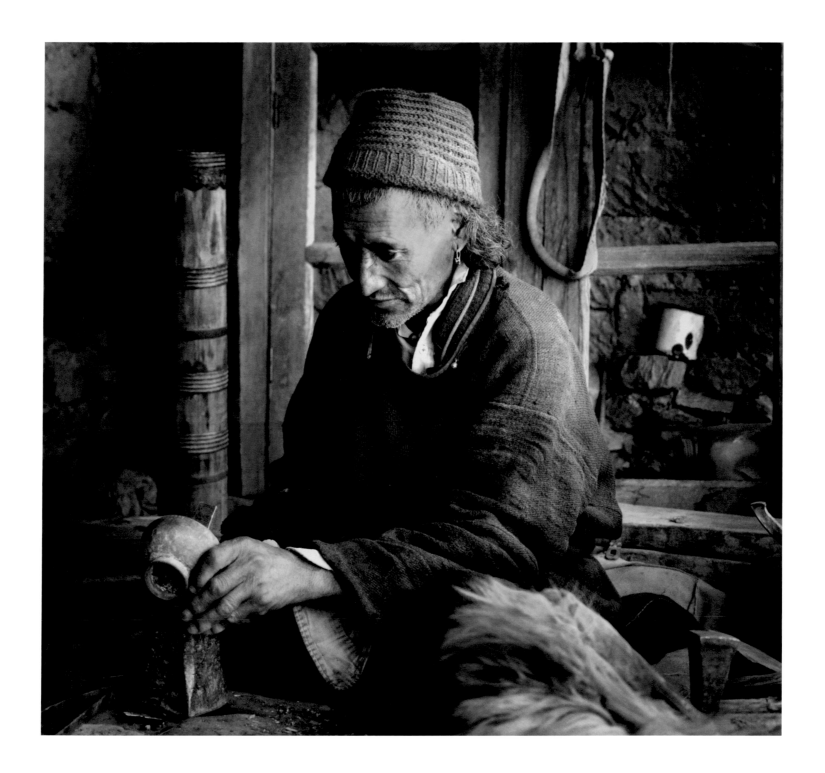

Coppersmith, Markha Valley

Highly polished copper wear is characteristic of Ladakhi houses. There is a small local industry making copper vessels in the Markha Valley. This coppersmith was a relative of our guide. The photograph was also taken on Day 4.

THE HIDDEN REALM

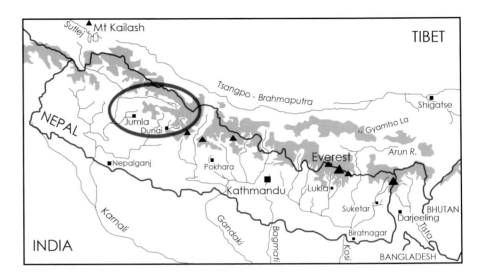

Outer & Inner Dolpo, Western Nepal

Western Nepal is defined by the watershed of the Karnali river system. Within Western Nepal is the ancient region of Dolpo (or Dolpa) that once owed formal allegiance to the kings of Jumla. The greater part of the region, Inner Dolpo, lies on the far side of the Himalayan chain and can only be reached by crossing high passes that are closed by snow for several months in winter. The landscape is fashioned from sedimentary rocks of the Mesozoic era laid down 251-65 million years ago (as is the Tsangpo valley of Tibet). In the main section a fan of rivers drains westward to join a branch of the Karnali system that has cut through the Himalayan chain to the west of Kanjiroba (6,883m/22,583ft). To the east, beyond the Tsharka La (5,030m/16,500ft), is a second basin that is drained by the Barbung extension of the Thuli-Bheri River that cut through the main chain to the north of the Dhauagiri Himal. In general, Inner Dolpo consists of deep valleys separated by high moorland with villages and settlements above 12,000 ft and some as high as 15,000 ft. The inhabitants have survived in this isolated world by raising barley, goats and yaks and also by trade using caravans of yaks. Barley was formerly traded for salt in Tibet that was then traded for food and goods in the Jumla region. High rounded hills form the border with Tibet and passes through the hills make access to the Tsangpo valley relatively easy. As a result of its isolation from, yet proximity to, Tibet, Inner Dolpo has preserved ancient traditions of Tibetan Buddhism that were partly displaced in Tibet in the seventeenth century when the Gelug-pa, the yellow hat sect associated with the Dalai Lamas, became ascendant.

The culture of the higher regions of Outer Dolpo is similar to that of Inner Dolpo, but the hills and steep valleys to the south of the Himalayan crest are often deeply wooded with deciduous forests and conifers. At the lower elevations, and as Jumla is approached, the village culture becomes Hindu, but there are villages with curious blends of Buddhist and Hindu beliefs. The major divide between Inner and Outer Dolpo is the Kang La (5,346m/17,540ft). To the south of this pass across the Himalayan chain is Phoksumdo Tal (3,600m/11,811ft), a deep clear lake that was created by a massive earthquake-induced landslide. Near the outlet of the lake is the Tibetan style village of Ringmo. On the edge of the lake is a Bon monastery remarkable for its wall paintings. Monastic Bon has shared so much with Tibetan Buddhism that it can be regarded as an odd Buddhist sect. The Suli-Gad River that flows south from the lake joins the Thuli-Behri River at Dunai, the Dolpo regional center. The route for traders from Inner Dolpo to Jumla does not descend to Dunai, but follows a branch of the Suli Gad River past the village of Pungmo to the Kagmara La (5,115m/16,782ft), a broad snow-covered pass over a southward branch of the Himalayan chain. Beyond the pass the trail descends to the Bheri River and then crosses the Nari La (3,740m/12,276ft) to the south of Kanjiroba. Seen from the pass, isolated on the far western horizon, is the highest peak in India, Nanda Devi (7,816m/25,677ft).

Inner Dolpo is a unique island of Tibetan culture that has survived with limited change for several hundred years. Its temples and monasteries (gompas) with their beautiful wall paintings escaped the systematic destruction wrought in Tibet by the Red Guards in the Cultural Revolution launched by Mao in 1966. The region was unknown to Western scholars prior to 1956 when David Snellgrove, a student of Tibetan texts and

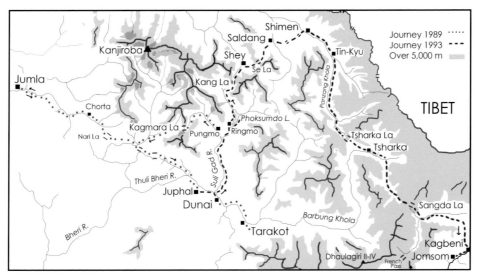

ceremonies from the University of London, visited the area. The account of his travels was the inspiration and guide for our journey (see Part II, Essay, Section 2). In Dolpo Buddhist and Bon practices have multiple layers in which monastic traditions have reformulated older Shaman-led beliefs. Local gods, clan gods and spirits, are an integral part of village life. That life is bound to the seasons of planting and harvesting that demand periods of extraordinary labor. Marriage, kinship, inheritance customs, ceremonies and festivals have evolved in response to the need for survival. If global warming should lead to greater aridity, this sky-island culture could exist only in memory.

The Chinese annexed Tibet in 1959; Inner Dolpo and Lo-Mustang provided a base for Tibetan guerrilla fighters between 1961 and 1971. The region was therefore closed to Westerners by the Nepalese government. 1989 was the first year that access was allowed for trekking groups, but our duffel bags were extensively searched for guns and we were only allowed to go as far as Phoksumdo Lake. In 1993 Inner Dolpo was opened, but we had to be accompanied by a report-writing liaison officer. At that time the Maoist insurgency was confined to a few remote events, but after 1996 the problem became serious. There was a major attack on the police post at Dunai. The insurgency again placed Phoksumdo-Shey National Park more or less off limits.

Outer Dolpo, 1989. The first journey consisted of a twenty-day loop that began and ended at the Jumla airstrip. We left Jumla October 7 at the tail end of the monsoon and for a week coped with mist and rain. When we returned to Jumla the landscape was transformed: almost all the millet in the wide valley had been sickle-harvested and threshed and every grain and wisp of straw had been gathered. Brilliant light created intense shadows in a stubble-sea of gold. The trek took us over the Nari La to the Thuli-Bheri River

and that river led us to Dunai and to Tarakot. This fortress-village must formerly have controlled a trade route linking Dolpo to the Kali Gandaki valley. On returning to Dunai we ascended the Suli Gad River to visit Phoksumdo Lake and then returned to Jumla via the Kagmara La.

Inner Dolpo, 1993. Most Nepal routes are well known to the trekking companies, but in this case the transit of Inner Dolpo was new to all concerned. The Juphal airstrip is poised on the hillside near Dunai. On October 6 our 16-seater plane crossed a shoulder and suddenly we were on the ground looking at sacks of potatoes awaiting the return flight. Twenty days later we returned to Kathmandu from the Jomsom airstrip in the Kali Gandaki Valley. From Dunai we ascended to Phoksumdo Lake and from there followed the cliff trail. After climbing a narrow gorge we reached the Kang La—despite its name the pass was snow free (kang = snow). The crest of the pass is not much lower than the neighboring peaks; Kanjelaruya (6,612m/21,700ft) was on our left. From the pass we descended a long gorge to reach the isolated Shey monastery (4,482m/14,700ft). From Shey, yak trails and a pass led to Saldang (3,850m/12,632ft) where the barley harvest was in full progress. We reached Shimen (3,853m/12,640ft) in the valley of the Pangjang Khola by way of a pair of high moorland passes. Here the harvest had long since been completed. The trail ascending the valley climbed steeply up and again down whenever the river swerved through narrow impassible clefts. At Tin-Kyu a valley led to Tibet, but we followed the wide arid valley to the south until we crossed the Tsharaka La. At Tsharka threshing and winnowing was in progress from morn till eve. Beyond Tsharka the land was high and cold, the coldest being the Sangda La (5,520m/18,100ft). The crest provided views of Dhaulagiri Himal to the south. Eventually we reached the overlook of the trail to Lo-Mustang, descend to Kagbeni in the Kali Gandaki Valley and reached the Jomsom airstrip. The transit completed, we returned to Kathmandu.

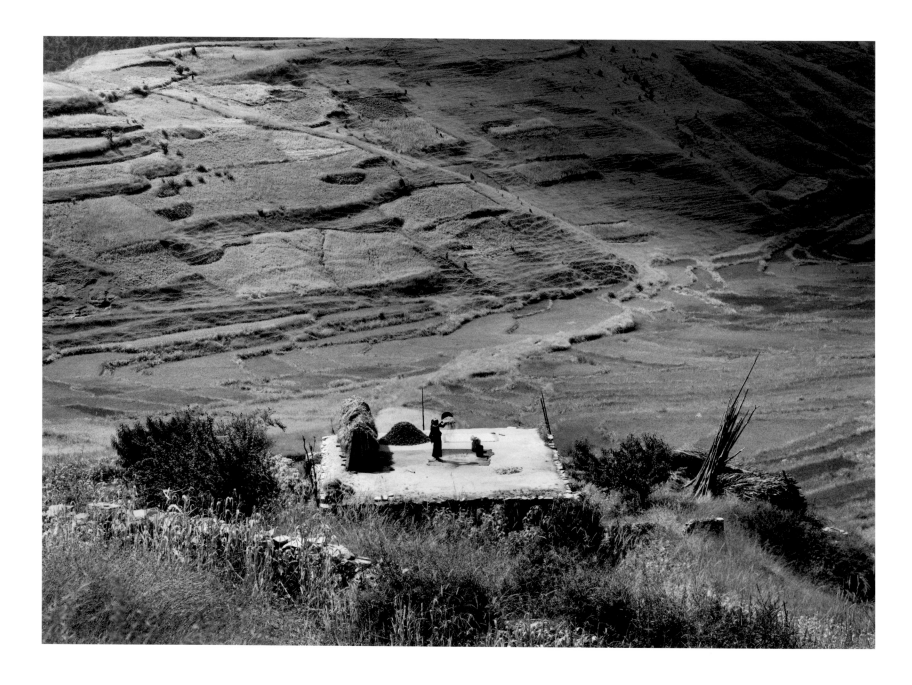

Woman on Roof Winnowing Millet; Jumla

Jumla is a major regional center in Western Nepal that was once the capital of an important kingdom. In 1989 we flew to Jumla from Kathmandu via Nepalganj. The tents, which had set out from Kathmandu 15 days earlier, were awaiting near the airport for our arrival, but a sufficiency of porters was missing. We had arrived on October 6, the high point of the fifteen day Hindu Dasain festival that commemorates the slaying of the demon Mahisasur by the goddess Durga. This, the eighth day (Maha Asthami), was the day for sacrifices to Durga (or to Kali). While the staff searched for extra porters willing to forgo the celebrations I photographed. (Day 2, 1989; elevation 2,340m/7,677ft.)

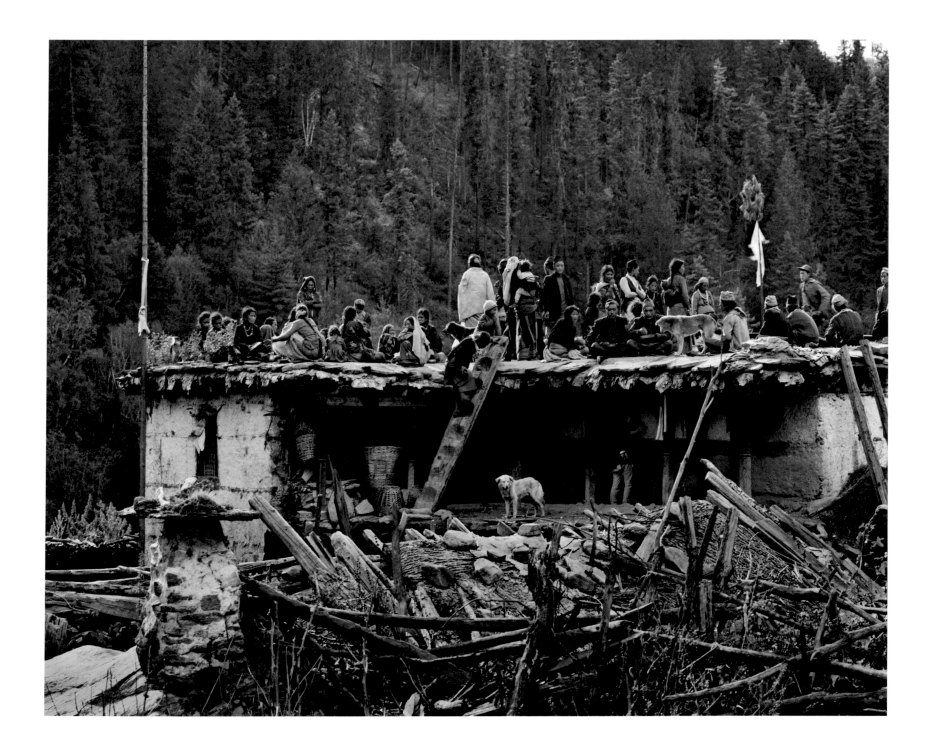

Chorta Village, Roof Party, Dasain Festival; Jumla Region

The village of Chorta was the first clearly Tibetan community encountered. The lama of the local Gompa had come there from Tibet 18 years earlier bringing with him important Thankas. When I first tried to take the photograph lively children besieged my camera and giggled at the image on the ground glass screen. I left and then returned to make a second attempt. The roof celebration appeared to be a Tibetan adaptation of the Hindu festival—any excuse for a party! (Day 4; elevation 3,050m/10,007ft.)

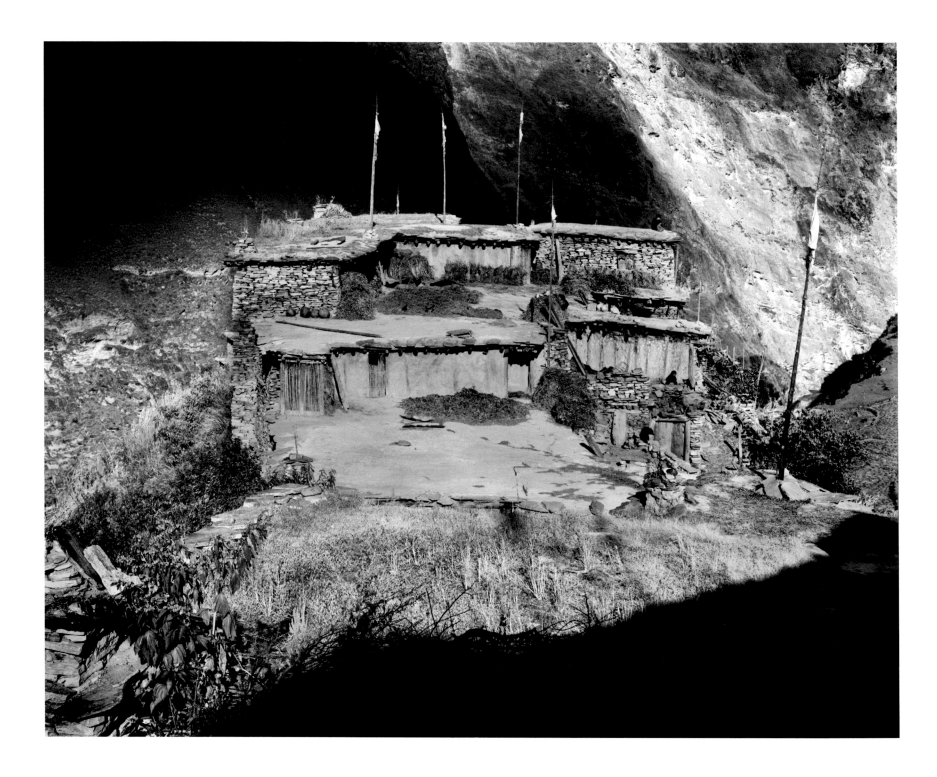

Tarakot Village, Children on the Roof; Afternoon Light

We reached Tarakot after following the Thulo Bheri River to Dunai and then ascending the Barbung Khola. The village is poised on the hillside overlooking the junction of the Tarap Khola with the Barbung Khola. Both valleys lead to Inner Dolpo. In 1989 police posts were alert to prevent our sneaking into the area; the police threatened to hold our sidar in custody until we had departed for Dunai. To the southeast is a route to the area south of Dhaulagiri that I visited in 1992. Tarakot's position as a trade-route hub probably explains its fortress appearance. (Day 10; elevation 2,500m/8,202ft.)

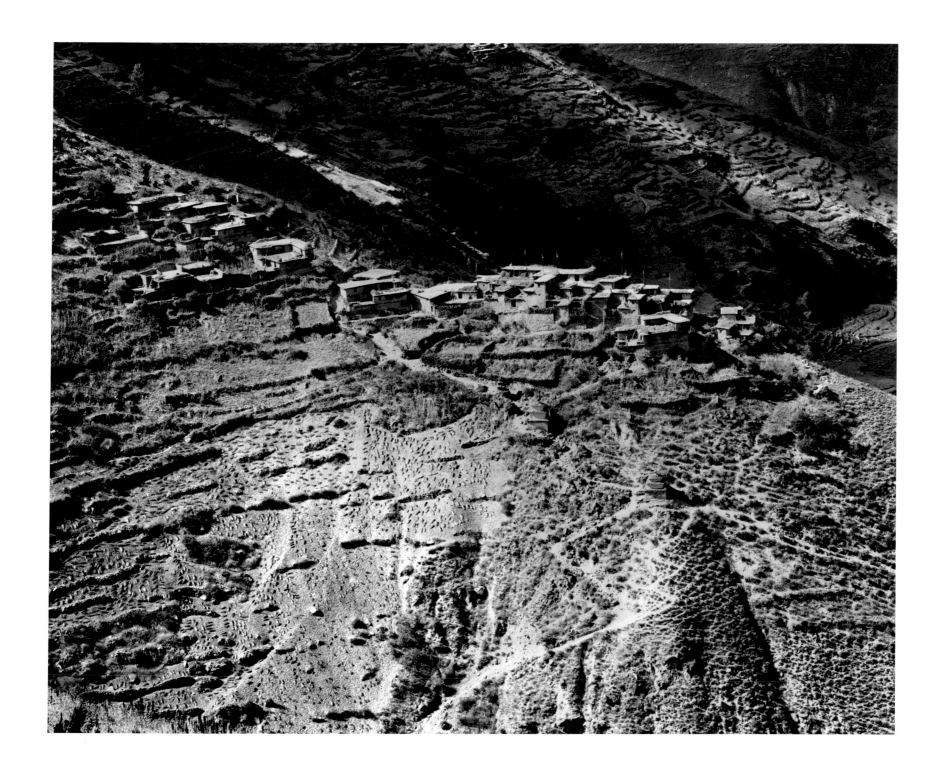

Tarakot Village, Buckwheat Harvest; Afternoon Light

This photograph was taken from just below the Tarakot Gompa that is perched on a shoulder high above the other settlements (about 2,770m/9,088ft). The Gompa is of the Nying-ma-pa sect (the Old Sect) that holds its founder, the Tantric teacher and miracle worker Padma-sambahva, to be a Buddha ranking with Sakyamuni Buddha. As at Chorta, the Lama was married. Most of the buckwheat had been cut by sickle and bound into the sheaves that form a pattern in the photograph. As I climbed the steep trail past the gateway chorten to the village, women were ascending with wicker baskets full of grain from the days threshing. Others were burdened with great piles of straw.

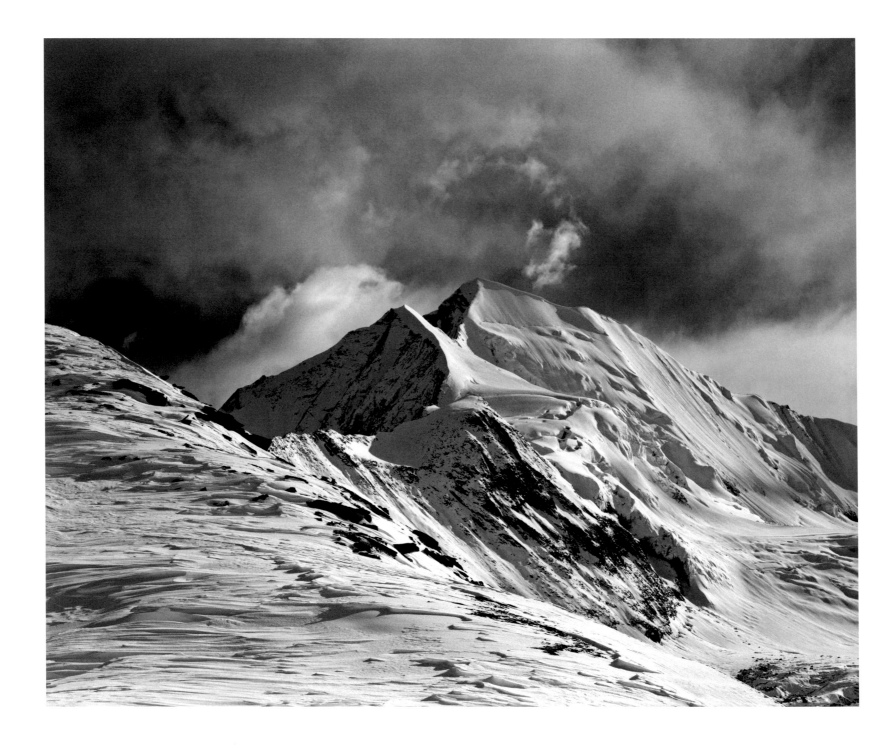

Kagamara La and Peak to South

The shortest route from Inner Dolpo to Jumla is by way of the Kagmara La (5,115m/16,782ft). The pass has been used since ancient times by Dolpo traders driving yaks that carry Tibetan salt, wool and hides. The pass was crossed on Day 17 on our way back to Jumla after we had made a loop to Tarakot and Phoksumdo Lake.

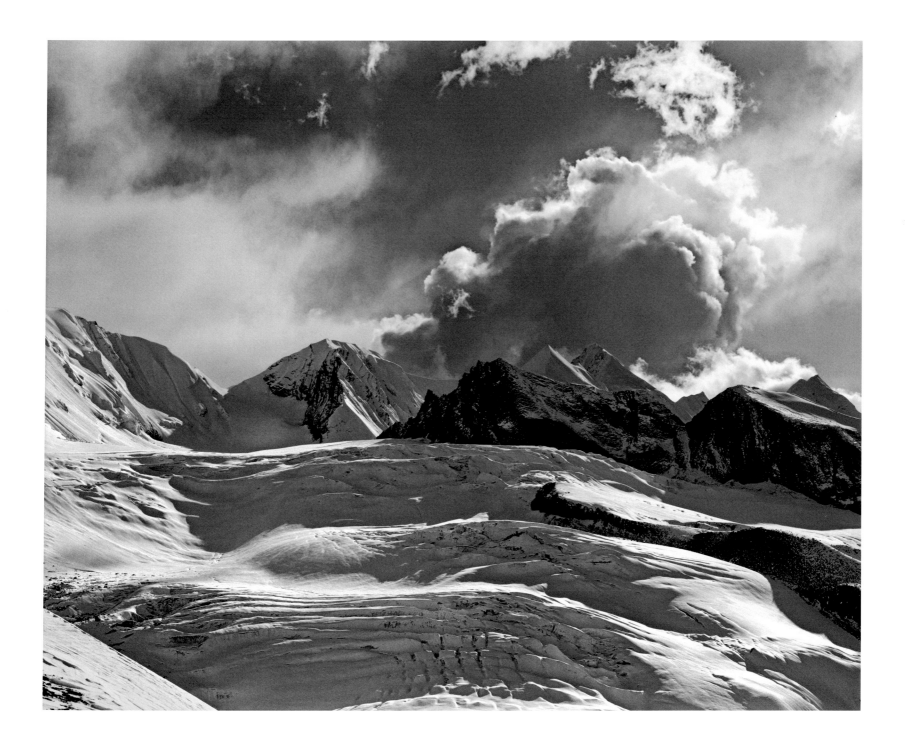

Kagmara La, Range to South and Glacier

This photograph overlaps slightly with the facing picture. The Kagmara range (Peak I: 5,961m/19,558ft) is a southern offshoot of the main Himalayan chain that swings round from the Kang La past Kanjelaruwa (6,612m/21,700ft) to Kanjiroba Himal in the northwest (Peak I: 6,883m/21,927ft).

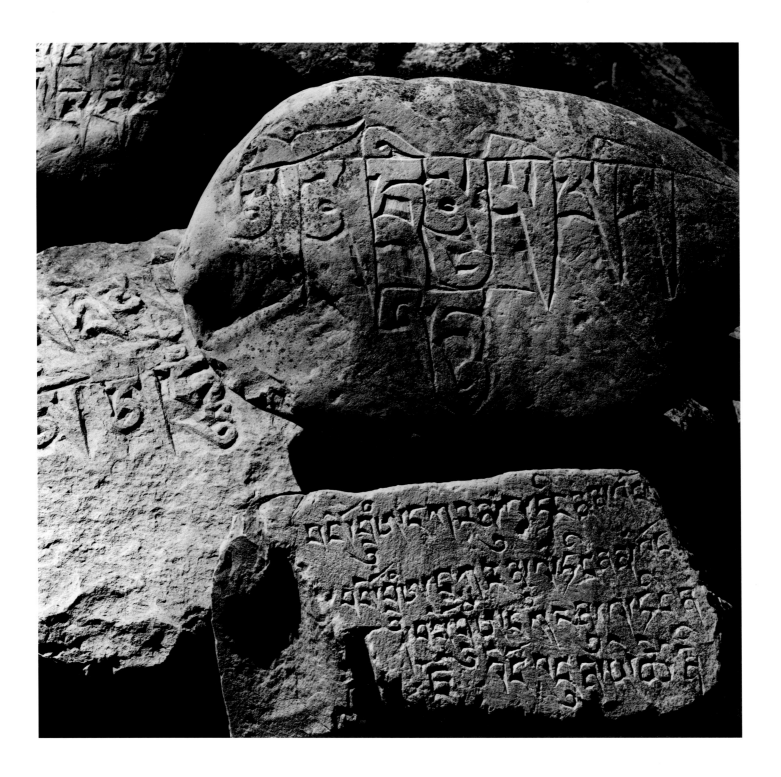

Pungmo Village, Mani Stones on Mani Wall

Shey-Phoksumdo National Park was approached on both of my visits by following the steep Suli Gad River from Dunai, the regional government and police center (2,100m/6,890ft). Pungmo Village (3,170m/10,400ft) lies inside the park on the route west to the Kagmara La. The prayer stones were on a wall of stones carved with mantras near to the Bon Gompa. Monastic Bon (white Bon) has many practices in common with Old Sect Buddhism, but identifies its founder as Shen-rap rather than the historical Buddha Sakyamuni. (Day 16, 1989.)

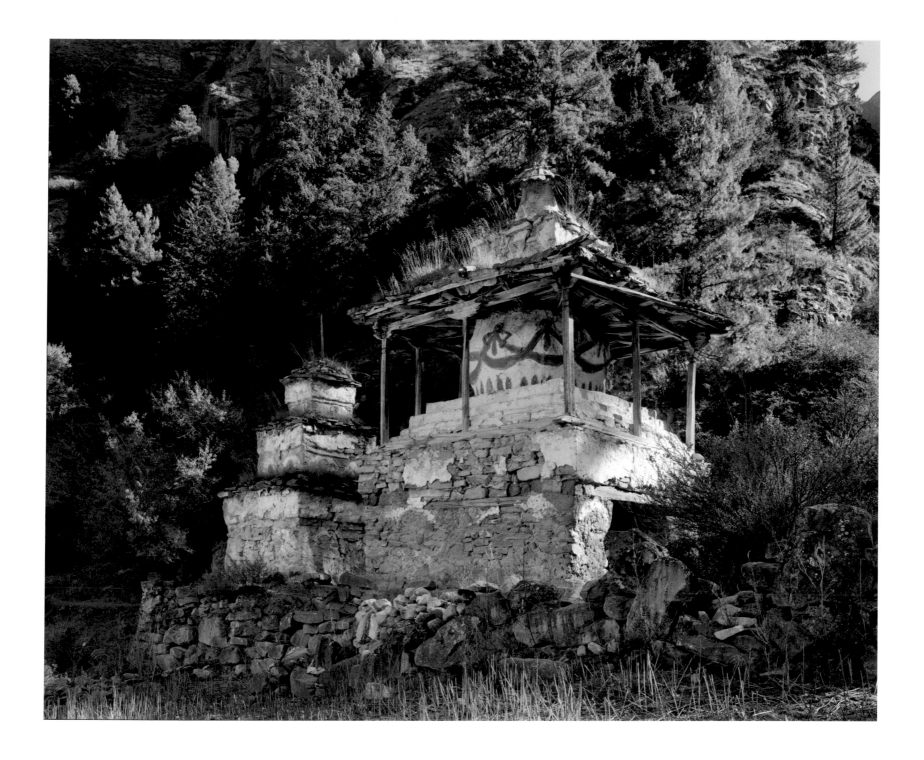

Pungmo Village, Gateway Chorten

Gateway chorten serve to mark the entrances to villages. The roof of the passageway is usually decorated with colorful mandalas and the inner walls with paintings. The chorten started out in India as a dome stupa which often contained a Buddhist relic. Here the dome has acquired platforms, a canopy and a pagoda. Often there is no dome and only a juniper branch to mark the axis. The Buddhist practice is to walk around a chorten with the sun (clockwise). The Bon do the reverse, thus Buddhist chorten are often decorated with clockwise swastikas and on Bon chorten they are anti-clockwise. (Day 16, 1989.)

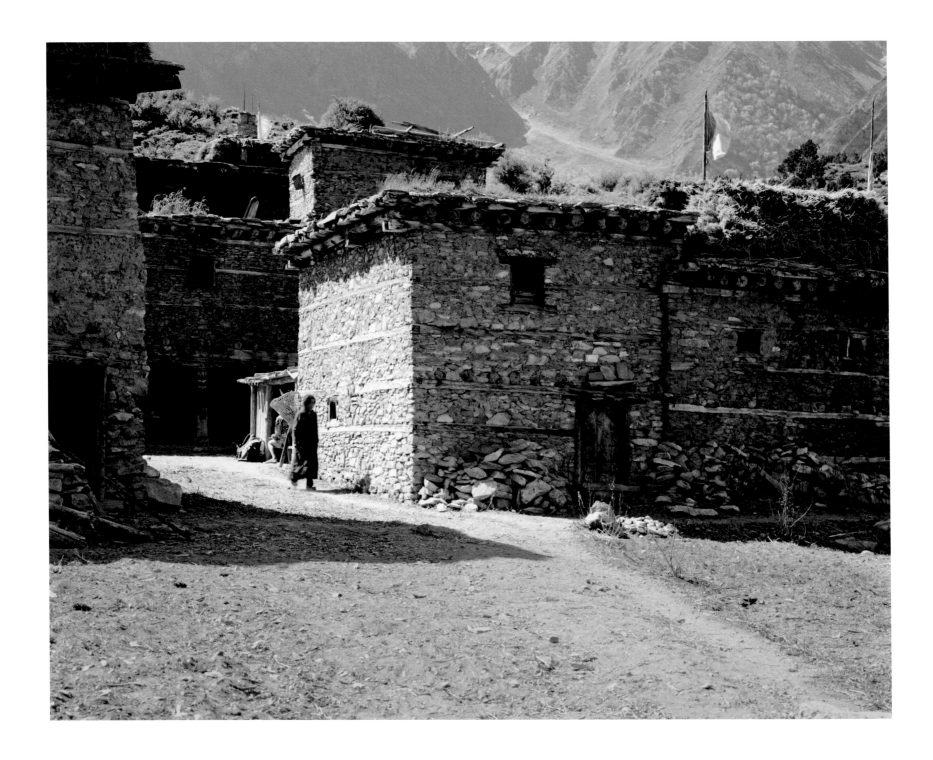

Ringmo Village, Tibetan Style Houses

Ringmo village is adjacent to Phoksumdo Lake (3,530m/11,582ft). The lake, the source of the Suli Gad River, was created in the distant past by a massive landslide. Tibetan houses are solidly built. Animals reside on the ground floor and scarce wood and straw is stored on the roof. The layers of wood built into the stonework may protect the houses against earthquakes. The land supports the growing of barley and potatoes. (Day 4, 1993.)

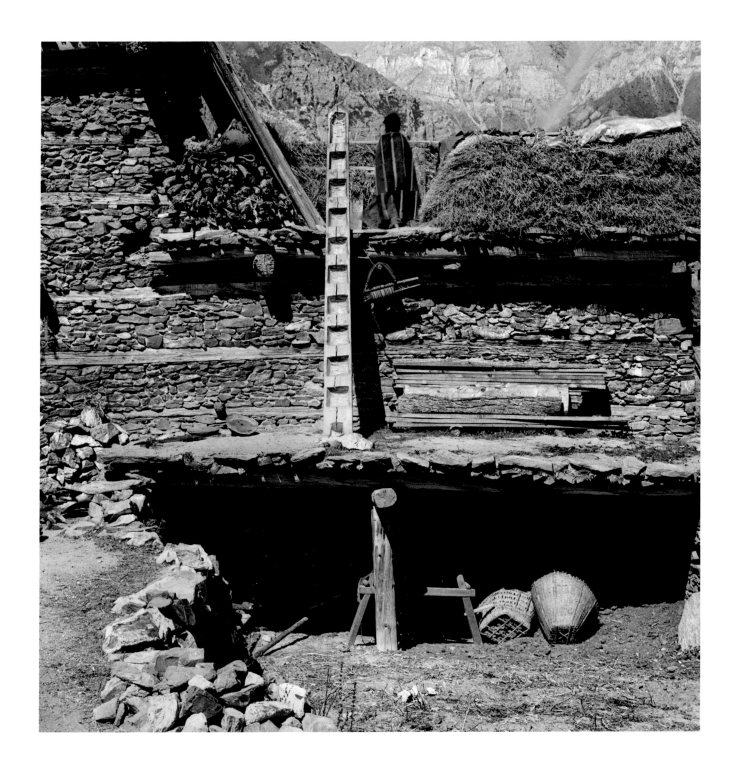

Ringmo Village, Woman and Ladder

Ladders carved from tree trunks are common in Tibetan style houses (see pages 47 and 86). The striped cloth about the woman's shoulders is probably a barley sack woven from course yak hair. (Day 4, 1993.)

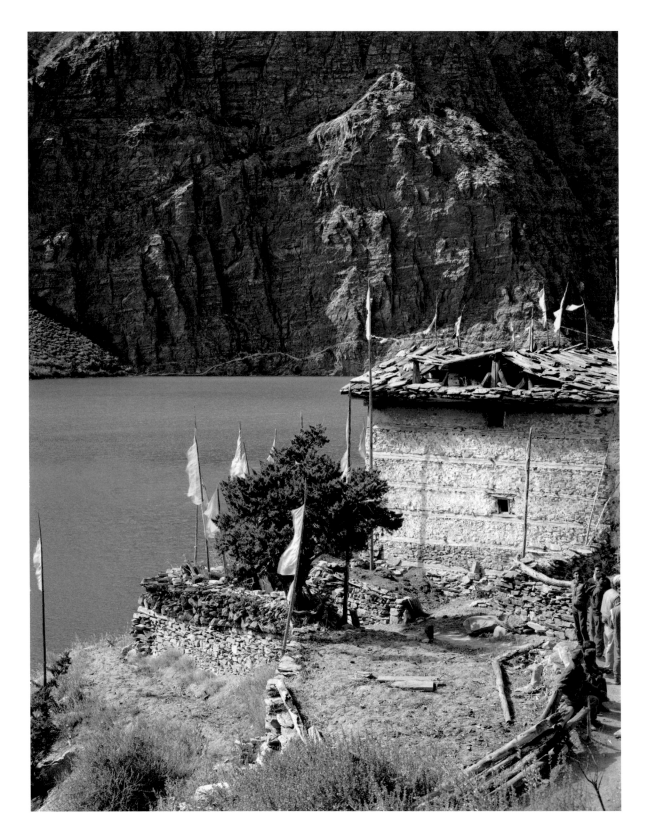

Phoksumdo Lake, Bon Gompa and Cliff Path

The beginnings of the cliff path to Inner Dolpo, here close to the water, can be seen across the lake. In 1989 a police post made certain we did not set foot on the path. The lake is unclouded by glacial silt and takes on translucent blue and green colorations in the afternoon light. This small monastery has a number of remarkable fresco paintings in an upper room. In 1993 there was a new Lama in residence. He was instructing two student monks sitting on a low roof and the robes worn were the same maroon and yellow colors typically worn by Buddhist monks. (Day 15, 1989.)

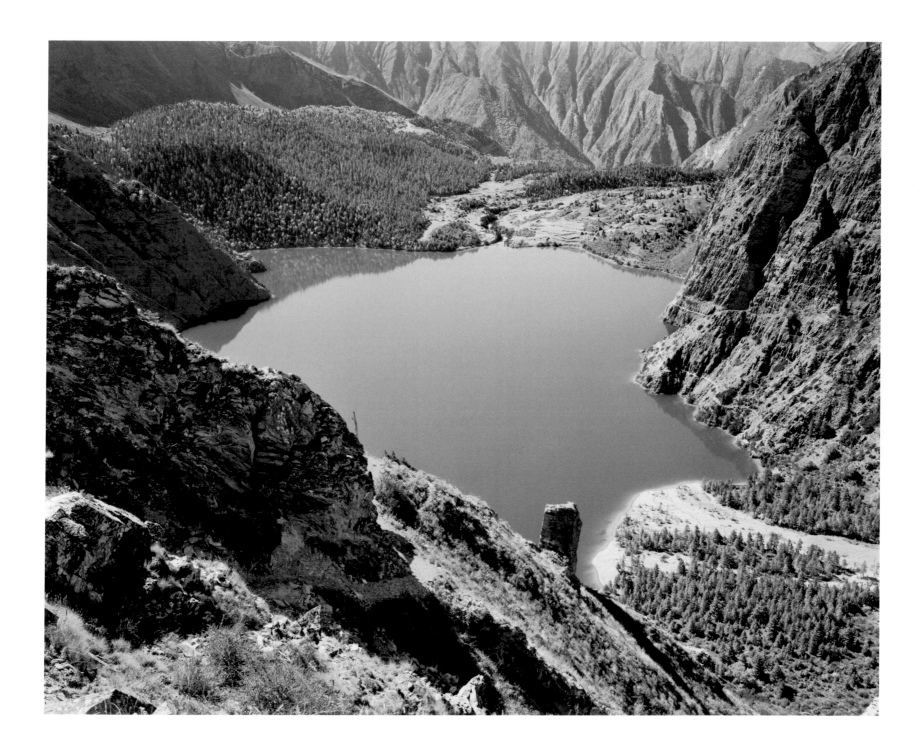

Phoksumdo Lake, View towards Ringmo

The cliff path leading to Inner Dolpo starts from near the village in the distant right. The Bon monastery is close to the waters edge to the left. (Day 6, 1993.) The cliff walk took us over a shoulder and down again to the lake. Our trail from there followed a broad wooded valley with the snow capped ridge of Kanjelarwa on the left (6,612m/21,693ft). A steep gully led to a stony high camp and on Day 8 a long slope of glistening schist brought us to the Himalayan crest, the Kang La (5,334m/17,500ft). Ahead was a barren landscape. A very steep descent led into a gorge cut through younger sedimentary rocks.

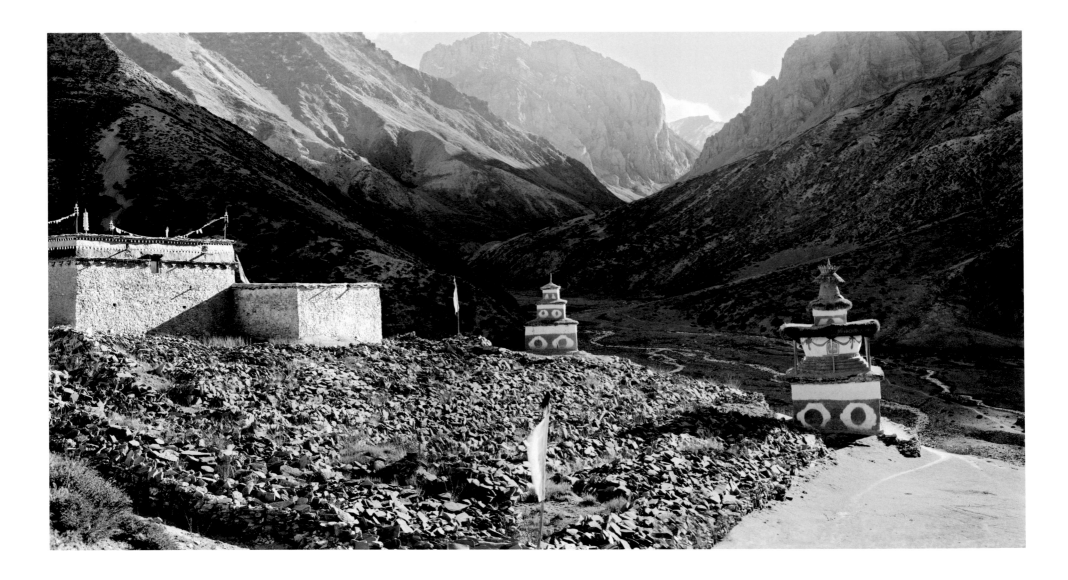

Shey Gompa, Afternoon Light

The gorge below the Kang La finally opened up as Shey Monastery was approached (Day 8, 1993; 4,480m/14,700 ft). The end of the gorge can be seen in the photograph. 'Shey' means crystal. This isolated monastery exists because of the Crystal Mountain (5,563m/18,350ft) that is to the right of the gorge. Pilgrims who circumambulate this sacred mountain must cross several passes. The monastery is of the Karma-pa sect of the Ka-gyu-pa order. The Ka-gyu-pa was founded by Marpa (1,012-1,097 CE), the great translator of Sanskrit texts into Tibetan and the disciple of the yogin Naropa. The prominence given to Padma-sambahva in the assembly hall of the monastery suggests that Shey may have Old Sect connections. The monks had all gone to their villages to help with the harvest.

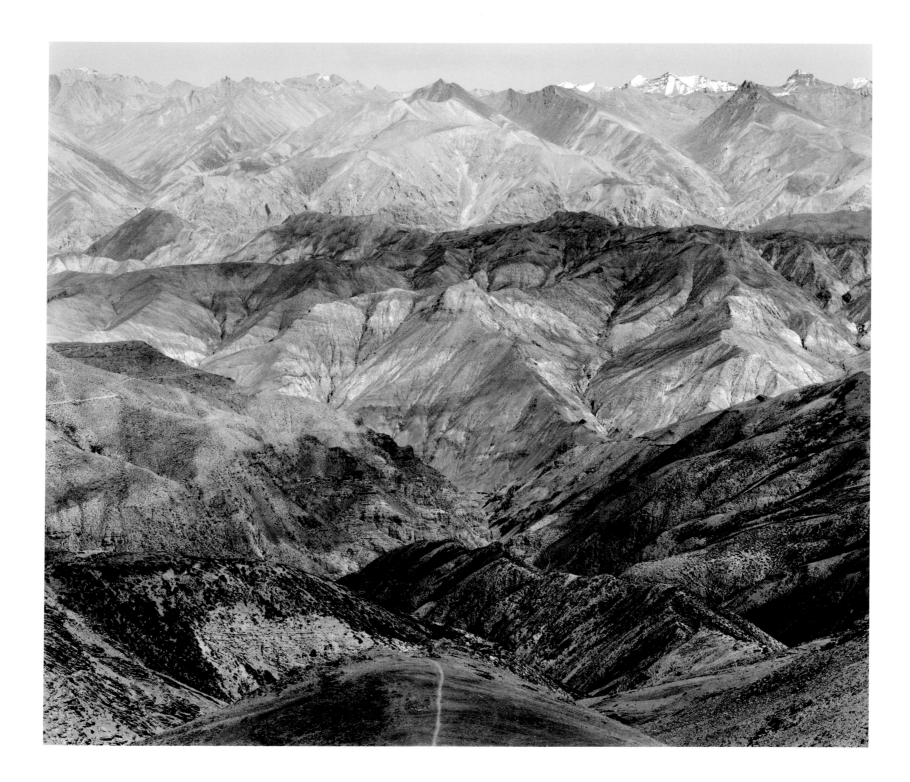

View Towards Tibet from the Se La Between Shey and Saldang

The rivers in this region drain into the upper Karnali River to the northwest whereas our trail to Saldang and to Shimen on the Panzang Khola took us to the northeast. This route required we cross two passes: the Se La (Day 9; 5,093m/16,710ft) and, after Saldang, a second broad pass (Day 11; 4,460m/14,633ft).

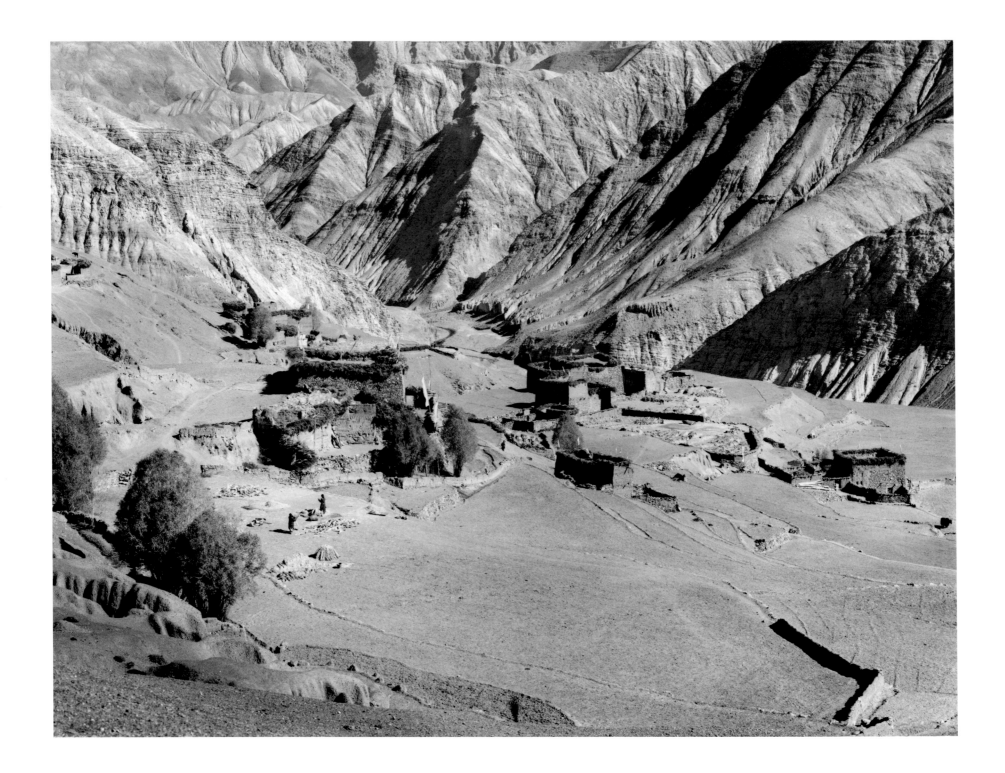

Saldang, Barley Threshing

Saldang village is spread out over a large area of high ground with a steep drop to the river. There were no signs of a fort. The area was too poor and too remote to be worth plundering. In a few places there was just enough water to support a willow tree. To grow barley must require very careful irrigation in the spring. (Day 10, 3,850m/12,632ft.)

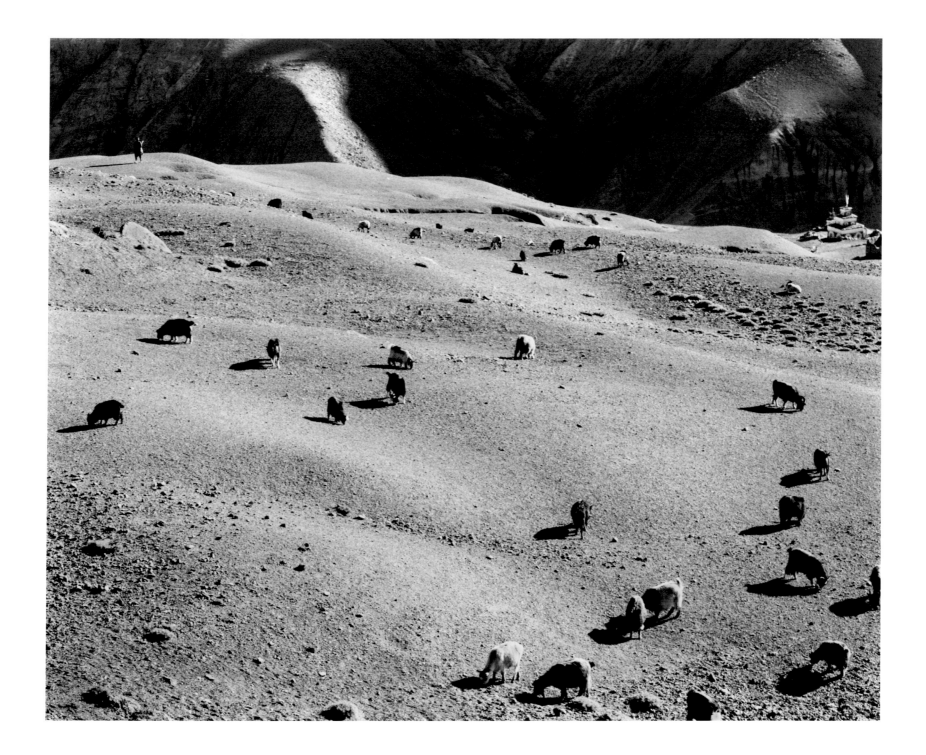

Saldang, Grazing Goats

In this region there are occasional thorn bushes, but the grass is invisible except to goats and yaks. These are domesticated goats; there are also goat-like blue sheep in the region that are wild, hard to see and bound into the distance if encountered by chance.

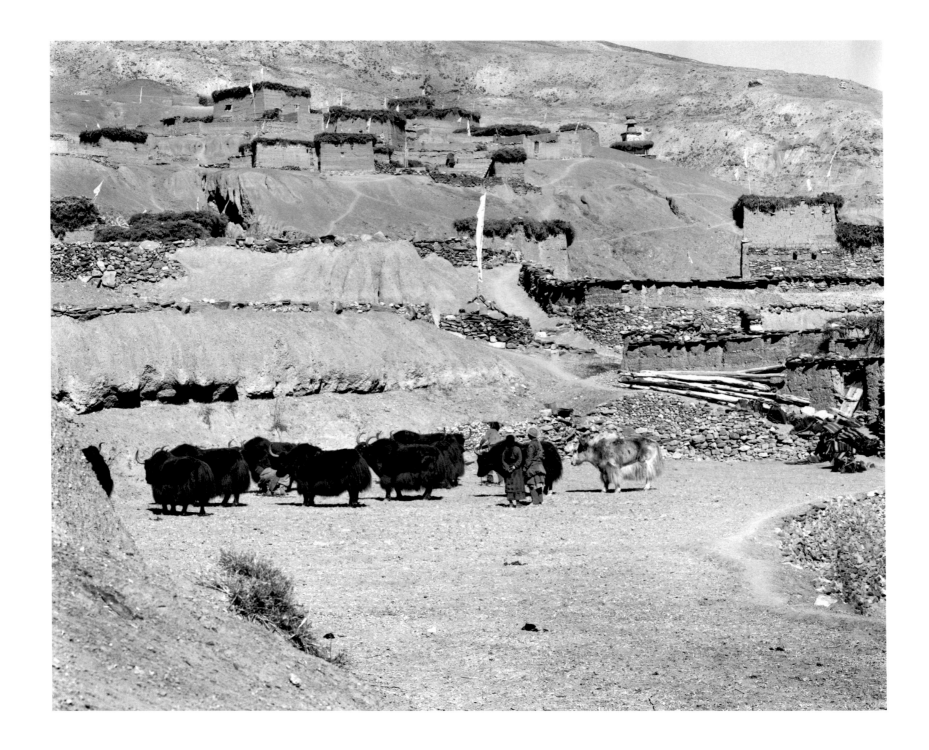

Saldang, Yaks Being Saddled

It is possible the yaks were being prepared for moving grain and personal goods to lower down the valley for the winter. We encountered a procession in which a lama and his family were making such a journey.

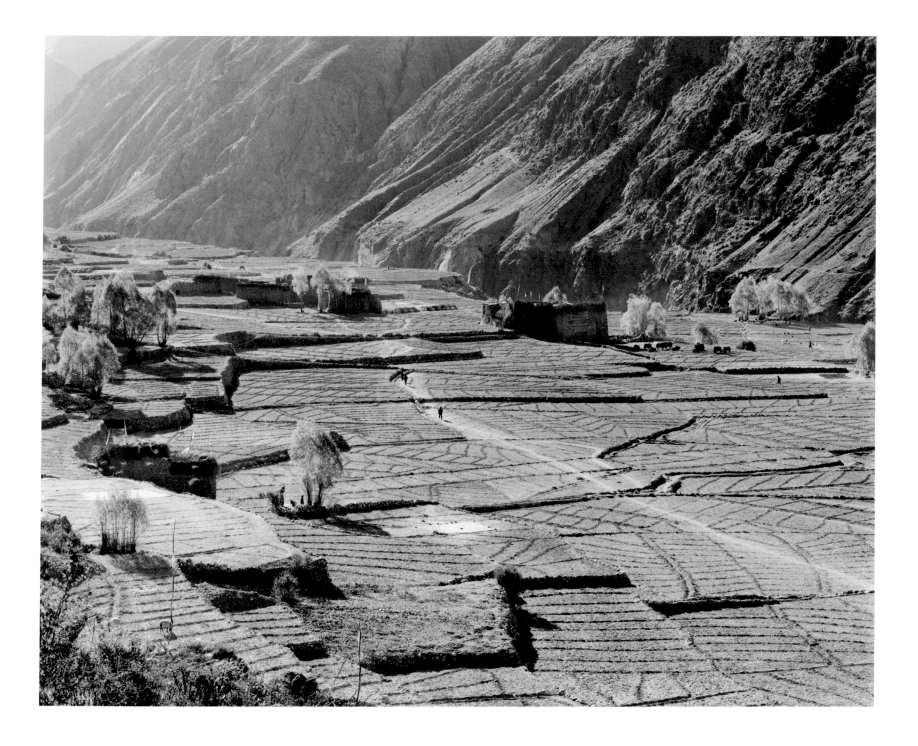

Shimen, Harvested Fields, Panzang Valley, Morning light

Shimen was reached by a steep relentless descent at the end of a very long day (Day 11). The village is at the same height as Saldang but the valley is less exposed and there is more irrigation available to raise crops. The narrowness of the valley required that the houses be clustered. The village boasted a school house but no regular teacher. We visited a small neglected Karma-pa Gompa with magnificent wall frescoes that included 21 manifestations of Tara the 'Saviouress'. Some other figures looked like Mongol warriors on horseback. Both the Karma-pa and the Sakia-pa sects had connections with the court of Kublai Kahn.

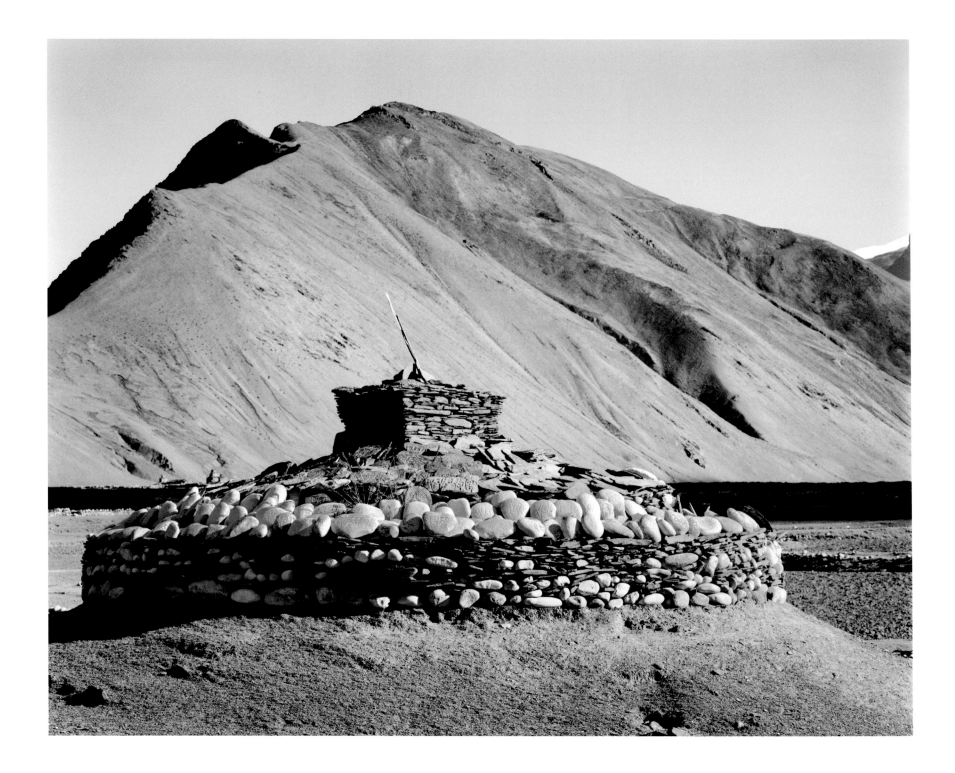

Tin-Kyu, Circular Mani-Wall and Chorten; Late Afternoon Light

The Panzang Valley is very narrow and where the river creates cliffs the trail makes steep ascents and descents. We passed long mani walls composed of carved stones of rounded granite derive from a layer of deposited sediment. Eventually at Tin-Kyu (3,918m/12,860ft; Day 12) the trail opened up to the junction of two valleys. The eastern valley led to the Tibetan border about 8 miles away, our route was to the right of the hill in the photograph. This is the only place I have encountered a combination of a circular mani wall and chorten. The central stone on the wall bears the Tibetan characters for the six-syllable mantra *Om Ma-Ni Pad-Me Hum*.

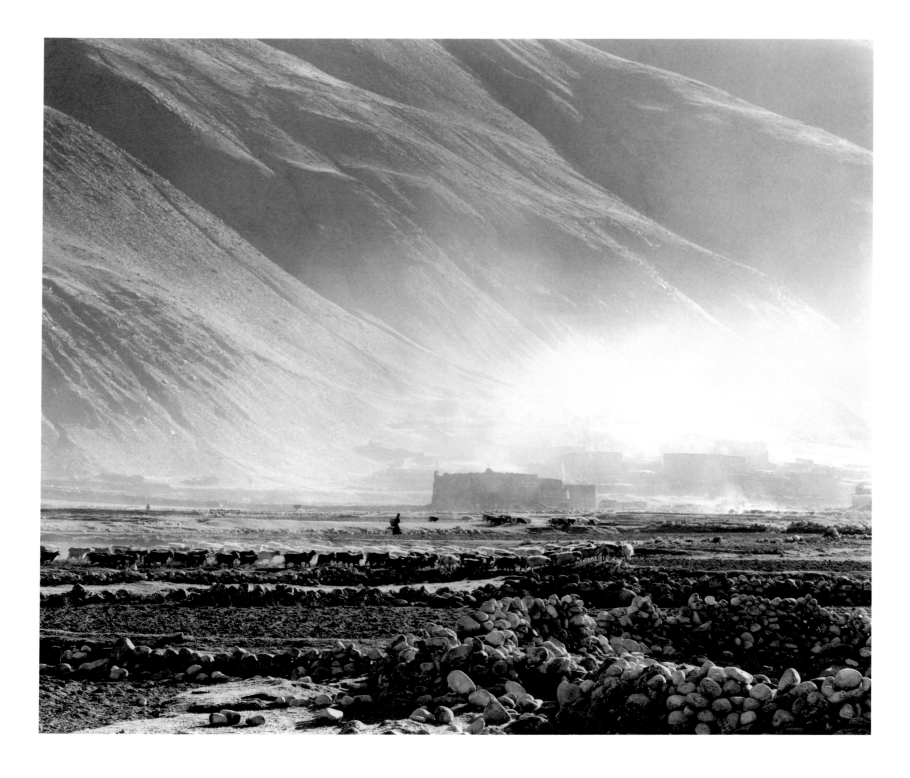

Tin-Kyu, Goats from Tibet

The sun was just beginning to reach the fields as we set off on Day 13. I was about to photograph the village—the smoke of yak-dung fires drifting upwards from the houses—when a cloud of dust arose to the left and before long there were flocks of goats being driven across the fields. The goats had been raised in Tibet and were on the way to the Kali Gandaki valley to be sold in time for the next festival. We followed the goats for several days.

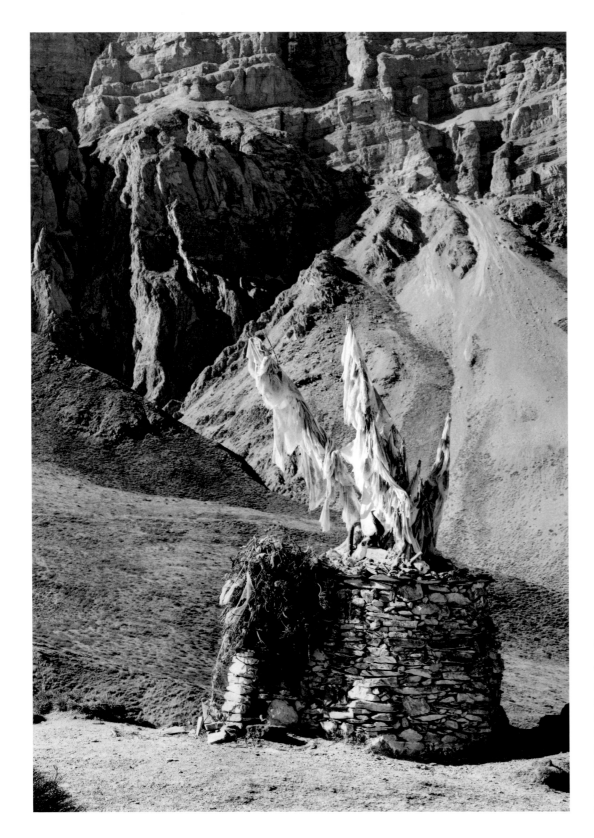

Cairn With Prayer Scarves

The summits of passes are invariably marked by a pile of stones about a juniper branch that is draped with prayer scarves and strings of flags. Sometimes there are animal sculls painted with red earth. Such cairns are associated with the pre-Buddhist mountain gods. Within Buddhism these gods are accepted as sentient beings to be treated with respect. On crossing a pass they are greeted with the cry: "May the Gods be victorious." This cairn, photographed in a gorge beyond Tsharka on Day 16, is unusual in that there are no flags and the cairn has been carefully built.

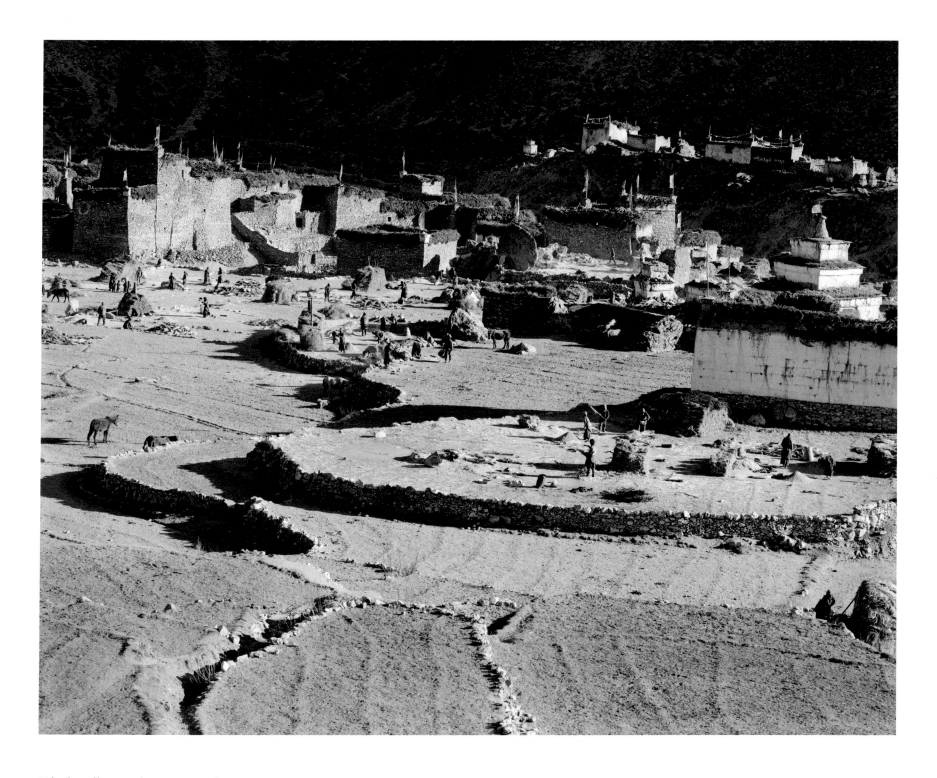

Tsharka Village, Barley Harvest Tasks

From Tin-Kyu the trail followed broad valleys. After fording a wide cold river we crossed the Tsharka La (5,030m/16,502ft) and descended to a basin drained to the south by the Barbung Khola. From the pass the Dhaulagiri Himal was visible to the south. Tsharka (4,180m/13,714ft) commands the upper valley. The houses, like those of Tarakot, are huddled together as if for defense. On Day 15 the entire village was hard at work from first light until darkness threshing and winnowing the harvested barley and loading it into striped sacks woven from yak wool.

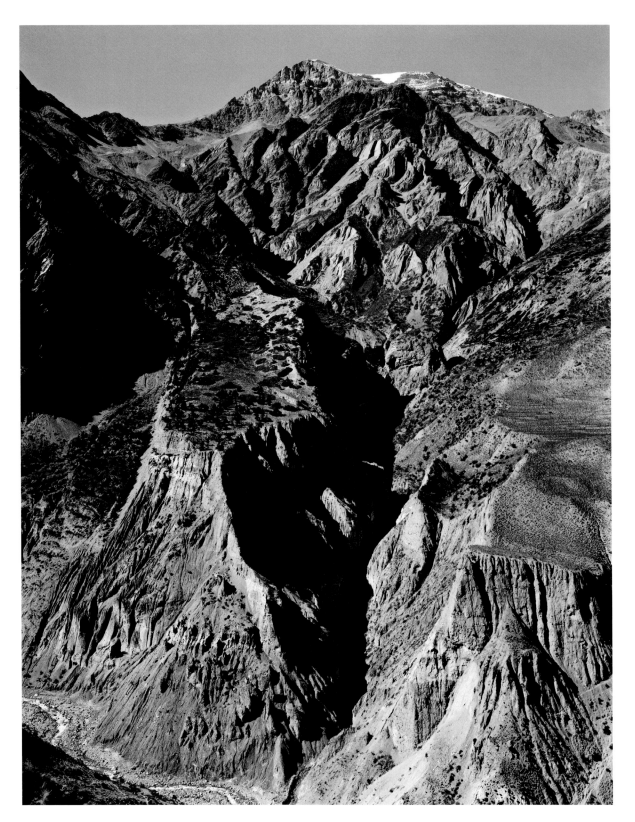

Descent from the Sangda La

As it was now past mid October, there was a serious chance that the Sangda La (5,520m/18,110ft) would be closed by snow (the pass is also known as the Kyi-tse La or Gunsa La). The route from Tsharka took us through a narrow gorge. Another river had to be forded. Finally, on Day 17 (October 21), we crossed the pass and spent an exceedingly cold night below the ridge to the right in the photograph. The next day we descended about 5,500 ft to the Chalung Khola by a path to the right in the photograph and then ascended about 1,740 ft before we camped near Sangda Village (4,400m/14,346ft).

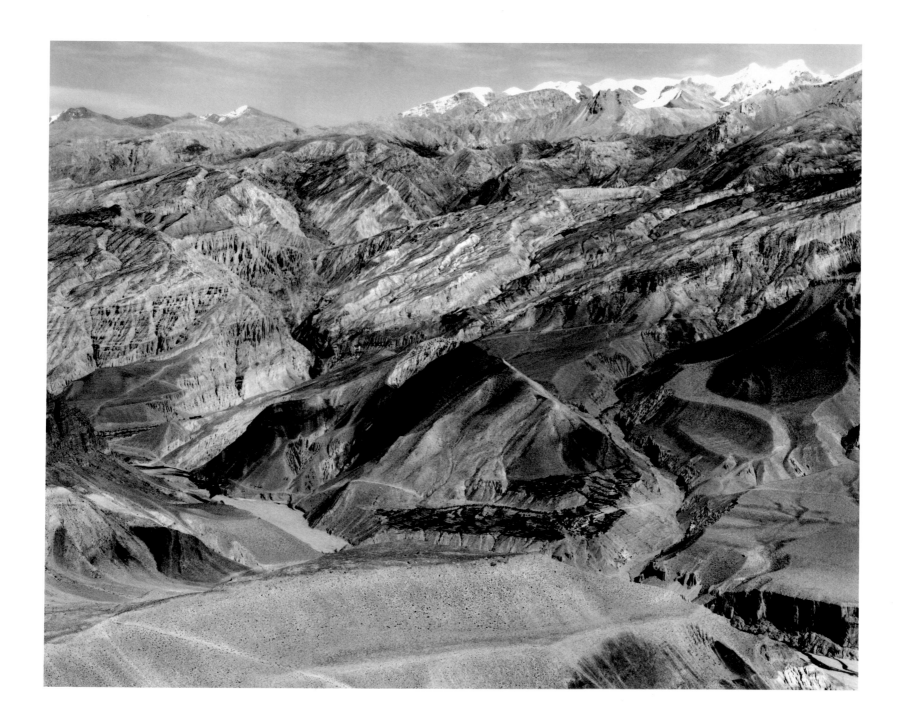

View of Lo-Mustang and the Kali Gandaki Trade-Route to Tibet

On the final part of the journey we contoured as best we could to this viewpoint overlooking the Kali Gandaki route towards Tibet and then descended to Kagbeni (page 93). The photograph shows the extreme aridity of the Kingdom of Lo. (Lo is usually known by the name of its major town, Mustang). On Day 21 we flew from Jomsom, first to Pokhara and then to Kathmandu. The Kali Gandaki flight provides dramatic views of Annapurna to the east and Dhaulagiri to the west.

MOUNTAINS ABOUT THE GREAT CLEFT OF THE KALI GANDAKI

Around Dhaulagiri & Annapurna, Central Nepal

Central Nepal is defined by the Gandaki river system. The mountains of the Himalaya as they rise upwards create the weather that leads to their erosion. Glaciers and rivers have ground their way through the solid rock. Lakes formed behind glacial moraine or generated by landslides have burst their dams and scoured out valleys. Rivers have cut through the mountains to drain the arid regions to the north. The Arun River drains the north side of Everest. The Kali Gandaki has cut through the Himalayan chain between the limestone capped peaks of Dhaulagiri and Annapurna to drain the Lo-Mustang rift valley whose layered sedimentary rocks were laid down after the Indian continent collided with Eurasia. Between Dhaulagiri I (8,167m/26,795ft) and Annapurna I (8,091m/26,546ft) the cleft exceeds 18,000 ft.

At the boundary with Lo-Mustang, at a point where the river spreads out to form a wide stony flood plain, is the town of Kagbeni. Every afternoon the diurnal heating of the Tibetan plateau causes fierce winds to blow up the valley towards Tibet. For many centuries the river has acted as a trade route to Tibet. Pony trains still travel the valley, but the traditional trade of Tibetan salt for rice and millet may be no more. Kagbeni, made prosperous

by controlling the trade, boasts a ruined palace and passageways that protect the residents from the wind. The valley is also an ancient pilgrimage route. Groups of pilgrims, many from India, carrying bedrolls, pots and pans, walk up the valley and camp by the riverside until they reach Muktinath not far from Kagbeni. There Hindu and Buddhist shrines are gathered around a spring where flames of natural gas issue from the rock.

Around Dhaulagiri, 1992. Pokhara is a resort town that can be reached in a day's drive from Kathmandu or by plane. In 1992 we flew to Pokhara and on October 6, after a short bus trip, set out to trek. The trail followed the Myagdi, a western branch of the Kali Gandaki, through terraced villages. Damp trails through moss-laden woods eventually brought us to open moraine and to the Chhonbardan Glacier. The glacier was reached by a narrow gorge; Dhaulagiri I was to the east and a series lesser peaks, II to VI, to the west, but they were not visible—clouds surged up the valley, then came snow. The cairn tracks were hard to find and the snow on the moraine blended into the clouds. It was a great relief when a faint representation of a tent could be seen though the mist. The brilliant sun next morning gave way to clouds by noon and snow by evening. From the Base Camp area on October

19 we made the slow ascent to the French Pass (5,360m/ 17,600ft) getting to the pass just ahead of the clouds. Beyond the pass is the extended plateau known as the Hidden Valley. The plateau falls off to the north giving a wide view of Inner Dolpo. The names of pass and valley derive from the 1950 French Annapurna expedition. Their scouting party examined the icefall feeding into the main glacier before deciding to concentrate on Annapurna. We left the bitterly cold Hidden Valley by the Thapa (Dhampus) pass (5,250m/17,250ft). Afternoon clouds in the Kali Gandaki Valley often deposit snow below the pass causing great difficulty for trekkers, but fortunately a trail had been broken. As we

valley to the north of the Annapurna range. Several spectacular peaks are visible from the valley, but Annapurna I is masked by the Roc Noir (so named by the 1950 French expedition). The upper valley, whose main village is Manang, is notable for the village of Braga clustered on the hillside around an extended monastery that must have been built in times of relative prosperity, perhaps 500 year ago.

The high pass on the circuit is the Thorung La (5,415m/17,765ft). We started in pitch darkness as one party amongst many—a long procession of lights wandered through the snow. The early departure was necessary because of the

descended we faced on the other side of the valley Nilgiri (7,061m/23,116ft), an outlier of the Annapurna Himal. The name means misty mountain; Dhaulagiri means white mountain. Below we could see a small plane making its way from the Jomson airstrip to Pokhara. After a long decent we reached the prosperous village of Marpha in the valley in time for a festival at the local gompa. Our flight from nearby Jomsom on Day 19 gave dramatic views of the Dhaulagiri and Annapurna peaks.

Around Annapurna, 1986. In 1986 my wife and I made the popular Annapurna Circuit trek that begins at the small town of Dumry on the Kathmandu to Pokhara road. There was morning mist on the rice fields. The trail followed the Marsyangdi, an eastern branch of the Gandaki river system, which cuts thought the main Himalayan chain between the Annapurna Himal and Manaslu (8,163m/26,781ft). Beyond this narrow gorge, whose trail in places has been blasted out of the rock face, the river drains a broad dry

high winds that can occur on the pass in the early afternoon and make progress impossible. By dawn we were well along the snow covered trail and the crest was reached by 11 am. Thereafter came a long descent on a trail, devoid of snow, to Muktinath. We continued to Kagbeni and were sand blasted by the full force of the wind as we marched down the valley to Jomsom. The circuit trek was completed by first following the Kali Gandaki. Along the way there were brief glimpses of Annapurna I though the clouds. From Tatopani (= hot water) the trail climbed through a forest of rhododendrons to reach a colorful farming area that provided delightful views of Dhaulagiri. Finally, after 20 days, we reached Pokhara and returned to Kathmandu. This was our first Himalayan experience—miraculously my system for carrying the camera bag in an old frame rucksack proved itself in this totally new context.

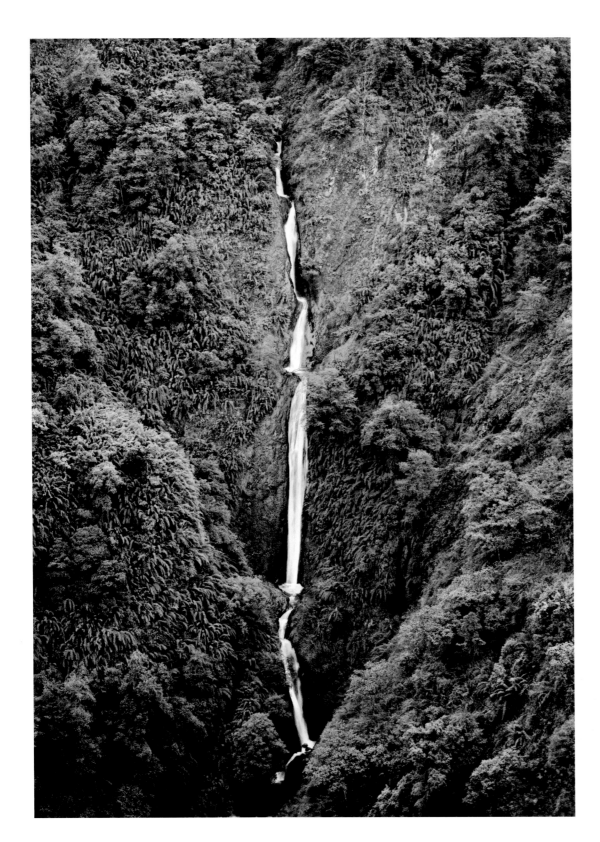

Waterfall, Approach Trail to Dhaulagiri

Beyond the village of Muri the Myagdi Khola trail to the Dhaulagiri Base Camp ascended a steep narrow valley. The trail, a slippery grade-B goat path along a slope with the pitch of a house roof and with a river 200 ft below, afforded almost no place to set up the tripod. None the less, spectacular waterfalls were photographed. (Day 9; 1992.)

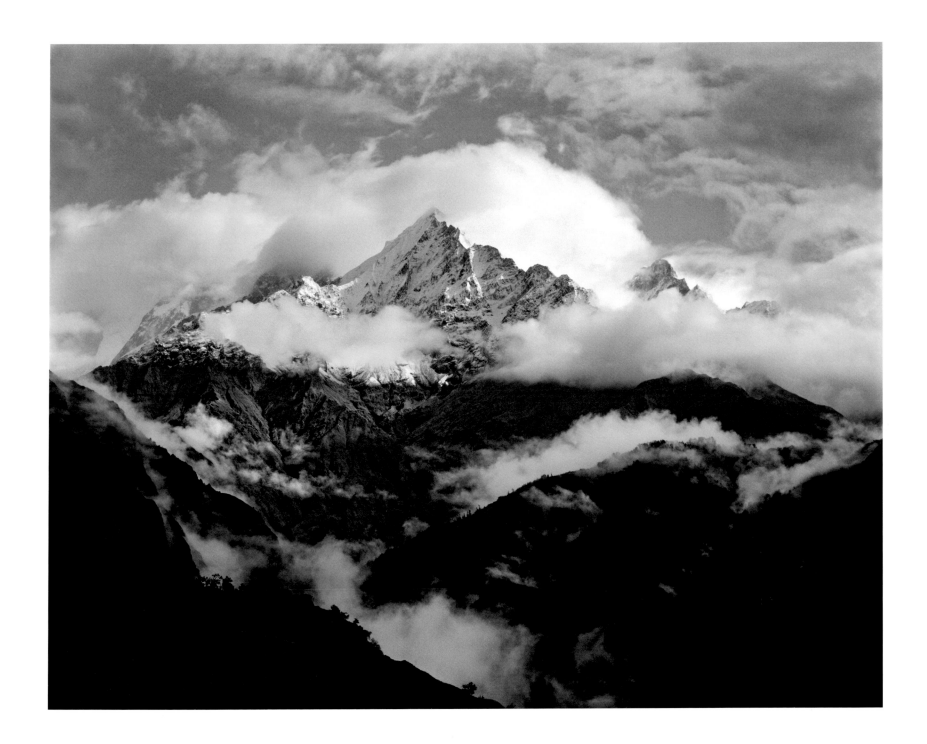

View from Muri Towards Dhaulagiri, Morning Clouds

The 1992 journey began with a day's drive from Kathmandu to Pokhara. We spent a week, beginning on October 6, following the Kali Gandaki and Myagdi Khola through terraced villages until we reached Muri (1,524m/5,000ft). On the morning of Day 7 rain fell and clouds filled the valley, but then the clouds began to dissolve. The photograph, looking northeast, shows the subsidiary peaks Jirbang (6,062m/19,889ft) and Manapati (6,380m/20,933ft); Dhaulagiri I was still in the clouds. Our route was to the left of these peaks.

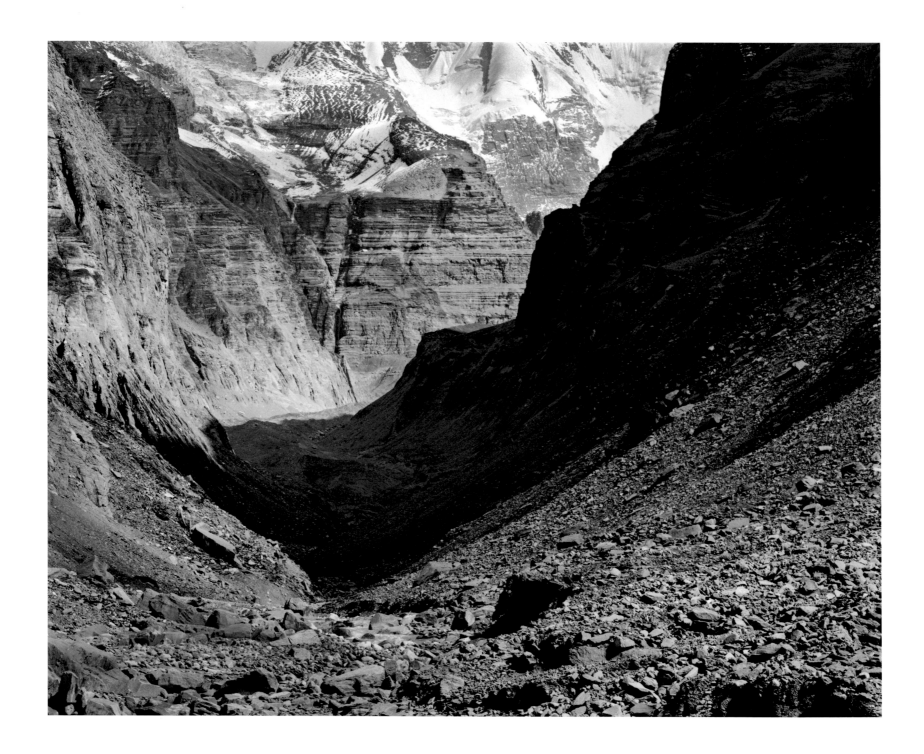

Gateway to the Gorge of the Chhonbardan Glacier; Morning Light

As we ascended the Myagdi Khola, the valley became a rainforest with moss hanging from the trees. Every afternoon the forest was wrapped in clouds. Eventually the trees thinned to brush and on Day 11 the gorge of the Chhonbardan Glacier lay ahead (4,300m/14,108ft). The glacier has cut between Dhaulagiri I (8,167m/26,794ft) to the east and Dhaulagiri II, III and V to the west (heights around 7,700m). Beyond the gateway the glacier hooks around to the north of Dhaulagiri I. In the photograph the snout of the glacier is in shadow.

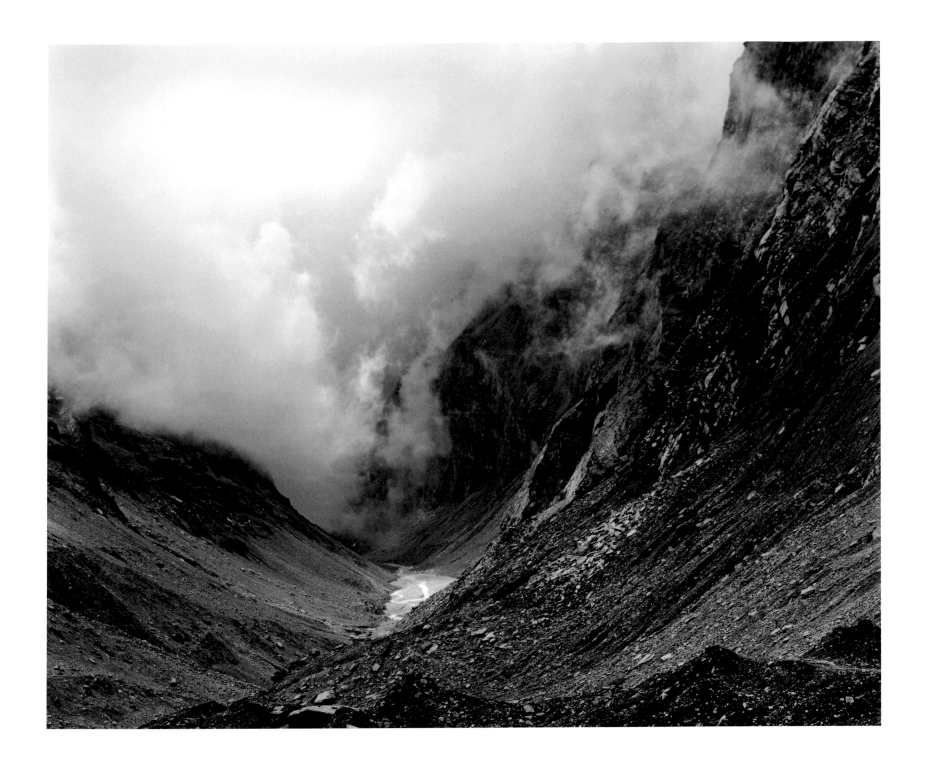

Advancing Clouds, Gorge of the Chhonbardan Glacier; Early Afternoon

The clouds started forming about noon on Day 11 and as we slowly climbed on the glacial moraine we were overtaken by mist which divided us into isolated groups. There were few cairn markers, snow began to fall, the trail disappeared and the porter I had been following became invisible. It was a great relief to see figures ahead and a tent being erected (elevation 4,660m/15,300ft). The next morning was astonishingly clear and the tent site was surrounded by peaks. The view of the Dhaulagiri North Face used as a front image (page 2) was taken about 7 am from within a few yards of the tent. By 1 pm the clouds rolled in and there was light snow.

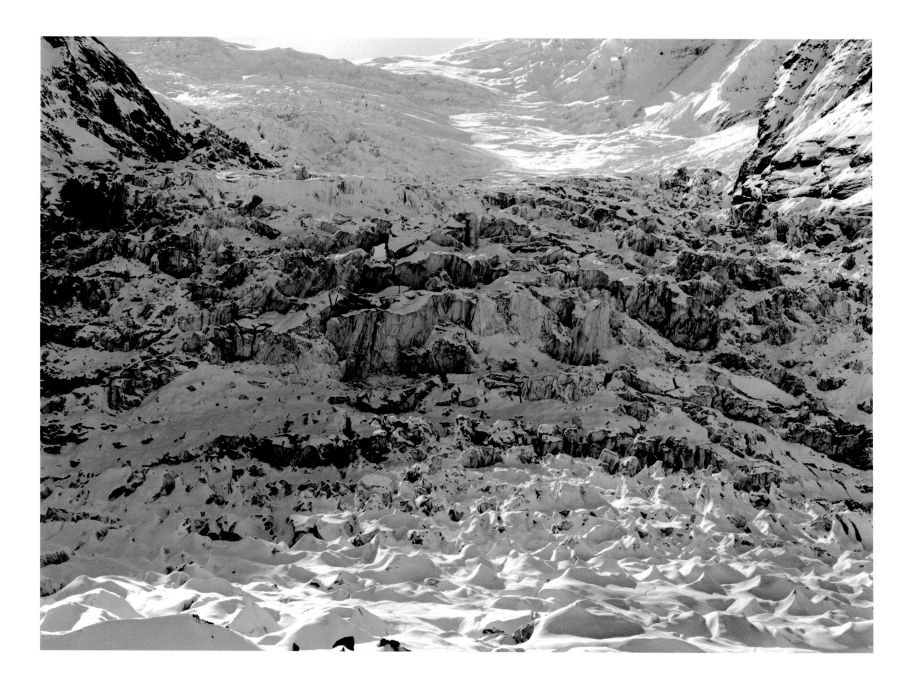

Icefall, Chhonbardan Glacier from near the Dhaulagiri Base Camp

The photograph of the icefall was taken as we set out to climb to the French Pass on the morning of Day 13 (elevation 4,750m/15,585ft). In 1950 a reconnaissance party of the French expedition led by Maurice Herzog climbed to the point at which the glacier leveled out, but found the seracs to be unstable and the route too dangerous to allow the placing of the supplied camps needed for a summit assault. They decided to look to Annapurna instead.

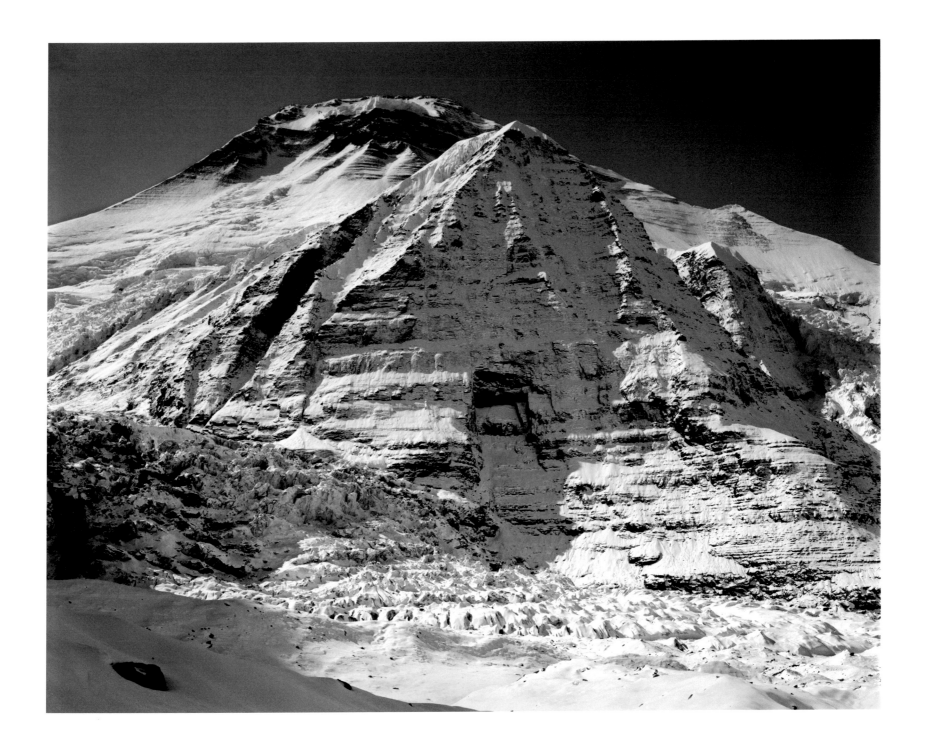

Dhaulagiri I from the Trail to the French Pass

Dhaulagiri I is the seventh highest peak and the last but one of the 8,000 meter peaks to be climbed (climbed in 1960 by the Swiss). The French in 1950 considered an ascent from the top of the Icefall (bottom left in the photograph) by the diagonal Northeast Ridge. The glacier-carved cliff face that dominates the photograph on page 2 is here seen obliquely.

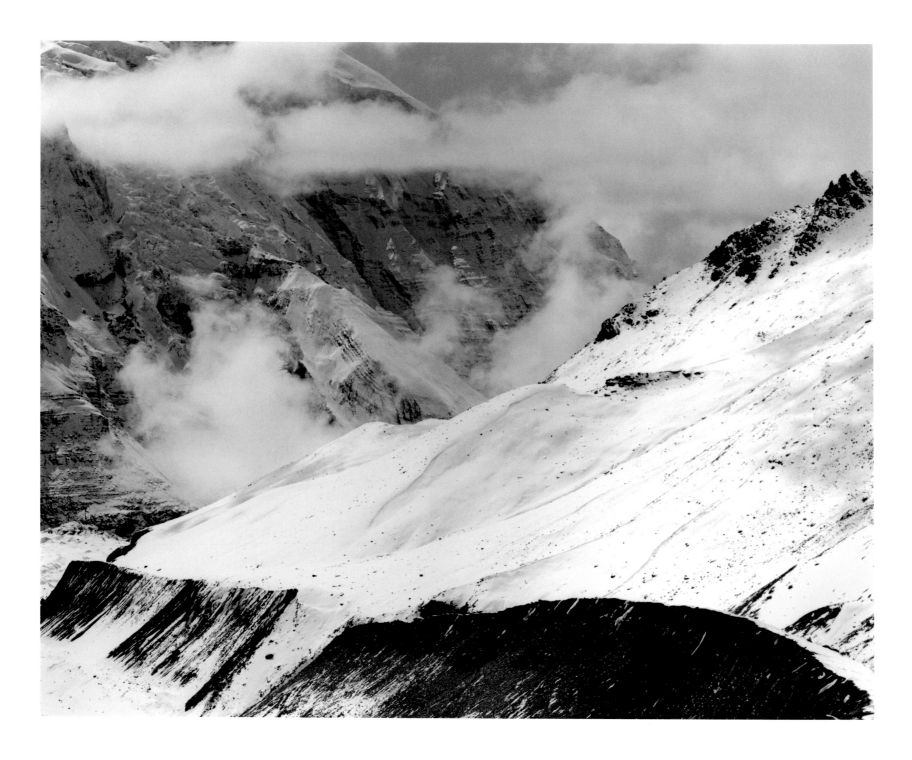

Moraine Ridge on the Trail to the French Pass; View Towards the Dhaulagiri Base Camp

The ascent to the pass on Day 13 was a slow plod (summit 5,360m/17,586ft). Cloud formation repeated the pattern set on the previous days; by the time the top of the pass was reached the mountain was totally obscured.

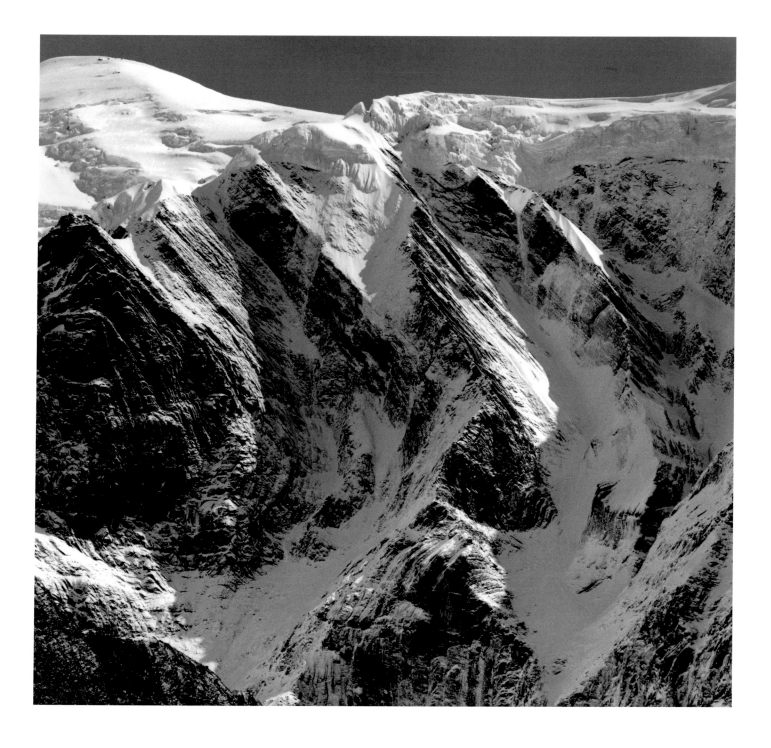

Folded Rocks and Tukuche Peak from the Chhonbardan Glacier

Tukuche Peak (6,920m/22,705ft), a continuation of the Dhaulagiri range to the northeast, dominates the end of the Chhonbardan glacier. The summits of the Dhaulagiri and Annapurna ranges are limestone that was laid down on the Indian continental shelf in the Ordovician period between 435 and 505 million years ago when India was still attached to Antarctica and Africa. The folded sedimentary rocks are separated from the underlying crystalline gneiss by a detachment fault; see Part II: *On the Structure of Mountains*.

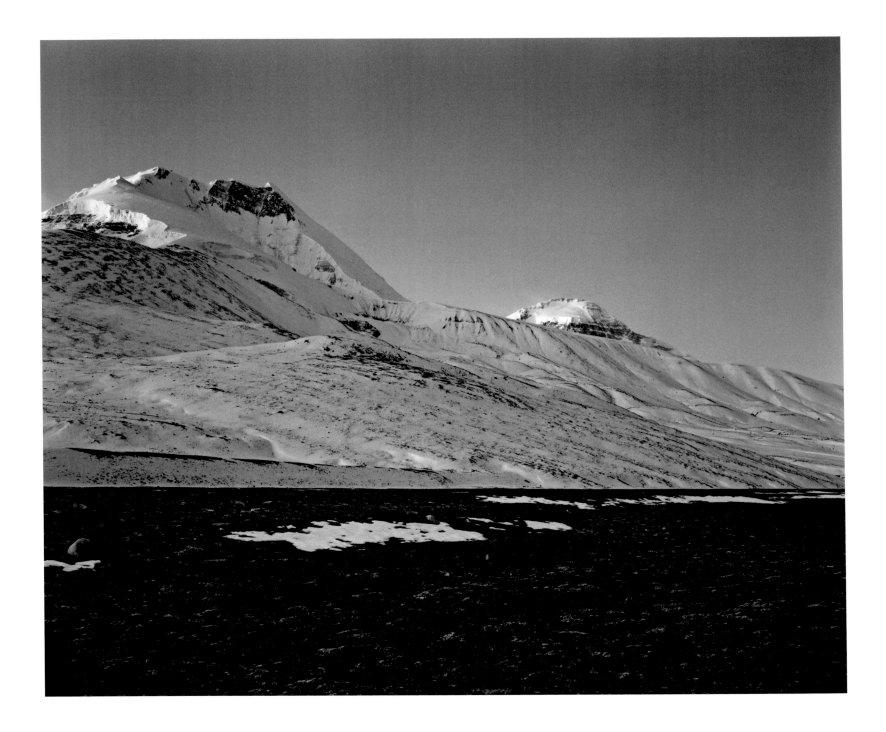

Tukuche Peak and the Summit of Dhaulagiri from the Hidden Valley Plateau; First Light

On crossing the French Pass we came to a gently sloping area with little snow that dropped off to a shallow valley. This Hidden Valley drains to the Cha-lung (or Lung-pa) Khola near to the Sangda La, Inner Dolpo (see page 68). The valley and the plateau provide grazing for yaks. The morning of Day 14 was exceedingly cold. I set up the camera close to the tent and then retreated inside until the sun started to catch the two summits (camp elevation 5,100m/16,733ft).

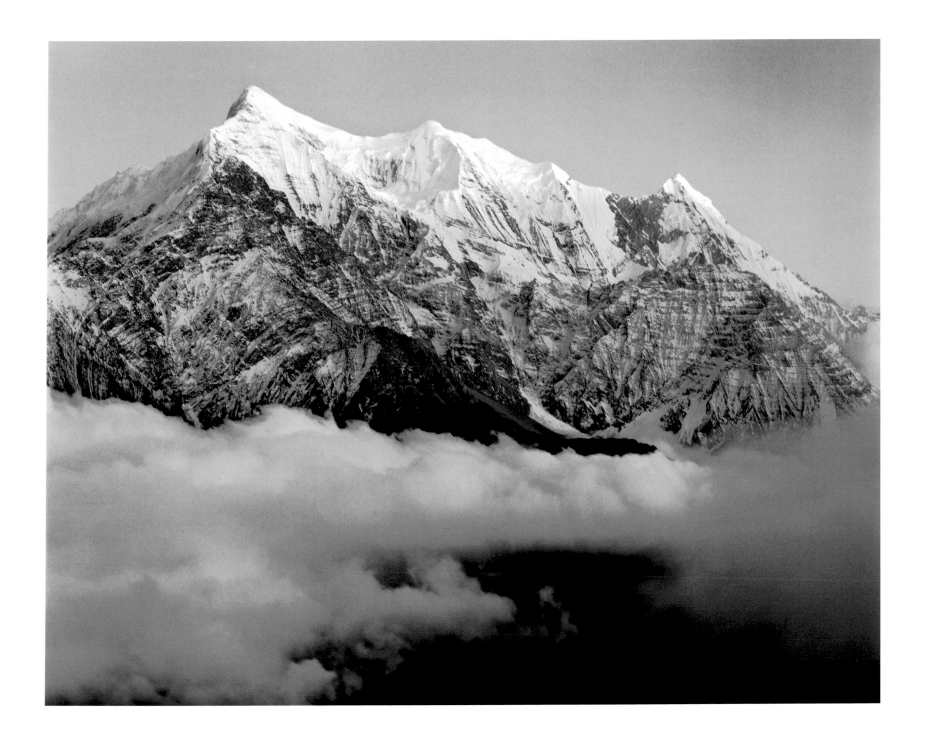

Nilgiri across the Kali Gandaki Valley seen from the Yak Camp below the Thapa Pass

Before descending to the Kali Gandaki valley it is necessary to cross the Thapa pass (5,250m/17,225ft), also called the Dhampus pass, which lies between Tukuche and the Thapa and Dhampus Peaks. Once over the pass the snow tends to be deep, but we found that others had already broken the trail, and the Yak Kharta camp (4,750 m/14,994ft) was below the snow line. The photograph of Nilgiri, the misty mountain (7,061m/23,167ft), was taken as the morning clouds were rising in the valley. Annapurna I is directly behind Nilgiri. Once in the valley we camped by the neat and prosperous village of Marpha (2,667m/8,750ft) and on Day 19 flew from Jomsom back to Kathmandu.

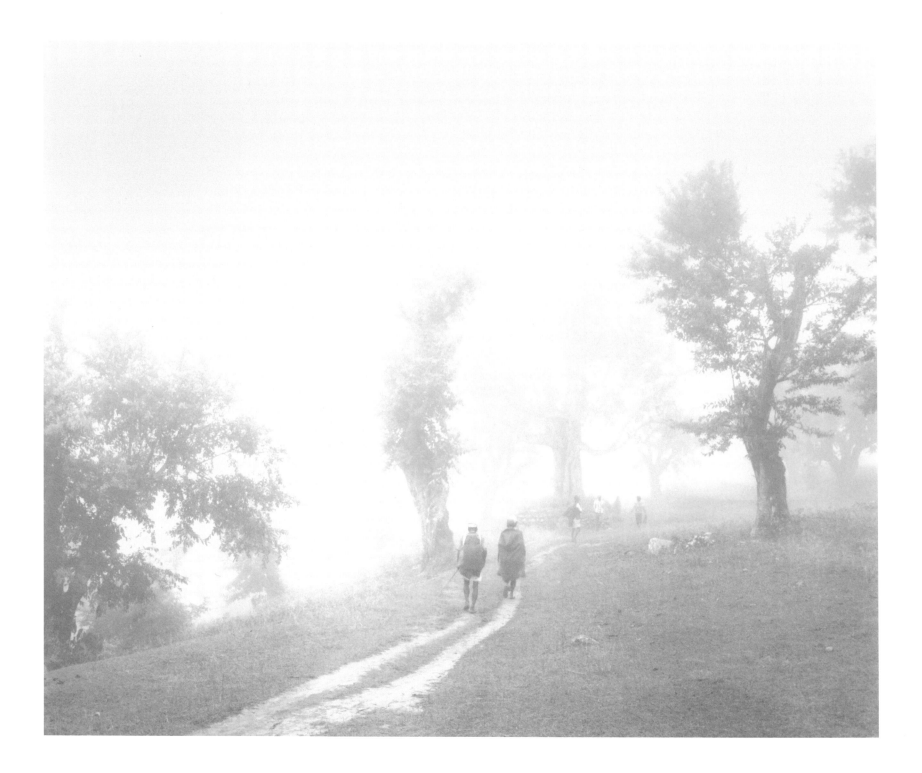

Travelers in the Mist

The start of the Annapurna Circuit is the small village of Dumre, the point where the road from Kathmandu to Pokhara crosses the Marsyangdi River. In 1986 our first night, October 20, was spent amidst rice fields at a mere 500m/1,640ft elevation. The tread of local workers could be heard passing the camp before dawn. The further trail led through a Hindu area with colorful thatched adobe houses set amidst terraced rice fields. Ahead were glimpses of Manaslu (8,163m/26,783ft), a peak only 4 meters lower than Dhaulagiri.

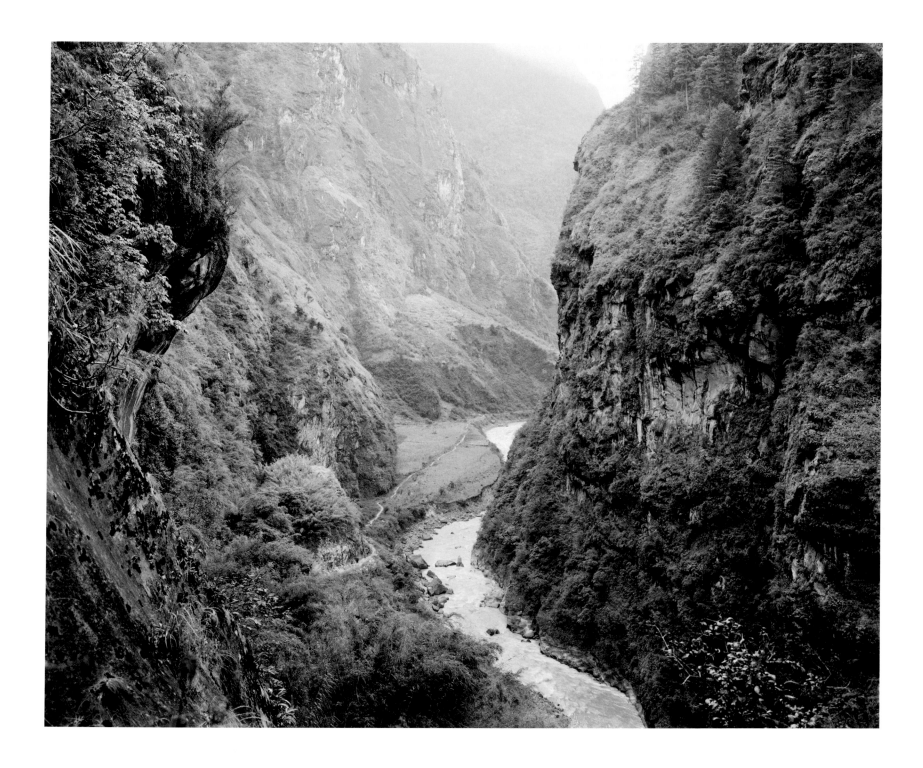

Marsyangdi Gorge

The Marsyangdi River cuts through the main Himalayan chain with Lamjung Himal to the west and Manaslu to the east. In places the trail has been blasted out of the rock face high above the turbulent waters, elsewhere it crosses landslides. (Photograph Day 6, elevation about 1,530m/5,020ft.) The villages in this Gyasumdo region belong to two different layers of Tibetan migration. The Gurung, the first to arrive, follow a shaman-led Bon tradition. The second wave of Tibetans, who arrived over 100 years ago, follow the Nying-ma-pa Buddhist tradition (the Old Sect founded by Padma-sambahva).

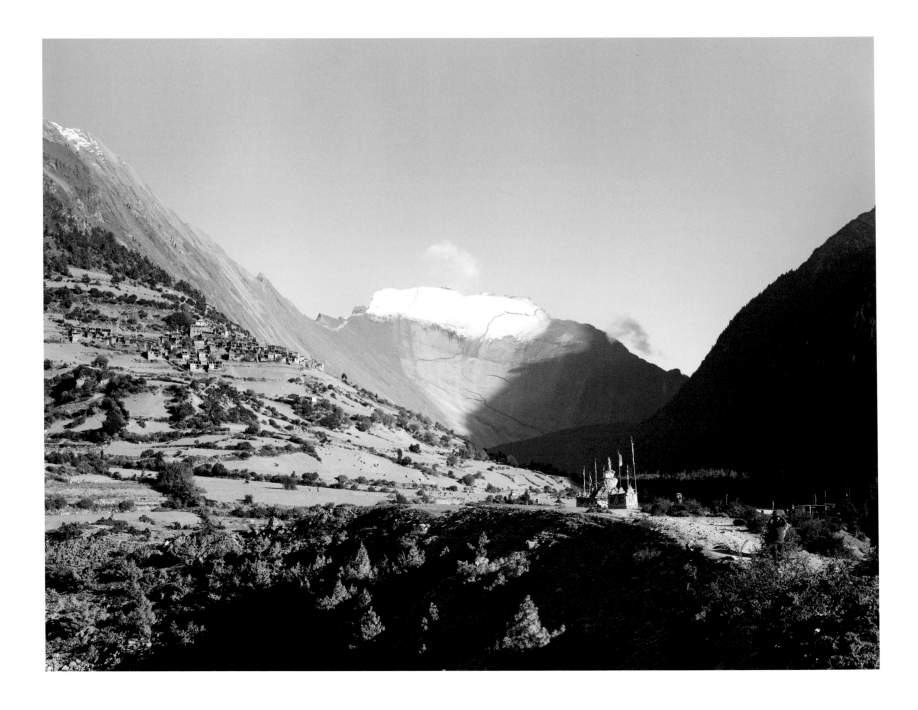

Pi Village and the Oble Rock Dome of the Dead, Upper Marsyangdi Valley; Afternoon Light

The Marsyangdi gorge leads to the Nye-Shang region, a broad increasingly dry valley with an elevation above 3,000 m that continues westwards past Braga to Manang, the main center. To the south are the ice covered peaks of Lamjung (6,931m/22,741ft) and the Annapurna series beginning with Annapurna II (7,937m/26,041ft). The photograph, taken on Day 9, shows the face of the Oble limestone dome near Pi village (Pi-sang in Nepalese). The Gurung shaman ceremonially guides the souls of dead villagers past the black-water entrance to the underworld and then climbs a long winding trail to the summit. There he councils the souls not to return. Some say the released souls journey to Tibet.

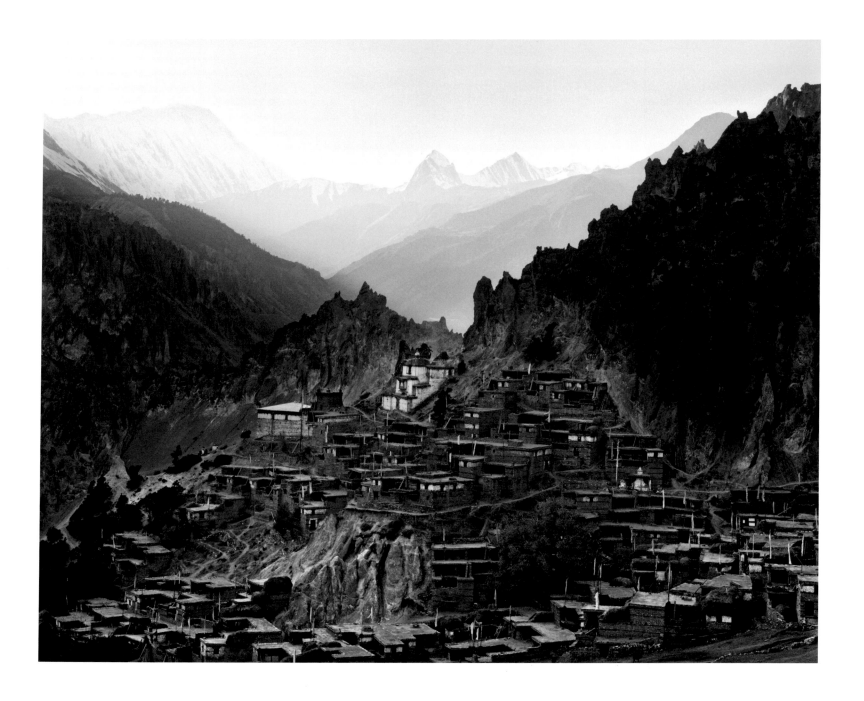

Braga in Evening Light

The village of Braga (3,510m/11,516ft), Drakar in Tibetan, is on the northern side of the upper Marsyangdi Valley below the trekking peak Chulu West (6,625 m/ 21,737ft). The photograph was taken on Day 10 looking to the northwest just as the light was fading. Top left is the shoulder of Tilico Peak (7,134m/23,406ft). The monastery is probably 400-500 years old and must have been built in more prosperous times. Like Shey (page 58) it is of the Ka-gyu-pa order. In the large assembly hall there are many bound texts and pictures of the Kagyupa lineage that begins with the supreme Buddha figure of the order Vajra-dhara (Tib. Dorje-Chang) and continues with the yogins Naropa, Tilopa, Marpa, and Mila-rapa, etc.

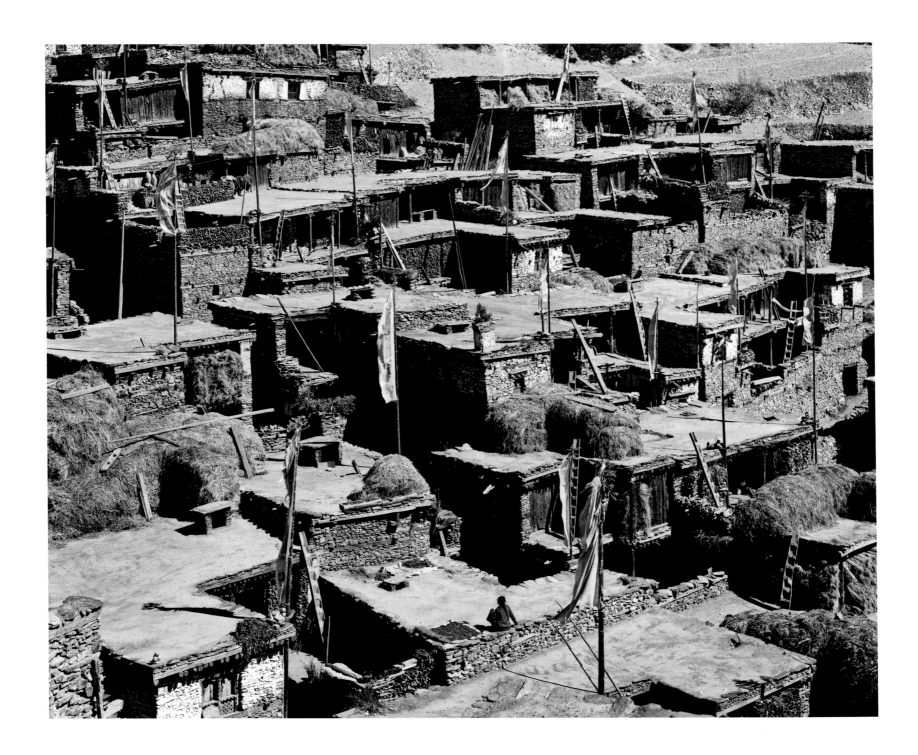

Braga, Roof Pattern and Seated Woman

The photograph was taken on Day 11 looking towards houses on the viewer's right in the preceding photograph. They are constructed against the hillside to conserve arable land and to reduce heat loss; the roof of one house serves as the patio of another. There are no chimneys only roof vents. This makes for very smoky interiors. A narrow passageway threads through the assembly of houses allowing access for people and animals.

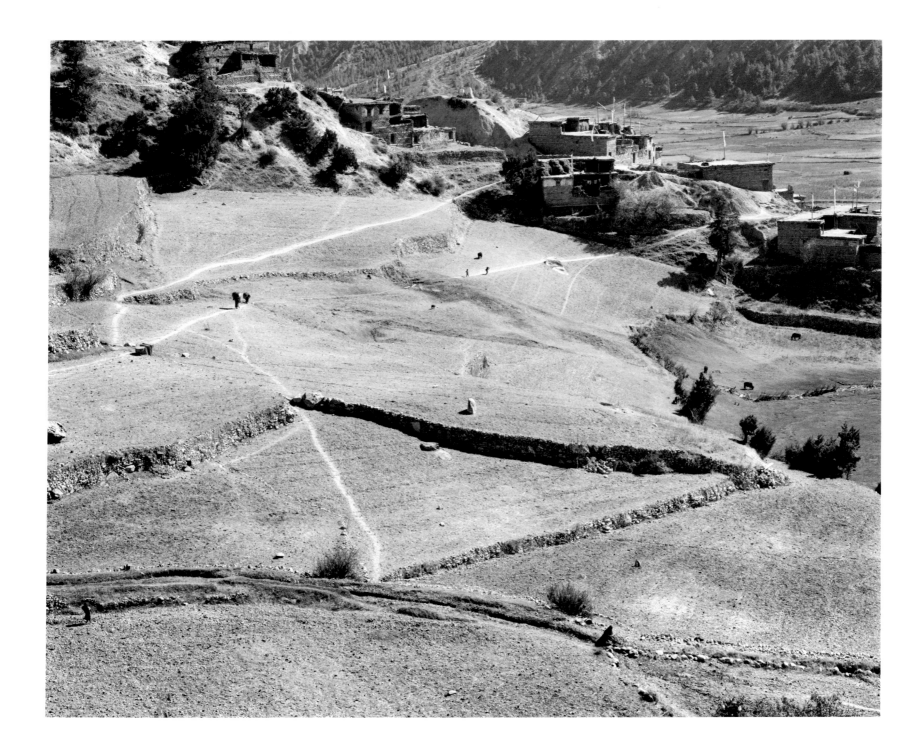

Braga, Field Pattern

The photograph was taken from the terrace in front of the main assembly hall of the monastery looking towards the valley. Every last grain of buckwheat and every piece of straw had been gathered from the fields. The woman in the bottom right was washing her clothes in the small stream.

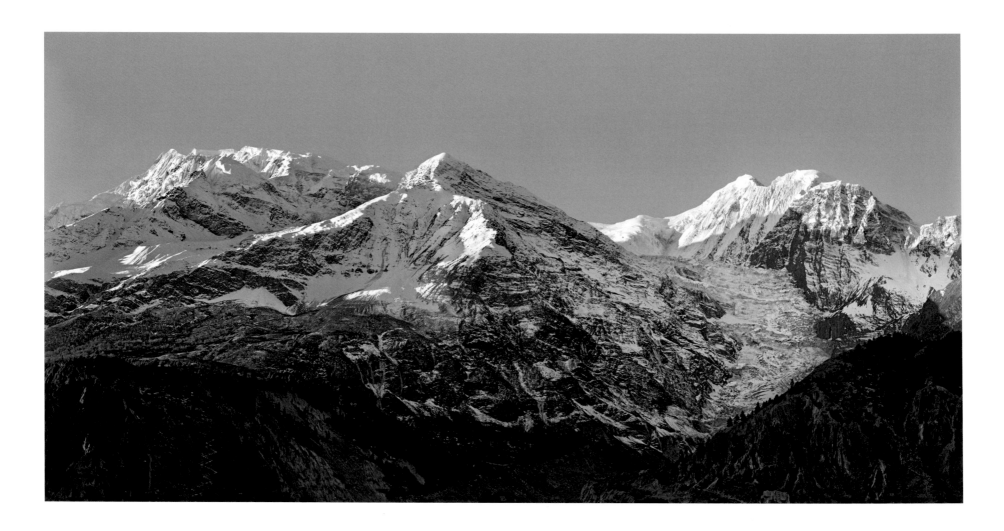

Sunrise From Manang, Annapurna III to the Rock Noir

Annapurna III (left): 7,555m/24,788ft; the Rock Noir (right): 7,485m/24,558ft (also known as Kangshar Kang:); elevation of Manang: 3,536 m/11,601ft. The Annapurna Sanctuary, reached from Pokhara, is on the far side of the ridge. The ridge continues to the Great Barrier and to Tilico Peak. The name Roc Noir was given by an exploratory party of the 1950 Annapurna Expedition. The French came to Manang in search of an access route to Annapurna I. Their eventual approach was from the Kali Gandaki by way of the Miristi Khola.

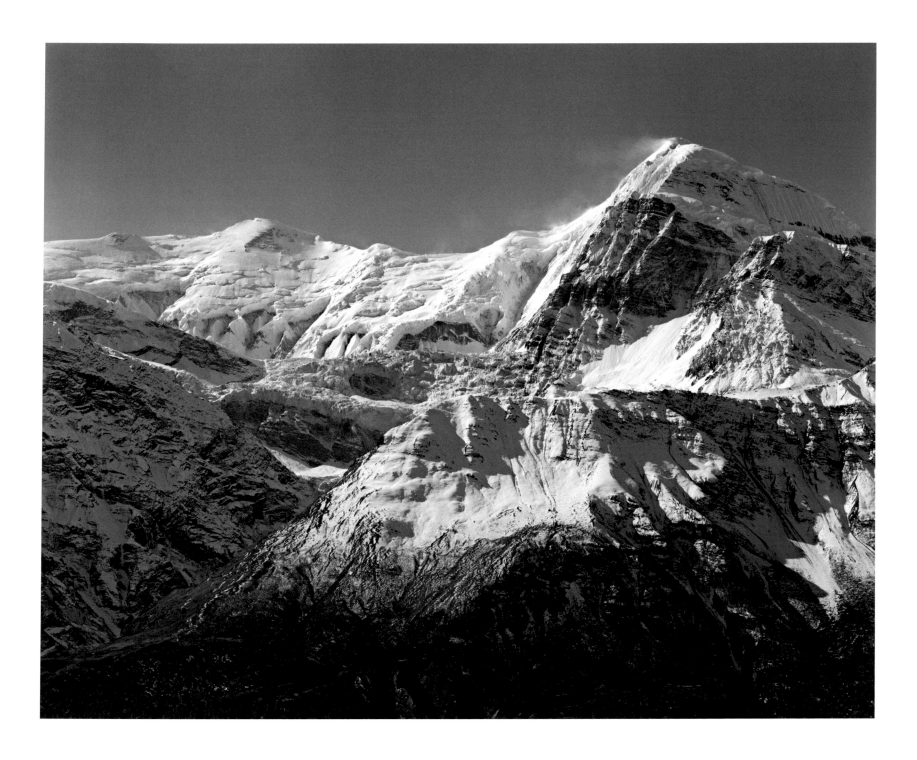

Roc Noir and Manang Glacier; Morning Light

The photograph was taken from the trail a mile or so after leaving Manang. The elevation difference shown in the photograph is about 4,000 m. Annapurna I (8,091m/26,547ft) is directly behind the Rock Noir.

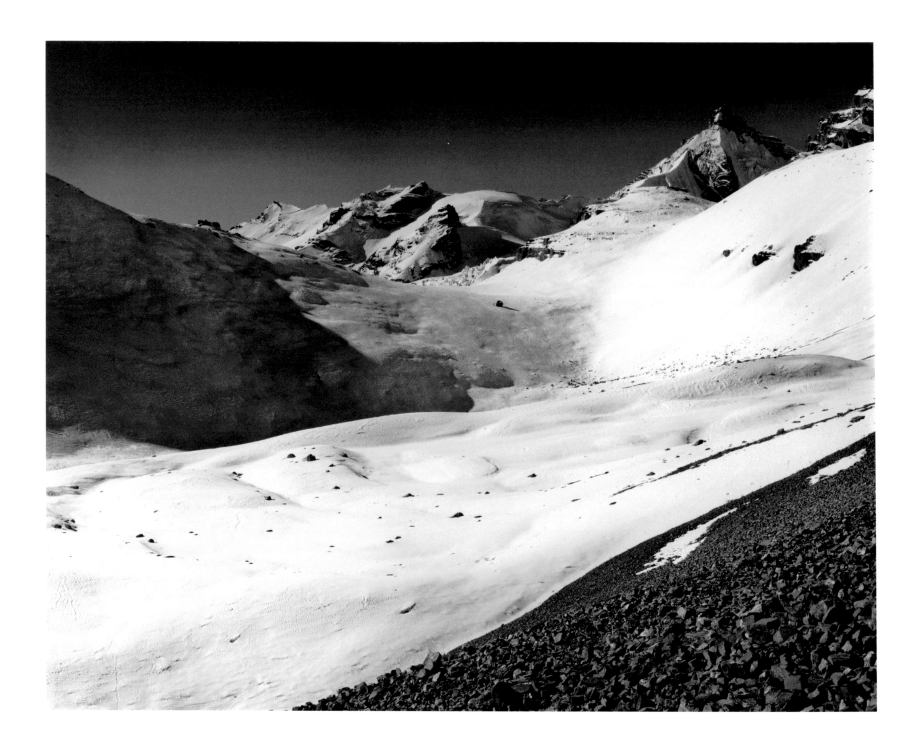

Approach to the Thorung La, View to the West of the Trail; First Light

The main route to the Kali Gandaki from the upper Marsyangdi valley is by way of the Thorung La (5,415m/17,765ft). The pass is about 1000 m lower than the adjacent peaks. The ascent began at 3 am of Day 13 from a high camp at 4,570m/14,994ft. The early start was necessary because high winds may be encountered on the pass in the early afternoon. Several trekking groups and a line of porters formed a long procession carrying lanterns, but by dawn the column was widely spread. I began to discover the necessity to set a very slow and regular mountain pace. An exceedingly slow pace, with or without a rest step, can greatly reduce the need to stop and gasp for air.

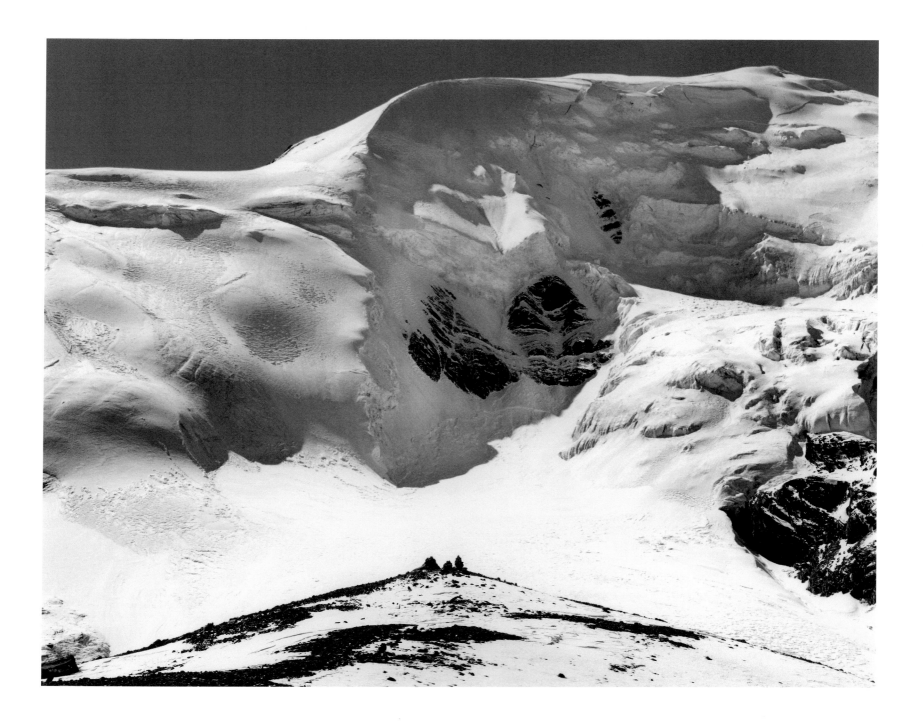

Thorung Peak from the Thorung La

The Thorung Peak (6,483m/21,273ft) is to the southwest of the Thorung La. The three cairns in the photograph were a short distance below the flag-draped cairns at the top of the pass. The photograph was taken about 11:30 am. In crossing the pass we crossed the Himalayan chain; ahead was an arid territory of layered sedimentary rocks without snow. A long descent took us to Muktinath, an ancient place of pilgrimage. Buddhists and Hindus walk for many days up the Kaki Gandaki Valley to see a spring where flames of natural gas emerge from the rock.

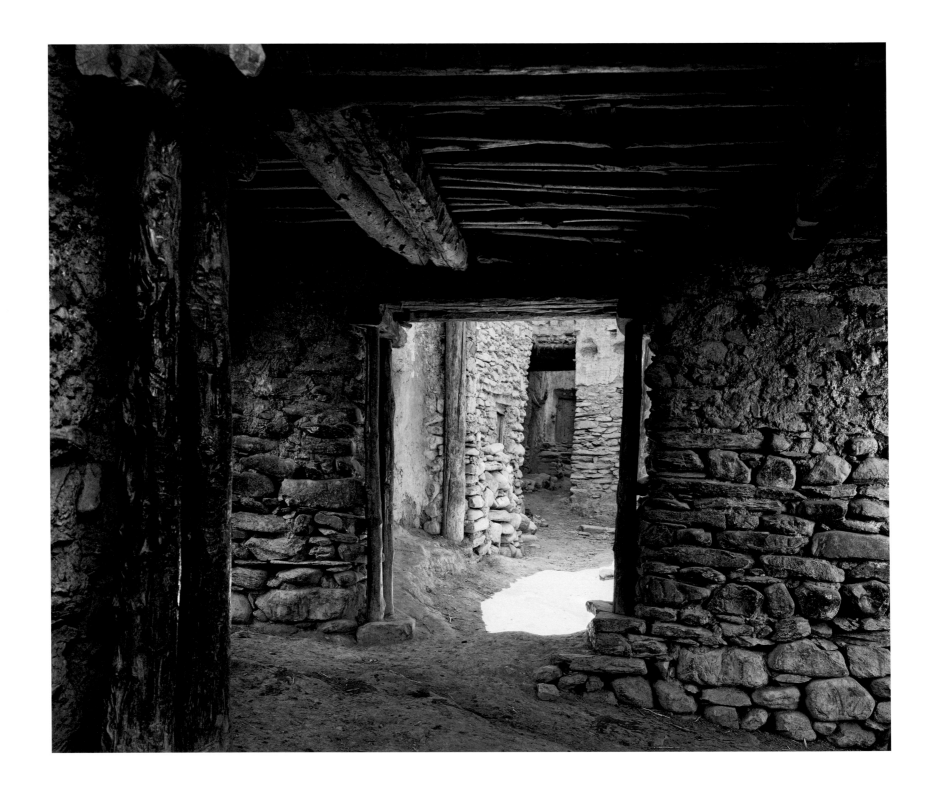

Kagbeni; Passages and Palace Door; Kali Gandaki Valley

From Muktinath we came to Kagbeni (2,804m/9,200ft) in the Kali Gandaki Valley and in the afternoon experienced a sandblasting as we walked onwards to Jomsom (Day 14). The intense winds that blow up the valley every afternoon led the inhabitants of Kagbeni to make covered passageways through the town. The town was a key point in the trade route with Tibet, but the local rulers have abandoned their fortified palaces. The crooked passageway and the smallness of the palace door were thought to prevent the entrance of demons.

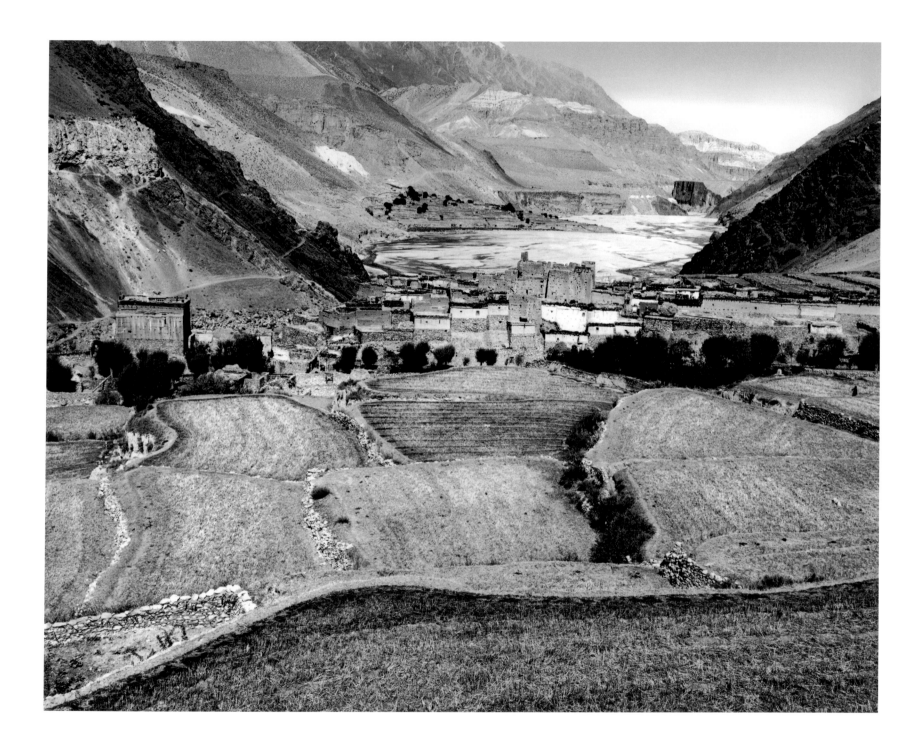

Kagbeni and the Route to Mustang

Kagbeni is on the edge of the Lo-Mustang region, a rift valley formed after the collision of India with Eurasia. The trail from Inner Dolpo followed in 1993 comes down on the left (see page 69). In 1986 we continued down the Kali Gandaki Valley to Tatopani (Nepali for hot water), ascended through rhododendron forests to Goropani (Day 17), and walked through a pleasant farming region to reach Pokhara on Day 20. From there we returned to Kathmandu.

THE REMOTENESS OF EVEREST

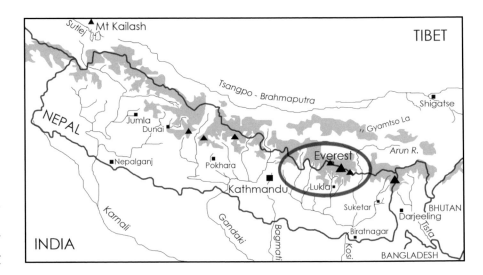

The Rolwaling Valley & The Khumbu Region,
Eastern Nepal
The East Rongbuck Glacier, Tibet

In 1893, after some four years of calculations, Nepal Peak XV was declared to be higher than any other known peak and renamed Everest—a recent estimate is 8,850m/29,035ft. Because Nepal was closed to foreigners by treaty, Everest could not be approached. For Tibetan Buddhists the mountain was *Chomolungma*, Goddess Mother of the World, a bountiful provider both sacred and remote, guarded by the isolated Rongbuck Monastery. The mountain was finally reached in 1921 by the British Reconnaissance Expedition that set out from Darjeeling in early May and took until June 29 to establish a base on the Rongbuck Glacier. In 1950 the rulers of Nepal decided that they might be in need of friends if they were to avoid annexation by India or China and started to admit Western mountaineers. An exploratory group that included the pioneering Bill Tillman and Dr Charles Houston left the railhead in India at the end of October and reached Namche Bazaar in about two weeks, but it took the 1951 Reconnaissance Expedition, under Tillman's old companion Eric Shipton, a month of monsoon traveling to get there by way of the Arun Valley. The southern Everest Base Camp (5,357m/17,576ft) is about five day's journey beyond Namche. Namche Bazaar (about 3,440m/11,283ft), the center of the Khumbu region and of the Sherpa community, provides travelers with an

abundance of lodges and cyber cafes. It is a two-day trek from the Lukla airstrip (2,886m/9,466ft) that is pasted onto the hillside above the Dudh Kosi Valley (dudh = milk). Helicopters and sixteen-seater planes whisk trekkers and climbers between Lukla and Kathmandu. To reach Everest from the north the traveler can now drive from Lhasa (3,658m/12,000ft) all the way to the northern Everest Base Camp (5,181m/17,000ft). But these are just the approaches; Everest itself remains remote and inaccessible.

Rolwaling 1996. My first approach to the Khumbu region was by way of the Rolwaling Valley, a deep furrow that lies parallel to the Tibetan border and south of Gauri Shanker (7,145m/23,436ft). The Sherpas of the valley can visit the Khumbu by way of a difficult high pass, the Tesi Lapcha (5,755m/18,882ft). The first mountaineers to cross the pass were Edmund Hillary and Earl Riddiford at the end of the 1951 Reconnaissance. In 1996 we reached Rolwaling on Day 7 having started on November 6 from Barabise on the Chinese built road from Kathmandu to the Tibetan border. Five days were spent in a detour south to the Ramdung Base Camp area (5,000m/16,400ft). From the main valley we crossed the Tessi Lapcha and descended to Thame in the Bhote Kosi Valley. This valley connects the

Nangpa La, the important Sherpa pass to Tibet, to Namche Bazaar. At last we reached the patio of the Everest View Hotel (near Khumjung above Namche). The clouds briefly parted and I finally saw Everest rising above the Lho-tse/Nup-tse Ridge. Lukla was reached on Day 21.

Khumbu; Mera 1999. The primary objective of my trip was to climb Mera. This highest trekking peak in Nepal (6,461m/21,198ft) is east of Lukla and outside the Khumbu. We left Lukla on November 2. The trail over the Zatrwa La (4,436m/14,550ft) led to the seriously scarred Hinku valley that had recently been swept

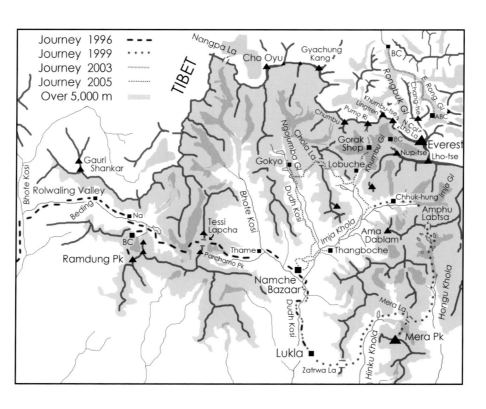

out by the collapse of a glacial moraine lake. Mera was ascended via the Mera La (5,110m/16,760ft) and a high camp. We reached the summit under ideal conditions; a total of five 8,000-meter peaks were visible with Everest some 20 miles to the north. The further route followed the icy Hongu Valley northward and crossed into the Khumbu by the steep and glacial Amphu Lapcha pass (5,780m/18,958ft)—we had to rappel down the northern side. The first Westerners to cross this pass were Eric Shipton and Edmund Hillary, who, towards the end of the 1951 Reconnaissance Expedition, explored the Imja Glacier and circled the dramatic peak of Ama Dablam (6,812m/22,349ft). From Chhukhung at the edge of the Imja Glacier the trail to Namche Bazaar led us past Thangboche Monastery that is dramatically placed on a shoulder below Ama Dablam. Lukla was reached on Day 22.

Khumbu 2005. The trek followed the standard pattern of hiking from Lukla to Namche. We followed the Dude Kosi Valley and the edge of the Ngo-jumba Glacier to the Gokyo Lakes. At the valley head on the Tibetan border is Cho Oyu (8,201m/26,906ft). After an eastward passage

across the Ngo-jumba Glacier and the stony Cho La (5,480m/17,979ft), the trail contoured into the main Khumbu Glacier route to Everest. Following the glacier edge we reached the yak grazing area Gorak Shep (5,200m/17,056ft). Beyond was Kala Pattar, a shoulder of Pumor Ri, and the trail across the glacier to the Base Camp. From this area the Everest summit appears over the shoulder of Nuptse; the Khumbu Ice Fall that is the barrier to the Western Cwm is seen as a thin line of ice. The Cwm was first seen on 19 July 1921 by George Mallory and G. H. Bulloch when they explored the cols on the border ridge from the West Rongbuck Glacier. We returned to Lukla on Day 16 (November 16). Again, Everest was seen but not visited.

Tibet 2003. The Land-Rover journey from Lhasa to the Everest Base Camp on the Rongbuck Glacier, by way of the fortress and monastery towns of Gyantse and Shigatse, was over high rolling moorland, the highest point being the bleak Gyamtso La (5,218m/17,120ft). From the Base Camp we trekked by slow stages up the moraine of the East Rongbuck Glacier to reach, on September 17, the Advanced Base Camp (6,400m/21,000ft). This moraine viewpoint gave a prospect of the Everest North East Ridge and the North Col (7,066m/23,176ft). As I ascended the moraine towards the Col, late monsoon clouds veiled everything in translucent mist. The North Col was first reached on September 23 at the end of the 1921 Reconnaissance expedition. Mallory and companions encountered violent winds, characteristic of the post monsoon season, and had to retreat. We returned to the Base Camp in light snow on Day 12. Our drive, by moorland roads and a narrow gorge, brought us to the border crossing and the road to Kathmandu.

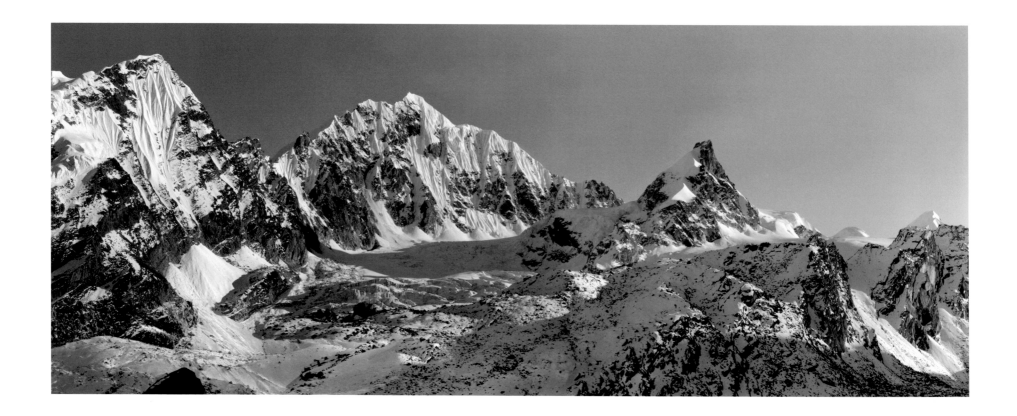

Panorama of the Ramdung Glacier and Peaks to the South from above the Ramdung Base Camp; Late Afternoon Light

One of the less convenient ways to enter the Everest-Khumbu region is by the Rolwaling Valley. In 1996 on November 7, Day 1, we drove from Kathmandu to Barabisi on the road to the Tibetan border and from there, on Day 7, reached the Rolwaling Valley. The Ramdung Base Camp (4,900m/16,076ft) is in a hanging valley to the south of the main valley. This 60° panorama was taken on Day 14 from the ridge 1000 ft above the camp. Ramdung Go, a trekking peak due south, is the round summit second from the right (5,930m/19,456ft). Continuing right, the peak heights are 5,766m/18,917ft, 6,259m/20,535ft and 5,945m/19,504ft.

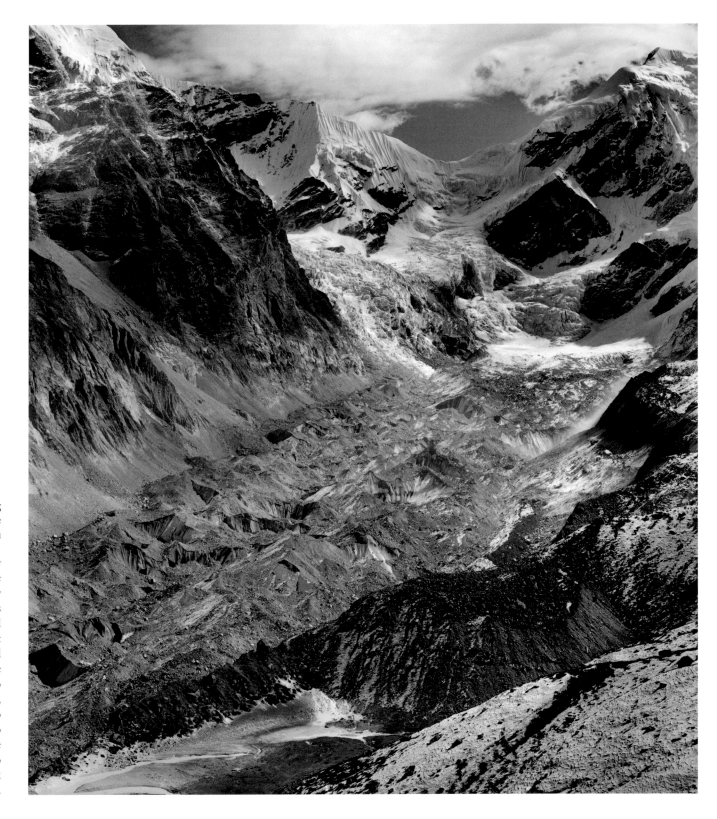

Upper Rolwaling Valley; The Trakarding Glacier and Approach to the Tesi Lapcha Pass to the Khumbu

On Day 16 we descended to the main valley and started to negotiate the upper glacier. The Tessi Lapcha (5,755m/18,882ft), slightly lower than the col in the photograph, is behind the shoulder to the left. We camped on the moraine near the end of the glacier (at 5,010m/16,437ft) and the next day ascended the steep rock and ice to the left until we came to an extended snowfield that took us to the pass. At the end of the valley to the left, partly behind the shoulder, is Parchamo (6,273m /20,580ft) and right, Bigphera Go Shar (6,730m/22,080ft). From the pass we descended to Thame, Namche Bazaar and to the airstrip at Lukla, and from there flew back to Kathmandu on Day 21.

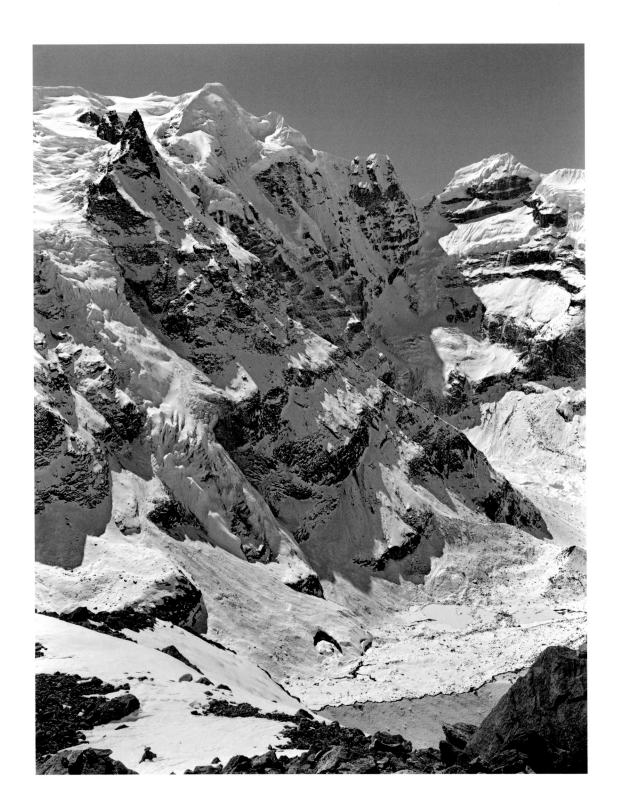

Mera Glacier and Peak from above Khare Camp

A second indirect way to the Everest area is a loop though the Hinku and Hongu Valleys. In 1999 we left the Lukla airstrip (2,886m/9,468ft) on October 27 and on Day 3, climbing east, crossed the Zatrwa La (4,436m/14,550ft) to reach the Hinku Valley. The photograph was taken on Day 9 (elevation about 5,000m/16,404ft) as we ascended towards the Mera La. Mera summit is the small bump top left (6,461m/21,197ft). The summit was reached on Day 11, alas without my view camera.

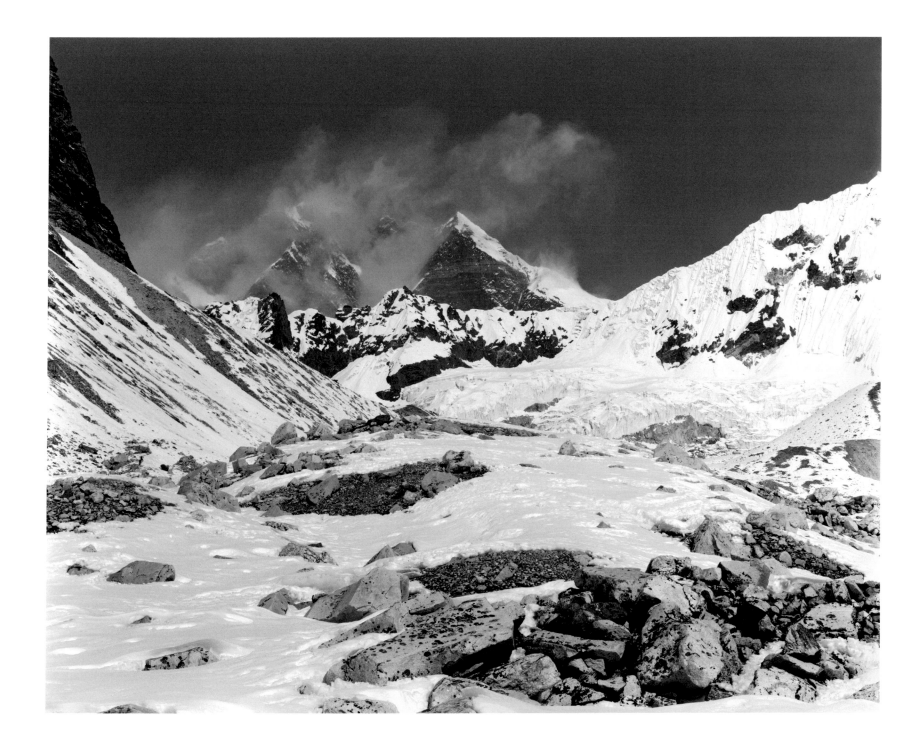

Upper Hongu Valley, Approaching the Sacred Lakes

From the Mera La (5,110m/16,765ft) the route descended to the icy Hongu Valley. The photograph was taken on Day 14 a little before reaching the Panch Pokhri sacred lakes (5,360m/17,585ft). From a camp at the lakes we crossed the Amphu Labtsa pass (5,780m/18,964ft) and thus reentered the Khumbu by a glacial ascent and a rappelled decent to the Imja Glacier. By following the glacier, we reached the settlement at Chhuk-hung (4,730m/15,518ft).

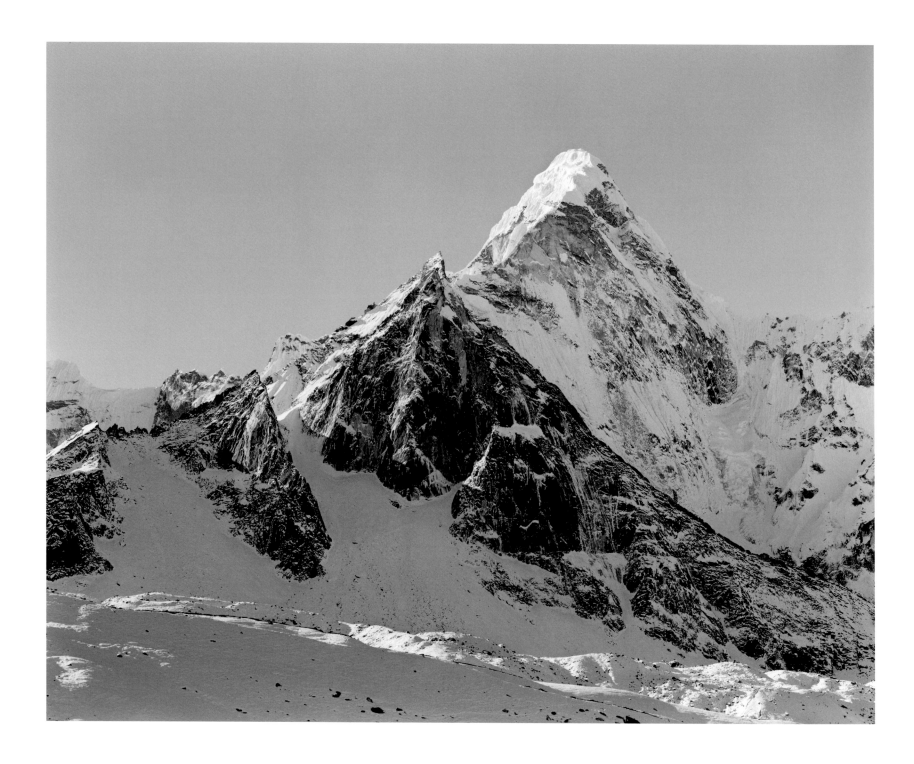

Ama Dablam from Chhuk-hung; Morning Light

Ama Dablam (6,856m/22,495ft) dominates the landscape for all those who pass beyond Namche Bazaar on their way towards Everest. Its distinctive shape must have been created by a sequence of glacial flows. When viewed from Chhuk-hung, looking south, the mountain takes on a triangular simplicity. The peak to the left on some maps is named Amphu Gyabjen (5,630m/18,471ft). The photograph was taken on Day 18, 1999; thereafter we continued to Namche Bazaar and flew from Lukla on Day 23.

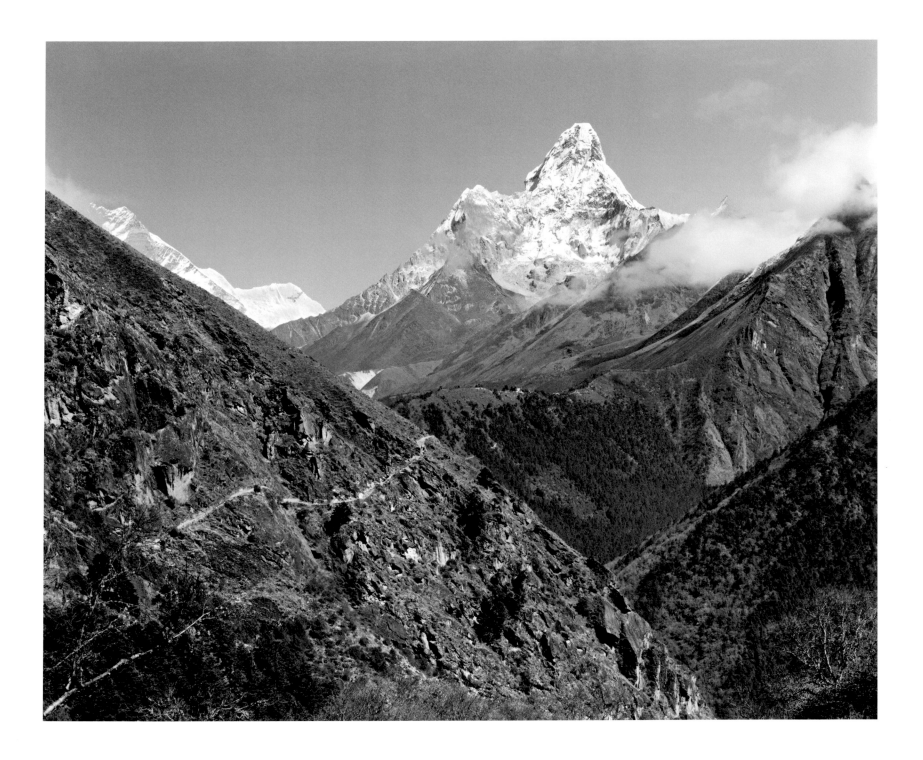

Ama Dablam, the Mon La Trail, and Tyangboche Monastery

The 2005 trip began from Lukla on October 24. This photograph, taken on Day 4, shows the familiar view of Ama Dablam set above the deep Imja Khola Valley. The Mon La trail to the left leads to the Dudh Kosi Valley. Tyangboche Monastery (3,867m/12,687ft), the small dot on the shoulder almost directly below the peak, is reached by ascending a very steep trail from the bridge near the junction of the Dudh Kosi and the Imja Khola. This gompa was established in 1916 as a celibate Nying-ma-pa (old sect) institution with the support of a wealthy trading family. Its founder Lama Gulu was inspired by a Tibetan Lama, Zatul Rinpoche. It has been substantially rebuilt since a fire in 1989.

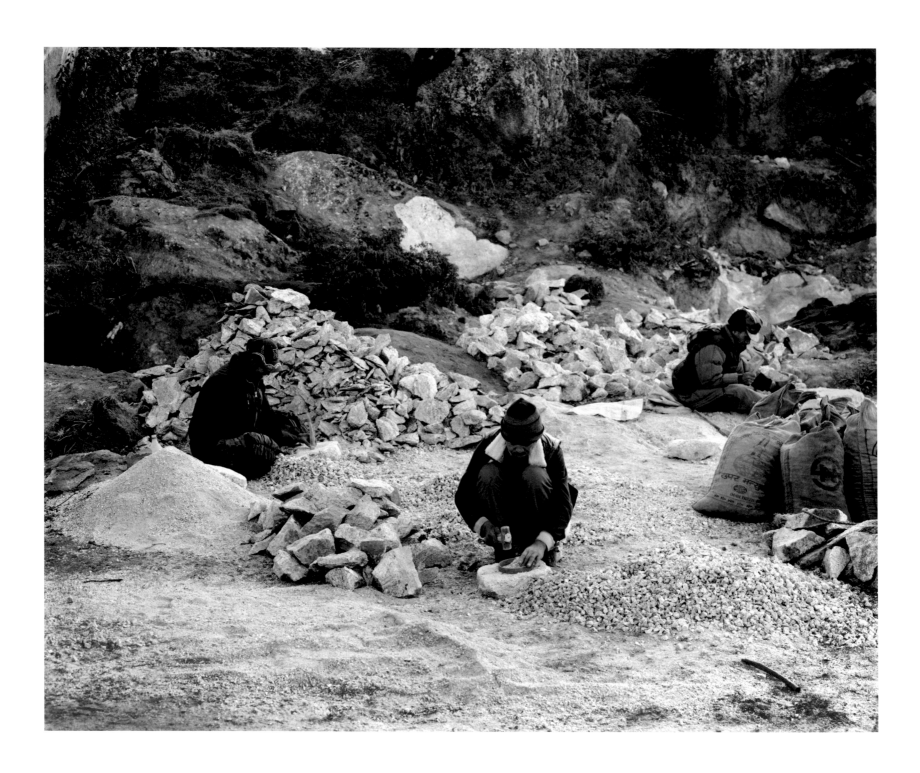

Stone Breakers near Namche Bazaar

The small fragments produced by these stone breakers were probably for use in Namche Bazaar. In Namche the sound of tapping mason's hammers mingles with the tinkling of yak bells. The houses are all built of stone that has been meticulously shaped by hand. Much carpentry is by hand even though electricity is now available. Concrete, where used, must be carried there by yak. (Photograph, Day 3, 2005.)

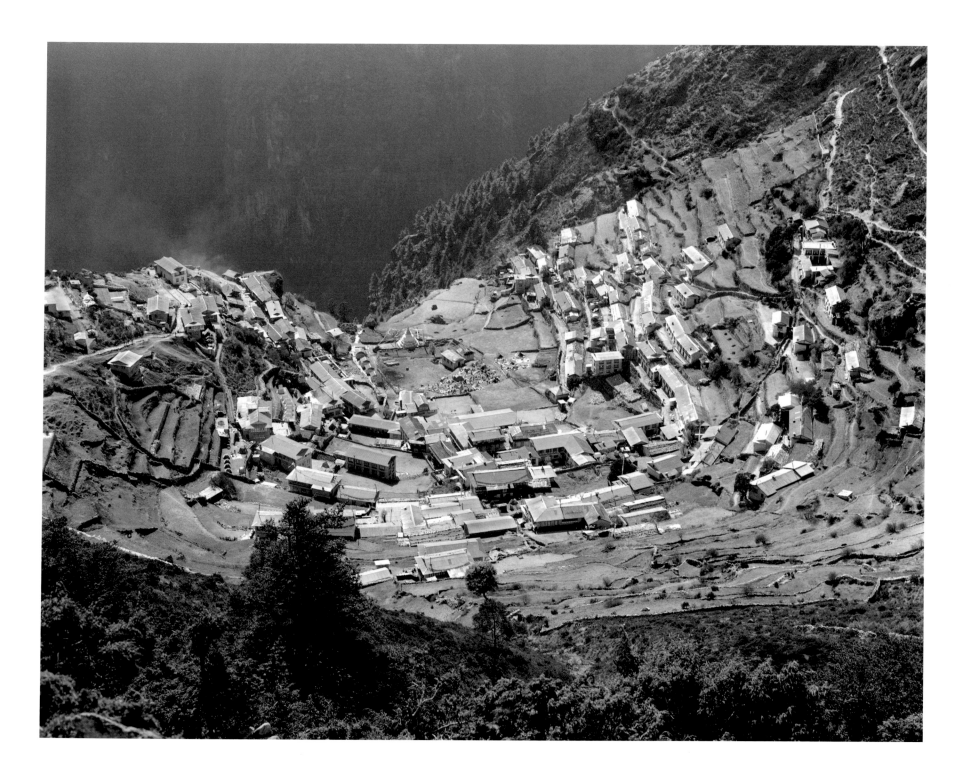

Namche Bazaar

Namche Bazaar (3,440m/11,286ft) is normally reached in two days when approached from Lukla (2,886m/9,468ft). The last part of the ascent is unpleasantly steep for those beginning their acclimatization. The town is set in a bowl above the Bhote Kosi just past the point at which it joins the Dudh Kosi. The tourist trade has transformed the original Sherpa trading center into a collection of tourist lodges and visitors now have a choice of several internet cafes. (Photograph, Day 20, 1999.)

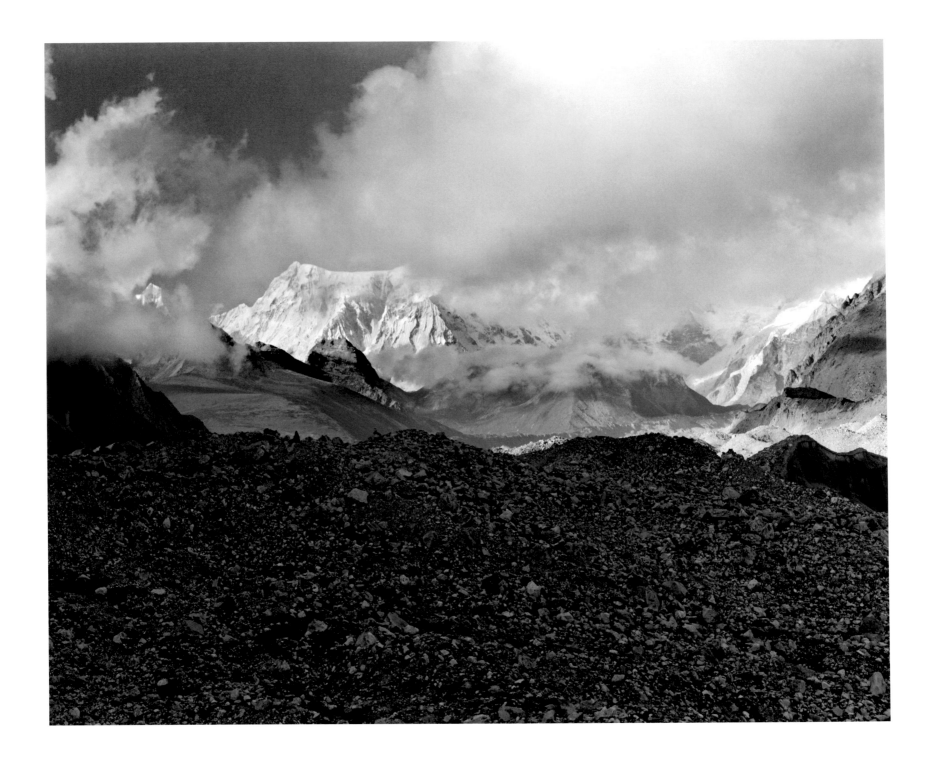

Crossing the Ngozumba Glacier: View North Towards the Cho Oyu to Gyachung Kang Range; Afternoon Light

In 2005 we ascended the Dudh Kosi to the Gokyo Lakes that are adjacent to the Ngozumba Glacier. On Day 9 we turned east from the second lake and ascended the edge moraine (4,700m/15,420ft). The peaks began to disappear in cloud as soon as I set up the camera. The range from Cho Oyu to Gyachung Kang defines the Tibetan border (8,153m/26,750ft to 7,922m/25,992ft). Thereafter we crossed the glacier by a rocky winding cairn-marked route past ice clefts and ponds of melt water.

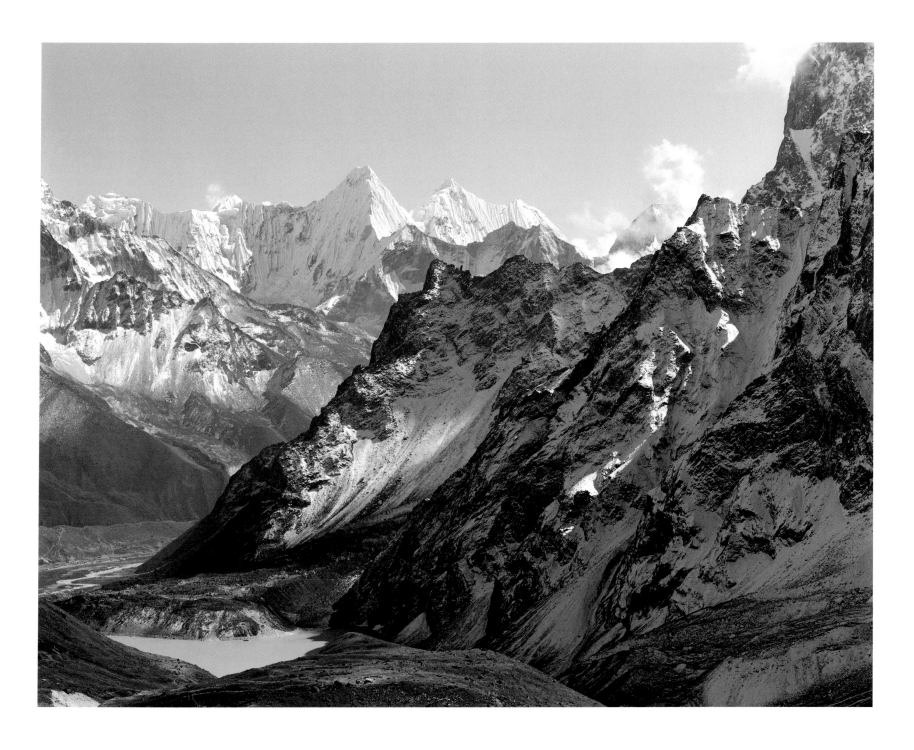

View Southeast from Below the Cho La towards the Labuche Khola

On the day after crossing the Ngozumba Glacier our trail passed to the south of the Kangchung Peaks that are a little over 6,000 m and then crossed their southern extension by the stony Chola La (5,420m/17,782ft). The shoulder to the right belongs to a group that ends in Tawache Peak (6,543m/21,468ft). To the left is a shoulder of Ama Dablam. The peak to the center right is Malanphulan (6,571m/21,558ft) that is due south of Ama Dablam.

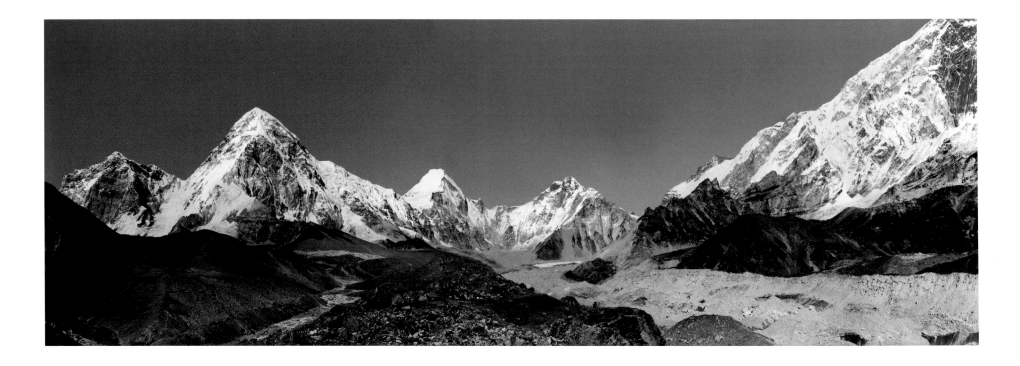

Panorama of the Khumbu Glacier and the Tibetan Border from the Edge Moraine at Lobuche

From the Chola-tse Valley the trail contoured round to meet the main Lobuche Khola route to Everest. This route, seen to the left in the photograph, follows the ablation valley alongside the Khumbu Glacier. The peaks on the Tibetan border are, from left to right: unnamed peak (6,363m/20,876ft), Pumo Ri (7,145m/23,441ft), Lingtren (6,713m/22,024ft) and Khumbu-tse (6,640m/21,785ft). Kala Patthar is the shoulder in front of Pumo Ri. A shoulder of Nuptse obscures the Lho La Col adjacent to Khumbu-tse. Chang-tse in Tibet (7,550m/24,770ft), the extension of Everest beyond the North Col, is just visible over the shoulder (Chang- means north). (Photograph, Day 11; elevation about 4,930m/16,175ft.)

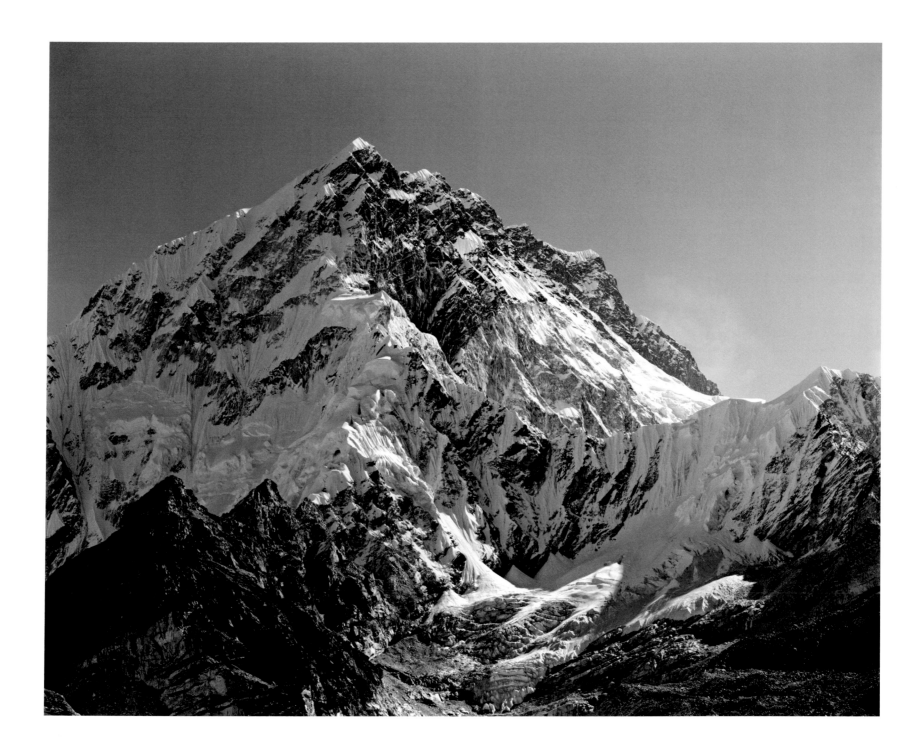

Nuptse from the Trail between Lobuche and Gorak Shep

The Nup-tse (7,855m/25,771ft) to Lho-tse (8,501m/27,890ft) ridge forms the south wall of the Western Cwm (Nup- means west, Lho- means east). This photograph of Nuptse looking east was taken from the point where moraine from a side glacier disrupts the trail to Gorak Shep. (Photograph Day 12, elevation about 5100m/16,732ft.)

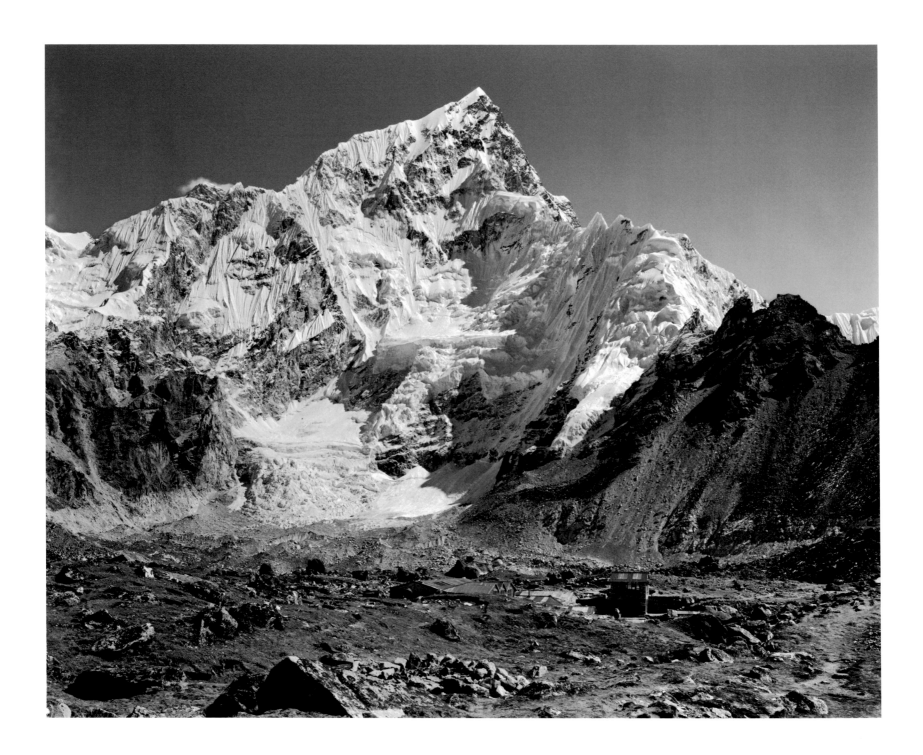

Nuptse from Gorak Shep

Gorak Shep is a flat and dusty yak-grazing area used for camping (elevation 5,288m/17,349ft.) The vertical height confronting the viewer is 2,567m/8,422 ft. The photograph on page 107 was taken two or three hours earlier; the rock formation seen there to the left is here to the right. The similarity in lighting arises from the rotary movement about the mountain of both the sun and the photographer. The summit of Everest is just visible over the right shoulder of Nuptse.

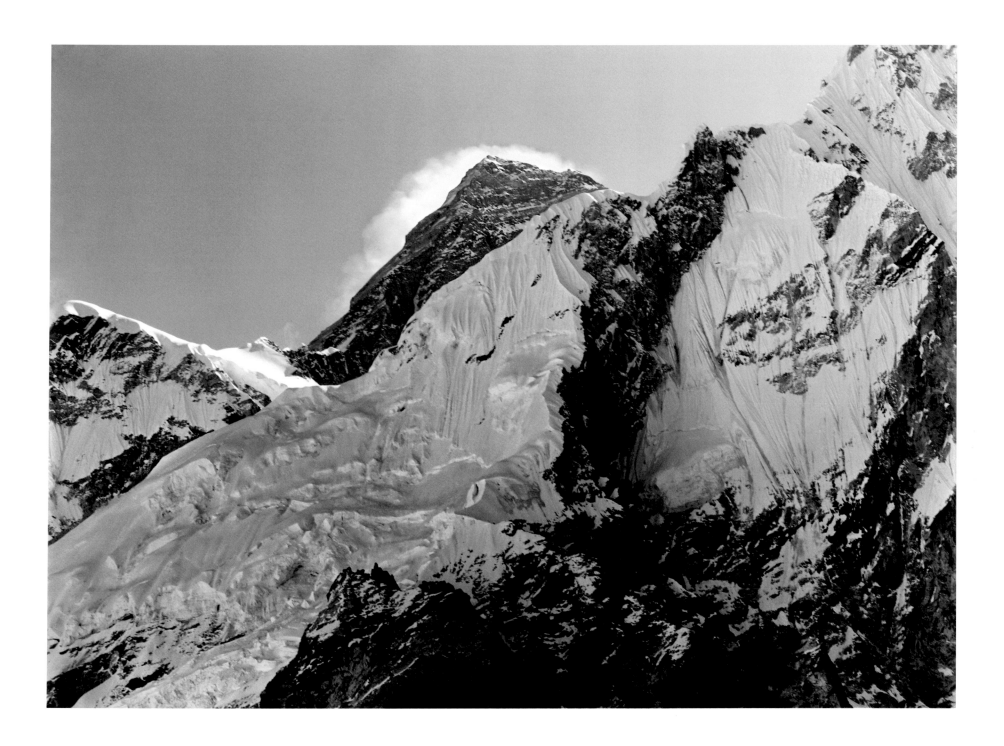

Everest and the Everest West Ridge above the Nuptse Ridge; from Kala Patthar, Morning Light

Everest (8,850m/29,035ft) is due east of the Kala Patthar viewpoint (5,545m/18,192ft), hence the morning light leaves Everest, Nuptse and the Khumbu Icefall in shadow. The photograph was taken part way up Kala Patthar about 10 am on Day 13, as the light was just catching the West Ridge and before the summit cloud faded away. Seen from this angle the West Ridge, the left triangle behind the ice-covered diagonal of Nuptse, is considerably foreshortened. From Gorak Shep we followed the regular trail to Namche and Lukla and flew back to Kathmandu on Day 17.

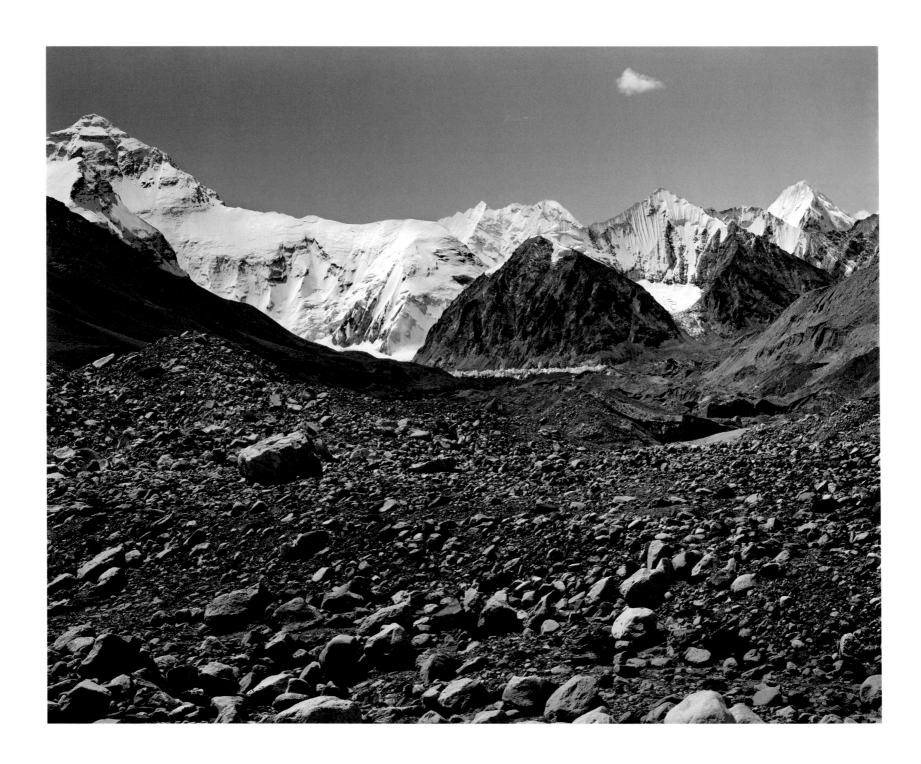

Everest West Ridge from the Rongbuck Glacier

In 2003 the Everest Base Camp (5,200m/17,060ft) was reached on September 9 by road from Lhasa. We had stopped briefly at the Rongbuck Monastery (5,000m/16,404ft) earlier in the day (Day 1). The Photograph was taken on Day 3 before turning east to enter the East Rongbuck Glacier (elevation 5,460m/17,913ft). A little to the right of the summit (8,850m/29,035ft) is the Hornbein Couloir climbed by Thomas Hornbein and William Unsoeld on their 1963 Everest traverse. They reached the Couloir from the Khumbu Ice Fall via the West Ridge shoulder. To the right of the shoulder (7,309m/23,979ft) is the Lho La Col (6026m/19,770ft), partly masked by a northern extension of Lingtren.

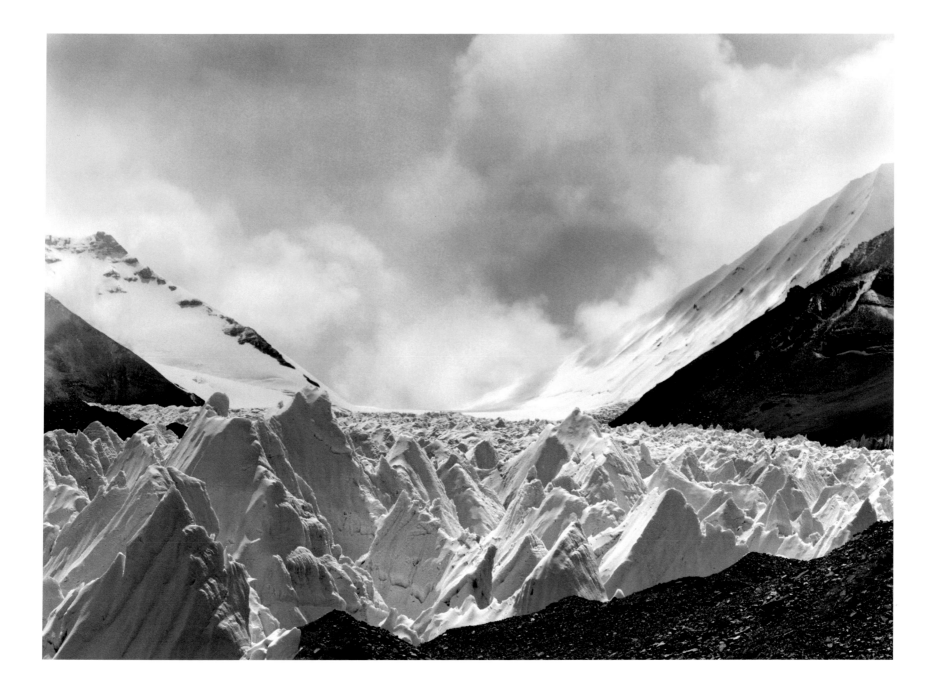

Ice Pinnacles, Upper East Rongbuck Glacier, Clouds on the Raphu La; Late Afternoon Light

The route up the East Rongbuck Glacier switches from the eastern edge to the highway of central moraine that derives from the junction with the Changtse Glacier. After the junction the trail follows the glacier's western edge to the Advanced Base Camp (ABC) that is around the corner of the first right shoulder in the photograph. Beyond this point the glacier is smooth and relatively free of crevasses. The Raphu La (6,548m/21,483ft) that is at the foot of the Everest North-East Ridge, the second right shoulder, leads to the Kangshung Glacier and, under more favorable condidions, can provide views of the north face of Makalu. (Photograph Day 9, 6,100m/20,012ft.)

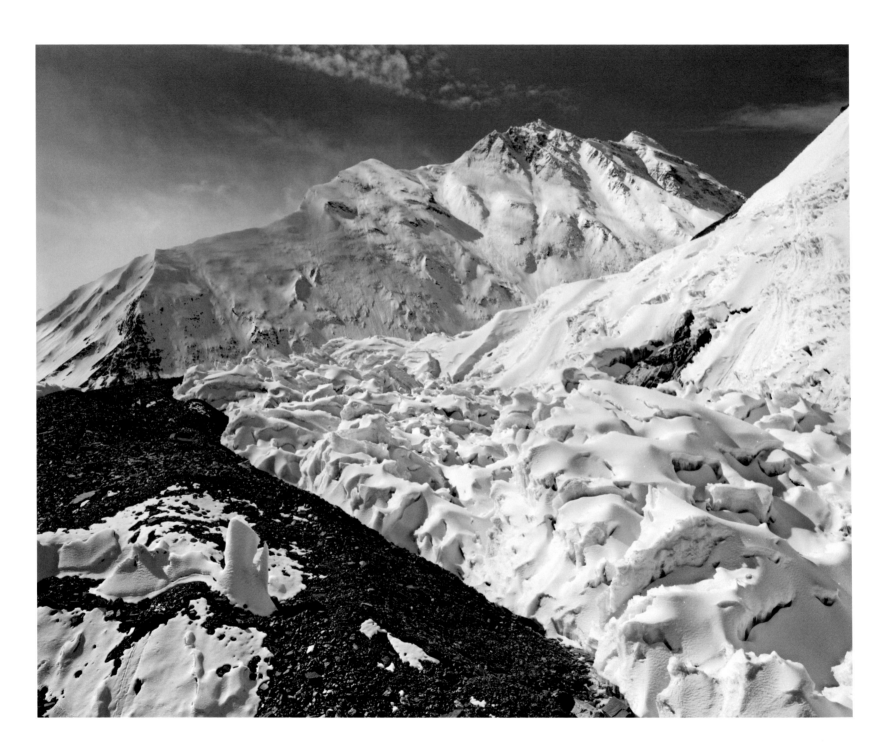

Everest North-East Ridge from the Advanced Base Camp, East Rongbuck Glacier

The ABC is a patch of moraine at 6,400m/21,000ft. The photograph was taken on Day 9 about 10 am, as the oblique light maximized the modeling of the Everest snow. The summit is to the right; on the jagged ridge to the left is The Pinnacles. A shadow triangle marks the edge of the Great Couloir and the North Ridge. The usual line of ascent from the North Col swings to the right of the North Ridge and cuts across to the Second Step and then ascends the summit pyramid. The direct route up the North-East Ridge is very difficult. In 1982 Pete Boardman and Joe Tasker died somewhere near the Second Pinnacle while attempting an alpine-style ascent without oxygen.

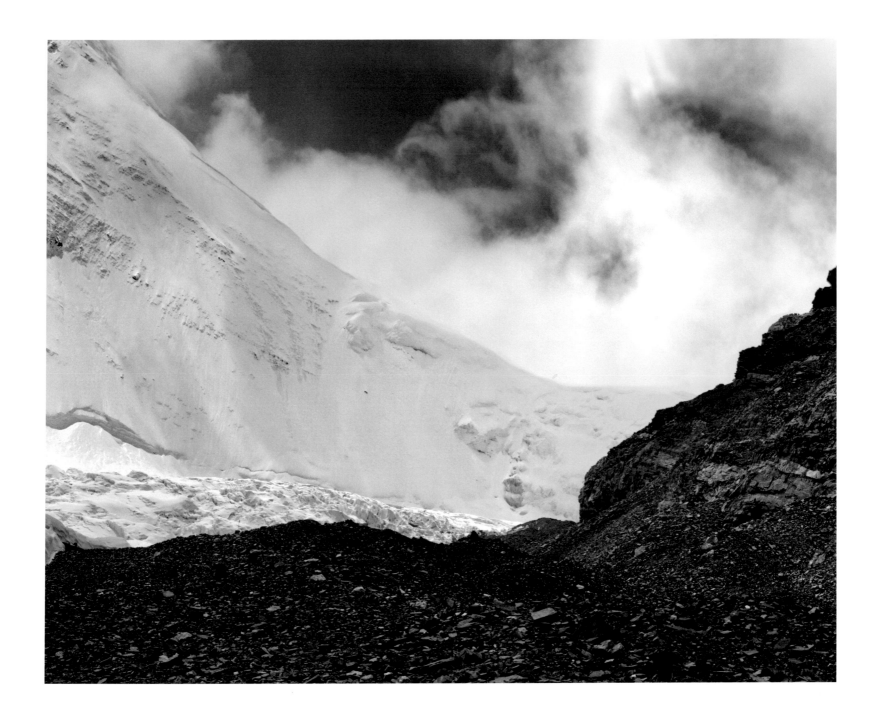

Everest North Col, Approach from the East Rongbuck Glacier

By 11 am the clouds were rapidly forming as I ascended the moraine leading from the ABC to the North Col (7,069m/23,192ft). The Col lies between Everest and Chang-tse (7,550m/24,770ft). The steep and dangerous part of the ascent begins beyond the rock cliffs. My elevation was about 6,530m/21,425ft. We returned to the Base Camp on Day 11 and from there traveled by road to Kathmandu.

FIVE TREASURIES OF GREAT SNOW

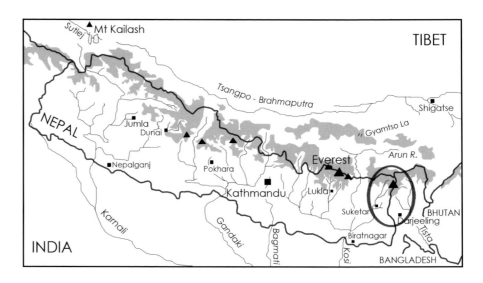

Approaching Kangchenjunga, Eastern Nepal

For many years Kangchenjunga (8,586m/28,169ft), situated on the border between Nepal and Sikkim, played the role in the Western imagination now taken by Everest. The most easterly of the 8,000 m peaks, it was long thought to be the highest mountain; in fact, it is the third highest. Ever since the Chogyal of Sikkim in 1835 leased to the British Raj the hill of Darjeeling, the view of the Kangchenjunga range 45 miles away has been repeatedly described painted, and photographed. The Tibetan form of the name can be interpreted as "Five Treasuries of Great Snow". The sacred nature of the mountain with five summits was affirmed by the Sikkim government when it obtained a commitment from the 1955 British expedition, led by Charles Evans, that no one would step on the highest summit. Their ascent was successful, but they left the last 5 feet untrodden. Sikkim, formerly a Buddhist monarchy, became an Indian state in 1975. This was, in part, the result of a slow influx of Hindus from Nepal. Darjeeling, annexed by the British Raj after an 1849 dispute, has been the home for a large contingent of Buddhist Sherpas since the mid nineteenth century.

The Kangchenjunga group stands as a separate unit. It lies on a north-south watershed: the Tamur River that drains the Nepal side is part of the Khosi river system that flows into the Ganges; the Teesta River that drains the Indian side flows into the Brahmaputra in Bangladesh. There are four main glaciers about a central hub. To the north is a branch of the Kangchenjunga Glacier that is a source of the Tamur River. The Kangchenjunga Northern Base Camp at Pangpema (4,940m/16,208ft) is directly north of the hub. Curving north the glacier leads to the Jongsang La (6,145m/20,161ft), a pass to northwest Sikkim. On the border slightly to the nor-noreast of the hub are The Twins and Nepal Peak. Moving clockwise into Sikkim are glaciers that feed into the long Zemu Glacier. East: a main ridge runs to the spectacular ice-covered Siniochum Peak; next is the Talung Glacier. South on the border is a series of summits including Kabru IV (7,395m/24,263ft) and Ratong (6,670m/21,884ft) and continuing to the Singalila Ridge. On the Nepal side the Yalung Glacier drains into the Simbua Khola, a tributary of the Tamur River. West of the hub is a branched series of peaks, including Kambachen (7,902m/25,926ft) and Jannu (7,710m/25,296ft).

My 1998 trek involved flying from Kathmandu to Biratnager and from there in a 16-seater plane to the Suketar airstip near the town of

Taplejung in the Tamur Valley. Our route looped back to return by the Tamur Valley. We set off to the northeast on November 1 through well kept colorful Limbu villages into the Kabeli Valley. From that valley we ascended though trees with hanging moss, bamboo and rhododendron and descended to the Simbua Khola. On Day 8 we reached Tseram (3,750m/12,303ft), an important junction: to the east is the Khang La, a snow pass to Sikkim leading to Darjeeling in the south; west is the Mirgin La route to the Tamur valley. The moorland near Tseram was covered with low-growing aromatic bushes of *Rhododendron nivale* (Hooker), the worlds highest growing shrub.

A few miles beyond Tseram is the Yalung Glacier. From an ablation-zone camp at Ramze we visited Oktang (4,630m/15,185ft) that provided a view of the great cirque that forms the southern aspect of Kangchenjunga. After backtracking we crossed a moorland trail, the Mirgin La and Sinon La, and made a steep decent through rhododendron forests to the Ghunsa Valley. Ghunsa is a large Bhotiya (Tibetan) village with alpine-style log houses. On Day 15 we reached the yak-herding settlement of Lhonak (4,560m/14,961ft) where a side river flows into the Kangchenjunga Glacier. Clouds obscured the valley and peaks. From Lhonak the trail followed ablation terraces, dropped to the moraine, then again climbed to a high terrace near Pangpema, the Northern Base Camp. In late afternoon the clouds began to blow away from the northeast face of Kangchenjunga. Streamers generated by high winds swept from the upper mountain. Next day was still and the sky clear; light reflected onto the shadowed northeast face; spindrift

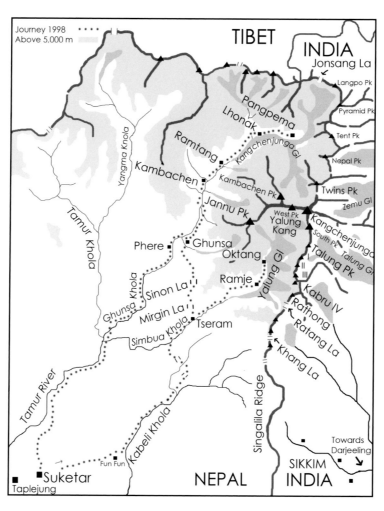

illuminated the skyline. Our return journey by the Tamur Valley passed through dense bamboo forests with wild cardamom growing near the trail. Snow fell on the hills and warm soft rain fell on ourselves. There were prosperous farms as we approached the Taplejuung area. The airstrip was reached on the 24th day.

The journey has been made more memorable by those who have gone before. In 1899 Douglas Freshfield (1845-1934), later President of the Royal Geographical Society, mounted an expedition around Kangchenjunga that began and ended in Darjeeling. The expedition included the famous mountain photographer Vitorio Sella (1859-1963), E.J. Garwood (1864-1949), a geologist, and a mountain surveyor. (Garwood is noted for his studies of the carboniferous limestone associated with the English Lake District.) On October 6 they crossed from Sikkim to Nepal by the Johnsang La in deep snow and thus became the first Westerners to see Kangchenjunga from the north. They returned to Darjeeling via the Mirgin La and the Kang La. Even more remarkable were the 1848-9 journeys made by the great botanist Joseph Dalton Hooker (1817-1911), friend of Darwin (later Director of Kew Botanical Gardens and President of the Royal Society). In Sikkim and Nepal he studied the whole range of plant habitats from the subtropical to extreme Alpine, collected specimens and recorded the geology. In 1848 he ascended the Tamur Valley and its tributaries as far as the Tibetan border. These experiences led him to recognize the validity of Darwin's concept of variation with natural selection and to urge Darwin to publish. In November of 1859 appeared *The Origin of Species*.

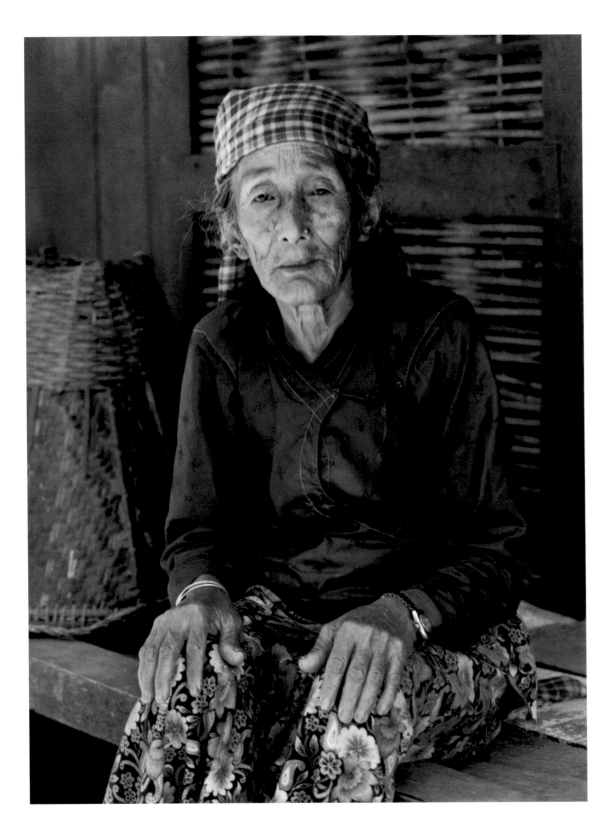

Limbu Woman with Basket; Taplejung District

The beginning of the 1998 journey to Kangchenjunga took us through relatively prosperous villages with well kept houses. We flew from Kathmandu first to Biratnager and next day, by small plane, to the Suketar airstrip (2,020m/ 6,627ft) near Taplejung (Day 1, October 26). On Day 2 we passed a pleasant house with a basketwork tray of red peppers drying in the sun. Our guide chatted with the owner and complemented her on her display of marigolds and I then tentatively asked if I might take her portrait. She was gracious enough to agree. Her age, we learned, was 72.

Limbu Woman on Charpoy, Drying Millet; Taplejung District

This photograph was taken on Day 4 a little beyond the village with the intriguing title Fun-fun. The trail passed a courtyard where a man and woman were applying mud to repair cracks in the adobe walls. The old lady appeared to be watching. Again our guide was able to get permission for me to photograph. Afterwards I bowed to express my thanks but I saw no response; she may well have been blind.

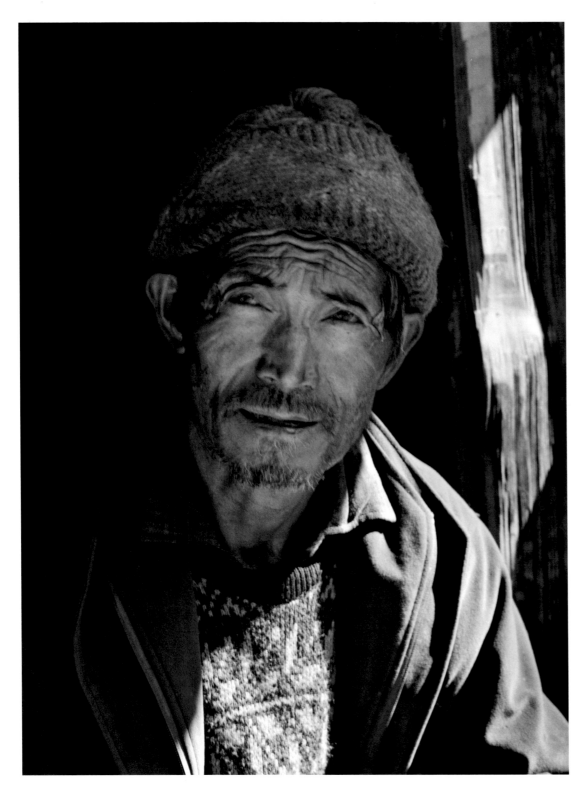

Miller at Phere; Ghunsa-Kambachen Valley

This photograph was taken on Day 20 as we journeyed back to Suketar. A little below Ghunsa we came to Phere (elevation 3,140m/10,302ft) that, like the other villages in this upper valley, is a small Tibetan-style community. For the children, we were the entertainment for the day. The miller was most anxious to show us his water-driven mill in which the grindstone was turned by a horizontal water wheel and a hopper was automatically jiggled to deliver the grain. He cheerfully sat in the door of the mill for a portrait.

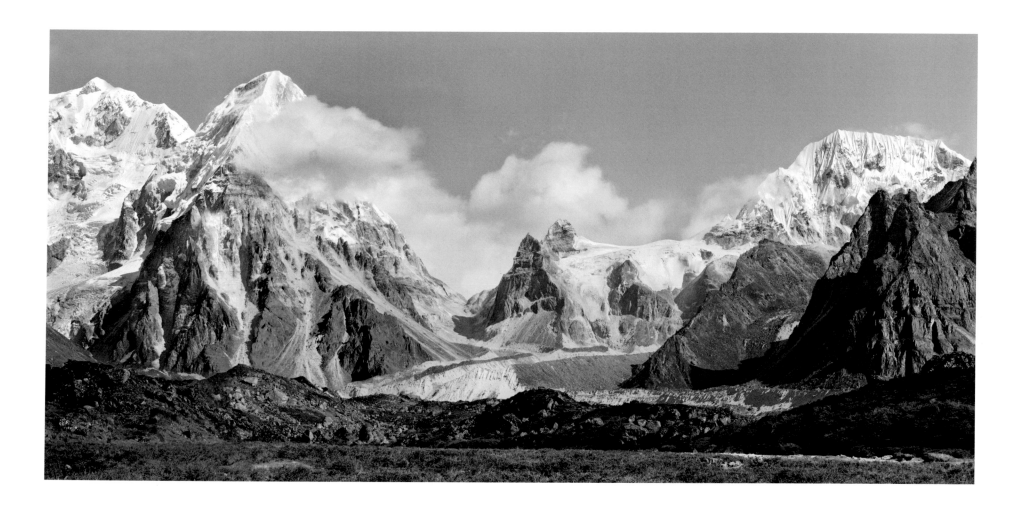

Panorama of the Indian Border from Ramje: Yalung Glacier and Kabru IV, Ratong, the Ratang La, and Koktang

The trail to Kangchenjunga from the south passes from the Kabeli Valley through rhododendron forests to the Simbua Valley. Ramje (4,580m/15,026ft) is a flat ablation terrace, a yak pasture adjacent to the Yalung Glacier that drains into the Simbua Khola. Panorama from left to right, Kabru IV, 7,395m/24,263ft; Ratong, 6,678m/21,909ft; the Ratang La, 5,611m/18,408ft; and Koktang, 6,147m/ 20,167ft. The historically important route to Darjeeling is not by the Ratang La, but by the Khang La five miles to the south near Tseram. (Photograph, Day 10.)

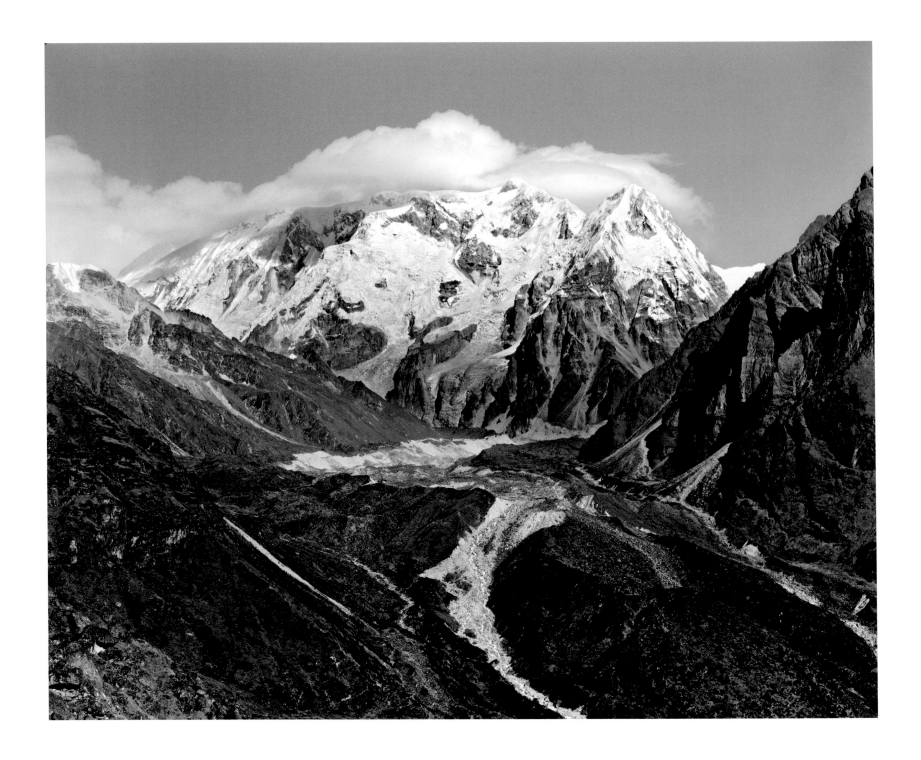

Kabru, Rathong and the Yalung Glacier; View from above Tseram on the Trail to the Mirgin La

The photograph was taken on Day 12 as we set out to cross the passes from the Yalung Valley to the Ghunsa-Kambachen Valley. The Kabru peaks in the photograph are partly obscured by cloud; Ratong is to the right. Kabru played a key role in establishing the Darjeeling Shepas in mountaineering. In 1907 two Norwegians, Rubenson and Aas, assisted by two Sherpas, came within 100 ft of the Kabru summit. It was the highest altitude attained up to that time. Of the Sherpas the Norwegians said: "they will achieve the impossible."

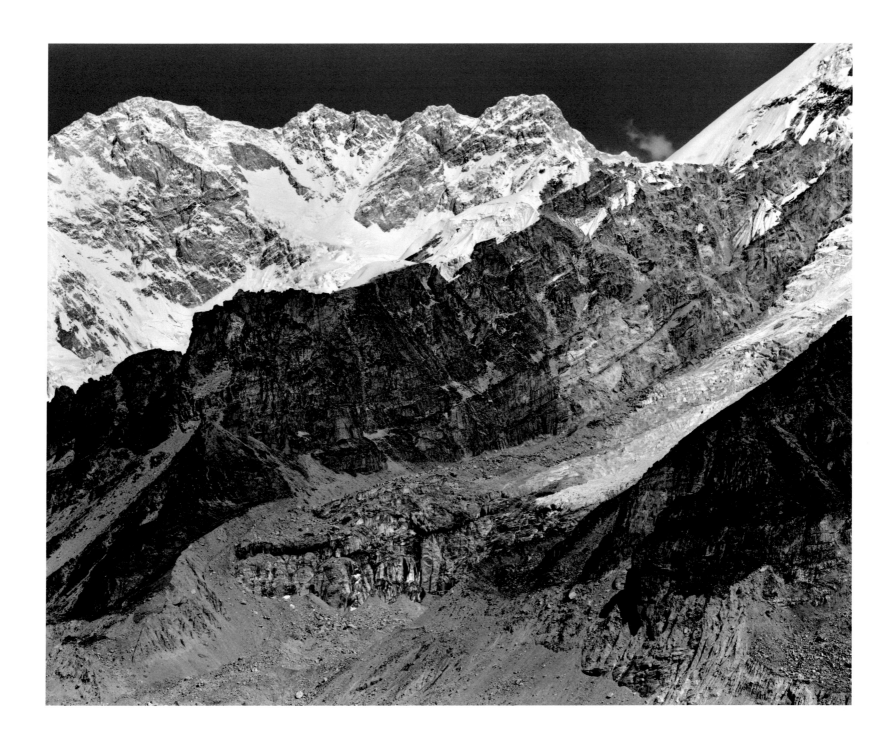

Kangchenjunga South West Face (Yalung Face) from Oktang

Oktang (4630m/15,385ft) is at the end of the ablation terrace that forms the west bank of the Yalung Glacier. The glacier has created a large amphitheater: Jannu and Kambachen to the left, Kangchenjunga center, and Kabru and Ratong right. The photograph, taken on Day 11, shows the Kangchenjunga peaks: the West Peak (Yalung Kang), the main summit (8,586m/28,171ft), two bumps and the South Peak. The 1955 British expedition, lead by Charles Evans, climbed the icefall to the left of the massive rock wall seen in the photograph and set Camp 4 on the Great Shelf above the wall at 23,500 ft. The summit route was to the right of the dark 'Sickle' rocks. On May 25 and 26 pairs of climbers reached the summit crown: George Band and Joe Brown, then Norman Hardy and Tony Streather.

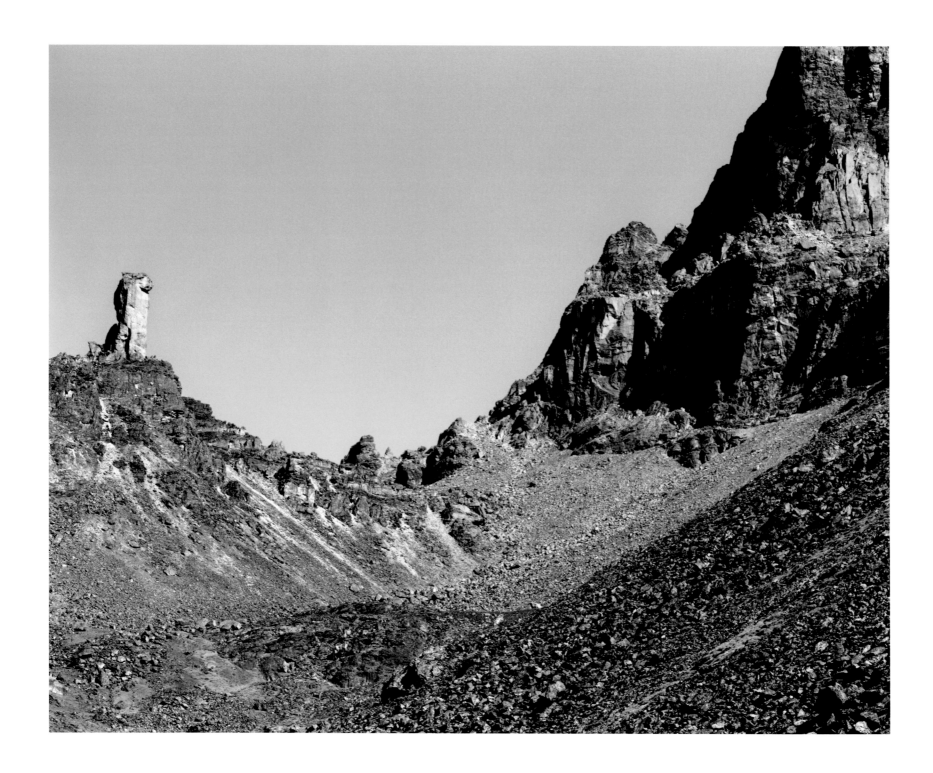

Hooker's Obelisk North of the Trail Between the Mirgin La and the Sinon La

This "strange obelisk" was encountered in the course of crossing from the Yalung Valley to the Ghunsa-Kambachen Valley. Sir Douglas Freshfield in *Round Kangchenjunga* noted that the great botanist Sir Joseph Dalton Hooker had recorded seeing the pillar in the journal of his 1848 botanical and geological expedition. As Hooker played a critical role in inducing Darwin to publish, he deserves to have a pillar named after him. (Photograph, Day 13; elevation slightly less than the Sinon La, 4,854m/15,925ft.) (Joseph Dalton Hooker, *Himalayan Journals, Vol 1* (London, Murray, 1854) Ch. XI,165; See www.books.google.com)

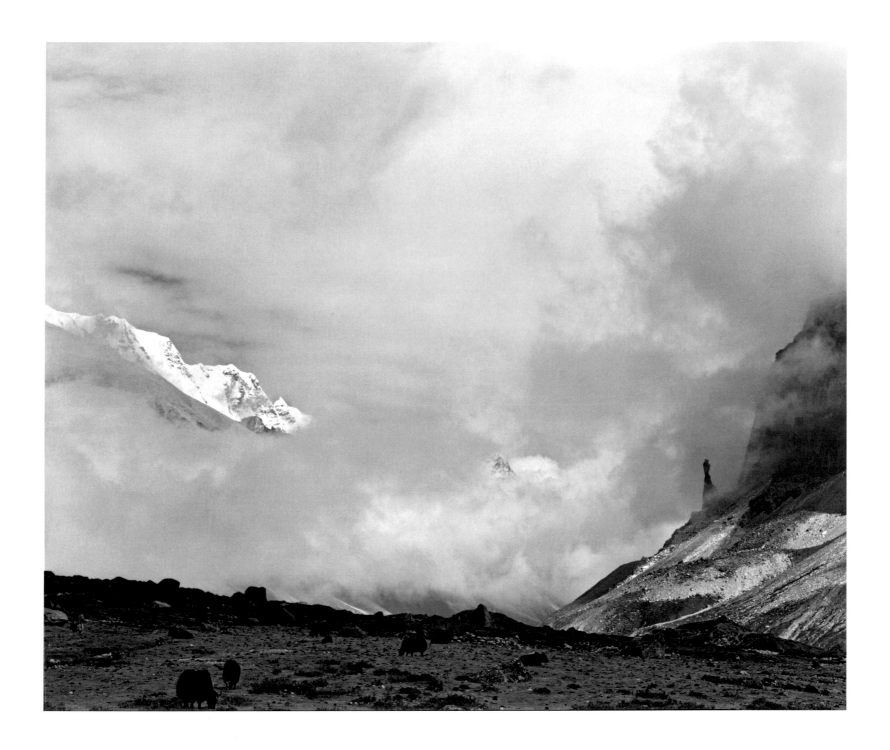

Yak Pasture at Ramtang; View Towards Lhonak

A long descent from the Sinon La, the last part after dark through rhododendron forests, brought us to the large Tibetan village of Ghunsa (3,475m/11,342ft). On ascending this wooded alpine valley, we reached Ramtang about noon, Day 15. Ramtang (about 4,300m/14,107ft) is adjacent to the snout of the Kangchenjunga Glacier. Warm sun in the morning changed to cold mist; the peaks and glaciers to the southeast were only glimpsed. My failure to carry emergency warm clothing brought me to near hypothermia by the time we reached Lhonak.

123

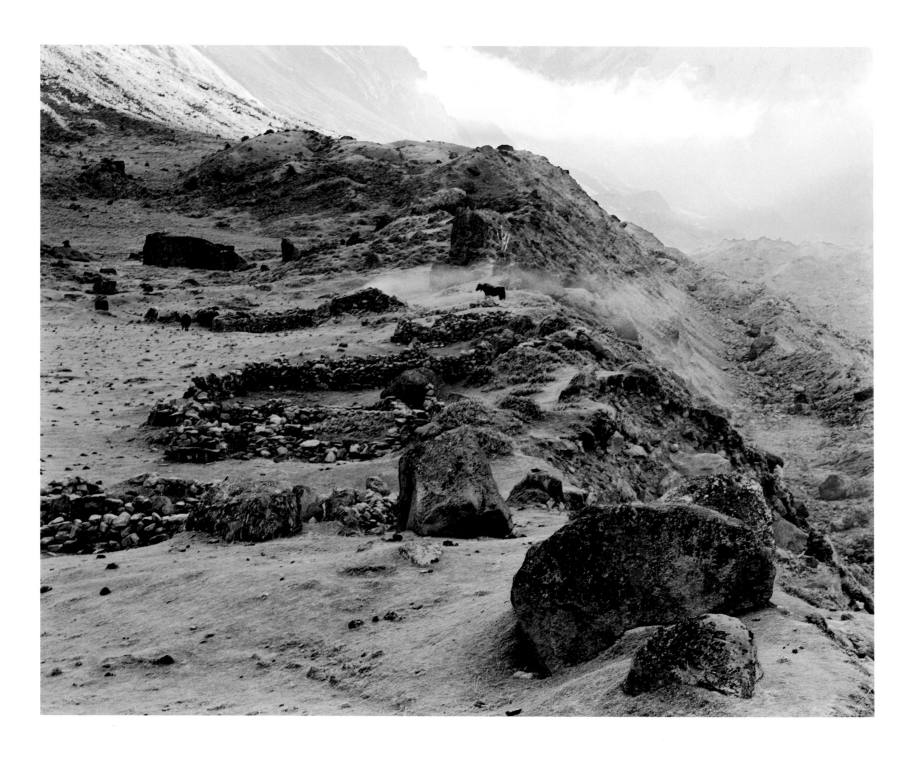

Yak Pens at the Lhonak Settlement; View up the Kangchenjunga Glacier; Early Morning Light

At Lhonak (4,560m/14,960ft) the moraine of a side glacier joins the Kangchenjunga Glacier. A route to Tibet climbs up the side valley to a pass above 6,500m/21,325ft. The Pundit Surveyor Chandra Das, disguised as a Buddhist pilgrim, crossed the pass in 1879 on his way to the Tashi-lumpo monastery in Tibet. The summer settlement includes several substantial wooden houses. The photograph, taken on Day 16, shows the moraine ablation terrace that is the route towards the Kangchenjunga Base Camp.

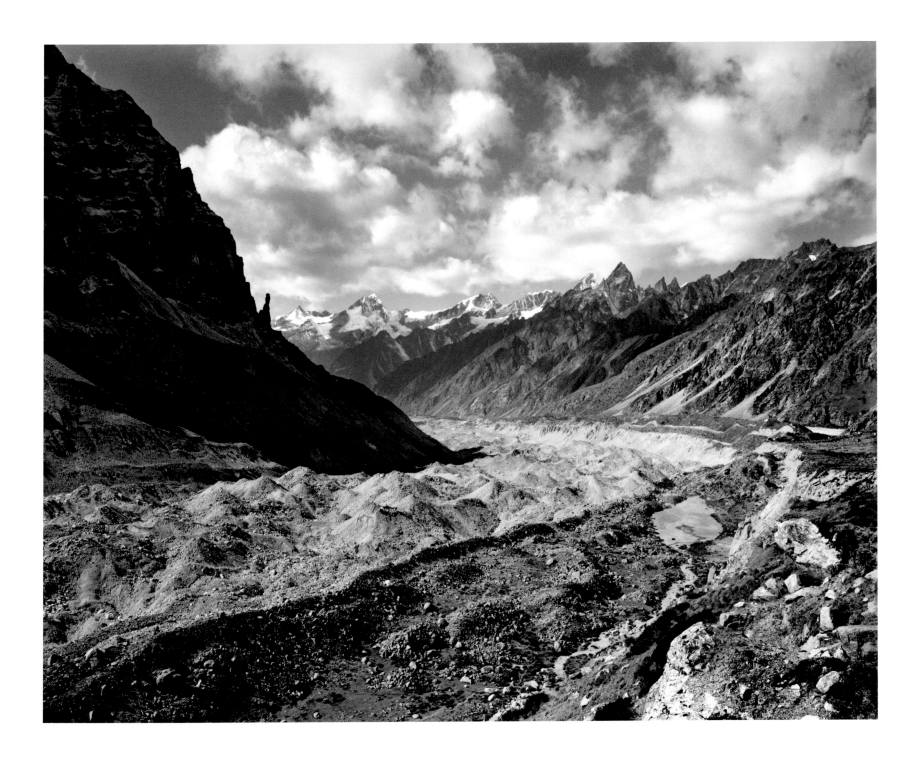

View Down the Kangchenjunga Glacier towards Lhonak

This photograph, taken on Day 18 as we returned from visiting the the northern base camp, provided a fuller picture of the ablation terraces and moraine-covered glacier.

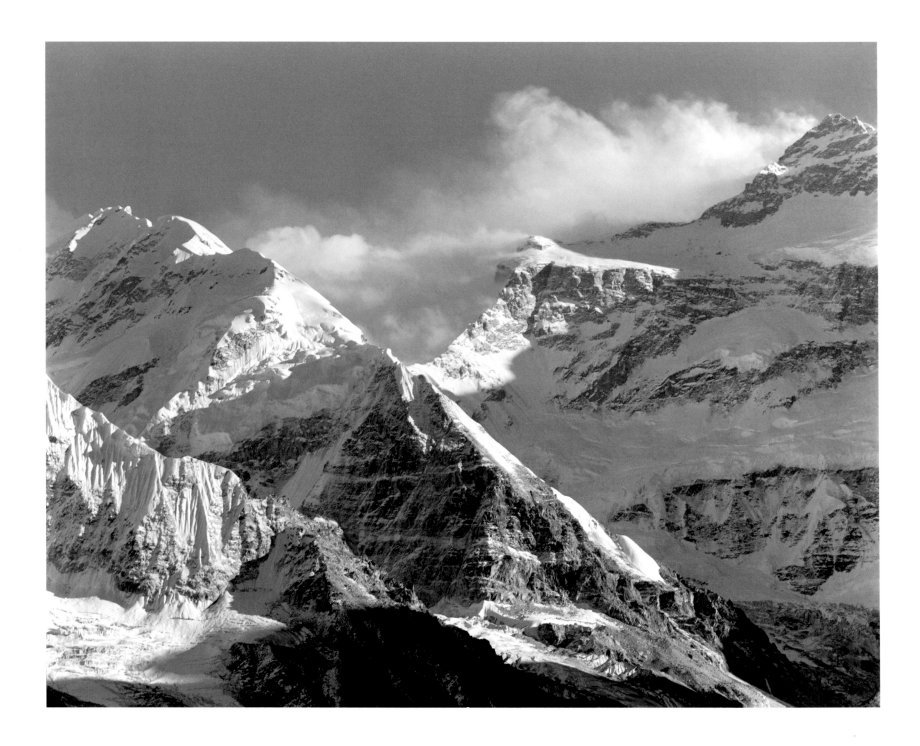

Kangchenjunga with Storm Clouds; Approach to the Base Camp at Pangpema; Afternoon Light

By late afternoon of Day 16 the clouds were beginning to break up. In the photograph the streamer blowing off the end of the North Ridge indicates the ferocity of the storm. The North Col (6,858m/22,500ft) is catching the light below the formation known as The Castle. To the right is the main Kangchenjunga peak (8,586m/28,169ft). In 1978 Georges Bettembourge, Pete Bordman and Doug Scott encountered 120 mph winds when they camped on the North Ridge. The tent was ripped apart and a rucksack was blown into Sikkim. They managed to crawl back across the plateau and climb down to their glacier camp. The peak to the left that partly masks the wall of the North-West Face is known as The Twins.

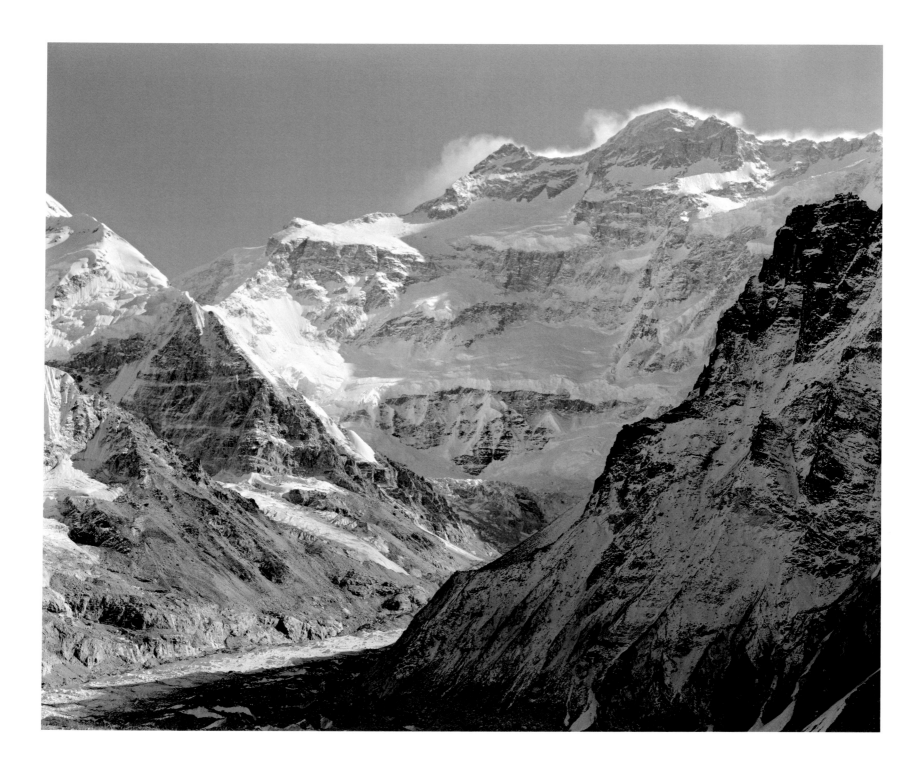

Kangchenjunga with Spindrift Halo; View of the North-West Face from the Pangpema Base Camp

Pangpema (5,150m/16,896ft) is the end of the broad ablation plateau north of the Kangchenjunga Glacier. Beyond this point the glacier swings north towards the crossing point of the 1899 Freshfield expedition, the Jonsang La (6,145m/20,160ft). The main Kangchenjunga peak is towards the center of the picture, the peak to the right is the West Peak, Yalung Kang (8,505m/27,903ft). (Photograph, Day 17; early afternoon.) In 1978 Joe Tasker, Bordman and Scott climbed The Castle from the North Col and crossed the terrace that catches the sun in the photograph before going for the main peak (without oxygen). From Pangpema we retreated to the Tamur valley and reached Suketar airstrip on Day 24.

Monsoon Storm, Gyamtso La, Tibet

The Gyamtso La (5,218m/17,120ft), the highest point on the road from Lhasa to the Everest Base Camp, is the watershed between the Tsangpo-Brhamaputra and the Arun River. The Arun River, that collects the melt water from the Everest region, flows through narrow gorges cut through the main Himalayan chain before it eventually joins the Ganges. The storm on September 8, 2003 soon passed; the Chinese overlordship of Tibet remains.

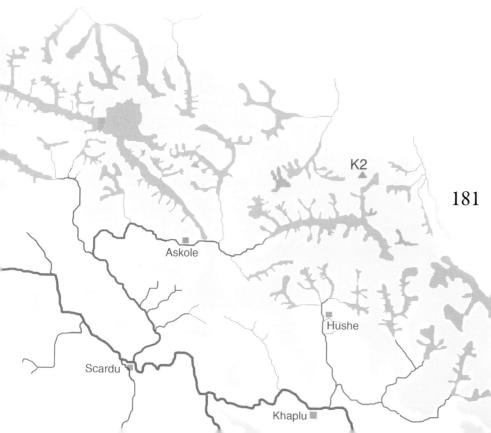

PART II

COMMENTS & REFLECTIONS

K2

Askole

Hushe

Scardu

Khaplu

GO LIGHT. KEEP IT SIMPLE. BE BOLD. - DOUG CHABOT

Light, simple and bold is the mantra of an alpine climber, and no place tests this better than the soaring, jagged, technical and fearsome peaks of the Karakoram Range of Pakistan. Climbing alpine-style in these mountains brings out the best in a climber. It forces climbers to focus and work as one unit with a shared goal. Unlike expedition climbing which requires huge teams, big money and lots of high altitude porter support, alpine-style is a small, dedicated team climbing technically challenging terrain in one push with no fixed ropes, no caches, no other help. Self sufficiency, total commitment and complete dependence on climbing partners are the only path to the summit.

In 2004 I climbed the Mazeno Ridge, the southwest end of Nanga Parbat—a ridge like the tail of a dragon that extends 10 kilometers over eight distinct summits, all of them above 7,000 meters. It was a first ascent as the five previous attempts by others ended in failure because of thigh-deep snow, bad weather or avalanches. My partner, Steve Swenson, and I had a vision of a fast, light, alpine-style ascent. We trained hard, took time to acclimate and then launched up one of the more committing lines in the Karakoram. After our second day we realized that a retreat off the ridge in the event of bad weather was impossible. We took the bare essentials: one tent, one rope, a paltry rack of climbing aids such as snow pickets and ice screws, 5 days of food and a belief we could pull it off.

Climbing technical terrain up and over eight summits wasted us, but we achieved success by reaching the Mazeno Col; four peaks were first ascents, Manzeno peak (7,120m/23,359ft) being the highest and the last being the hardest: a long series of challenging rock towers. On day 5 we were literally and figuratively at the end of our rope. Steve was sick, he coughed most of the night and got little rest; there were disgusting bloody gobs on his handkerchief; weather was moving in and we were both exhausted. Our camp was at the end of the ridge where it intersected the Schell route, an easier and established way to the Nanga Parbat summit that would have been two days climbing away (8,125m/26,658ft). We made the difficult but intelligent decision to head down. Our descent was anything but easy. With brains foggy from exhaustion, stress and altitude, we erroneously thought we were going to cruise to our base camp (at 3,600m/11,811ft) and cached our extra food and fuel and our climbing rope. We envisioned climbing the Schell route to the summit later in the trip and anticipated this cache would allow an even faster ascent. Leaving the rope was a decision we'd regret.*

A thousand feet below the cache in poor visibility and soft snow I fell in a crevasse up to my waist. From then on we roped up with a 20 foot piece of accessory cord and our remaining slings. The terrain steepened and became too difficult to down climb. The weather was getting worse and we knew the avalanche danger would quickly increase if it snowed. Going back up to get the cached rope was an option, but it would have taken enormous energy and at least one full day. So we searched for other possibilities and miraculously found an old fixed line buried in ice on the ridge. After three hours of chopping we were proud owners of a 25 meter piece of braided cotton line that must have been on the mountain at least since the Doug Scott climb 12 years earlier.

The next morning there was only 30 meters of visibility and we had a difficult time finding the descent. I had a digital picture of the ridge on my camera taken from base camp. We referred to it often to pinpoint our location and made good time simultaneously down-climbing, but soon found ourselves in a steep ice gully that forced us to rappel. With our rope we could only do ridiculously short 12 meter pitches. Our lean rack dwindled as we set anchors, but, luckily, after five rappels we were able to down-climb again. Rockfall on the Schell route was substantial, and at one point a large rock avalanche narrowly missed us. By the time we reached the bottom we had decided that climbing back up later was out of the question.

This climb typifies the risks and rewards of alpine climbing. A technical challenge, limited resources and a commitment to give the climb everything we have are the basic ingredients. Success is never certain, danger is real and rescue out of the question. Alpine climbing, with all its risk, keeps my senses sharp and soul alive and makes summits even more meaningful.

* From my experience of Doug's instruction I am confident that the cached climbing rope, when recovered, will be found to be meticulously coiled. K. H.

Doug Chabot, director of the Gallatin National Forest Avalanche Center in Bozeman, Montana, received his B.A. in Outdoor Education from Prescott College in 1986. He's worked as a professional mountain guide in Alaska and the western US from 1989 to the present, and is a senior guide at Exum Mountain Guides in the Tetons. Doug has been on 16 Alaskan climbing expeditions as well as climbs in Nepal, India, Afghanistan and Pakistan. He was formerly on the board of the American Alpine Club. An account of the Manzeno Ridge climb, with photographs, can be found in *The American Alpine Journal*, 47, issue 79 (2005): 52.

Uncertain Boundaries - Singular Destinations

1) The Necessary Journey

If I am asked: Why photograph the Himalayas? I give the answer: They are an emblem of the ultimate challenge and the final passage between life and death. But there is a longer answer that is a story and the story must be unfolded. It begins: The journey is necessary; the camera is an essential companion.

From childhood on we seek to define ourselves by strange journeys of the imagination: by quests, by pilgrimages of transformation, by searches to recover an enchanted kingdom. Such journeys are rooted in the apprehension that beyond the safety of our immediate world there is a region of great joy and great terror that must somehow be traversed. In childhood we absorb the world of nature; we follow the great myths that once defined tribal origins and remake them to our needs. But then we forsake childhood and constrain our wandering and allow the world of property and obligation to fashion walls and boundaries. We neglect the establishing words that allowed us to explore creation, faith and love. How then shall we recover the capacity to journey into the unknown, to make the necessary journey?

This essay is about twelve journeys to the Himalayas that are in reality one imaginative journey. My essential and constant companion has been an old-fashioned view camera that for use must be mounted on a sturdy wooden tripod. This approach to the world is a determinative constraint: it sets bounds and limits to discovery. It may also be the magic gift that relates the visible and invisible, reveals the hidden and untrodden paths and protects the foolish traveler. This essay is part of the discovery process.

In my physical journeys I have encountered two realms of the imagination—the realm of the high passes and ice-carved peaks and the realm of the people who live amongst the mountains. The former realm is defined by beauty and by great dangers. The latter is defined by those who have formed trails, built temples and monasteries and erected cairns to mark their uncertain passage through regions that cannot be possessed. The photographs yield a path through these domains; they become the iconic record of the exploration. The outcome of any journey of the imagination is uncertain. The more that is at hazard, the more important the enterprise.

A Warning:

Thou art like to meet with, in the way which thou goest, wearisomness, painfullness, hunger, perils, nakedness, sword, lions, dragons, darkness, and, in a word, death, and what not.

John Bunyan, *The Pilgrim's Progress*[1]

A Challenge:

Then saw they a knight armed all in white, and was richly horsed, and led in his right hand a white horse, and so he came to the ship, and saluted the two knights upon the high lord's high behalf and said, 'Sir Galahad, ye have been long enough with your father; come out of the ship and leap upon this horse, and ride where adventures shall lead thee in the quest of the Sancgreal"... And so he took his horse and they heard a voice, that said, "Think for to do well, for the one shall never see the other till the dreadful day of doom."... And therewith Sir Galahad entered into the Forest."

Sir Thomas Malory, *Morte D'Arthur.*[2]

2) HIGH PASS & SECRET REALM

The photographer who sets out for the Himalayas will readily find an abundance of travel and climbing narratives to act as guides. They tend to be shaped by four primary emblems:

— The high pass that must be crossed
— The secret realm guarded by dangerous paths
— The place where no traveler has stood before
— The unclimbed summit whose ascent requires a total commitment and where the boundaries between life and death dissolve.

In the background, but emerging in the narratives in a various ways, is a further emblem, the sacred mountain—a source of wisdom and understanding that may be the focus of an extended pilgrimage yet also be a forbidden territory. Such emblems carry with them multiple associations that can interact and shift in dominance as if they had a life of their own. The second two themes will be examined in the context of the history of Himalayan exploration and mountaineering. In this section I wish to concentrate on the high pass and the secret realm as they allow me to introduce Himalayan Buddhism near the outset, where it belongs—the imaginative realm of those who live amongst the mountains—and not as a footnote to Western preoccupations with conquest and adventure. There is another account that deserves to be written: that of the mountain people of Baltistan who have their own tribal connections, traditions, songs and stories. They follow several different forms of Islam but are mainly Shia, as are the Muslims of Ladakh. Once, long ago, they were Buddhist. I have not the contacts or the knowledge from reading that would enable me even to begin to undertake this task.

2.1) Emblems of Passage

The crossing of a high pass has been a constant element in all but one of my Himalayan journeys. A high pass is both a physical challenge and a symbol in a larger narrative. The two are interwoven so that one cannot be understood without the other. Let me begin with practicalities. The passes are usually above 5,500 meters (roughly 18,000 ft). At this elevation the oxygen concentration is about half that at sea level and human physiology becomes limiting. Much effort prior to crossing the pass has to be devoted to acclimatization. Time must be given for the body to adjust. Excess hydration is an essential part of the process. Side trips to a higher elevation followed by a return to the main route are advisable. Even for those who adjust well, hacking coughs and headaches are common, the faces of most travelers become noticeably puffy and at high altitudes minor abrasions fail to heal. As the high pass is approached every breath must be numbered. To complete the transit requires a major commitment of the will—there is total concentration, total clarity, and enveloping light.

Healthy active people sometimes fail to adjust and have to turn back. Helicopter evacuation is an option only in certain regions. Even in the Everest area the circumstances may be problematical. Mera peak (6,459m/21,192ft) lies about 20 miles south of Everest. Mera—higher than Mt McKinley in Alaska, the highest point in North America—is the highest non-expedition peak in Nepal (page 98; map page 95). While climbing the peak in 1999, one of our party began to have chest pains. In order to reach the place where evacuation was possible, we had to cross the Amphu Labtsa, a pass at 5,779 m/18,958 ft. This required a steep glacial ascent with crampons and rappeling down the Imja Glacier side. It was a great relief when he was finally whisked away from Chhuk-hung by a small evacuation helicopter. In Kathmandu his condition swiftly improved. Pulmonary edema, in which the lungs begin to fill with fluid, is a more common problem than heart attacks. In 2005 at Gorak Shep (5,288m/25,771ft, page 108, map page 95) one member of our group spent an unpleasant night too sick to alert others about her condition. At first light she had to be escorted as fast as possible over a stony trail to the mountaineering clinic at Pheriche that is just before the trail reaches the Imja Khola. After being helicopter-evacuated to Kathmandu, she soon returned to normal, but it was a close call.

The journeys I have made have all been commercial treks with 6 to 15 members. The same territory might have been explored as private trips, but the logistical constraints would have been similar. Loaded porters travel only so many miles a day. If the trip begins or ends with a flight in a 16 seat Twin Otter, or similar small plane, flight dates must be set well in advance. Porters to carry duffel bags, tents and food may have to set off days ahead in order to arrive at the starting airstrip in time. Delays caused by ice or fresh snow can eliminate extra days intended for photography; freak unseasonable snowstorms, as in 1996, can be disastrous for trekkers and climbers alike. Finally, there is always the chance that heavy snow will close the high pass. In general, advance planning can only take the photographer so far—the important photographs tend to be taken as an immediate response to chance conditions.

To confront the physiological effects of oxygen limitation is a complex experience. For the large-format photographer the tasks of focussing on the ground glass screen, deciding on the composition, setting the exposure

and making sure the lens is shielded from the sun can require more judgment than seems to be available. Photography is possible because some of these steps have been repeated so many times that they can be performed without conscious thought, but far too many times I have become confused about a film holder and ended up with a double exposure. The pack-drill reflex is exceedingly important; not only for photographers but also for high altitude mountaineering where slow responses and mistakes in judgement can be fatal. For the mountaineer, clipping onto a fixed rope or placing the ice axe to create an instant belay must be instinctive, as must be the actions to initiate a self-arrest using an ice axe.

In the course of the journey the high pass becomes an emblem of passage. In terms of the individual narrative there is a boundary crossed and an implied transformation. Emblems of passage are part of our wider awareness—they are not just of Himalayan interest. For example, the river Jordan symbolizes the crossing from bondage to freedom, entry into the Promised Land, and the end of the final journey. The different possible meanings interact. For each traveler the high pass takes on its own meanings. For the photographer, crossing the pass does not impose a pattern, but the possibility of transformation provides a context to the photographic process.

My approach to mountains and to Himalayan photography has been influenced, both directly and indirectly, by the poetry of William Wordsworth (1770-1850). This is, in part, a consequence of my childhood association with the English Lake District that I mentioned in the Preface on page 6. A key example of the high pass as an emblem of passage occurs in his long autobiographical poem *The Prelude*.[3] Wordsworth describes how in 1790, aged 20, with a friend from Cambridge University, he crossed the Alps by the Simplon Pass. At the time it was a confusing experience. They followed an obvious trail and became lost, but ten or more years later as he is writing the poem the process of recollecting their journey suddenly reveals an "invisible world." In crossing the Alps he stepped from a carefree student identity to that of a poet. A poet who sees in descending from the pass, raving streams and unfettered clouds, "Tumult and peace, the darkness and the light..." "Characters of the great Apocalypse / Types and symbols of Eternity."

The crossing reveals and invisible world, but it is not a final assurance. The descent foreshadows the darkness of events to come. He must shortly confront the chaos of the City that has "no law, no meaning, and no end" and the Terror of the French Revolution: "Friends, enemies, of all parties ages ranks, / Head after head and never heads enough / For those that bid them fall." Thereafter he finds himself laboring with "a sense / Death

like, of treacherous desertion, felt / In the last place of refuge—my own soul." I shall leave Wordsworth there for the moment, but I will return to him and *The Prelude* at various points in this essay. Later will come the converse to the decent: the approach to the summit of Mount Snowden in Wales.

A Himalayan example is provided by Peter Matthiessen's book *The Snow Leopard*.[4] In it the author describes his 1973 journey into Inner Dolpo in Western Nepal. He was accompanying the zoologist George Schaller on an expedition to study the behavior of Blue Sheep near Shey Monastery (page 58). The critical pass, the Kang La (5,334m/17,500ft), which I crossed in 1993, was covered in deep snow (map page 45). The journey had a rational purpose—to study the differentiation of sheep and goats—but for Matthiessen the journey across the pass was part of a necessary transformation—a coming to terms with his wife's death from cancer. Beyond the pass was a great void of snow into which one might either vanish without trace or perhaps find the legendary Tibetan realm of Shambala. His moving account of his journey is examined in the context of both Zen and Tibetan Buddhism. The book is part of a long tradition in which an occidental traveler struggles to come to terms with oriental beliefs.

The emblem of passage need not define an individual transformation. The crossing of a high pass may signify the formation of a collective identity. The Nangpa La (5,716m/18,753ft) is a pass that crosses the main Himalayan chain some 20 miles to the west of Everest (map page 95). It appears in the news from time to time because the Chinese guard the pass and occasionally shoot Tibetans trying to escape to Nepal on their way to India. The Sherpa leader on two of my Nepal treks related to me that as a boy he had helped drive his father's yaks over the pass to Tingri Dzong in Tibet. The traditional trade was to exchange lowland rice, cloth and dyes for salt from Tibet's dry lakes, wool and dried meat. This annual trek for Solu-Khumbu Sherpas persisted for generation after generation for perhaps 500 years. The trade greatly diminished after 1959 when the Chinese completed their annexation of Tibet. At that time the Dalai Lama fled Lhasa, finally reaching India, and Tibetan refugees began to flee over the Himalayan passes. Nonetheless, the linkage remains, both in memory and actuality, as a cultural determinant.[5]

The Sherpa ancestors were a small group of Mongol-Tibetan families that moved from Kaum in Eastern Tibet to central Tibet about 1480. Beginning about 1533, some of these families crossed the pass into the Khumbu region. Individual clans (originally six) settled different regions. There was no paramount clan and, although there were clan leaders, in theory, there was no inherited leadership. The Sherpas brought with them the

tradition that all unrelated men are equal. Women had significant property rights. The principal activity of the community was yak herding. Yak physiology and disease susceptibility is such that yak herding is not successful below about 3,000 m (roughly 10,000 ft), hence yaks anchored many of the Sherpa clans to the higher ground even though the fields scratched out in the Khumbu are exceedingly stony. As the land was limited, inheritance subdivisions had to be avoided if the farms were not to become too small to be viable. A non-inheriting son could become a trader or enter a monastery. Supporting a family member as a monk provided social status. Pangboche monastery was founded in 1667 and other monasteries soon afterwards. It was not unusual for a traveling and home brother to share the same wife, pending success in trading. The Sherpas existed as a sky-island community separated from the Hindu regions of the lower areas of Nepal. Other Bhotiya (people from Tibet) moved into high Himalayan valleys about the same time defining themselves in parallel ways, but the Sherpas are the best known to the outside world. The pass protected the Sherpas from Tibetan power, defined their origin as Tibetan Buddhists and defined their identity as a people willing on their own initiative to make difficult journeys. The collective identity defined by the high pass later evolved from that of traders to that of mountaineers (see Section 5.2).

2:2) Himalayan Buddhism

From the photographer's perspective a discussion of Himalayan Buddhism is necessary because the monasteries, sacred monuments and prayer flags encountered by the traveler are a part of the landscape. The reason for their existence becomes a part of the photographic subject. A photographer who records the cliff dwellings at Mesa Verde in the American West can know little about the beliefs of the people who built and abandoned these structures. The strangeness of recording the works of people that are forever lost to our knowledge is part of the iconography of the photograph. In contrast, the buildings in the Himalayan villages are part of a complex *living* Buddhist tradition. In addition, this Buddhist culture interacts in various ways with the culture of mountaineering. There are two ways in which Tibetan Buddhism is linked to the idea of a secret realm only to be reached by crossing a high pass. The first of these, already mentioned in connection with Peter Matthiessen, is mythical, the second cultural. To approach these I must first give a brief sketch of the emergence of Himalayan Buddhism.

Buddhism is a great tree with many branches.[6,7] The enlightenment of its founder Sakiamuni Buddha is traditionally set in 531 BCE, a point in time that roughly corresponds to the end of the Jewish Babylonian exile (597-539 BCE).[8] Early Buddhism was largely monastic and devoid of representations

of the Buddha. *Maha-yana* Buddhism, the greater/broader path, emerged in the first century CE, becoming dominant in India. It evolved from the earlier austere Buddhism by transforming various Hindu gods into Buddha figures that emphasize different aspects of the Buddha reality. Mahayana spread to the Kathmandu valley and also, by way of the Silk Road, to China and from there to Japan; to a significant extent it replaced the Buddhism that had reached many of these areas at an earlier age. In China it fused with Taoist beliefs to form Zen Buddhism and Pure Land Buddhism. The spread of Mahayana Buddhism is associated with the *bodhisattva* ideal: various Buddha figures (bodhisattvas) have chosen not to ascend into the transcendent Nirvana realm, but have committed themselves to lead all sentient beings to enlightenment. The process leading to enlightenment may require many lifetimes of reincarnation. Bodhisattvas may be petitioned for guidance and blessings. Alongside the traditions with specific teachings and rituals were hermits (yogins) who, with great intensity, sought to dissociate themselves from all religious paraphernalia. They regarded all teachings as mere props, and sought to achieve ego transcendence in one lifetime. These two traditions continue to coexist in Tibetan Buddhism.

Vajra-yana Buddhism, the diamond or thunderbolt path, developed in India as a part of the Mahayana in the Fifth Century CE. It incorporated yoga practices and some magical Tantric traditions that promoted the one-lifetime possibility of enlightenment. Female counterparts to the male Buddha figures were emphasized—often as consorts. The simplest thing to say about the weird Tantric literature embedded within Buddhism that appalled early Western travelers is that, like the *Battle Hymn of the Republic* and other apocalyptic literature, it requires guidance and interpretation. As *Vajrayana* spread by various routes into Tibet it was further modified by fusion with older indigenous shamanistic beliefs and by adaptation to a culture based on yaks, goats and barley. By the end of the twelfth century the great schools of Buddhism in India had withered away as a result of a Hindu revival, economic changes and Muslim pressure.[9]

The diversity of these paths of development has created for the non-specialist much iconographic confusion. Different traditions and sects have arisen in Tibetan Buddhism each with a distinct chain of transmitted teaching. At various times great teachers, such as Atisa (982-1054), who was invited to Tibet from Bengal in 1042 CE, chose to clean up the accumulated variations and thereby generated new schools, orders or sects. Buddha figures usually have a Sanskrit name and one or more Tibetan names that may be descriptions or honorifics. Buddha figures can be represented in benign and wrathful manifestations, alone or in sexual union with a consort. This makes

for very colorful wall paintings. They may be shown as part of a mandala of Buddha figures in which one figure represents supreme Buddhahood.

A further complication is the chains of reincarnate lamas, such as the Dalai Lamas, that are recognized as special manifestations or representatives of a particular Buddha figure. As each successor is identified as a child, religious guardians or secular regents, or both, play an essential role in maintaining the lineage. In the case of the Dalai Lamas that are associated with the Yellow Hat sect (the *Gelug-pa*), its presiding bodhisattva is *Avalokitesvara* (Sanskrit name), the Buddha of Compassion, the Lord who comes down for above; *Chenresig* (in Tibetan), Glancing Eye. Various associations indicate Avalokitesvara derived from the Hindu god Shiva. Hindu rulers often claimed to be special representatives of Shiva. (The kings of Nepal have followed this tradition.) As a result of exchanges between Tibet and Mongolia around 1600, the Gelug-pa became dominant in Tibet, although the *Karma-pa* sect had pioneered the Mongol connection. In 1642, with Mongol help, the fifth Dalai Lama was enthroned in Lhasa to be both a secular and religious ruler. An important consequence was that many dissenting monasteries were taken over by the Gelug-pa, but the older traditions remained dominant in the distant mountain valleys of Tibet, Nepal and Ladakh. Himalayan Buddhism is thus defined by these older traditions whose beliefs are less accessible to the West.

A key figure of the older traditions is *Padma-sambahva* (lotus born). He is the part-legendary and part-historical miracle worker from northern India who is honored for bringing Tantric Buddhism to Tibet around 760 CE. He was probably invited more for his ability to cast spells than as a religious innovator. Buddhism had, in fact, reached Tibet at least 100 years earlier during the reign of the powerful king *Songsten Gampo* whose Buddhist treaty-wives from Nepal and from China are said to have brought Buddhism to the royal courts in Yarlung and Lhasa. (The Tibetan script was invented during Songsten Gampo's reign with the aid of Indian Buddhists.) The indigenous shamanistic tradition that Padma-sambahva and others encountered is known as Bon. Padma-sambahva is most strongly associated with the *Nying-ma-pa* (the Old Sect) who revere him as a Buddha figure comparable to Sakayamuni Buddha. Tyangboche monastery in the Khumbu area was founded in 1916 as a Nying-ma-pa institution (map page 95). Over the years, as a result of interchanges with the Nyng-ma sect, there evolved a monastic Bon, sometimes known a White Bon, which mirrors Buddhism. The two share many practices and texts and draw on the same folk material, but White Bon claims a different founder, *Shen Rap*. The mirroring is ritualized. The pepper-pot shaped monuments and the sphere and pagoda combinations encountered near temples (gompas) and villages are known as chorten. Those near Shey Palace in Ladakh (page 40) and Shey Monastery in Inner Dolpo (page 58) are regular chorten, those at Tarakot village (page 49) and Pungmo village (page 53) are gateway chorten. They are a modification of the most ancient Buddhist monument, the dome shaped stupa that is often crowned by a tower-like pagoda. When the Stupa concept migrated to China, only the pagoda survived, but it still retained its celestial orientation. The traveler walks around a Buddhist chorten *with* the sun and a Bon chorten *against* the sun. The distinction is indicated by clockwise and anticlockwise swastikas used as decorations. Buddhist and Bon monasteries usually have magnificent fresco wall paintings. To the non-expert they seem to be entirely equivalent. The frescos in the Bon monastery at Phoksumdo Lake are particularly impressive (page 56).

Himalayan Buddhism incorporates many local mountain gods, goddess and demons in subsidiary roles. In most gompas wall paintings show fierce guardians who are often local deities that have found reemployment as protectors of the Dharma (the teaching) as a result of their mythical encounters with the all powerful form of Padma-sambahva. Often the guardians are confined to a separate chapel. Wall paintings of Padma-sambahva can be seen in almost every monastery and gompa in Dolpo and Ladakh along with other important Buddha figures in benign and wrathful manifestations. He is shown wearing a red pointed cap, or alternatively, a hat with a stiff front and sides flaps that has a soft crown and occasionally is topped with a short plume. Clearly the hat is not a very sure iconographic identifier. The head is slightly inclined to his left and he has a small moustache and small triangular beard. In a festival my wife and I attended in 1997 at Sakti in the mountains of the Ladakh Range opposite Hemis monastery, an enormous thangka depicting Padma-sambahva hung on the wall of the monastery above the courtyard. After much horn blowing and drum beating the figure of Padma-sambahva appeared on the Monastery steps. He headed a procession accompanied by his two female disciples, sometimes said to be his wives. All were wearing oversize masks and magnificent silk costumes. They settled in a place of honor under a yellow umbrella. Fierce guardians, former demons wearing red masks, and other gods and goddesses performed a slow circle dance to the sound of long horns and cymbals. The dancers then assembled to make obeisance to Padma-sambahva. We stood on our toes to get a glimpse of the formal gestures. The high lama presided at the ceremony and a row of elders in long finely-woven traditional Tibetan coats watched while spinning their prayer wheels. It was a joyful relaxed festival. Smiling children squeezed through the crowd to watch the performance and families enjoyed picnics. This was Himalayan Buddhism at its most open and accessible.

But why the secret realm? As many readers approach Himalayan Buddhism by way of James Hilton's enduring 1933 novel *Lost Horizon* (Frank Capra's movie version appeared in 1937), some comment seems appropriate.[10] The novel creates a plausible location for the secret realm of *Shangri La,* placing it somewhere to the East of the Karakoram in Western Tibet near the Kung Lun Mountains that border the Takla Maken desert. In the novel the high Lama is concerned with finding a successor who will preserve for the future, with supernatural assistance, a humane version of the culture and religion of the European Enlightenment. It was written at a time when the rise of Fascism seemed to be pushing the world into a new Dark Age. *Lost Horizon* is a powerful and relevant myth, but it is only tangentially about Himalayan Buddhism.

The novel, however, derives from a floating Buddhist legend concerning the sacred magical kingdom of *Shambhala* that is guarded by a ring of impenetrable high mountains whose location in the east cannot be told. From this hidden secret realm of peace, it is said, when all the signs are fulfilled, a savior king, the twenty fifth *Rigden* (Tib.), will emerge with apocalyptic powers to overcome the forces of evil and establish a new golden age. Various versions of the legend have reached the West over the years where it has a certain resonance with popular myths about the Second Coming of Christ. The legend appears in the *Kalachakra Tantra* (the Wheel of Time) that, like many other late documents, is attributed to Sakyamuni Buddha. It is the basis for the teaching ritual about the Fundamental Wisdom of the Middle Way that has been performed in recent years by the Dalai Lama for large assemblies of people. The ritual is intended to open the door to further meditative practice and compassion. The woman from Marpha that I photographed in Ladakh had been attending such a ceremony in Leh (page 42). The concept of a secret blessed realm has thus an established place in Buddhist teaching—a realm of the imagination that may also become an earthly territory.[11]

2:3) The Secret Realm

In 1993 crossing the Kang La into Inner Dolpo was for me an entry into a separate world that came to serve as a symbol, not of Shambhala, but of the imaginative-reality of Himalayan Buddhism. I had glimpsed this realm in 1986 in the Annapurna region and later, in 1989, in the high villages of Outer Dolpo, most notably Ringmo on Phoksumdo Lake. This lake at 3,503m/11,500ft glows in the afternoon light with an intense ultra-marine and translucent green that is reminiscent of the sea off the coast of Crete. The lake is bounded on one side by a precarious cliff walk (pages 56

and 57). In 1993 we followed the cliff walk, ascended a wooded valley and eventually climbed a steep narrow gully to make a high camp below a cliff of twisted older rocks of the Tethys Sedimentary Zone (see below *Structure of Mountains*). The trail above the camp was exceedingly barren. There was mica-schist gleaming endlessly in the sun. At last we rested at the rocky summit of the Kang La—the snow pass but without snow. Beyond was a vast sea of barren ridges carved out of younger and softer Tethys sedimentary rocks. There were icy peaks to the west and east. We made a steep descent and in so doing crossed the Great Himalayan chain. Some nineteen days later we left Inner Dolpo to the east by a second high pass, the Sangda La (5,517m/18,100ft, page 68), and descended to the Kali Gandaki valley at the point where this river leaves the isolated kingdom of Lo-Mustang (page 69, map page 45).

This barren country, carved up by deep valleys, is removed from the rest of the world by high passes that are closed by snow for much of the year and by deep gorges in the Karnali River system. There was a significant risk on our journey that the Sangda La might be closed by snow before we had made the passage. On most of the hillsides the grass is so meager that it is visible only to yaks and goats. The barley grown in the valleys had been mostly cut, but threshing and winnowing was still in progress. The growing and harvesting of barley requires endless labor. In part, the people have survived by a trading multiplier mentioned on page 44. Yak loads of barley were exchanged for salt in Tibet and then the salt was carried over the high passes into Outer Dolpo and over the Kagmara La (pages 50 and 51) on the way to Jumla to trade salt for rice and other goods.[12] This arduous way of life has been portrayed in a remarkable movie, made by a French team led by Eric Valli, entitled *Himalaya* (also named *Caravan*.) In the film the crucial transformation takes place in the snow on the Kagmara La when the old leader dies and the young leader takes his place. In this narrative the pass becomes an emblem of the passage between generations.

The Buddhist gompas and monasteries of Inner Dolpo are mostly of the Nying-ma-pa (the Old Sect), the *Sakya-pa* (Red Hat) and the *Karma-pa* (Black Hat) traditions.[13] In the Nying-ma sect Padma-sambahva is often shown, along with Avalokitesvara, as derived from the supreme Buddha figure of the sect *Samata-bbadra*. The role of Avalokitesvara, the Buddha of compassion, is everywhere implied by the use of the six-syllable mantra *Om Ma-Ni Pad-Me Hum* that is associated with this bodhisattva. It can be found carved into prayer stones and mani-walls and on rocks in Inner Dolpo and elsewhere. According to Snellgrove, the mantra addresses a feminine Thou: Oh Thou of the Jewelled Lotus. Thou may thus be the bodhisattva

Tara as the consort of Avalokitesvara, however this meaning is secondary to the use of the mantra as a chant or as a guide to meditation.[14]

Westerners have seldom visited Inner Dolpo because the Nepalese government has been reluctant to allow free access to this region that borders Tibet as it had formed a base for the struggle of Tibetans against Chinese occupation. The area, which had been closed soon after the visit by Shaller and Matthiessen, had been reopened in the year of our visit. Recently, the Maoist insurgency almost eliminated travel in Western Nepal, but there is now hope that this conflict is being resolved. The region has continued more or less in its present state for hundreds of years. Some of this history has been recovered by the work of the Tibetan scholar and cultural anthropologist David Snellgrove whose book *Himalayan Pilgrimage* was an essential source for our journey. Snellgrove, who was associated with the School of Oriental Studies at London University, visited Inner Dolpo in 1956 and in the winter of 1960-61 to study Buddhist ceremonies and wall paintings and to copy Tibetan texts.[15]

Reaching Phoksumdo Lake and crossing the Kang La had led in imagination and in reality to a far country, a secret realm. As a secret realm, Inner Dolpo melds with the other sky-island communities where Himalayan Buddhism is practiced, although its isolation is unique. Let us, therefore, look again at the Tibetan Buddhist traditions in general. Great stress is placed on the lineage of doctrinal transmission from one yogin, guru or lama to another. In 1986 my wife and I visited another sky-island, the Manang and Gysumdo regions of the upper Marsyangdi valley that is on the rain-shadow side of the Himalayan chain and isolated from the lower regions of Nepal by a narrow gorge formed where the river cuts through the mountains (page 83, map page 71). There are a number of gompas and monasteries in the area but the most remarkable setting is in the village of Braga (pages 85-87).[16] The village is gathered about a three-part monastery on the side of the valley. Above are eroded cliffs. To save land the houses are stacked such that the roof of one house forms the patio of the house below. David Snellgrove, who visited there in 1956 and found it much neglected, likened it to a Tibetan altar loaded with offerings—"man and nature combined in a perfect symbol of their unity." Among other paintings in the gompa he identified a sequence showing the lineage of 39 lamas of the Kagyu-pa tradition that goes back to the famous yogins Milarepa, Marpa, Tilopa, and Naropa and finally to the supreme Buddha figure of the sect, *Vajra-dhara* (Tib. *Dorje-Chang*.) Shey Monastery in Inner Dolpo is also of this tradition (page 58).

The chorten monuments that, along with mani-walls and prayer flags, are such a distinctive feature of the landscape reflect the belief that we live in a three-tiered universe: the upper spirit world, the human world, and the lower world. A World Axis links the three. The concept of an *Axis Mundi* is shared by Buddhists, Hindus and the older Shamanistic cults. The axis may be invoked by circumambulating a sacred mountain, the Great Stupa in Kathmandu, or the Jokhang Temple in Lhasa, or even by merely walking around the village chorten. Shey Monastery derives its name from the sacred Crystal Mountain which it faces (Shey means crystal), but the most important example is Mount Kailash (6,714m/22,024ft) in Western Tibet, north of the northwesterly corner of Nepal (see maps on page 44 etc.). It lies to the north of the Indus-Tsangpo suture zone and owes its layered look to sedimentary deposits laid down by the erosion of the volcanic mountains that once marked the coast of Tibet (see below, *Structure of Mountains.*) Mt. Kailash has been a place of pilgrimage for Hindus, Buddhist and Bon since before recorded history because it lies at the hub of four sustaining rivers: the Indus flows north before turning west, the Tsangpo-Brahmaputra flows east, the Karnalai River that joins the Ganges flows south, and to the west flows the Sutlej River. Depending on the local legends, the summits of all mountains are to some extent sacred. An agreement was made in Sikkim before the 1955 British expedition to climb Kangchenjunga that no climber would set foot on the sacred summit. Beliefs about Mount Zion and the rock on which the Dome of the Rock in Jerusalem is built attach themselves to any photograph of Jerusalem; beliefs about sacred mountains are an integral part of the iconography of Himalayan photography.

The imaginative world of Himalayan Buddhism is populated by local gods, demons and spirits. There are categories: the black *Bdud* demon kings of the high cliffs that wear tiger and leopard skins, the red *Btsan* chiefs that are clan gods, and the *Klu* leaders, the serpent kings of the underworld. The *Klu* earth spirits are connected to the growth of crops and abundant harvests. In general, the gods and spirits are intimately connected with the disasters and blessings of Nature: with landslides and hailstorms. but also with bountiful harvests. It is these gods that the villager invokes on crossing a pass and when adding a prayer scarf to a juniper branch mounted in a stone cairn (as on page 66). For important life-cycle events such as birth, marriage, illness and death, the clan lama must ritually address the spirits. Each sky-island community has its own legends and practices. Gods associated with particular mountains may become clan gods if the group migrates. Opinions about someone else's clan god can be very unfavorable. The Dalai Lama had spoken against the worship of Shugden (Shugs Idan), a regional and sectarian

guardian.[17] Our guide in Ladakh was troubled by this injunction that had been included in the recent assembly in Leh.

A valuable insight into the incorporation of the spirit world into the ethical world of Himalayan Buddhism has been provided by an anthropologist, Stan Mumford.[18] He spent three years, 1981-83, living in the Gysumdo area of the Marsyangdi valley to the east of Manang where the river turns south (map page 71). Mumford studies the interaction between Nyng-ma-pa Tibetan villages and Gurung villages that follow Shaman-led animist Bon practices. In *Himalayan Dialogue* he describes a ritual that was designed to stop the Nyng-ma Buddhists from participating in the animal sacrifices of the nearby shaman-led village. The Nying-ma-pa Tibetans had migrated to the area about 100 years before; the Gurungs probably migrated much earlier from pre-Buddhist areas of Tibet, hence the conflict provides a recapitulation of the crucial battle over animal sacrifice (red offerings) that characterized the introduction of Buddhism into Tibet. The ritual was drawn up by a senior lama who came to the valley in the early 1960s fleeing from Tibet. In the ritual the local lama addresses the *Bdud* demon kings, the *Btsan* chiefs, and the *Klu* serpent kings. All these are sentient beings, capable of good and ill. In the legendary past they had been vanquished by Padma-sambhava. In the ritual they are addressed in the name of Padma-sambhava and bound over to obedience for the coming year; grain and fruit offerings are made.

In the corresponding annual shaman-directed spring festival the still beating heart is torn from a ritually slaughtered deer. This older Tibetan religion, of which this practice is a part, is sometimes called Black Bon to distinguish it from the White Bon that emerged under the influence of Buddhism. Within Himalayan Buddhism there is no place for the unnecessary killing of animals. Biographies of Lamas frequently mention as an accomplishment that they stopped the practice of hunting in their area. The issue is somewhat complicated by the fact that yak and goat meat is regularly eaten (the yak is said to be fallen), however, the theory is clear. The bodhisattva ethical commitment is to the liberation of all sentient beings. This is reinforced by a belief in reincarnation. In the chain of reincarnation humans may be reborn as animals, although this is a step down in the multi-life cycle of karmic ascent. Lamas often teach that the animal you kill may be your mother.

The slaughter of the deer in the sacred grove by the shaman is associated with a story about a hunter's journey to the underworld. Mumford reports a counter story that sets out the Buddhist priorities. It concerns the great Yogin Buddhist teacher and poet Milarepa (1040-1123.) who is the subject of as many legends as Padma-sambahva. He was mentioned above as having an early place in the Kagyu-pa lineage. One important legend relates his contest with the Bon lamas at mount Kailash in which at the last moment he triumphs by ascending to the summit on a ray of light.[19] This legend and the one that follows are not included in his eminently readable folk autobiography that includes many of Milarepa's songs.[20] There are multiple hermit caves where Milarepa is said to have meditated while living on roots and nettles and one of them is in the Marsyangdi valley. Pilgrims to this cave tell the following story: A hunter chased a deer who fled to the cave where Milarepa was meditating. Milarepa broke off his meditation and sang to the deer, inviting him in the song to seek refuge. The hunter's dog followed the deer and it too was calmed by Milerapa's singing and crouched down on the other side of the yogin. Finally the enraged hunter climbed to the cave and shot an arrow at Milarepa, but the arrow could not touch him. Milerepa sang to the hunter and urged him to kill the passions within him. The hunter remained with the yogin living on roots and nettles until he had achieved enlightenment. The dog and deer when they died escaped the wheel of reincarnation and passed on to the Buddha realm. In this story, in essence, Milarepa establishes the harmony of the secret realm of Shambhala in the isolated cave; but note, the arduous path to Shambhala is through meditation.

In the above discussion I have tried to focus on the anthropology of belief and avoid the Western assumption that higher Tibetan Buddhism can be separated from animist beliefs. To attempt such a separation is to abstract the religion from its real life setting and to smooth out its many peculiarities. One major difficulty for me as a scientist is the use of astrology in multiple contexts.[21] Clearly this complex practice in which one expert reading can be set against another has multiple social functions. At its simplest it is the equivalent of tossing a coin to open a cricket match. Another difficulty is that we are accustomed to thinking in absolute terms. The recitation of creeds is part of the Christian liturgical tradition. Precise wording about beliefs separated Byzantium and Rome and fueled the struggles of the Reformation. The world of Himalayan spirits and gods does not lend itself to precise formulations.

How much reality do the villagers accord the chaotic unseen world of gods, demons and spirits? Is their outlook changing as a result of contact with the Westerners who pass by and for whom they may occasionally work? Mumford notes that when lamas or shamans invoke this spirit world in connection with severe illness and madness the rituals make little sense unless there is serious emotional commitment. Most of the time there is no alternative treatment or consolation available. Infant mortality and death in childbirth are as common as they once were in the West. Medical help may be

many days journey away.[22] Helena Norberg-Hodge, who has spent many years in Ladakh, however, emphasizes the contrast between all the references to gods, ghosts and evil sprits and the spontaneous cheerfulness of the people.[23] No one seems afraid of these demons. They are part of oft-told stories that bind together the community, much like fairies and trolls or Santa Clause. When asked, people answer "it is said that…"; a word for belief seems to be missing. The truth about belief lies somewhere in between.

I will return again to the subject of Himalayan Buddhism when I discuss the contribution of the Sherpas to mountaineering. The peculiar challenge of these sky-island communities—hidden realms—is that the Buddhism practiced in the mountains is far removed from Western concepts and yet it functions as a valid agent of compassion and supports a way of life bound to the landscape. In some inexplicable way the landscape determines belief.

3) NATURE & NATURE'S GOD

We approach the Himalayas as Westerners through the vision of others. These visions are not fixed categories—science, philosophy, poetry and belief have interacted and continue to interact. They provide the intellectual context in which Himalayan explorers and mountaineers have defined their activities. They stand in contrast to the vision of the Himalayan villager who may be preoccupied by thoughts of local gods, demons, and earth spirits and the constraints of astrology. In this section I will initially outline four distinct approaches taken by Western writers. They were largely formulated before the emergence of scientific geology and the development of evolutionary theory. By the mid-nineteenth century the new science had began to subvert the poetic and religious language about mountains. It happened that this disruption coincided with the rapid development of both mountaineering and mountain photography. From the first the status of mountain photography has been ambiguous—it provides scientific documentation and yet it can be a vehicle for poetry. My concern is with that ambiguity.

3:1) The Geologist's Eye

Himalayan landscapes with their isolated monasteries, prayer walls, chorten and prayer flags, their trails and high passes, are fashioned by the Himalayan peoples, but in the deep valleys and great mountains the photographer encounters the drama of the geological record. The reality seen includes a reading of the processes that generated the landscape. How and when did these transformations take place? In the section *On the Structure of Mountains* I will initially explain how in the last 50 years the theory of Plate Tectonics has come to provide the framework for understanding the Himalayan mountain-building process. This new description, however, does not change the earlier understanding that the process has taken place on a

time scale that is beyond our intuitive grasp and that the forces involved are so enormous that they become mere numbers. We can more or less accept the idea of 8,000 years of recorded history and we can imagine 65,000 years of human migration out of Africa and from there step back to 195,000 years of human existence,[24] but it is almost impossible to step back 65 million years to the end of the age of dinosaurs. The time scale of the drama is part of our understanding of mountain structure, and it is structure that confronts the photographer as an irreducible reality. Mountain photography is inseparably linked to geology.

The scale of geological time and the processes of mountain building became significant issues in the eighteenth century Enlightenment when the idea of geological science was beginning to emerge (Section 3:5). It became a matter of widespread debate in the early nineteenth century. A representative figure was the Victorian art critic John Ruskin (1819-1900). As a boy Ruskin collected minerals and, living in London and sponsored by wealthy parents, he was able to attend the meetings of the Geological Society. He also became interested in poetry. In 1839 at Oxford, age 20, he received the Newdigate prize for poetry—from the hands of Wordsworth, no less—and in the same year was elected a fellow (member) of the Geological Society. He was greatly influenced by the descriptive geology of Horace-Bénédict de Sassure (1740-99) whose famous work *Voyages dans les Alps* (published 1779-96) he had read before first visiting the Alps in 1813.[25]

Geology and poetry were important, but it was with art criticism that Ruskin first made an impact. In 1843 he published the first volume of *Modern Painters*. (Four more volumes appeared over the years.)[26] The book set out to be a defense of the painting of Joseph Mallord William Turner (1775-1851), but the great theme of Volume I is Truth to Nature. All of the

volumes are prefaced with a quotation from Wordsworth's poem *The Excursion* that speaks about having "walked with Nature and with Truth." The volume was written about a year after Ruskin's way of seeing had been transformed while drawing an aspen tree in Fontainebleau forest in northern France. He had learned to draw and paint in a conventional picturesque manner, but suddenly in tracing the lines of the tree he saw that they were not according to the conventions that he understood. "*At last the tree was there, and everything that I had thought before about trees, nowhere.*" This respect for objective reality had profound philosophical implications. The irreducible quiddity of the tree, the integrity of its thus-ness, became the key to his approach to mountains.

The chapter headings of *Modern Painters* Volume I include: Of Ideas of Power, Of Truth of Chiaroscuro, Of Truth of Skies, Of General Structure. After reading Ruskin's descriptive analyses of Turner's paintings, I, like many others before me, had the feeling that I was looking at mountains and skies and water for the first time. It is Volume V (1856), however, that contains his most influential writings on mountain structure, with most of his examples drawn from the Alps. The task of the artist is to reveal their inner structure and history by showing their outward volume and form. "As an artist increases in acuteness of perception, the facts which *become* outward and apparent to him are those that bear upon the growth or make of things."[27] It does not matter that no one at the time knew exactly how the Alps were formed; Ruskin understood that vast forces were involved exercised over a vast span of time. He writes about his ten years of study that had gone into learning how to draw mountains so that the curves and profiles and fissures separate the dominant from the subordinate. His pen and watercolor drawings are occasionally exhibited. They have a fine detail but are also remarkable for their luminous quality. Ruskin, as an advocate of Turner, was aware that this approach may be trumped by other considerations such as revealing the terror of a gathering storm, but, even then, the form must not be forgotten. His demand for directness of vision may well have been influenced by Wordsworth's preface to his *Lyrical Ballads* (1800) in which he stated as a moral principles: "Look steadily at the Subject;" avoid "falsehood of description." Wordsworth's aim was to create a new poetic language based on ordinary speech that would make a direct appeal to experience.[28] Such poetry is "the first and last of all knowledge". The poet must be at the side of the Man of Science and follow the "remotest discoveries of the Chemist, Botanist, or the Mineralogist".[29]

For Ruskin, as for Wordsworth, directness of vision was a form of moral rectitude. One may not substitute that which one would prefer for what is. Experience is primary. But moral experience need not filter out emotion. His writings were often poised between ecstasy and terror and this emotional range reflected his experience of the Alps. Yes, the mountain experience could be understood as a divine revelation, and yet in Vol. I, Ch 11 (*Respecting the Truth of Turner*) he writes in his best prophetic mode about experience rather than theology:

> I cannot gather the sunbeams out of the east, or I would make *them* tell you what I have seen; but read this and interpret this and let us remember together. I cannot gather the gloom out of the night-sky or I would make that teach you what I have seen; but read this and interpret this and let us feel together.... And if you have not that within you which I can summon to my aid, if you have not the sun in your spirit and the passion in your heart, which my word may awaken...leave me.

Ruskin took quite creditable photographs, but saw them only as an aid to drawing and painting. In the hands of a master landscape photographer such as Vittorio Sella, however, the camera can reveal the structure of a mountain—'its severe reality' (*la realt severa*). The magnificence of Sella's photographs was unknown to me until 2000 when Mt. Holyoke College, Massachusetts, mounted a major exhibition.[30] Sella (1859-1943) read de Sassure as a boy and may have read Ruskin. He was an experienced mountaineer who started out in the golden age of alpine mountaineering. In 1882, with three others, he made the first winter traverse of the Matterhorn. With his brother Ermino he accompanied the Douglas Freshfield expedition that circumambulated Kangchenjunga in 1899.[31] He was also the photographer for several of the Duke of Abruzzi's expeditions and in particular that to the Karakoram in 1909. In climbing, the clear perception of every crack and crevasse is essential for survival. A soft focus photograph provides little survival information. His photographs are far more than records—he had a wonderful sense of mountain form and mountain light—but they transcend precisely because they are truthful. They show both beauty and danger and a respect for irreducible reality.

3:2) Beauty & Terror

I have begun with Ruskin because he embodies elements of the three other approaches that I wish to discuss. Ruskin led us to Sella, and the example of Sella raises a key issue that will be discussed further in connection with mountaineering, namely the linkage between rendering the structure of mountains, describing their beauty and revealing the fear they engender. In

1757 Edmund Burke (1729-1797), better known these days for his contributions to political theory, published a book with the remarkable title: *A Philosophical Inquiry into the Origin of our Ideas of the Sublime and the Beautiful.*[32] The book was an immediate success. It was reprinted ten times in 30 years. In those days a philosophical inquiry could be a best seller. As a true child of the Enlightenment in search of clear and precise ideas, Burke begins: "The first and simplest emotion that we discover in the human mind is Curiosity." Beauty, he associated with the passions of affection and love and with security, but for the sublime he states, following a Latin author Longinus:

> Whatever is fitting in any sort to excite the ideas of pain, and danger, that is to say, whatever is in any sort terrible, or is conversant with terrible objects, or operates in a manner analogous to terror is a source of the *sublime*; that is it is productive of the strongest emotions which the mind is capable of feeling.

Burke had a significant effect on painters—particularly on Turner.[33] In terms of mountain watercolors, nothing is more powerful than Turner's painting of Goldau (1843). An avalanche of rock largely destroyed the village of Goldau in 1806 when 457 people died. To the right in the painting a Swiss valley dissolves in an explosive sweep of blood red, gold and white. At the center seems to be a lake of molten gold. There are enormous foreground rocks, a few ill-defined figures and on the right in blue shadows the ghostly domed tower of the surviving church. Turner's major excursions into the sublimity of terror, however, were in terms of marine and coastal painting. One major example is in the Tate Gallery, London. The 1842 picture is entitled: *Snow storm—steam-boat off a harbors mouth making signals in shallow water and going by the lead. The author was in this storm on the night when the Ariel left Harwich.* A small boat at the center of a vast vortex is almost obliterated by the paint. Even more powerful is the 1840 painting *Slave Ship (Slavers Throwing Overboard the Dead and Dying),* in the Museum of Fine Arts, Boston, that depicts Turner's outrage at the institution of slavery. Ruskin, who's father bought the painting, wrote "the sunset falls along the trough of the sea, dying it with an awful and glorious light, the intense and lurid splendor that burns like gold and bathes like blood." The raised arm of a drowning slave in the lower left quadrant replicated the arm of a freed slave in a 1836 medal issued to commemorate the abolition of slavery in the British colonies. Its companion 1840 marine piece *Rockets and Blue Lights...,* in the Clark Institute, Williamstown, Massachusetts, shows a powerful vortex of blue and white against a black center. The painting concerns a coastal rescue instead of destruction; compassion struggles against an elemental fury. In these paintings Turner depicts human frailty in the face of violent Nature and is much less certain than Ruskin about divine revelation, but, like Wordsworth and Ruskin, he is concerned with the truth of experience. Faced with desolation, the role of the artist emerges. The artist is the protagonist—a witness to what is—a recorder of the limits of human existence.

3:3) Snowdon

The Burke-Turner view of the artist as recording the limits of human existence stands in contrast to that of Wordsworth. Although Ruskin prefaced each volume of *Modern Painters* with a quotation from Wordsworth, one cannot rely on Ruskin to know fully what Wordsworth thought. The autobiographical poem *The Prelude,* a key document in understanding Wordsworth's approach to Nature, was not published until1850, the year of his death—by that time two volumes of *Modern Painters* had already appeared. Wordsworth, like Ruskin, Burke and Turner is concerned with experience, but he framed experience differently. Wordsworth is unique in placing infancy at the center of an adult interactive encounter with Nature. But before discussing childhood, let us consider the slow emergence of the idea of the Mountain Sublime.

St. Augustine (354-430), whose autobiographical *Confessions* might be likened to *The Prelude,* had an introspective concern with childhood (as a child he stole an apple), but it is introspection, not childhood, that he links to the idea of Nature. He wrote about the plains, caverns and abysses of the mind and his struggle to find God within this inner landscape.[34] Augustine saw landscape is a metaphor for the mind—but the mind is more wonderful than anything that might otherwise be encountered in the external world.[35] In Book 10 of the *Confessions* he wrote: "Men go forth, and admire lofty mountains and broad seas, and roaring torrents and the ocean, and the course of stars and forget [neglect/do not notice] their own selves." Augustine did not feel it necessary to climb lofty mountains and did not surmise that the act of ascent itself might be essential for self-understanding.

The Swiss nineteenth century historian Jacob Burckhardt in *The Civilization of the Renaissance in Italy* (1860) traced the notion that mountains should be climbed to a critically important change in perception. In particular, he cited the humanist poet and geographer Petrarch who in a letter of April 26, 1336 described how he came to ascend Mont Ventoux near Avignon. With his brother he stood above the clouds looking toward Italy. He took from his pocket a copy of the *Confessions* and enigmatically read aloud the passage cited above. Petrarch seemed to endorse Augustine's idea

that Nature is a metaphor for the spiritual life, and yet, in his letter describing the ascent, he glimpsed the novel idea that introspection alone—just thinking about the mountain—was not enough. To encounter the inner self it was necessary for Petrarch to actually encounter the integrity of the mountain.[36]

To the above concept Wordsworth adds the idea of a childhood interaction with Nature. He begins the earliest two-part version of *The Prelude*, dated 1799, with a reference to his infancy in which the security provided by his nurse is blended with the sound of the river Derwent.[37]

> Was it for this
> That one, the fairest of all rivers, loved
> To blend his murmurs with my nurse's song,
> And from his fords and shallows, sent a voice
> That flowed along my dreams?

Later he grounds the security provided by his nurse to that provided by his mother:

> Blest the infant babe –
> For my best conjectures I would trace
> The progress of our being – blest the babe
> Nursed in his mother's arms, the babe who sleeps
> Upon his mother's breast, who when his soul claims
> Manifest kindred with an earthly soul
> Doth gather passion from his mother's eye.

> ... those first-born affinities that fit
> Our existence to existing things,
> And in our own being, constitute
> The bond of union betwixt life and joy.

Wordsworth relates many childhood memories that he calls '*spots of time*' whose significance grows upon reflection. His descriptions have the rich complexity of a good photograph. He begins with the memory of being a naked boy playing in the river in sight of the mountains. He includes a stormy moorland experience a few days before his father's death. Towards the end of the two-part *Prelude* he writes about the growth of his creative sensibilities. Having walked with Nature he finds "An auxiliary light / Came from my mind, which on the setting sun / Bestowed new splendor... the midnight storm / Grew darker in the presence of my eye." The encounter with Nature is not a psychological regression, but a creative dialog grounded in childhood experience.

Near the beginning of this essay I cited a passage from the later versions of *The Prelude* about crossing the Simplon Pass. I noted that in the descent there were many turbulent images and that the journey preceded his experience of the lawlessness of the City, the Terror of the French Revolution and its aftermath of acute depression (traumatic stress disorder). The escape from "treacherous desertion" was through the intervention of Nature and the support of his sister Dorothy. His rescue by Nature is akin to that of John Newton, his near contemporary, who, while a slaver, was saved from shipwreck. Newton subsequently wrote the well known hymn *Amazing Grace* to celebrate this divine rescue.[38]

For Wordsworth, the descent is replaced by an ascent. The poetic narrative leads to a night ascent of Snowdon, the highest mountain in Wales. Slowly with a guide he climbed above the clouds, leaving behind "the roar of waters, torrents, streams," a realm of loss and struggle. Separated from this confusion and danger he reaches the summit. The moon is set in an azure firmament above a sea of mist. The ascent has reestablished the first-born affinities. It is a setting of basic trust in which he beholds an 'emblem of a mind.' In these 'circumstances awful and sublime' men 'see, hear, perceive, / And cannot choose but feel'. The mind encountered is above all a poetic mind; a mind that acts and possesses, craves, "in itself it is and would become"—the mind glimpsed, but less understood, on the descent from the Simplon pass. The case for the unity of the poetic mind discovered in Nature with the mind encountered in music and mathematics has been made by Edward Rothstein in a fascinating essay *Emblems of Mind*.[39] (Rothstein was formerly a music critic for the New York Times.) His Platonic interpretation is more in tune with the passage in Wordsworth's poem known as Tintern Abbey, written in 1798, that reflected his interaction with Coleridge. In that poem Nature is more a subject of contemplation and less an active agent:

> And I have felt
> A presence that disturbs me with the joy
> Of elevated thoughts; a sense sublime
> Of something far more deeply interfused,
> Whose dwelling is the light of setting suns,
> And the round ocean and the living air,
> And the blue sky, and in the mind of man:
> A motion and a spirit that impels
> All thinking things, all objects of all thoughts,
> And rolls through all things....

Wordsworth's achievement is not diminished by placing it in a historical context. Among other things, he was born the same year as Beethoven

and one can imagine, in theory, a meeting of these two egotists in Germany in 1798 when Beethoven was composing the Pathétique piano sonata. Wordsworth's outlook was probably shaped by Platonism and by conversations with Coleridge about European philosophy, but it is important to bear in mind the traditions of religious dissent that had existed in Cumbria at least since the period of the English Civil War. The Dissenters, such as the Congregationalists, Baptists and Quakers and later on many Methodists, placed their emphasis on experience rather than a dogmatic theology shaped by theories of guilt and retribution. In 1653 George Fox, the founder of the Quakers, preached of the "Inner Light" standing on a rock on an open fell near Sedburgh to a great gathering of sheep farmers who thought of themselves as 'seekers'. In a photograph I took from near the rock known as 'Fox's Pulpit' I counted over 200 sheep in the valley below and on the fells beyond. Fox's contemporary John Milton set out the link between light in Nature and 'Inner Light' in Book III of *Paradise Lost*.[40] In a passage that begins "Hail holy light" he laments his blindness. He is "Cut off, and for the Book of Knowledge fair / Presented with a Universal blanc / Of Nature's works to me expunged..." Long before Wordsworth encountered Milton he may have heard Methodist preachers speaking of the 'Book of Nature.' They looked for emblems and signs in Nature following biblical precedents. Here is a passage from the book of Isaiah (55:12-13), written near the end of the Babylonian Exile, which illustrates the language:

> For you shall go out in joy, and be led forth in peace;
> the mountains and the hills before you shall break forth in singing,
> and all the trees of the field shall clap their hands.
> Instead of the thorn shall come up the cypress;
> instead of the briar shall come up the myrtle;
> and it shall be to the Lord for a memorial,
> for an everlasting sign which shall not be cut off.

For the poet, what matters is the integrity achieved through a life in touch with the natural world that is responsive to its *signs* and *emblems*. Wordsworth defines the "imaginative form," of the free man in terms of the mountain shepherd who follows his solitary task in all weathers; in winter to "wait upon the storms" and in the spring when "all the pastures dance with lambs" to climb and climb to "watch their goings". "A freeman, wedded to his life of hope / And hazard." The shepherd may or may not understand his role. It is Wordsworth, the poet, who writes: "His form has flashed upon me glorified / By the deep radiance of the setting sun." The imaginative form of the poet, or photographer, is that of the free man—one who waits upon the storms and lives in hope. For Wordsworth, the artist is not concerned with defying Nature but living with Nature.

There is a philosophical and theological ambiguity in Wordsworth's language that can either infuriate, or force the reader to be selective. Could one, perhaps, approach the Snowdon passage not in terms of Plato, but Immanuel Kant (1924-1804)? Kant had discussed the sublime in nature in the *Critique of Practical Reason* (1788) and the *Critique of Judgement* (1790) and Wordsworth may have known of his opinion. In the latter *Critique* he wrote: " hence it comes that the sublime is not to be looked for in things of nature, but only in our own ideas.... it is the disposition of the soul evoked by a particular representation engaging the attention of the reflective judgement, and not the Object, that is to be called sublime." [41] In using the term *emblem* Wordsworth avoids the pathetic fallacy in which a mountain may have an intention to create awe and thus be in itself sublime. However Wordsworth's preoccupation in *The Prelude* is to write an account of the 'growth of the poet's mind' and as a poet he must be true to the experience that mountains can seem to terrify and create awe, to have agency. The passage in *The Prelude* I find most powerful is the account of his boyhood escapade in which he rows out in the moonlight onto Ullswater in a shepherd's boat. A huge cliff upreared its head and "With measured motion like a living thing / Strode after me." For days afterwards his brain worked with a sense of "unknown modes of being." In his thoughts "huge and mighty forms that do not live / Like living men moved slowly through my mind / And were a trouble to my dreams." As a scientist I walk with Popper and the post-Kantians, but surely Wordsworth describes the way that other mountain photographers beside myself feel. As with Hamlet and some of Dostoyevsky's characters, it is the very changes in sensibility that give Wordsworth's journey of self understanding such immediacy and transparency.

3:4) Sinai

Wordsworth's concept of the sublime in Nature that gives fear and terror a subsidiary role is a direct challenge to Burke's views. It is also hard to mesh Wordsworth's view of the sublime with the biblical view of the sacred and holy as it is contained in the book of Exodus. Exodus is closer to Burke than to Wordsworth. Mt Sinai in the Bible is a sacred landscape that can be entered only by the chosen. In Exodus 19:21 The Lord speaks to Moses from the thick cloud upon Sinai. There is thunder and lightening and a trumpet blast: "Go down and warn the people, lest they break through to the Lord to gaze and many of them perish." In Exodus 33:18 Moses says to the Lord: "I pray thee show me thy glory," and God replies: "You cannot see my face; for a man shall not see me and live...while my glory passeth by, I will put you in a cleft in the rock, and I will cover you with my hand until I have passed by. Then I will take away my hand and you shall see my back [hind quarters?]; but my face shall not be seen." In this dialog, as in the Psalms, it is evident

that the Lord who thereafter gives the Torah to Moses is also the all-powerful creator of the universe. This picture of the Mosaic Sublime echoes through Western sensibility and is part of the consciousness of many who have no Jewish or Christian allegiance.

The Sinai story links the holy mountain with the controlled terror associated with sacrifice. After Moses brings down the Tablets of the Law he seals the Covenant between God and the people by performing multiple sacrifices. Half the blood of the slain oxen is dashed against the altar and half on the people (Exodus 24.) The terror of Sinai is prefigured in the events leading up to the escape of the Israelites from Egypt. By Moses' command, before the Exodus the Passover lambs were sacrificed and their blood was smeared on door-posts and lintels to protect the Israelites from the last and most terrible of the plagues, the death of the first born (Exodus 12:7, 11-13, 22, 27. 13:11-16.) In these actions Moses is in step with Turner who infused his pictures of the sublime with black and red and the red is inevitably described in terms of blood.

The imagery of the forbidden sacred associated with Sinai had to be made accessible to future generations, therefore the Ark of the Covenant was assembled at Moses' direction to contain the tablets of the Torah. To touch the Ark, even by accident, was to die. Later this vision of the sublime and sacred was transferred when the Ark was placed in the Holy of Holies in the Temple of Jerusalem. The idea was preserved in the rebuilt temple after the Exile—even though there was no longer an Ark—there was only an empty room. Mount Sinai was brought to Mount Zion. Two major festivals commemorated the Mosaic connection: Passover and Pentecost. The former commemorated the Exodus from Egypt, the latter the giving of the Torah to Moses on Sinai. The Jerusalem temple was especially dedicated to the correct performance of sacrifices related to matters of ritual purity, sin, and thanksgiving. The Holy of Holies was forbidden to all except the High Priest, and he could only enter once a year on the Day of Atonement. So central were sacrifices to Jewish worship that when in 70 CE the Romans broke into the magnificent temple that had been reconstructed by Herod the Great, sacrifices continued until the very end. The Roman-Jewish historian Josephus described the glories of the temple, the ritual and also the slaughter of the priests.

Once the temple was destroyed, Judaism and the emerging Jesus movement had to be radically reconstructed. The Jewish Essene sect and the temple-oriented part of the Jesus movement did not survive. Within the Rabbinic Judaism that evolved, temple sacrifices were eventually held to belong to a former dispensation.[42] Moses Maimonides (1135-1204)

expressed the view that God did not desire animal sacrifices, but commanded them as an accommodation to the psychology of the ancient Israelites.[43] Jewish worship came to center on the Torah and the synagogue. The efficacy of sacrifice, however, is generally assumed in the New Testament. For the Jesus movement by the time the gospels were being written, the overwhelming problem was to interpret the violent death of their leader who had proclaimed the coming destruction of the temple and a new beginning akin to the Exodus. The teaching of Jesus had to be reframed in the context of the death. In part, they drew on the strange powerful Pharisaic belief in resurrection, but they also turned to Moses. In all four New Testament gospels the Passover narrative frames the death of Jesus. In the gospel of John the chronology makes Jesus the Passover lamb that was slain, thus defining his death as a protection for the small and beleaguered Jesus community.[44] The floating concept of the Mosaic sublime that had moved from Sinai to Zion became part of the ritual of the incipient church. It later became part of the visual presentation of the crucifixion, as in Rembrandt's handling of light in the different states of his etching of The Three Crosses. Also, it is central to the quest narratives relating to the Holy Grail. Sinai and the crucifixion are part of the Western heritage that the photographer brings, either consciously or by way of layers of cultural transmission, to the recording of mountain storms and mountain light.

The quest for the Transcendent and Sacred has been a major factor in human history and sacrifice has been a part of that quest for reasons that are hard to explain. The justifications given have meaning only to participants. The intense physiological responses to the sight of blood, that may have conferred survival value upon our ancestors, are part of the story. (I confess to fainting when I first saw a hospital operation.) Sacrifice was universally practiced in the Greco-Roman world and, as I have already noted, was part of the shamanistic religion indigenous to the Himalayas. None the less, it is a topic that tends to be avoided in polite society. It was something of a shock, therefore, to discover that it is normal in Nepalese Hinduism. According to the Kathmandu Post (Nov 3, 1996), the Hindu sacrifice merges the worshiper with the supreme power of the goddess *Devi Durga* in her concquest of an evil demon. I have managed to avoid seeing the annual slaughter of buffalo by Ghurka troops in Kathmandu that takes place in the presence of the royal family (this was before the royal family took to slaughtering itself.) However, I encountered an official procession to sacrifice a goat on 6 October 1989 in Jumla on the eighth day of the Dasain festival. Bugles were blown by Ghurka troops and the procession returned with the goat suspended in a bloody sheet.

To summarize—Of the four approaches to the Mountain Sublime I have described the first I associate with Ruskin. His view is concerned with structure, beauty, and danger and above all with irreducible reality. The second I associate with Burke and Turner—the sublime arises when beauty shades into terror. In the third, defined by Wordsworth, the sublime is separated from terror; there is basic trust and an encounter with the poetic mind. All of these emphasize direct visual experience. In the fourth, represented by Moses, the emphasis is on the unapproachable sacred and holy, with the possibility of death ever present. In this last view the borderline between life and death may be symbolically crossed through animal sacrifice, or an equivalent representation. The Mosaic emphasis is less on direct experience and more on a tradition that frames experience.

In the above approaches ideas overlap. All are concerned with mountains, all are ego affirming and all have deep psychological roots, though only in the case of Wordsworth is the psychology explicit. I think of them as a triangular island with Turner, Wordsworth and Moses at the three corners. Ruskin, who has connections to the other three, is more or less at the center, but closer to Turner that to Moses or Wordsworth.

This map may be extended to include the possibility of ego transcendence—the oceanic experience of being merged with the infinite. Somewhere offshore from the triangle of ego affirmation can be found a circular island of ego transcendence. At the center is the sacred mountain of Buddhist tradition. If our subject were the American West, we would have to include the Transcendentalists such as Emerson and Thoreau. I set them also offshore, perhaps on the edge of the circular island, but gazing towards Wordsworth wrapped in his Tintern Abbey mode. We can use this map to place individual mountaineers or photographers. As the Second World War approached, Ansel Adams, photographer of the California Sierra, moved from the calm of the Transcendentalists towards the sublime of Burke and Turner. But such movement cannot be forced: I have struggled for years to capture Turner's vortex. There is, perhaps, a memory of the vortex in the cover photograph for this book, but only a memory.

3:5) Natural Philosophy & Reason

The above views about the sublime in Nature were variously challenged by the transformation of descriptive geology into scientific geology and the emergence of Darwinian biology. The critical developments took place in Ruskin's lifetime at the point where Himalayan exploration and mountaineering was just getting underway. To describe the changes we must step back before Ruskin and Wordsworth to consider the Enlightenment and the growth of science.

The Greeks discovered structure and symmetry, but it was Galileo (1564-1642) and Newton (1642-1727) that established the idea that Nature was governed by laws that could be understood by Reason, and this conviction became a central concept of the Enlightenment. Modern physicists would probably speak less of laws and more of the symmetry theory of groups that classifies the equations described as laws. Arguments incorporating symmetry theory have given rise to Relativity, and the powerful quantum theory 'Standard Model' that classifies sub-atomic particles.[45] If anything, this shift in emphasis only strengthens the status of Reason. John Locke (1632-1704) in his *Essay Concerning Human Understanding*: wrote "he governs his assent aright, and places it as he should who, in any case or matter whatsoever, believes or disbelieves, according as reason directs him."[46] This principle applies equally to science, ethics and religion. Within the Church of England in the seventeenth century there was a strong movement of Latitudinarians who were determined supporters of the Royal Society and the light of Reason. Both Newton and Locke adopted an essentially Unitarian theology and saw physical laws and universal moral laws as manifestations of the same divine wisdom. In the *Principia* (more fully: *Philosophiae Naturalis Principia Mathematica*) Newton wrote: "This most beautiful system of the sun, planets, and comets, could only proceed from the council and dominion of an intelligent and powerful Being."[47] There were scientific universals; therefore by analogy there must be moral universals. The same point was made later by Immanuel Kant in the forward to his *Critique of Practical Reason* (1788) who wrote: "Two things fill the mind with ever new and increasing awe and admiration the more frequently and continuously reflection is occupied with them; the starry skies above and the moral law within me." Beethoven copied this passage into his Conversation Book.[48] Wordsworth makes the same argument in *Tintern Abbey*, but the parallelism goes back to Psalm 19 where verse 1 begins: "The heavens are telling...", and verse 7 continues: "The Law of the Lord..." Order in the scientific world stands as an emblem of a universal basic moral order.

The views of Newton and Locke were expressed in the context of the Glorious Revolution of 1688. James II, who believed in the Divine Right of Kings, had been deposed. William III of the Protestant house of Orange was imported and installed as a constitutional monarch subject to the law of the land. No one, not the King, not even God, was above the universal moral law, and that law should be discernable though Reason. These Newtonian-Lockean views were still in place in 1776, allowing "Nature and Natures God" to be incorporated into the Declaration of Independence. Thanks to Benjamin Franklin, the moral principle that "All men are created equal" was seen to be a self-evident truth of Nature.[49]

Within this context the mountains could well be acknowledged as the setting for the human drama and symbols of God's majesty. Sinai was not far in the background, but each of the other approaches to the mountain sublime can be adapted to this scheme without too much fudging. Inevitably, however, questions about the structure and formation of mountains arose from the needs of mining and the development of chemistry. There were many founding fathers of modern geology but I will concentrate on three. The first, a contemporary of Locke, was the wandering Danish anatomist Niels Stenson (1638-86), known as Steno from his Latin name, who put forward the idea that shell-containing rocks had been laid down as sedimentary deposits. Seashells on the tops of mountains must have got there through massive earth movements. (I have a simple bivalve shell I picked up at 18,000 ft on the way out of Inner Dolpo.) With layered sedimentary rocks those at the bottom must be the oldest.

The idea that the earth had a history with primary rocks distinct from secondary sedimentary rocks became widespread amongst the learned across Europe. French was the major language of scientific communication. The Lisbon earthquake of 1755 and the eruption of Vesuvius in 1776 were great stimuli to the study of the earth. Much effort was directed at the collection and classification of minerals, rocks, and fossils. In 1179 de Sassure published the first volume of his *Voyages dans les Alps* (already introduced) which included observations on folded rock formations. In 1787 he made an ascent of Mt Blanc and observed: "What I saw with the greatest clarity was the ensemble of all the high peaks, the arrangement of which I so long wanted to understand.... I was seeing their relationships, their connections and their structure." He died before he could write a general history of the earth based on his extensive fieldwork.[50]

Others approached geo-history not through field observations, but by the Newtonian method of setting up a grand deductive scheme and then seeking to justify it by particular observations. Amongst such effort was the work of the Scottish Natural Philosopher James Hutton (1726-1797) who argued that rocks have been laid down and eroded over vast periods of time. Some rocks, such as basalt and granite, derive from rocks melted by the earth's heat. Great was his joy in 1785 when he discovered in Glen Tilt veins of red granite branching out from their principal mass and running through sedimentary rocks. In that same year he presented a paper: "*Theory of the Earth, or an Investigation into the Laws Observable in the Composition, Dissolution, and Restoration of land upon the Globe.*" to the recently formed Royal Society of Edinburgh. It is recorded: "He communicated his results...with the fearless spirit of one who was conscious that love of truth was the sole stimulus of all his exertions." He was "loved for the simplicity of

his manners and the sincerity of his character." The essence of the "Huttonian theory" was that *the present is key to the past*. The geological record can be understood by studying observable processes: erosion, deposition, earthquakes, volcanism and the transforming effect of the earth's heat. The reprocessing of the earth has taken place to such an extent, wrote Hutton "we find no vestige of a beginning,—no prospect of an end." This pattern was the work of a rational creator and Hutton, his spokesperson through many volumes, had a rational theory of almost everything. Other writers favored a history of the world that progressed though a series of eons.[51]

A third founding father was a mine surveyor William Smith (1769-1839).[52] In mapping the strata of the Somerset coalfields in1791, he recognized that the distinctive character and distribution of embedded fossils could identify strata and was fortunate to begin his work in a region of England where there were uniform sedimentary deposits over large areas. After years of fieldwork, in 1815, 'Strata' Smith published the Great Map of England, 18 ft x 6 ft.

Much progress was made in systematic geology in the early years of the nineteenth century to develop the idea of geological eras and the idea that certain species had become extinct in the course of the earth's history. There was squabbling about 'Biblical' views of geological time and about Lamarckian ideas of evolution, but these were amongst academics and informed amateurs. What changed things was the publication of the *Principles of Geology* by Charles Lyell in 3 volumes (1830, 31, and 32.) Lyell's first volume appeared just in time for Charles Darwin to have a copy with him on *The Beagle*. The other volumes caught up with him on the voyage. It was republished for popular consumption and updated (1867-8) after the publication of the *Origin of Species* in 1859. Darwin first established his reputation by his geological publications. In 1856 he received for his contributions the Geological Society's highest honor, the Wollaston medal.[53] The fossil record provided Darwin with the knowledge that species had evolved in stages through many millions of years. The *Origin of Species* was published at the urging of his friends Lyell and the botanist Joseph Dalton Hooker (of whom more below.) Lyell's objective was to make geology a science and get rid of Moses, i.e., all attempts to square geology with the Creation and Flood narratives of the book of Genesis (traditionally written by Moses.) Lyell was at pains to show that earthquakes, eruptions and floods continue without any respect to man.[54]

Just as in the present day USA, there were stubborn factions that dismissed the science as conjecture and followed their own beliefs irrespective of the arguments. They were not impressed by geology, and they were even less

impressed with evolution. At the other end of the spectrum were those who read passages about nature and creation in the bible as figurative language, allegory and metaphor.[55] The Genesis creation story is poetry about man's place in Nature that might also be an inspiration for human creativity. The flood story is an allegory about a covenant between god and humanity, but not a source as geo-history. Such non-literalist approaches to biblical exegesis have a very long history going back to the early church fathers. For some non-literalists the essence of their religion was in contemplation; the poetry was a guide to contemplation. There were, however, two important groups who found Lyell very troubling. One group was concerned about the Enlightenment synthesis in which the moral law was seen as parallel to the Newtonian physical laws, the other group was concerned about God's *immanence*—the idea that God is an active agent both in the natural world and in human history.

There was nothing in Lyell's geological account that suggested the work of a moral creator who set the stage for the human drama. Darwin's contribution made the cleavage between creation and morality even greater. In countless instances, random variation (later attributed to mutations) and survival through natural selection served to explain the origin of species without invoking moral purpose. A 'natural theology' argument that complex biological structures imply a designer was put forward by, amongst others, William Paley (1743-1805) and was accepted by Ruskin and some pioneering geologists, including Adam Sedgwick, professor of geology at Oxford, friend of Wordsworth and teacher of Darwin. But the argument is a two edged sword. In contemporary terms: one must assume that the moral designer that created 'man' also created with equal skill the intricate life cycle of the malarial parasite and designed the way in which the AIDS virus avoids the human immune system. Also, there are many instances where the natural selection account seems to be a better explanation of peculiarities than intelligent design (the pain associated with human childbirth for example.) It was clear that the belief of Newton and Locke that moral order was implied in Nature was no longer sustainable. Moral universals might exist, but they were certainly not self-evident or deducible from the inspection of Nature. Darwin, the scientific humanists, came to his conclusions with much pain knowing that the *Origin of Species* would just add to the existing conflicts. Poems in Tennyson's 1850 collection *In Memoriam*, published nine years prior to *The Origin,* starkly defined the issue: In poem LIV,

> Are God and Nature then at strife,
> That Nature lends such evil dreams?
> So careful of the type she seems,
> So careless of the single life;

and in poem LV,

> [Man] Who trusted God was love indeed
> And Love Creation's final law—
> Tho' Nature, red in tooth and claw
> With ravine, shrieked against the creed—

These arguments are not appreciably countered by explaining how natural selection can lead to degrees of altruism between kin in primate families.[56] The conclusion that all was not well with the assumed relationship between Nature and Nature's God might be said to place the *Declaration of Independence* in serious trouble and, if we step to more recent times, might gnaw away at the *Pledge of Allegiance.* Strangely enough, no one seems to worry about this. I shall return to Tennyson in the context of mountaineering in Section 6 below.

As to immanence; what status has the language in which God, outside Nature and history, is said to act in history through Nature? Can Nature, or Providence, be said to be an active agent? This language, partly derived from the psalms, informs many Christian hymns. For example, Isaac Watts 1715 hymn: "I sing the almighty power of God / Who made the mountains rise." But by the mid nineteenth's century this language was clearly questionable. Natural events often influence history—storms devastated the Spanish Armada and ocean calms allowed the evacuation of Dunkirk—and such coincidences can be so remarkable that they seem to imply divine intervention—but, in the wake of Lyell, coincidences are simply coincidences. In contemporary terms, we trust our lives to the extraordinary reliability of physical systems every time we fly in a plane and if it crashes our sorrowful friends will assume a component failure not the hand of God. The idea that God intervenes in the physical world by somehow tweaking quantum mechanics is not popular with physicists.

This leaves us with the question of human agency. Can a superior non-human agent, God or Providence, interact directly with the human mind? The question is hard to formulate because studies of consciousness, memory, and identity in terms of brain neural networks and brain biochemistry are in a period of rapid development.[57] But nineteenth century notions of the mind were not particularly material, although philosophers had discussed causality in perception. A mid-nineteenth century roundup could be as follows: The God, whose moral values, if inferred from Nature, are unacceptable, and who cannot act in human history through nature, can speak to our hearts (core identities, souls) through emblems of nature. If you allow that 'God' can stand for some superior non-human agent, such as the 'Spirit

of the Hills', then this view seems to be an ongoing photographic tradition: John Sexton in his beautiful 1990 book *Quiet Light* writes: "if we approach the light on its terms we can hear the land speak to us."[58] This contemplative language is of the Transcendentalist mold. But the voice of God as heard by the Hebrew prophets of the wilderness, was not tentative. In anguish, rage and hope, they cried out *Co Amar Adonai*—Thus says the Lord. In the same mold, such wanderers on moor and fell as George Fox proclaimed the Day of the Lord.

How do the four approaches to the Mountain Sublime listed above react to these strictures? Burke and Turner escape the challenge because they are concerned with subjective experience, not divine action or Reason. Moses is directly confronted: the Mosaic God acts in history and controls nature. Both concepts are central to the Exodus-Passover narrative. (Their absence makes hymn writing difficult.) Wordsworth occupies a middle ground. He presents Nature as both a source of moral values and an active agent; but the status of his 'presences' is ambiguous: they do not move mountains or create storms like their Tibetan counterparts, there are no miracles—their only intervention is in the mind. His main currency is emblems and types. They belong to childhood and to the adult world of poetic experience—to the mind of man. Within that realm of creative sensibility morality is found and Nature acts. It, perhaps, provides some insight into the transitions of the nineteenth century to know that the younger Darwin took Wordsworth's poems with him on the *Beagle* voyage and many years later, after the death of his daughter Annie, he turned to the poem Wordsworth had written on the death of his own daughter that begins "Surprised by Joy—."[59]

There remains Ruskin. Insofar as Ruskin is focused on the irreducible experience of mountain structure and mountain glory, he is on safe ground. If in this context he makes moral judgments, that is *his* valid subjective experience. In pointing to this complex experience through his drawing, he is fulfilling his identity, his imaginative form, as an artist. Sella could make the same claim about his photographs. There is drama in the photographs, but the drama exists in the poetic imagination of the photographer.

Ruskin had been raised in Christian evangelical circles. *Modern Painters* reflects the struggle to bring together his enthusiasm for geology, the intensity of his experience of nature and his evangelical heritage. This influence appears in Volume V of *Modern Painters* (1856) where he prefaces the chapters on the beauty and structure of mountains with a chapter that contains a cascade of quotations from the Psalms and a claim that the natural world is sculpted especially for man's benefit and instruction. The fearsome mountains are sources of "life and happiness far fuller and more beneficent than all the bright fruitfulness of the plains." If you take out the Biblical quotations, he seems to be making a reasonable ecological case for the role of mountains, but his theological stance is suspect. Some years before he wrote Volume V his belief system was crumbling. He could not fend off Lyell and the geological establishment forever. In 1851 he wrote in his diary "If only the Geologist would let me alone, I could do very well, but those dreadful hammers! I hear the clink of them at the end of every cadence of the Bible verses." He was slowly moving away from the idea of mountains as a source of divine revelation and toward the ethical reasoning that later deeply influenced Gandhi. He dated his *uncoversion* to 1858, but that is another story.[60]

My further example of a transformation in belief relates not to the Alps, but to the Himalayas. The first major photographer to reach the Himalayas was Samuel Bourne (1832-1912).[61] He came to India in 1863; this was just 6 years after the Sepoy Rebellion (also known as the Indian Mutiny and the First War of Liberation.) The East India Company had been set to one side and direct rule established. Bourne set up in the business of providing pictures of India for travelers and administrators to mount in their albums and take back to England as mementos. Many of his photographs of temples, monuments and forts are of extraordinary quality. There is a scientific directness in this work. The placement and detail reveal the structure of the monuments photographed. He came to the mountains with a European sensibility and a conviction of his European superiority. His reading of Lyell inspired him to take photographs of convoluted rock formations. Amazingly he managed to make wet-plate photographs at 4,659 meters (15,286 ft) on the Taree pass—higher than Mont Blanc. In describing his 1863 trip to the Spiti Himalaya he wrote in the British Journal of Photography about the "terrible majesty of the mountains" "the uplifting of the souls capacity" and the "silent uplifting of the heart to Him who formed such stupendous works."

On his second trip in 1864 to Kashmir his response was different. He wrote of "the interinable mountains which seemed to stretch to infinity on every hand. To attempt to grasp or comprehend their extent was impossible, and the aching mind could only retire into itself..." Arthur Ollman in a forward to a book of Bourne's photographs remarks: "his delicate and specific grasp of reality, his analytical photographers mind, his religious constructs

and his enormous sense of rightness were all lost in this immensity." For Bourne this was a great shock of circumstance. The vast empty extent of geological time was spread out before him. He confronted the ancient fear that if there is purpose and a moral order in the universe, it is not perceptible to human understanding. On the temporal edge, before the avalanche and

earthquake, certainty crumbles. Ollman writes: "In this experience of the pass the void stared back at him." "Cracks started to form in Bourne's concept of photography, in his sense of reality, in his worldview. Finally, thousands of miles from home, months away from European influence, Bourne really began to see."

4) THE HAND OF EMPIRE

Our perceptions of the Himalayas are conditioned by the history of their exploration—the story of those who sought to stand where no Western traveler had stood before. There is not one history, however, but several entwined histories in which politics, science and mountaineering interact.

4:1) The Makers of Maps

The quest hero who crosses boundaries to enter an unknown realm symbolically travels alone and without a map. Intuition, cryptic signs or spirit messengers must be the guide. When no map is available dangers increase exponentially. The fact that Samuel Bourne traveled and photographed in the Himalayas in 1864 using only rough maps is all the more remarkable when one considers the transportation logistics involved and the political uncertainties of the time. But map making was already underway. The struggle to make maps and measure the heights of mountains was itself a quest grounded in the objectives of Newtonian science. Along with the mapmakers came botanists, geologists and geographers. In the course of this quest the *mapmakers* pioneered Himalayan mountaineering.

The making of maps was a routine part of military activities, however, accurate navigation at sea required a knowledge of the shape of the earth. The earth is not a true sphere but compressed along the polar axis. Its shape can be deduced from the decrease in the length of arcs of equal degrees of latitude as the equator is approached. From the 1730s onwards arc measurements had been made in Ecuador and Lapland and also in Europe (from Spain to England.) Lieutenant William Lambton (1753-1830), a surveyor posted to India in 1796, was fascinated by the mathematical challenge of this geodesic problem. He developed the ambition to fill in the gap in knowledge for the latitudes north of the equator by measuring a great meridianal arc straight up the center of the continent of India. The scope of his project was far beyond anything previously attempted. Somehow he managed to

persuade Arthur Wellesley, the future Duke of Wellington, that this incredible dream was a good idea, even though much of the territory in question was not at that time under British control.[62, 63]

The story begins in 1802 in Madras (now Chennai) where the first baseline of the Great Trigonometric Survey was measured out near the racecourse that can be seen from the air on flying into the city. Working from the two ends of the baseline and measuring the angles to a distant point, the first triangle was established by precise theodolite measurements of horizontal and vertical angles. Triangles were added to triangles as the survey moved first westward, then south and north. The specially constructed theodolites had to be set on firm platforms. They were placed on tall towers and carried to the tops of mountains. The web of the Great Arc, anchored by astronomical observations and several base lines, ultimately stretched from the southern tip of India to Mussoorie, a small town that lies to the north of Dehra Dun in the foothills of the Himalayas. Wars in 1817-19 helped open up the way. Lambton died in harness in 1830, enthusiastic to the last, and George Everest, after enormous labor, completed the work in 1843. The Survey yielded the mathematical spheroid (a squashed sphere) that represented sea level at any particular point however far away from the sea. This information was needed as a reference in order to calculate the true heights of mountains. Between 1840 and 1850 an ever-expanding grid of triangles skirting the Himalayas was tied into the Great Arc. The precision of the survey was far beyond anything required for colonial map making. The Great Arc was hailed as an emblematic work of an 'Enlightened Government' bent on promoting scientific knowledge and truth. At the end of the century France, with great fanfare, took up the challenge by remeasuring the Quito meridian in Ecuador with the great mathematician Henri Poincaré in charge.

The heights of some Himalayan mountains were estimated well before the arrival of the master grid. Barometric pressure could be used to

estimate reference heights and theodolites, or, less reliably, sextants, could estimate angles of elevation. Sir William Jones, a high court judge in Calcutta filled with Enlightenment curiosity—founder of the Asiatic Society of Bengal and best known for his Indo-European linguistic theory—made calculations in the 1780s that suggested the Himalayas might be higher than the Andes. As to maps, prior to 1800 there was little but traveler's sketches. Charles Crawford between 1801 and 1803, as part of a diplomatic mission to Kathmandu, was able to make some rough maps of Nepal. The Surveyor general of Bengal became interested in the source of the Ganges and deputized Lieutenant W.S. Webb of the Tenth Bengal Infantry for the task. Webb made route maps of his 1808 journey, but did not realize that in reaching the source he had, in fact, crossed the chain of the Great Himalaya. In 1810, Webb calculated the height of the distant and inaccessible Dhaulagiri: to his surprise 26,862 feet (present value 26,810ft/8,172m). The Anglo-Nepal war of 1814-16 led to a treaty that closed the border of Nepal but gave access to the Gharwal Himalaya. An 1822 report established provisional coordinates and heights for 22 peaks in that region, including Nanda Devi the highest point in present-day India. These observations were later tied into the grid of the Survey. In 1848 the height of Kangchenjunga was calculated from the grid to be 28,176 feet (present value 8,598m/28,208ft). In 1856 a peak far inside Nepal, number XV, was calculated to be 29,002 feet (present value is 29,035ft/8,850m). In 1865, the Secretary of State for India and the Royal Geographical Society, having failed to find a local name, designated Peak XV Mount Everest, even though Everest's enthusiasm had been for measuring the earth's shape, not the height of mountains. The names Sagamartha and Chomolungma became known much later. The most recent effort at mapping Everest was sponsored by the National Geographic Society and organized by the American mountaineering pioneer Bradford Washburn (1910-2007), director and molding spirit of the Museum of Science, Boston. Not incidentally, he was noted for his magnificent black-and-white large-format mountain photographs, often taken from a small plane.[64]

Lambton and Everest were part of the Enlightenment Scientific tradition, as was the great botanist Joseph Dalton Hooker (1817-1911). Hooker was the friend of Darwin who encouraged him to publish the *Origin of Species*. Lack of maps did not hold Hooker back. Between 1847 and 1851, he was collecting specimens, making geological observations and drawing careful sketch maps in Sikkim and the Kangchenjunga region of Nepal.[65] On page 122 I show a photograph of a pillar rock formation noted by Hooker in his 1848 journal (map page 114). His degree was in medicine and this had given him a position on the 1839 Ross expedition to Antarctica. In his Kangchenjunga expedition he was the first to fully document a

mountain habitat range from tropical rain forest to alpine tundra, although his father, William Jackson Hooker (1785-1865), had studied mountain habitats with a less extreme range in both Iceland and Switzerland (William Hooker had been appointed in 1841 director of the Royal Botanical Gardens at Kew.) Joseph Hooker both published his travel journals and produced a monumental study of the flora of British India. He made elegant botanical watercolor paintings that were also published. The fact that he had identified 25 new species of rhododendron was reported in the British press before he had even left India—a measure of the public's interest in botany.[66] Joseph, who succeeded his father as Director of Kew in 1865 and, like his father, was knighted, was President of the Royal Society from 1873-78.

Before any British presence was established in the region a great deal was learned from traveler's reports about the Buddhist kingdom of Ladakh, centered on Leh, and about the Muslim region of Baltistan, centered on Skardu. Most notable of these were the extraordinary wanderings between 1812 and 1825 of William Moorcroft. He was a doctor and veterinary surgeon ostensibly in search of military horses (but he sent his reports to the Political Department.) His first trip to Western Tibet was made in the disguise of a Hindu trader-pilgrim. On his second trip he visited Ladakh. His companion George Trebeck served as a mapmaker and there was a trained Indian pacer to estimate the distances of each days walk. They ultimately died, probably of fever, somewhere to the south of Bokhara.[67, 68]

Information also came from a wealthy French botanist Victor Jacquemont, son of an Enlightenment philosopher, who visited the Vale of Kashmir, Ladakh and the Karakoram in 1830 on behalf of the Paris Jardin des Plantes. He returned with 50 porter-loads of plant specimens, but, unfortunately, he died in Bombay. In Ladakh, in a village close to the Tibetan border, he met in 1830 the remarkable wandering Hungarian scholar M. Alexander de Körös who for several years, most of the time completely cut off from other Europeans, had been studying Tibetan texts and composing a Tibetan-English dictionary. The work was eventually printed under his direction in Calcutta.

Thomas Vigne was more fortunate than Jacquemont. Ostensibly he was a gentleman traveler, always considerate and friendly towards his employees. He had, it seems, a commission from the East India Company to explore the passes of Kashmir and visit Baltistan. In 1835 he saw Nanga Parbat and, to his surprise, discovered the Karakoram. Mountain was "piled upon mountain in a most stupendous confusion of mist and glacier." He had been expecting a Tibet-like plateau. With the permission of the ruler of

Baltistan he explored the Hispar-Biafo Glacier, and visited Gilgit, but he did not visit the glacier that bears his name which I descended in 2001 on the way to Concordia and K2.

These reports encouraged the Survey of India to continue its work, even during the Sepoy Rebellion of 1857-8. A long-distance triangulation was carried out under the direction of Captain Thomas George Montgomerie. The Kashmir peaks were numbered off: K1, K2 etc. In 1858 peak K2 was declared to be the highest, but not as high as Everest. In 1861 Captain H.H. Godwin-Austen, made a preliminary map of the Braldu Valley and the region that included the Hispar, Biafo and Baltoro Glaciers (map page 9). He was the first to make the approach to K2 from the Baltoro Glacier by the glacier that now bears his name. Besides being an enthusiastic explorer, he was also a gifted artist who made topographical drawings and watercolors "with a geological eye".

Montgomerie noted that native traders in Ladakh were able to go where British travelers could not. [69] Because of concerns about Russian penetration, the British administration needed to have adequate maps of the border regions, yet Chinese Turkistan and Tibet excluded foreigners and the 1816 Nepal treaty had closed the border of Nepal. In 1862, at Dehra Dun in the Himalayan foothills, Montgomerie, assisted by Major Edmund Smyth, began training undercover surveyors. The course took two years. Indian Bhotiyas (ethnic Tibetans) from a border tribal group, the Rawats, who happened to have Hindu names, were trained in the use of the sextant and compass and how to take accurate notes without giving away their activities. They learned to measure distances by counting paces made uniform by long practice and they kept a tally of the paces with prayer beads. Their equipment and records had to be concealed in prayer wheels and trade goods. Collectively they were referred to as the Pundits and, in general, they were known only by numbers or letter codes. From 1864 to 1885 they traveled disguised as traders, Buddhist lamas and pilgrims. The first recruit traveled from Leh to Yarkand. Another followed the gorges of the Indus and others entered Nepal and Tibet. In 1865-6 Number 1 (Nain Singh) followed the Tsangpo-Brahmaputra for 600 miles and along the way accurately fixed the position of Lhasa. On his retirement he was given a pension and a gold Medal by the Royal Geographical Society. Number 9, Hari Ram, in 1871 made a complete circuit of the Everest group and in 1873 probably reaching the Kali Gandaki and Tibet by way of Inner Dolpo. The most remarkable record of loyalty and courage was that of Pundit Kinthup whose assignment was to establish that the Tsangpo in Tibet becomes the Brahmaputra in India. He spent four years on the task and endured slavery for 15 months.

Eventually, as planned, he threw 50 marked logs a day for 10 days into the Tsangpo, but unfortunately the message to alert the down-river watchers never reached its destination.

The extraordinary devotion of the Pundits to the Survey of India was in line with that of the scientific devotion of the surveyors who measured the Great Arc and then continued into the mountains. Kenneth Mason, a working Himalayan mountain surveyor for almost 25 years, who became Superintendent of the Survey of India and eventually Professor of Geography at Oxford, wrote of this devotion in *Abode of Snow*. By 1862 Indian and European surveyors in the course of making theodolite measurements had climbed more than 37 mountains over 20,000 feet and five over 21,000 feet. An unknown Indian ascended to 23,030 feet in 1860. The surveyors built platforms and cairns on the tops of mountains and sometimes built huts near the summits in which they could wait out storms. At that time the use of alpine gear (ice axes, instep crampons, ropes and pitons) was unknown in the Himalayas. [70]

Similar map making was going on in Russian Asia. In1896 the Russians and British negotiated to define boundaries in the Pamir Mountains to the north of the Hunza region of the Karakoram. A small finger of Afghanistan that extended to the Chinese border (the Wakhan corridor) was created to ensure that rival British and Russian interests did not touch. The 1907 international geodesy meeting in Potsdam sponsored a convergence of maps in this region. Mason, who was in charge of the 1913 British team, reported that the Russian estimate of the length of the junction line differed from the British estimate by only 1.5 meters.

Surveying, along with documentary photography, later blended into scientific expeditions, as I shall discuss below. Small teams of mountain surveyors continued to work. Their task was made easier with the introduction of photographic instruments to supplement the traditional theodolite. It was possible in 1937 for the pioneers of Himalayan exploration and mountaineering Eric Shipton (1907-1977) and Bill Tilman (1898-1977) to lead a low-cost survey expedition into the central Karakoram. Michael Spender (a brother of the poet Stephen Spender and the photographer Humphry Spender) was the surveyor and the geologist was J. B. Auden (brother of W. H. Auden the poet). Funds to support their adventure were scraped together by Shipton from the Royal Geographical Society, The Royal Society, and the Survey of India. His account of these explorations *Blank on the Map* with its introduction "Of the Real Value of Climbing" is essential reading. [71]

4:2) Political Determinants & the Great Game

I have told the story of the mapmakers that pioneered Himalayan mountaineering in terms of their devotion to a scientific ideal. This is the way Mason and his predecessors saw their work. But in the background as a driving force were the realities of international politics. The task of surveying began in 1760 as soon as the British East India Company, under Clive, had an area to control. As the years progressed, political control, direct or through client states, increased—usually as the result of military intervention in local conflicts. Eventually the conquerors took on the semblance of the Mughal rulers they replaced. Maps implied control; a fact that frequently generated a hostile local response to the appearance of surveyors. In the north a driving force for mapmaking was uncertainty about the activities of Russia. By 1807 Napoleon and Tsar Alexander were talking about collaborating to acquire India. Napoleon's potential route was from the Arabian Gulf by way of Sind. The British were aligning with the Shah of Persia who was unhappy about the way Russia was attacking his Caucasus territories. Suspicion of Russia continued after the defeat of Napoleon. A former British general Sir Robert Wilson, who had witnessed Napoleon's attack on Moscow and had seen the highly mobile Cossacks in action, laid out the Russian threat in an 1817 book. One route for potential intervention by mobile forces was that taken by the Moghul invaders from Afghanistan. Another was through the Pamirs and the Karakoram, a third was through Chinese Turkistan by way of Yarkand to Leh in Ladakh. A fourth, less plausible route, was through Tibet. Thus started the Great Game.[72]

The response of the British administration to Russian probes was known as the "forward policy". The goal of establishing a military presence in friendly frontier states led to repeated disasters in Afghanistan. In a move to counter Persian-Russian activities, a British force under Sir Alexander Burns marched into Afghanistan through the Bolan Pass in 1839. Burns death in 1841 was followed by a tragic winter retreat under continuous attack. Of 16,000 troops and camp followers that left Kabul, only one arrived in Jalalabad. Russian activities led to a second Afghan war. In 1878 the British again entered this buffer state and set up the treaty of Gundamark, but in 1879 the resident British force was slaughtered. A punitive expedition forcibly reestablished the buffer state and in 1893 the boundary between the North-West Frontier Province and Afghanistan (the Durrand line) was settled. It was not until 1919, after a short third war, that Afghanistan became officially free of British influence and independence was established. [73]

In the interim period between the first and second Afghan wars there were major changes. In 1845, as a result of the first war with the Sikhs, the Punjab became a protectorate, but a second war in 1849 led to outright annexation of the Punjab. As already noted on page 8, the Dogras, a Hindu tribal group, for helping against the Sikhs, received at the 1846 treaty of Amritsar the nominal control of the Kashmir valley (Muslim and Hindu), Ladakh (Buddhist), Baltistan (Shia Muslim) and Gilgit (Sunni Muslim). This led to a succession of Dogra Rajas of the Princely State of Kashmir and to the troubles that continue to plague this region. The Dogras were driven out of Gilgit in 1852 (only one person escaped), but regained it eight years later. It is not surprising that Baltistan, Hunza and Gilgit opted for Pakistan at the time of Partition.

Continued uncertainty about Russia's intentions led to the Crimean War (1854-56.) The Indian Sepoy Rebellion of 1857-8 may have been encouraged by Britains troubles in the Crimea, but the Sikhs this time helped the British to put down the uprising. After the war a new direct-rule system was set up to replace the East India Company, and, thanks to the development of a route to India via Suez, a major change in the culture of the British Raj took place. The British rulers became part of a caste system that emphasized toleration, but not equality.

Russia continued to advance into the trans-Caspian region of Central Asia. Cossack forces captured Kiva in 1868; Samarkand and Bokhara became a Russian protectorate and by 1875 the Khiva Khanate was completely subjugated. In 1881 Russian civilization was extended to Goek-Tepe with great slaughter. The next logical step in control and economic development was railroad building. Construction of a trans-Caspian railway that skirted the Persian border began in 1880. The railway reached Merv in 1885, Bokhara and Samarkand by 1888 and soon afterwards Tashkent. It was now possible to ship a substantial European-style army to a place where it could move towards India. Spurred on by a secret 1884 military intelligence report, George Nathaniel Curzon (1859-1925), the future Viceroy of India, but then a Tory Member of Parliament, decided in 1888 to make a personal investigation of the new Russian railways. It was obvious to him that the military officers in Central Asia, having pacified the area, saw an invasion of India as a wonderful chance to get military promotion. If Afghanistan was not a good route, then what about farther east? Russian probes in this area led to the Hunza war.

Hunza is in the northern part of the Karakoram. In my 1994 trip we descended to the Hunza Valley from the Hispar Glacier by a memorable Jeep ride. The Jeep swirled round hairpin bends on a dirt road as we clung

fearfully to the cross bar and looking at turbulent waters far below. Suddenly the bare rocks were left behind and a fertile green valley opened before us. Poplars and willows marked the watercourses. Here was the town of Karimabad, now a Silk-Route tourist stop on the Karakoram highway. Above the town was the Baltit fort, once home of the Mir of Hunza, and high above that was Rakaposhi Peak (7,788m/25,550ft). The present military and administrative center for the region is Gilgit. The British established a Political Agency there in 1877 as part of the Princely State of Kashmir.[74] When I visited Gilgit in 1994 the town had a Wild-West feeling. Men with Kalashnikov rifles were wandering the streets. Unlike in Hunza, the women were hidden from view except when escorted by a male family member.

The events precipitating the Hunza war were chance encounters by Lieutenant Francis Younghusband (1863-1942).[75] He was part of the military community that was the second major factor after the surveyors in the development of Himalayan mountaineering. Much later, as Sir Francis, and as a President of the Royal Geographical Society, he became a major force on the British Everest committee. In 1889 he was sent to investigate raids by Hunza tribesmen on the Leh-Yarkand caravan route. On reaching the Shimshal Pass, Younghusband unexpectedly encountered a Russian party that consisted of a Russian agent, Captain Gromchevsky, accompanied by a German naturalist and escorted by seven Cossacks. The two players in the Great Game dined together, drank much vodka, and politely avoided disclosing their intentions. August of 1891 found Younghusband confronting a force of 30 Cossacks in the Pamirs. After more courteous dining, the fact was established that the Russians, with a force of 400 Cossacks, were annexing the region. The British made a swift response to Younghusband's report. They deposed the slippery Mir of Hunza, a small time slaver and hereditary brigand who had been negotiating with the Russians, and they secured Chitral to the north. Garrisons were established in Gilgit and Chitral. The supply base for these outposts was very distant: they had to be reached from Srinagar in the Vale of Kashmir by crossing the main Himalayan chain by the Burzil Pass that is closed by snow for much of the year (4,267m/14,000ft, map page 8). This pass and the Soji La (3,536m/11,600ft) that leads to Skardu via Kargil, were the main routes to the Karakoram taken by climbers prior to the Second World War.

The final round in the Great Game was played out once Lord Curzon became Viceroy (from 1898-1905). There was evidence of Russian influence in Tibet. To avoid Russian encirclement it was desirable to establish a buffer-state agreement with Tibet. Preliminary discussions having failed, Curzon decided to send a military mission so large and impressive that it was unlikely to be opposed. In December of 1903 it left Sikkim with Younghusband in charge. Unfortunately the Tibetan army had not read the military textbooks and did not know that they were supposed to capitulate. Their shields and chain-mail, now on display in the castle poised above Shigatse, were no match for Maxim machine-guns that fired 500 rounds per minute. Eventually a treaty concerning trade was signed in Lhasa with a Regent appointed by China, the Dalai Lama having skipped town. There was no significant trade. Russia's interest in India waned as demands for reform within Russia became stronger and German power became the dominant European problem. Squabbles about borders had to be settled in the face of impending war.

It would be inappropriate to leave the Great Game without mentioning Kipling's novel *Kim*.[76,77] Kipling began in the 1880s writing this novel about the Great Game as seen through eyes of the Lahore street urchin Kim; the setting could be somewhat earlier. Kim, discovered to be an abandoned Sahib, is recruited for training as an agent by Colonel Creighton. (Creighton may have been modeled on Montgomerie or Smyth of the Pundit surveys.) But Kim has found a wandering Tibetan Buddhist lama and chooses to be his pupil. Together they encounter Russian agents. Contrary identifications with Sahib and Lama reflect Kipling's complex identity. He thought and dreamed in Hindustani before he spoke English and his earliest memories were of Indian sights and smells. This childhood experience allowed Kipling to celebrate the great diversity of Indian life as it passed along the lifeline of the Great Trunk Road, a road that reaches from Calcutta to the Afghan border (map page 8). The lama is the central character of the novel and is portrayed with deep sympathy and admiration. He teaches Kim that there is no servant and Sahib, no black and white, only a common humanity. The American contemporary equivalent is the Mississippi journey in Mark Twain's *Huckleberry Finn*.

In this chapter I have described two contradictory activities. On the one hand there were the scientific mapmakers, explorers and naturalists who were determined to push beyond the boundaries. Their goal was to seek out difficult passes, enter new regions, and stand where no Western traveler had stood before—with or without official backing. On the other there were the boundary makers, determined to set out the limits of the Empire and make sure that foreign powers did not cross those limits. The strange fact is that the same people were often engaged in both activities.

5) The Mountaineers

At the beginning of this essay I introduced four primary emblems that shape Himalayan narratives. We have considered the high pass, the secret realm and the place where no traveler has stood before, not as separate topics but as interwoven ideas. The fourth emblem is the unclimbed summit whose ascent requires a total commitment and where the boundaries between life and death dissolve. This emblem was partially formed as Europeans confronted the Alps. The transfer of alpine experience to the Himalayas was essential for the development of Himalayan mountaineering, but the process was surprisingly slow. It took place both before and after the First World War, but the war initiated a profound change in mountaineering. Kenneth Mason in *Abode of Snow* summarized the break: "The old friendliness of the mountain brotherhood had received a shock. Men who had met among the mountains of the world had fought as enemies and had learned to hate; men's names had been expunged from the membership of Alpine Clubs. Friends had been killed or maimed, especially those in the prime of life."[78] After the First World War new strands in Himalayan mountaineering emerged that expressed very different philosophies about the relationship of the climber to society and to the mountains themselves and these philosophies changed again after the Second World War. To varying extents they were influenced by the approaches to the 'Mountain Sublime' that I discussed in the third chapter, but nationalism played a significant role. Central to the story is the changing significance placed on mountaineering deaths by the general public and by climbers themselves. I shall attempt to sketch out these developments. Mountaineering history provides a major part of the context in which we view Himalayan photographs.

5:1) From Alps to Himalaya
The Alps and the Well-Known Rules

There were few enthusiasts for alpine climbing in the seventeenth century, but by the mid eighteenth century a transformation, sometimes called the romantic rebellion, was beginning to take place throughout Europe.[79] It antedated Wordsworth and Beethoven and emphasized, not Reason but 'pathos' in the sense of committed emotion (the opposite of apathetic). The result was a tourist trade with pensions in alpine valleys and local guides ready to take visitors to known vantage points, but few besides hunters and miners climbed to high elevation. It was not until 1786 that Mont Blanc (4,807m/15,771ft), the highest mountain in the Alps, was climbed. This was a response to the offering of a prize by the pioneer observer of mountain geology and glaciers H. P. de Saussure to anyone who would show him how to reach the summit. Then came the French Revolution and

the Napoleonic wars and climbing did not gain serious momentum until about 1850. A list of first ascents year by year is provided in *The Alps in Nature and History* (1908) by the Reverend W. A. B. Coolidge, a fellow of Magdalen College, who was editor of the *Alpine Journal* from 1880-89.[80] The numbers, when graphed, show the dramatic explosion in alpine climbing. From 1800-1830 slightly less than one new peak per year was climbed. From 1830-40, about 2 per year, from 1840-55 about 45 per year, and then for the next 30 years the tally was an average of 17 new peaks per year. By 1890 about 700 summits had been climbed. After 1900 the supply of new summits had run out and the rate dropped to about 1 per year. The emphasis turned to new routes. The initial surge was the product of several factors. These included the publication of the Dufor series of alpine maps in 1845-53 and the appearance in 1843 of *Travels through the Alps of Savoy* by J. D. Forbes, a disciple of de Saussure.

The explosion was very much linked to British involvement. From 1855 onwards, British mountaineers accounted for about half of the first ascents, most of which were technically challenging. In the peak year of 1865 there were 22 British first ascents out of 43. There was, it seems, an affluent social group in England able to devote weeks, or even months, to go climbing and traveling in the Alps. Railway connections were improving. English climbers formed the Alpine Club in 1857, initially as a dining club of 34 members. By 1859 the membership was 124. Members had to be of proven experience and nominated by other members, hence it remained a small committed organization. From the composite engraving in Edward Whymper's *Scrambles Amongst the Alps* one gets the impression that the entire original club spent the summer of 1864 in Zermatt.[81] There is in the engraving a lone woman, probably Lucy Walker (1835-1916), the first woman to climb the Matterhorn (in 1871).[82] Women climbers were certainly active. Coolidge, an expatriate American, gives a glowing tribute to his aunt, Miss M. C. Brvoort, his boyhood guardian and a determined mountaineer. She may well have been the first American woman alpinist.

The creation of the British Alpine Club was followed by a cascade of club formations (all less exclusive): Austrian, 1862; Swiss and Italian, 1863; German, 1869 (amalgamated with the Austrian in 1873); French, 1874. The initial euphoria ended in 1865 with Whymper's accident on the Matterhorn. Edward Whymper's classic *Scrambles in the Alps* is in many ways the model for subsequent alpine and Himalayan mountaineering literature. It describes attempts, setbacks, and equipment. It also gives a clear picture of the symbiosis between guides and their clients. Whymper's

interest in the Matterhorn (4,478m/14,690ft) began in 1861 when he was 20 years old. In 1864 he realized that the eastern face, seen from Zermatt, is not as vertical as it seems, but a series of steps produced by the inclination of the strata (downwards towards the west.) He and six others made a first ascent on July 14, 1865 by this face. Unfortunately it was a scratch team that had been put together in Zermatt and disaster struck on the descent. Individually the seven were reasonably experienced; collectively they were not. The second on the line fell and pulled off three others. Whymper and two guides survived because they were only roped to the others by a weak line that broke. It was some years before Whymper resumed serious climbing. The English newspapers, that had been praising the achievements of the British mountaineers, now condemned them: "Is it duty? Is it common sense?" asked *The Times*.[83]

Whymper's 1871 book is an attempt to meet public criticism and give some understanding to those who found the sport of mountaineering totally unintelligible. Risks would be acceptable for the scientific ends of de Sassure and Forbes, but the Alpine Club claimed to be a sporting institution. He mentions exulting over the grandeur of the views seen only by mountaineers, but says we mountaineers "value more highly the development of manliness, the evolution, under combat with difficulties, of those noble qualities of human nature—courage, patience, endurance and fortitude." By so doing he shifts the moral debate. Mountaineering builds *character*. Any one of my age who has been through the British school system knows building character is precisely what British schools do. Lord Curzon described the North West Frontier as a "school of character". The character-building view is that taken by Outward Bound. Their motto: "To serve, to strive and not to yield." is an adaptation of the last line of Tennyson's poem *Ulysses* (to be discussed below.) Whymper's last words in the *Scrambles* are to counsel prudence: "Look well to each step; and from the beginning think what may be the end."

The above moral justification skims over the fact that both the guides and Whymper were a part of social systems that were goal-driven and reward-driven. The guides of the different valleys were very proud of their accomplishments and there was considerable recognition, and therefore an economic incentive, for making a difficult ascent. Whymper, having spent a season or so in the Alps, was an acknowledged part of the Alpine Club fraternity. A first ascent of the Matterhorn was likely to bring great prestige. After fixing on this goal he worked at improving his equipment and hired the best guides he could. When he had to give up on one approach he showed independent thinking by looking at the face everyone else had dismissed.

Although Whymper did not claim an interest in science, he was working within a goal/reward system essentially the same of that of science. In science, apprenticeship and early work establish the researcher's credential for election to a society (the club.) A major problem must be chosen; an original and elegant approach must be devised. Obsessive work may be needed to complete the critical experiments. The researcher talks and dreams about nothing else. Once the goal is attained, the club acknowledges the result by invitations to speak. Scientists, like mountaineers, have the greatest difficulty explaining to non-club members why what they do is so worthwhile. I give this anthropological argument in some detail because I think it is important when faced with behavior or beliefs hard to explain to look at the structure of social transactions and psychological rewards in which the actions or beliefs are embedded.

The Alpine-Club perspective on the Matterhorn tragedy was set out in 1866 by its President the Reverend Leslie Stephens. It appeared in Vol 2 of the *Alpine Journal*. (Stephens, a Fellow of Trinity, Cambridge, and Editor of the *Dictionary of National Biography*, is probably best known these days as the father of Virginia Woolf.) The Club doctrine is essentially that espoused by *The Mountaineers* of Seattle in their perpetually-revised *Mountaineering, The Freedom of the Hills*. Mountaineering can be acceptably safe given experience. What is needed is "prudence and skill." Stevens proposed that a set of rules for sound mountaineering should be drawn up. Club discussions referred to the Well-Known Rules, but according to George Abraham's *The Complete Mountaineer* (1907), they were mostly unwritten.[84] Abraham suggested 21 rules such as "Pay constant attention to the condition of the boots." *The Freedom of the Hills* gives 9 rules. Abraham concludes: "The danger's of mountaineering fade into insignificance before its joys and pleasures." The Alpine Club was not given to gloom. Abraham attributes to Stephens the maxim: "Don't get drunk if you have to walk along the edge of an Alpine cliff." (Rule 22?) In the period before the First World War the English death toll amongst Alpine Club members was remarkably low. The Well-Known Rules seemed to work.

A word about the Abraham brothers seems appropriate. They were photographers and mountaineers from Keswick in the English Lake District. As a boy I used to visit the family shop that still displayed their superb photographs of rock climbs and alpine snow (the shop is no more). George Abraham's book is illustrated with his own photographs, e.g., "A difficult crevasse on Mont Blanc." and "A view from the highest point of the

Matterhorn." The book also explains how alpine climbing led to the development of climbing in Great Britain. The alpinists needed places to practice and found challenging new rock climbs in the Lake District, North Wales and the Isle of Skye. Some members of the Scottish Mountaineering Club, founded in 1889, showed a perverse enthusiasm for climbing under "full conditions," i.e., on ice and rock in a blizzard.

Sportsmen and Scientists in the Himalayas

The transfer of alpine experience to the Himalayas was very slow for the obvious reason that an enormous commitment was needed to get there. A few wealthy climbers made it. W. W. Graham, then 24 years old, is usually listed as the first. In 1883, accompanied by Swiss guides, he visited the Kangchenjunga massif in Sikkim and the Nanda Devi region in the Gharwal Himalaya. He said he climbed purely for sport and adventure; as a result of this unserious attitude it has been very hard to decide what he actually ascended. In Sikkim he claimed to have climbed Kabru (7,316m/24,076ft, pages 119 and 112), but Kenneth Mason argued that Graham probably climbed a lesser peak (about 6,200m/20,340 ft.)[85]

Some of the incentive for alpine climbers to make the journey to India came from the exploits of those already there. Indian Army personnel could get recreational leave that they often used to travel or go hunting, but mountaineering was an option. Adding to this pool were doctors in medical missions and teachers in missionary schools and elite establishments such as the Doon School. In addition, there were a few enterprising wives anxious to get away from the social round of cantonment life. One Military officer showing both determination and audacity was Francis Younghusband, already introduced.[86] In 1884, as a 24-year-old lieutenant, he managed to get travel leave to visit China. He crossed Manchuria to Peking and from there returned to India by way of the Gobi desert and Yarkand. He crossed the Karakoram by first ascending the previously unvisited Scarpo Laggo Glacier and then joining the Baltoro Glacier by a hair-raising descent of the Mustagh Pass without any appropriate equipment. He was the first Westerner to see K2 from the east. He describes rounding a spur "and there suddenly came into view a sight which brought me to an immediate standstill and made me gasp with amazement. I knew not what mountain it was."[87] Younghusband was invited to London to address the Royal Geographical Society and was awarded its gold medal.

More powerful as an incentive for Himalayan mountaineering than sportsmanship and adventure was science. It was an extension of the work of the surveyors. However, the Royal Geographical Society was concerned not just with mapmaking, but with the comprehensive reporting exemplified by

the expeditions of Alexander von Humbolt to South America between 1799 and 1808 whose work had inspired Darwin. In addition to observing rivers, volcanoes and vegetation, von Humbolt made magnetic and meteorological observations and in the process more or less created the discipline of physical geography. Expeditions included surveyors and artists to paint the discovered landscapes. Topographic drawing and painting was part of the training of military engineers and surveyors. The Survey of the American West, 1870-1878, led by the geologist Ferdinand Hayden, was of this pattern. It included, in addition to mapmakers and geologists, the superb photographer William Henry Jackson. It is in this intellectual context that a number of important Himalayan expeditions should be viewed: those led by Sir Martin Conway, later Lord Conway (Karakoram 1892); Douglas Freshfield, later Sir Douglas (Kangchenjunga circuit 1899); and the Duke of Abruzzi (Karakoram 1908). I have already mentioned that Vittorio Sella was photographer on the last two. Each of these leaders was a recognized alpinist.

Before describing these expeditions I need to refer once more to the involvement of the military in Himalayan mountaineering. Lieutenant Charles G. Bruce of the Fifth Gurkha Rifles (1866-1939), later General Bruce, had recognized the potential importance of mountain troops as a result of the rock-climbing assault on the Nilt Fort in the Hunza campaign of 1891. Bruce, aiming to create such troops, worked with a small group of selected Gurkhas to learn mountaineering by doing. Their names, notably Harkabir Thapa, Goman Sigh, Ragobir and Karbir Burthoki, entered mountaineering history. They were seconded to major expeditions and on these expeditions they had the chance to learn from Swiss guides. There was an intense mutual commitment between the British and Nepalese officers in the Gurkha regiment that was not a sahib and servant relationship. Bruce had extraordinary energy and was noted for his load carrying, his gift for local languages, and his sensitivity to local customs.[88]

The Conway expedition, sponsored by the Royal Geographical Society, included Bruce, four climbing Gurkhas, several Swiss guides, an artist, a botanist and an ornithologist. Conway was a professor of art at Liverpool University. One unfortunate consequence of such massive expeditions was the social stratification that arises when there is a base of unwilling coolie labor delivered by a local headman to a military-style baggage master. The Conway expedition approached the Karakoram from the Hunza valley (the reverse of my 1994 journey; map page 9). They explored and mapped the Hispar, Biafo and Baltoro glaciers, but, curiously enough, did not approach K2. Conway, the Swiss guide Zurbiggen, Bruce and the Gurkhas Harkbir and Karbir reached a subsidiary summit (about 6,888m/22,600ft) of the 'Golden Throne' peak near Concordia. From there they made triangulation

measurements, sketched the view and took photographs. The expedition was the first to deploy base camps and high camps and use the alpine mountain tents developed by Whymper and Mummery. A careful report of the expedition's findings was published. Conway bestowed the name Snow Lake on a high level area of the Biafo Glacier and also named the prominent isolated peak that guards the end of the Snow Lake 'The Ogre' (page 23).[89]

Douglas Freshfield's circuit of Kangchenjunga in 1891 was probably self-financed and therefore smaller, but it included, beside Sella and his brother, an Indian surveyor and the geologist-climber E. J. Garwood. The account of the trip *Round Kangchenjunga* includes a long section by Garwood. Sella had come to Freshfield's attention because he had photographed in the Caucasus in 1889, 1890, and 1896 and Freshfield had been the first alpinist to explore and climb in that area. Although there was a treaty excluding travel in Nepal, Freshfield's party passed to the north of Kangchenjunga and entered Nepal from Sikkim by way of the Jonsong La (6,767m/22,000ft) and thus approached the north side of Kangchenjunga that I visited in 1998 (map page 115). Before any Nepalese official could find out, they were on their way back to Darjeeling by the easier Khang La route to the south. The expedition had as background the reports of Joseph Hooker and two Pundit surveyors, Das (1881) and Namgyal (1884).[90]

The Duke of Abruzzi falls into the same pattern as Conway and Freshfield, but he climbed in even more regions of the globe. In 1897 he was the first to climb Mount Ellias in Alaska, and this expedition was followed by trips to the Arctic and Africa. He was accompanied by Vittorio Sella to Alaska in 1897, Africa in 1906 and the Karakoram in 1909. The second in command of the 1909 Karakoram expedition was Filippo De Filippi, a physician and naturalist. There was a topographer, four Italian guides, three Italian high altitude porters and an assistant to Sella, Ermano Botta. Over 300 local porters were needed to provide food and equipment to this remote area from May to July. The expedition is mainly noted for climbing up a south-eastern spur of K2, known as the Abruzzi Ridge, which feeds into a main eastern ridge high on the mountain. They reached approximately 6,250m/20,505ft. In the photograph on page 31 the start of the route is seen to the right before it disappears into the clouds. They also reconnoitered the northeast ridge, and this approach Sella documented from Windy Gap at the head of the Glacier. A record elevation of about 7,500m/24,606ft was reached on Chogolisa, a peak at the head of the Vigne Glacier. A great deal of time was devoted to surveying. Some 37 days were spent above 16,000 feet. The Duke named a pass after Sella. As the name Sella means saddle, it seems the Duke was also making a little joke. Scientific and surveying expeditions continued to be mounted. The most ambitious was that led by

De Phillipi to the Eastern and Northern Karakoram in 1913-14. With support from Italian and British scientific societies and the Survey of India, it included experts in geophysics, geology, meteorology and a photographer.

At this point it is only right to acknowledge the totally unclassifiable activities of Fanny Bullock Workman and her husband Dr. William Workman—definitely not part of the Alpine Club crowd. They were wealthy Americans who had ridden their bicycles across North Africa and India and were inured to hardship. In 1898-9 they turned their attention to the Hispar-Biafo Glaciers in the Karakoram and mounted a large expedition with Swiss guides who, as far as I can tell, instructed them in mountaineering then and there. They aggravated Kenneth Mason, by their sloppy survey work and failure to acknowledging their predecessors—but they were unstoppable. The highest point they reached was probably 6,953m/ 22,819ft. Amongst their achievements is a photograph of Fanny at 21,000 feet on the Siachen Glacier holding a placard "Votes for Women."

One of the great figures of alpine rock climbing of the post-1870 generation was the British climber A. F. Mummery. In 1895, along with G. Hastings and Professor J. Norman Collie, he traveled to India to climb Nanga Parbat in Kashmir. Bruce supplied two Gurkhas and accompanied the party for two weeks, but could not get further leave. Mummery and Raghobir, did some challenging rock-rib climbing at about 20,000 feet with avalanches falling on either side. They camped for two nights above the rib, and then rejoined the others. The party split with Mummery and the two Gurkhas choosing to explore a shorter way down. They were probably swept away in an avalanche. The mountain was to claim many more lives. This first notable accident in Himalayan mountaineering was a great shock to the alpine community. It seemed that in the Himalayas the Well-Known Rules might not ensure survival.[91]

5:2) *Everest*

The early Everest expeditions have achieved a legendary status, molding the concept of mountaineering for later generations. Younghusband claimed that the British preoccupation with Everest derived from his 1893 conversation with Bruce on the polo ground in Chitral. Everest thereby became the symbol for all singular destinations. There was a predestined logic in this goal. The Great Trigonometric Survey had released an arrow towards the Himalayas and the mountain named after its superintendent was an obvious political target. Lord Curzon, Viceroy of India—the choreographer and principal actor in the 1903 Mughal-style Durbar in Delhi, replete with maharajas and elephants—well understood

the importance of political gestures. In 1899 Curzon began a correspondence with Freshfield about climbing Everest or Kangchenjunga. In 1905 he hinted at Government of India support and suggested Freshfield take up the idea with the Alpine Club and the Royal Geographical Society. Three interested parties were thus assembled: the political-military activists, the sportsmen and the scientists.[92]

Plans for a 1907 expedition were blocked by the Secretary of State for India on the grounds that it would violate the Anglo-Russian hands-off agreement concerning Tibet. The expedition was diverted to the Gharwal Himalaya. Dr Tom Longstaff, Karbir and two Swiss guides managed to reach the summit of Trisul (7,120m/23,360ft); the highest *undisputed* summit reached before World War I. In 1910 the Chinese decided to aggressively assert their suzerainty over Tibet and the Dalai Lama fled to India, however, by 1912 the Manchus were swept from power by the Sun Yatsen revolution, the Chinese retreated and the Dalai Lama returned. Tibet achieved, by default, an autonomy that lasted until 1950.

In the aftermath of the First World War the agreement with the Russians was no longer a factor and the Dalai Lama was inclined to be appreciative of the help received from the Indian Government. At this point the Royal Geographical Society decided it should make its own foreign policy and use public opinion to fight the India Office. As an opening salvo they promoted a lecture in March of 1919 by Major J. B. Noel who in 1913, disguised as a Muslim, had traveled to within 40 miles of Everest. The discussants included Freshfield, Younghusband (President Elect of the Royal Geographical Society), and the President of the Alpine Club. The second salvo was a widely reported speech by Younghusband. He said that climbing Everest would "elevate the human spirit." A joint Everest committee with the Alpine Club (plus a representative from the War Office) was created. The geographers favored careful science, the Alpine Club "go-for-the-top"; the opinion of the War Office is uncertain.

It was a measure of the times that the committee resolved this was going to be an all-British game. The war had killed or disabled many of the best young climbers that might have been selected; the slaughter had crushed internationalism. Not even a Swiss mapmaker would be added. Also, jingoism was good for fund raising—to climb Everest would show by a pure unambiguous symbolic act that the British were by nature intended to rule the lower races. In 1918, Younghusband, like many in high places, still believed in England's destiny to rule. By 1930 a mystical sense of destiny, that he associated with his crossing of the Mustagh Pass, led him to promote Indian independence—he wrote, "We must trust India"; but that is another story.[93]

In December of 1920 Younghusband learned from the India Office that consent for an expedition had been obtained from the Dalai Lama. A two-stage attack was planned: for 1921 a surveying reconnaissance and for 1922 a summit assault (note the military terminology.) In fact, the citadel was not taken until the eighth assault 32 years later. By 1953 the Empire had gone (India was partitioned in 1947). By fortuitous timing, and the use of coded messages, *The Times* of London was able to present Everest to Elizabeth II on the occasion of her Coronation, much as Disraeli had presented India as the Jewel in the Crown to Queen Victoria. India and Nepal, whose nationals had contributed so much to the achievement, learned about the result from London, as did the Swiss, who had pioneered the Lohtse face/South-Col route and who might have been considered to be colleagues.

The Sherpas

Before discussing the early Everest expeditions it is necessary to introduce the fourth cultural group that played an essential role in the evolution of Himalayan mountaineering, namely the Sherpas. Alexander Kellas, a Scottish physician, was chosen for the 1921 expedition because of his experience in oxygen use. Unfortunately he died of a heart attack on the way to Everest. His health had probably been compromised during the First World War when he worked with the famous biochemist, and later geneticist, J. B. S. Haldane on altitude problems and the use of oxygen in flying. Haldane and Kellas probably used themselves as experimental subjects. Kellas managed to get enough leave from his work at the Middlesex Hospital, London, to make seven journeys to India between 1907 and 1921. On these trips he was able to combine his enthusiasm for climbing in remote places with studies of the physiological effect of working at high altitude. His journeys were mainly to the Kangchenjunga region and he chose as his travel companions Darjeeling Sherpas. These he instructed in basic mountaineering technique. They were not only skillful and tough, they had a sense of humor. It was Kellas' admiration that brought Sherpas to the 1921 Everest expedition.[94]

The Solu-Khumbu Sherpas had established a presence in Darjeeling as a result of economic pressure.[95] In 1846 the powerful Rana family in Kathmandu, having reduced the Ghorka monarchy to a ceremonial status, decided they needed to build more palaces and they therefore demanded more taxes. This forced the Solu-Khumbu families to turn to Kathmandu or Darjeeling for seasonal work and trade. A census in 1901 counted 3,450 Sherpas living in Darjeeling. To avoid accepting a low-caste Hindu status they strengthened their Tibetan Buddhist identification—they wore Sherpa (Tibetan) dress, particularly the women. As Buddhists, they were not bound by caste rules about pollution or by diet restrictions. As the home villages of

the Khumbu Sherpas lie in the 1,300 meter range above Namche Bazaar (3,440m/11,286ft, page 103), they were ideally suitable for employment as porters or guides by government surveyors, travelers and mountaineers. The trader model ensured that Sherpas viewed themselves as private contractors willing to work hard. They also had an ethic of commitment. There are many instances of climbing Shepas losing their lives rather than abandon their employers. Their identity displacement from traders to mountaineers was later reinforced by the colorful garments and money acquired at the end of expeditions. The returning climbing porters became objects of awe to the young. Mountaineering success began to confer status in the Sherpa community and mountaineering was a financially liberating possibility for those trapped by family inheritance problems. After the Second World War when Nepal began to welcome visitors, the Sherpas were in the right place at the right time. Many other Bhotiya groups are employed as porters, but the Sherpas in Kathmandu and Namche Bazaar have become the dominant players in the trekking industry.

The First World War was a great social leveler in British society. Officers tended to be out in front and killed off first. Of those who survived the fighting, such as Bill Tillman, there was the knowledge that in the trenches all are equal. It is understandable therefore that Tillman in his account of the 1935 Nanda Devi ascent wrote of the Sherpas: "To be their companion was a delight; to lead them, an honour."[96] They joked about his hairy chest and called him 'the bear'.[96] However, the social structure in India, despite the emergence of the independence movement, was resistant to change and the large Everest expeditions tended to institutionalize the Indian Army sahib/servant divide and consign nearly all Sherpas to "other ranks". This caste division was at variance with their own understanding of their status as independent contractors. The Himalayan Club, founded in 1928, made the Darjeeling section responsible for listing the available Sherpa porters and they introduced the practice of awarding 'Tiger' medals to outstanding climbing Sherpas—the military mind at work—but medals did not give equality.[97] Even after World War II the military cast structure was a problem for the Darjeeling Sherpas employed by the 1953 British Everest expedition. Tenzing Norgay, by then highly experienced, was given officer status, but the stratification caused many difficulties. Tenzing had found the Swiss, with whom he climbed on Everest in 1952, fully accepting.[98] The recognition of Tenzing by Nehru made a big difference to the Sherpa community. The work of the Hillary Foundation and the Himalayan Trust in building schools and clinics has been exceedingly important. However, it is still a major problem that some expeditions are willing to piggyback on the strength of climbing Sherpas and to pressure them economically to take risks against their better judgement. Over the years several trek guides have mentioned to me that

they were helping care for the children of a brother killed in a mountaineering accident.

The 1921 Reconnaissance

The personnel of the 1921 Reconnaissance Expedition selected by the Everest Committee exemplify the four cultural components that I have been discussing.[99] The military provided the leader, Lt. Col. Charles K. Howard-Bury. Science was represented by two very tough mountain surveyors, H.T. Morshead and E.O. Wheeler; one geologist, Dr. A. M. Heron; Dr. Alexander Kellas as altitude physiologist and Dr. A. F. R. Wollaston as medical officer. The alpinist-sportsmen were: Dr. Howard Raebern, a tough lead climber used to Scottish ice (age 56); Edward Leigh Mallory (age 35), a rock climber of natural grace but with no singular accomplishment to his name; and G. H. Bullock (age 34.) Of the large group of Sherpas, a number acquired significant climbing skills. On the approach march Kellas died and Raebern was taken ill and had to return leaving Mallory as lead climber.

The major purpose of the reconnaissance was to map out this totally unknown area and look for a possible route of ascent. On the approach march everyone was troubled by the "dry, dusty, unceasing wind" that arose in late morning and scoured their faces until evening. From Darjeeling it took over a month to reach, on June 26, the isolated Rongbuk monastery, 16 miles north of Everest. At 5,029m/16,500ft it is near the physiological limit of permanent habitation. (The oxygen level is too low for the fetuses of most placental mammals to survive; the dinosaurs managed with such low levels, but they hatched from eggs.)

The expedition established that the Rongbuk Glacier has three branches: West, Main, and East. From the West Glacier Mallory and Bullock reached a col, the Lho La, on the Nepalese border and, looking east, saw for the first time the giant horseshoe of the Western Cwm. The Cwm has Everest to the northeast and the Lho-tse/Nup-tse Ridge to the south. Lho-tse (8,501m/27,923ft) is at the head of the Cwm and the South Col (7,986m/26,200ft) is between Everest and Lho-tse (nup = west, lho = south, tse = peak.) The climbers recognized from the Main Glacier that the North Col (6,990m/23,000ft), which lies between Everest and Chang-tse (chang = north), was a key to a possible ascent—but to reach it was the problem. The existence of the East Glacier was initially missed and most of the party made a wide circle to approach the North Col from the east. They had to endure monsoon storms but finally reached the Lakpa La, a pass leading to the East Rongbuk Glacier. On September 23, after a very windy night on the pass, Mallory, Bullock, and Wheeler together with two Sherpas, Ang Pasang and Lagay, crossed the East Rongbuk glacier to the site of the future Advanced

Base Camp (ABC) at about 6,400m/21,000ft and then climbed to the North Col. They were turned back from any further ascent by high winds and retraced their steps. They noted an avalanche had swept their upward route. After three months at high altitude, the entire expedition was exhausted and they headed for home.

In 2003 on my trip to the Tibetan side of Everest (map page 95) our group reached the ABC by the East Rongbuk Glacier on September 17, almost 82 years to the day after it was first visited. For us there was no wind. The morning was brilliantly clear, but, as I ascended the moraine to photograph the North Col (page 113), clouds appeared very quickly and soon they were down to the glacier. The Monsoon was not completely over—there was snow at the Base Camp a few days later.

The reconnaissance was an amazing achievement. They had been where no person had stood before. They had a map and a possible route, gained an understanding of the weather problems and rock samples had been collected. Unfortunately they did not understand the process of acclimatization, the difficulty of decision-making at high altitudes, the importance of hydration, the need for early climbing starts and the objective hazards of Himalayan avalanches.

Walt Unsworth in his outstanding history, *Everest,* comments that the expedition had changed Mallory: "for the first —and last—time in his life he had a true ambition."[100] And yet he seemed frightened by the determination that had gripped him. Mallory wrote to his climbing mentor Geoffrey Winthrop Young: "Geoffrey, at what point am I going to stop?" Young admonished him that in any future expedition he should maintain "a resolution to return, even against ambition." After the 1921 expedition, Mallory wrote: "Principles time-honoured in the Alpine Club, must of course be respected....the party must keep a margin of safety.... It is not to be a mad enterprise rashly pushed on regardless of danger."[101]

The 1922 and 1924 Expeditions

The Everest Committee moved ahead with a 1922 expedition under Brigadier General Bruce, now 56 years old. The approach to the Advanced Base Camp was by the East Rongbuk Glacier. There were five climbers including Mallory (the oldest, now 38.) They set up a Camp IV on the North Col and V at 7,772m/25,500ft. They found the downward slope of the rock formations to be dangerous. Climbers Geoffrey Bruce and George Finch reached 8,321m/27,300ft with the aid of oxygen. On the seventh of June seven Sherpa porters were killed in an avalanche while ascending to the

North Col. This brought the expedition to an end. Mallory, felt he was to blame for having misjudged the fresh snow. The monks of the Rongbuck monastery believed the mountain gods had been offended by the collection of geological samples in 1921. A mural was painted to emphasize the point, but it was destroyed, along with the rest of the monastery, by the Red Guards following the 1966 Cultural Revolution. Recently the Chinese, with an eye to the tourist industry, have allowed monks and nuns to rebuild the monastery. A hideous pink hotel has been erected and the road is being prepaired for the passage of the Olympic torch.

The British team had difficulty in understanding the silent response of the surviving Sherpas. Bruce, perhaps reflecting the Gurkha regimental philosophy, assumed that the impassive and bewildered Sherpas were "oriental fatalists." The pain of the Sherpas, however, was very real. The Tibetan Buddhist death-rituals are directed to freeing the dead from their attachment to earthly things in order that they may proceed to rebirth. If there is no separation, they may become ghosts and haunt villagers and bring about evil events. Wailing and crying only serve to bind the departed. In a normal death the body is either dismembered and fed to the gyre falcons or cremated and the ashes cast into a stream. Sky-burial places can often be seen on a hill above a village. By meditating on these acts of separation the mourners adjust to their own loss. Burial by avalanche deprives the living and the dead of this ritual resolution.[102] In contrast, the Western emphasis tends to be on the preservation of both memories and the body, with the sarcophagus a powerful cultic symbol.

The 1924 expedition led by Major Edward F. Norton (age 40) is well known for the death on June 8 of Mallory and Irvine. Leadership passed to Norton when Bruce, stricken with malaria, had to turn back. There were 8 climbers with Norton passing leadership to Mallory in the field. Andrew (Sandy) Irvine was only 21, but he had shown skill and endurance in Spitsbergen and elsewhere. On the first attempt Norton, supported by Howard Somervell (age 34, a surgeon, then a medical missionary in India), traversed into the Great Couloir and reached 8,573m/28,126ft without oxygen (page 112). This was a record until after the Second World War. For the second attempt by Mallory and Irvine, four Sherpas carried oxygen to camp VI at 8,230m/27,000ft without themselves using oxygen. Only Noel Odell, the team geologist, was left in support at Camp V. The 1999 discovery of Mallory's body allows some definitive conclusions about the 1924 events.[103] The climbers made a late start (flashlight left behind). Without using modern crampons their progress must have been slow. They were probably seen somewhere above the first step at 12:30 p.m. The rock climb on the second

step would have been an insuperable obstacle, if not on the way up then on the way down. As Kenneth Mason had argued in *Abode of Snow*, they must have turned back before the second step, somewhat lower than the height reached by Norton four days earlier. At some point later, confused as a result of dehydration and lack of oxygen, Mallory set down his ice axe and failed to pick it up. Mallory's glasses were found on his body stored in his pocket; hence it must have been dusk when, roped to Irvine, he slipped while leading the descent of the yellow band.[104]

Why was the risk taken? It is curious that people who know of the difficulty of decision-making when oxygen deprived and know that Mallory and Irving were confused enough to set off without a flashlight, still write as if they debated the issue with the rationality of climbers at a meeting of the Alpine Club. Before he went Mallory had expressed the fear it was "going to be more like a war than mountaineering. I don't expect to come back." Noel reported Norton as saying that Mallory believed he was leading a "forlorn hope." In the First-World-War context this could mean 'almost certain death'.[105] Evidently he worried about the outcome, but how did he evaluate the risk? We do not know the answer, but there are a number of factors that could have *predetermined* a high-altitude impaired decision to abandon the Well-Known Rules. Firstly, there was the commitment to adventure. Having invested three years in Everest, Mallory believed himself to be better qualified than any one else to reach the summit. He may have felt he was predestined to the task—a Sir Galahad assisted by a squire who played the role of his younger self. (Note that for the *Morte D'Arthur* a presumed relative, Malory, was the author of the adventure.) Secondly, there was remorse—he may have felt that success would vindicate the 1922 deaths of the Sherpas. Thirdly, he was a part of an exceptionally powerful mountaineering goal-reward system that was driven by the patriotic ambitions of the Committee. Younghusband later wrote: "Everest was the embodiment of the physical forces of the world. Against it he had to pit the spirit of man.... He could imagine...the credit it would bring to England....to turn back or to die, the latter was for Mallory probably the easier." [106]

This mode of heroic-nationalism surfaced in Maurice Herzog's account of his final ascent of Annapurna, without the use of supplemental oxygen, on June 3, 1950. Annapurna (8,052m/26,493ft) was the first 8,000 m peak to be climbed. His companion Lois Lachenal was worried about frostbite and asked: "If I go back what will you do?" Herzog wrote: "Must we give up? Impossible! My whole being revolted against the idea. I had made up my mind irrevocably. Today we were consecrated to an ideal, and no sacrifice was too great. I heard my voice clearly: I shall go by myself.

The reply was: Then I will follow you." Having reached the summit, Herzog dropped his gloves. He had spare socks in his pack, but such was the effect of altitude that he never thought to take them out. The descent from the summit was a near disaster and fingers and toes were lost, but miraculously the climbers did return.[107]

Howard Somerville, who was with Mallory, was not impressed by heroic nationalism. He wrote in his autobiography: "The loss of these splendid men is part of the price that has to be paid to keep alive the spirit of adventure. Without this spirit life would be a poor thing and progress impossible." [108] Geoffrey Winthrop Young, Mallory's friend, at the end of his 1927 autobiography compared the destructiveness of the bombardment at Ypres with the risks in the mountains: "The breath of the mountains is life giving and humane. Their very perils are incitements to hardihood, to sincerity, and to self-discovery. Even for those of us to whom they have brought death the mountains have first given an appreciation of life, and the knowledge of a right way of living in which the probability of death could count for but little among many higher values." [109] Eric Shipton wrote in similar terms in his 1938 essay "On the Real Value of Climbing." [110] He rejected both patriotic fervor and cheap publicity: "The ascent of Everest, like any other human endeavor, is only to be judged by the spirit in which it is attempted....the greatest value of the art of climbing with its perfect co-ordination of mind and muscle, is that it teaches man a way of living in the beauty and solitude of high and remote places." For others this was no way to think about "an issue of National and Imperial importance". [111]

Odell the last person to see the climbers emphasized the sublime vision and the transfigured hero. In an obituary he wrote: "such a vision of sublimity that it has been the lot of few mortals to behold; ...few while beholding have become merged into such a sense of transcendence." There are echoes in this of Wordsworth, but also the image of a sacred mountain. In a passage at the end of John Bunyan's *The Pilgrim's Progress* the travelers Christian and Hopeful, having crossed the river, are met by two shining ones that lead them up the hill which they ascended with much agility and speed. [112]

... the foundations upon which the City was framed was higher than the clouds; they therefore went up through the regions of the air....The talk they had with the shining ones was about the glory of the place; who told them that the beauty and the glory of it was inexpressible. There they said is Mount Sion, the Heavenly Jerusalem.

As to Everest, it was nine years before Tibet would allow another intrusion. The 1933, '35 and '36 expeditions failed to get higher than Norton in 1924, but they initiated a new generation of climbers such as Eric Shipton and Frank Smythe (in 1933 ages 25 and 33). The 1935 expedition was a low-cost reconnaissance with Shipton and Tillman that included Tenzing Norgay—19 at the time. In this period a new ideal began to emerge to challenge the quasi-military approach to major peaks. Shipton and Tillman pioneered a low-cost no-frills expedition pattern in which the leaders were also load carriers. An important success was the ascent of Nanda Devi (7,817m/25,660ft) by Tillman and Odell in 1936 on a joint British-American expedition. Charles Huston and Adams Carter were the American participants.[113]

1953 Success

In 1947 British India was partitioned and Nepal found itself neighbor to a fast changing country. The new India was intent on consolidating its rule over the princely states that had been a part of the British Raj, and it was entirely possible that it would decide to annex Nepal (Goa was incorporated in 1961, Sikkim in 1972). Nepal had a sudden need for international visibility and decided to open its borders to mountaineers. In 1949 the Swiss made a first ascent of Pyramid Peak in the Kangchenjunga area. Bill Tillman led a small group into the Langtang region in 1949 and the Manang region in 1950, then he joined the Americans Oscar Houston and his son Charles on a quick reconnaissance of the Khumbu. In 1950 the French climbed Annapurna.

The Chinese ascendancy in Tibet, beginning in late 1959, closed the northern approach to Everest.[113a] India was worried by the Chinese move and was anxious for democratic reforms in Nepal. Since 1845 the Rana family had ruled Nepal, but had preserved the Kings of the Shah dynasty as Hindu spiritual heads of state that possessed semi-divine powers. A Nepali Congress Party was formed and late in 1950 there was an armed revolt, perhaps sponsored by India, which deposed the Rana family and established the King as full monarch. The King favored mountaineering. In 1951 the British Himalayan Committee, successor to the old Everest Committee, put together a reconnaissance expedition under Shipton to examine the Western-Cwm approach to Everest. When approached from the south, the summit of Everest remains largely hidden behind Nuptse (pages 108, 109). The ascent to the Lho La was seen to be formidably difficult. The expedition identified an Everest route via the Lohtse face and the South Col, but

the continually shifting Khumbu Icefall was so dangerous that Shipton feared it would be an unacceptable route for porters.

The British soon learned the Swiss were scheduled to attempt Everest in 1952. The climbers were all outstanding and they included Tenzing Norgay in their climbing team. They made a route through the Icefall and established a series of camps. In the spring Raymond Lambert and Tenzing reached 8,598m/28,210ft. After an unsuccessful attempt in the fall, the way was open for the British. The circumstances that led to Colonel John Hunt (age 52) being the leader of the 1953 expedition instead of Eric Shipton are complicated. Some felt that Shipton did not believe in national glory enough to take the needed risks. Hunt had a clear sense of military priorities and planning—no botanists or geologists—this was a siege. He built up a huge pyramid of support to get his climbers in place on the South Col. Support climbers were prepared to assist with the evacuation of disabled lead climbers. On the first try, at times in blowing spindrift, Charles Evans, a brain surgeon, and Tom Bourdillon, a physicist, reached the south summit. The next day the weather was bad, but on the following day, 28 May, the second team, Tenzing Norgay and Edmund Hillary, reached the main summit at 11:30 am having surmounted a major difficulty since known as the Hillary step. There were no casualties. All the planning, however, had somewhat attenuated the heroic role that Mallory represented and the French claimed. Science was no longer much of an issue.[114]

The comments of Tenzing about reaching the Everest summit are important. The Westerner's emphasis was in terms of conquest—military conquest, in the name of the team and Nation, and of the self (a matter of character and example). Tenzing, however, in dictating his autobiography spoke of his Khumbu childhood, of the mountain Chomolungma which in his mother's translation was the "mountain so high no bird can fly over it." He spoke of thankfulness and love towards *Miyo-langsang-ma* the goddess of the mountain. She was a demoness who had been converted to Buddhism by Padma-sambahva. A book by Tenzing's son *Touching My Father's Soul* reproduces a paintings of the goddess who is shown with a lotus flower in the left hand and a bowl of divine fruit in the right, a symbol of inexhaustible giving. She is one of five long-life sisters residing on five Himalayan Peaks. Tenzing came, he said, "not with pride and force, not as a soldier or an enemy, but with love, as the child climbs to the lap of his mother. Now at last I have been granted success and I give thanks. *Thuji chey*—that is how we say it in Sherpa—'I am grateful.'" Only when he became a pilgrim, giving up his competitive identity, could the summit be attained.[115]

There are fourteen summits above 8,000 m and all of them were climbed in the period 1950 to 1965 with only two incidental deaths. As far as I know, no women were involved. In all, 53 climbers summited and all returned. All but one of these expeditions were large national efforts. The most remarkable was the first ascent of Nanga Parbat on July 3, 1953 by Hermann Buhl climbing alone. He acted without the approval of the expedition leader. After a 16 hour day, he bivouacked a little below the summit ridge and after a second day alone rejoined his companions.[116]

5:3) The Great Wall Climbers
The Munich Climbers and the Rise of Hitler

In the inter-war period, when military-style siege tactics were being developed in the Himalayas, changes were taking place in alpine climbing. Edmund Hillary wrote of the Everest expedition: "The competitive standards of alpine mountaineering were coming to the Himalayas, and we might as well compete or pull out." What were these standards? In part, they depended on technical innovations, but many of the innovations were directed to making possible the ascent of sheer rock walls of unimaginable difficulty.[117]

In 1908 Oscar Eckenstein, a British alpinist who had been in the Karakoram in 1892 and 1902, invented the 12 point crampon and the flat footed technique that allowed steep icy slopes to be climbed. This method caught the attention of French mountaineers who found crampons particularly appropriate to the long slopes of frozen snow in the French Alps. The 150 cm ice axes used from Whymper to Mallory were good for probing glaciers, but hopelessly inconvenient on steep ice. Eckerstein introduced an 86 cm light-weigh ice axe—70 cm or less is now standard. Such axes are not much use as walking sticks, but held in the upper hand when moving sideways on a snow slope an axe is at the right height for the shaft to be plunged into the snow. The axe thus becomes an advancing belay with the moving body always resting on two points. In a fall on a snow slope the ice axe can be used to achieve a self-arrest. The shaft is held across the chest and the body rotated to be face down. The point of the pick can then be rotated into the snow to slowly increase the friction and stop the slide. Much practice is essential—as my instructor Doug Chabot emphasized. In 1932 Laurent Grivel added two front points to the crampon and the surge to climb vertical ice began.[118]

In the 1920s many long steep snow and ice climbs were ascended in the French Alps, then about 1930 attention shifted to the Eastern Alps where there is a mixture of rock and ice. A group of Austrian and German climbers known as the Munich School emerged. They pioneered the use of pitons and carabiners (the gated rings that clip in to slings and other protection devices.) In 1931 the brothers Toni and Franz Schmidt cycled from Munich to Zermatt and climbed the north face of the Matterhorn.

The post First World War period in Germany was a time of great economic and political uncertainty. No political party had a clear majority and the National Socialist Party (the Nazi Party) and the Communists played off one against the other. The Nazi ideology drew on popular science and popular culture. Genetics and ethnology gave plausibility to the idea of a blond blue-eyed Aryan master race. Athletics, mountain climbing and the romanticism of the Bavarian Alps reinforced these ideas. Hitler's enthusiasm for his Berchtesgaden Eagle's Nest is well known. In the 1920s groups of Munich students would cycle at the weekend to the Bavarian Alps, then "full of Promethean promptings," would climb difficult routes, smoke their pipes on the summit and look down on the "valley-pigs" below. [119] An important factor in the cult was a series of "bergsteiger movies" made by Dr. Arnold Fanck, a former geologist, that combined "precipices and passion." In *Der Heliger Berg* (1927) Leni Riefenstahl, Fanck's favorite star and a former Max Reinhart dancer, performed a "Dance of the Sea." The public loved her. Riefenstahl's apprenticeship with Fanck enabled her to make her own bergsteiger movie, *"Das Blau Licht"* (1932), in which she was not only the star, but did her own unprotected stunt climbing. If Riefenstahl had only stopped there, she would be a feminist icon.

In January 1933 President Hindenberg, in an attempt to control Hitler and the Nazi party, appointed Hitler to the honorary position of Chancellor. In February the Reichstag fire and the subsequent trial created the political conditions for Hitler to become leader of a one-party state: "The Fuhrer is the Party, and the Party is the Fuhrer." Thanks to Hitler's admiration for the "Dance of the Sea," and because many film makers had fled Germany, Riefenstahl was given enormous resources to design and direct *Triumph of the Will*, a pseudo-documentary about the 1934 Party Congress in Nuremberg. The film was shown throughout Germany in schools and cinemas. People kept their ticket stubs as proof of their patriotism. The shooting script for the movie were meticulously planned as visual propaganda, by Albert Speer, Hitler and Riefenstahl, to project the Aryan ideal, the might of the State and the mythical leadership of Hitler. The photographic image I find most terrifying is the view of three minute figures—Hitler, Himmler and Lutz—in an immense plaza with symmetrical rows of

assembled storm troops and swastika banners in the distance. Later came *Olympia*, which documented the 1936 Olympic Games held in Berlin.

The climbers of the Munich school became players in the grand Teutonic design symbolized in *Triumph of the Will,* and part of that design was to climb the Eiger North Face in Switzerland. Anyone who has seen this face while drinking beer and listening to the umpah band at the Kleine Scheidegg café will realize what a terrifying sheer limestone rock wall this is (1,300 m). In 1932 two climbers died on their fifth day of ascent. In 1936 three died on the second day and the fourth died on the fifth day just out of reach of a party of guides. In 1937 two climbed part way and managed to retreat. In 1938 two Italians were killed. Finally, in July 1938 four climbers, Andeas Heckmyer, and Ludvig Vörg (both German), Friz Kasparek and Heinrich Harrer (Austrians), succeeded in a four-day climb. Harrer is best known for his book *Seven Years in Tibet*.[120]

The Eiger climb and the *Triumph of the Will* raise similar problems. Harrer claimed to be a patriotic German but not a Nazi.[121] He only put on the SS uniform in order to get married. Heckmyer, a professional guide, worked in the Nazi "Strength through Joy" movement and was a friend of Riefenstahl. He had met Hitler twice before the climb and all four of the Eiger climbers afterwards were given secure jobs at the SS training barracks. The motives of the climbers and Leni Riefenstahl are difficult to reconstruct. Riefenstahl said: "Art and politics are two different things and one has nothing to do with the other." Her chief cameraman on *"Das Blau Licht",* Henry Jaworsky, said she was an obsessed artist who would have made movies for Stalin or Roosevelt. Janet Maslin in the *New York Times* wrote: it is plausible "that even while exalting Nazi ideals with breathtaking skill...this pioneering film maker was able to live and work in a self created vacuum."[122] It is possible that some of the Munich climbers with whom Riefenstahl associated lived within the envelopes of a goal-driven system without much reference to the outside world. Some German scientists may have made similar adjustments. I find this almost more frightening than the belief they accepted the Nazi ideology.

Although the Nazi ideology is no longer an issue, the Eiger North Face has changed mountaineering in two ways: it has set a standard of difficulty and it has raised the level of acceptable risk for aspiring elite climbers. Lionel Terray and Lois Lachenal, both members of the 1950 French Annapurna Expedition, made the second ascent of the Eiger in 1947. In 1962 a Swiss party of two men and two women made a strong attempt but were forced to retreat by appalling weather, but in 1964 a woman did com-

plete the ascent. Many well known mountaineers have succeeded, but even with improved strategies there has been a steady death toll from the climb.[123]

Post Second World War Climbing

The reaction of the British establishment to the Munich School in the 1930s was far from tolerant. These were the climbers who had clear memories of the slaughter of the Western Front. Geoffrey Winthrop Young had lost a leg in the war, but continued to climb. In a preface to Eric Shipton's *Upon That Mountain* he contrasted "the frantic feats of young Fascists and Nazis" with Shipton's "sense of the humour, the beauty, the deeper, harder values of life lived under natural conditions."[124] But the older generation had simply ignored the new techniques. Climbers of the post Second World War generation such as Chris Bonnington, Doug Scott, Joe Taskar, Peter Bordman and Joe Brown, brought up on the crags of Northern England, accepted the challenge. There were technical advances: nylon ropes, climbing helmets, and rubber soled boots; later came plastic boots, short ice axes with curved picks and handier types of crampons. The climbers absorbed the idea of carrying food and fuel for several days and progressing by way of bivouacs—sometimes with a light tent, sometimes with a snow cave, and sometimes just crouching in a huddle with feet and boots in rucksacks and each person belayed. Initially the ascent of the Eiger North Face required about five days of such exposure, but later climbers rethought the strategy. In 1974 Reinholdt Messner and Peter Habeler reduced the Eiger time to ten hours by careful training. They were past the region of falling stones before the sun could reach the upper crags and start a rock cascade.[125]

The lessons learned on the alpine routes opened the way to pushing new and more challenging routes in the Himalaya. Climbers were approaching the mountains with new eyes. The small mobile-party alpine approach began to replace the siege methods. In 1978 Reinhold Messner and Peter Habeler following the southern route, made the first ascent of Everest without oxygen, thus satisfying the ideal of many old timers such as Tillman.[126] Messner, however, had even greater ambitions. In 1980 he made a solo ascent of Everest from the North during the monsoon. On August 17 he departed from the Advanced Base Camp, collected his 20 kilo pack below the North Col and ascended for a while the standard route to the ridge. After an overnight camp, he traversing to the Great Couloir (page 112, below summit), camped again and then climbed upward until he could break out onto rock to the right. He reached the summit at 3 pm on the nineteenth, having left all but essentials below, then returned to his bivi-tent and next day, more or less on automatic pilot, descended to the East Rongbuck Glacier.[127] In 1995 the British woman climber Allison Hargreaves, who in

1988 had climbed the Eiger North Face, essentially duplicated Messner's ascent (solo and without the use of supplemental oxygen).[128]

The first two examples that follow were selected because they relate to some of my photographs and illustrate the modern approaches of elite climbers to Himalayan mountaineering: The Ogre, 1977 (first ascent, no supplemental oxygen) and Kangchenjunga, 1979 (third ascent, but the first from the north and the first without oxygen).

The Karakoram Ogre (7,285m/23,903ft) is an isolated granite peak with three summits: West, Main, and East. In my 1994 photograph (page 23), taken from ten miles away, the West Summit obscures the others. Immediately in front of the West Summit is the Western Col that can be reached from the glacier in the adjacent valley. Toward the end of June 1977 Chris Bonnington and Nick Estcourt climbed to below the Col and then ascended the West Summit by the South West Ridge (in profile in the photograph). At this point they ran out of fuel and food and returned to their advance base camp. Bonnington and Doug Scott, with support from Clive Rowland and Mo Anthonine, made a second attempt in early July and they all reached the West Summit from the Col. Bonnington and Scott then skirted the ridge and on July 13 climbed the rock wall of the main peak. As part of the climb, a pendulum swing was made by Scott to find another crack when the crack he was following ran out. Near the start of the evening decent Scott swung out of control and broke both legs at the ankles. They were able to bivouac on a tiny ledge—no tent, no down clothing, no food or water. Next day they reached their previous snow cave and help. The further descent was complicated by running out of food, descent in a storm, and by Bonnington falling and breaking several ribs. All survived.[129]

Kangchenjunga (8,597m/28,208ft) was first climbed from the south in 1955 by a British group led by Charles Evans (page 121).[130] In the 1979 ascent the party consisted of Georges Bettembourg, Pete Bordman, Doug Scott and Joe Tasker, assisted by Ang Phurba and Nima Tenzing. My 1998 photograph, taken from their base camp Pangpema (5,150m/16,896ft), page 127, shows over 3,300 meters of vertical climbing ascent. The triangular rock shoulder on the left forms part of a horseshoe basin. Behind the ridge is a 1,200 meter near-vertical rock wall. This wall was climbable and relatively safe from falling ice. Once a fixed rope had been installed, supplies could be ferried to a tent set up on the far side (lee side) of the North Col (6,858m/22,500ft). Having installed the fixed ropes, all four retreated to Pangpema to rest. Tasker on returning to the Col developed altitude problems and descended. The remaining three established a snow cave at

7,468m/24,500ft—up the ridge just below the rock formation they called the Castle. They climbed the Castle, putting in fixed ropes, crossed the snow plateau to the right and camped over the ridge beyond a small notch. Winds of 120 mph demolished their tent in the night; they returned to Pangpema. On the third climb all four established a higher snow cave below the crescent shaped rock formation (in photograph: in the shadow and to the right of center), but they then retreated to the Col because of bad weather. Bettembourge descended, but the other three returned to the higher snow cave and from there managed to reach the main summit. They all returned safely.[131]

Both of these expeditions were small. Rock-wall climbing was the only option. The cycles of ascent and retreat greatly helped acclimatization. By preparing the way for the final ascent, the debilitating time at high altitude was minimized and the need to carry oxygen eliminated. Climbing Sherpas helped on Kangchenjunga, but they were used only in the relatively safe jobs of ferrying supplies to the North Col after the fixed ropes were established.

The prelude to this essay by Doug Chabot gives a first-hand account of contemporary alpine-style climbing. The training for the climb was an achievement in itself. In 2004 at the end of June, a group of six climbers set up a base camp at 4,200m/13,779ft in the Charakusa valley to the east of Hushe, not far from the route to the Gondogoro La that I took in 2001. From there they divided up and made a series of ascents.[132] Amongst these Doug Chabot and Bruce Miller climbed the sharp peak of K7 (6,934m/22,749ft) by way of a dangerous gully and a series of granite turrets with names like the Fortress—this 300 meter little-big-wall was climbed via rock and an ice chimney. They reached the summit on the afternoon of the third day and made the base camp on the fourth (July 24-28). Their route followed, with variations, a Japanese route that 20 years earlier had taken 40 days. They carried one tent, three dinners, three fuel canisters and a limited rack of climbing aids. At the same time Steve House, following a simpler route, reached the summit at 7:45 am after a 27 hour climb and was back at the base camp at 42 hours after leaving, having had one brief nap along the way. They then moved to the Nanga Parbat area. Steve House and Bruce Miller climbed the Direct Rupal Face of Nanga Parbat to 7,500 meters at which point Steve House began to have respiratory problems (August 12-17). Doug Chabot and Steve Swenson climbed the Mazeno Ridge (August 12-18).

The major new factor in the postwar mountaineering picture is the

emergence of elite climbers who play by self-chosen rules, yet are dominated by the concept of style. Many are full-time athletes committed to intense training and to a life of mountain activities such as competitive skiing or commercial guiding.[133] This is very different from the collection of real professors, schoolteachers, medical doctors, geologists, and ministers of religion that were so prominent in the early alpine tradition. The elite take serious risks well beyond those normal in sports, but are not driven by the issues of national prestige and the need for fame in the normal sense. They establish speed records on known routes, or they pioneer new difficult routs on already climbed peaks, or they seek out challenging unclimbed peaks. The large scientific expeditions and the big jingoistic siege-style peak assaults seem to be things of the past.

Commercial guiding has more or less swamped some routes. Many have found such guiding very troubling. W. H. Murray, a pioneer in Scottish mountaineering and deputy leader of the 1951 Everest Reconnaissance, held that the Everest success "was the most damaging to mountains and to real mountaineering that there has ever been." [134] Instead of seeking adventure by exploring new mountains and new challenging routes, climbers who are content to be ferried to standard summits place at risk both themselves and their Sherpa guides and litter the landscape with the equipment they abandon. Jon Krakauer after the 1996 Everest disaster expressed similar views in *Into Thin Air*.[135] But these are the actions of lesser mortals; it is the elite climbers, for good or ill, who we reward with iconic status. They are the central figures in the imaginative realm of high passes and ice-carved peaks.

6) A Matter of Life & Death

In the last 50 years it has become increasingly evident that following the Well-Known Rules in the Himalayas is a poor guarantee of a safe return. The hazards are not peripheral but intrinsic to Himalayan climbing. This fact underlies all Himalayan narratives and is implied in all Himalayan photographs. It accounts for the public response to Jon Krakauer's *Into Thin Air*. There are unavoidable objective dangers that can wipe out the most experienced climbers: avalanches, hidden crevasses, exceptional cold, intense winds and interminable storms. There are also subjective dangers arising from the limits of human physiology.

For Everest between 1921-1988 one person died on the mountain for every 6.6 that reached the summit. Of those that actually reached the summit of K2, roughly one in seven have died on the descent.[136] From 1954-94 the survival rate per attempt on K2 has been calculated to be 96%, i.e., one in 25 of those leaving the base camp do not return. Certain years have been particularly disastrous: 1986 on K2 and 1996 on Everest, however, the overall fatality rate per climber attempt on the 8,000 m peaks has decreased significantly as the number of attempts has increased. A Sherpa may decide to climb for 4 years in order to get enough money to start a trekking lodge. With each climb he survives his chance of making it to the end improves. The problem with elite climbers is that they keep on trying more dangerous routes. With a previously unknown route the chances of disaster become

particularly high. Pete Bordman and Joe Tasker, two exceptionally experienced British climbers mentioned above, died May 17, 1982 on the North-East Ridge of Everest (page 113). They were making an alpine style attempt without oxygen and probably died on the second ridge pinnacle (about 8,200 m).[137]

The limits of human physiology can convert a difficult situation into a disaster. In 1953 Art Gilkie was a young geologist who had just completed his PhD dissertation. He was part of the second United States K2 expedition lead by Charles Huston (the first was in 1938.) On August 7 at Camp VIII (7,620m/25,500ft) on the Abruzzi Ridge, Gilkie was disabled by blood clots in his left leg. It was decided to lower him down the mountain wrapped up in a sleeping bag and tent, but a severe storm delayed the start for three days. On the first day of descent an accident nearly carried everyone away. While the group was reassembling, Gilkie was swept away in an avalanche. Storms continued and it took five days for the others to reach the base camp.[138]

Before the expedition left, a memorial cairn was built on a tall rock outcrop at the junction of the Savoia and Godwin-Austen Glaciers, a little way from the base camp. The most painful part of climbing up to this cairn is the assembled collections of memorials to other climbers; some well known, some obscure. The names are of many nationalities. Some names are

carved in stone; others are stamped into an expedition plate with the point of an ice axe. Many visitors have left small tokens in tribute to climbers that have been their inspiration, particularly such women climbers as Julie Tullis, who died on the descent in 1986, and Allison Hargreaves, who was blown away in 1995, the same year she made the Everest solo ascent. Such memorials are a reminder that the Puja ceremony that is usually performed by the Sherpas and climbers in Nepal and Tibet before entering a climbing area is not just a quaint folk custom; it is a means of confronting the dangers ahead and accepting personal commitment.

All persons must confront death sooner or later; the confrontation by elite climbers becomes emblematic of that reality. What sort of role identifications lead to the acceptance of such risks by climbers, their families and friends? By what sort of interior dialog do climbers approach these risks?

6:1) The Eternal Quest

Historically the strongest role identification is that of the quest hero determined to seek out the unknown. Such heroes are by no means confined to mountaineering: Albert Einstein, Marie Curie, Michael Faraday and Louis Pasteur were major heroes of my childhood; Darwin certainly should have qualified but he made the mistake of growing an enormous beard. As a musical ideal, we encounter the heroic quest in a sequence of Beethoven compositions from the *Eroica* symphony (1803-4) to the *Hammerklavier* sonata (1817).[139] Tennyson defined the quest in his 1842 poem *Ulysses*. The poem was based on a passage in the *Inferno* in which Virgil introduces Dante to the Greek wanderer. Ulysses declares:

> I am a part of all that I have met;
> Yet all experience is an arch where thro'
> Gleams that untravell'd world, whose margin fades
> Forever and forever when I move.

He challenges his old comrades to make one last voyage beyond the western isles;
> To follow knowledge like a striking star,
> Beyond the utmost bound of human thought.

Tennyson's poem, that links science and exploration, was familiar to many climbers and explorers. In 1905 Roald Amundsen was honored by The Royal Geographic Society because he had just succeeded in completing the

Northwest Passage through the Canadian arctic. After his lecture the citation was delivered by the arctic explorer Fridtjof Nansen, who was then Ambassador to England from the newly independent Norway.[140] He concluded with the poems final lines:

> That which we are, we are;
> One equal temper of heroic hearts,
> Made weak by time and fate, but strong in will
> To strive, to seek, to find, and not to yield.

This theme is in keeping with the words of Somervell that I cited in connection with the death of Mallory and Irvine. It clearly helped shaped such climbers as Tillman and Shipton, who were always looking for new territory to explore. Shipton used the 'untravell'd world' quotation as an epigraph to *Blank on the Map*.[141]

The second role identification is that of the hero who defines national identity—resolute, if need be, in the face of death. Scott of the Antarctic portrayed the role for England, Nansen for Norway. In the USA one can point to Charles Lindbergh, the first to fly the Atlantic alone and to Neil Armstrong and Edwin Aldrin, the first to walk on the moon. This ideal influenced the Everest Committee, and therefore Mallory, and it shaped Hertzog's decision to make a do-or-die attempt on Annapurna.

The third role is that of the warrior. It is in keeping with the language of reconnaissance, assault and conquest. War both justifies taking risks and leads to an acceptance of death. Concerning his 1930 Kangchenjunga assault, Herman Bauer, the Munich climber, wrote of the "stern warlike disciplined spirit...a circle of men who have become one to death."[142] One can speculate that it influenced Hermann Buhl in his astonishing solo ascent of Nanga Parbat in 1953. The ideal of the heroic warrior only makes obvious sense when nationalism is the enveloping cause. But the warrior may be driven by personal anger even in a political context. Social and individual anger played a role in the rise of Hitler and anger could have influenced the daring of the Munich climbers. It is true that the Wrath of Achilles has no place on a mountain where judgment is always needed, but there are plenty of climbers with a reputation for brawling who seem to sober up once on the mountain; the anger becomes channeled. It is as hard to know to what extent the drive of anger can shape skill and determination—for mountaineers as for surgeons.

Many climbers have explicitly denied the warrior definition. I quoted Tenzing Norgay and Eric Shipton above. Chris Bonningto discussing his

1977 K2 expedition and the decision of one team member to return home wrote: "I would not have tried to dissuade him and I certainly wasn't angry. We weren't fighting a war. We were playing a game, admittedly a very serious one and it must be up to the individual to decide whether he wants to go on or not and the level of risk he wants to accept". Tillman, a veteran of the Somme in World War I and the Western Desert and the Dolomites in World War II, wrote that mountaineering is "Not war, but a form of amusement whose saner devotees are not willing to be killed rather than accept defeat." [143] Much of the talk about Serious Games by mountaineers goes back to a 1967 essay by Lito Tejada-Flores in which he described climbing as a "hierarchy of climbing-games, each defined by a set of rules and an appropriate field of play." With-or-without oxygen provides one simple division. [144] The Serious-Games language has a wider context in the use of Game Theory in the social sciences. To say one is a player in a Serious Game seems to be an attempt to extend the Well-Known Rules to Himalayan levels of risk. It is not a roll definition that can have much resonance outside the sports community—I do not think the term Serious Game describes the *essential* characteristics of science or landscape photography, though both have rules of conduct—but it clearly has meaning to contemporary mountaineers.

The fifth role is that of the seeker engaging in a symbolic struggle to place the self in an eternal frame. Requiring a total commitment is an analog of unconditional love. It is not itself love, although people talk about the love of mountains, but an analog. Climbers roped together place an absolute trust in each other. Mountaineering is a way of life that preserves an ideal of trust and dependence essential for society. The climber says, in effect: "What defines me as a person is that I am an elite mountaineer engaged in a symbolic struggle. I take risks. I have accepted a challenge." Wives and husbands say: "The person I married is defined by this symbolic struggle. This is his, or her, core identity." [145] The wider context of the struggle justifies the risks. A painful burden falls on the mountaineering community similar, in some ways, to that accepted by fishermen, police, firefighters and the military. These communities have created elaborate rituals to validate the death of their members. The Bonnington passage cited immediately precedes an account of his friend Nick Estcourt being swept away by an avalanche. Bonnington then quotes another climber: "At this level of mountaineering it was like being prematurely aged with so many of one's friends and contemporaries dying around one". [146] There is the sense that sooner or later one of your climbing partners, or you yourself, will be eliminated, but the anticipation does not make the loss of a friend any easier when it happens.

Those outside the climbing community may be unable to understand such decisions. And yet, the idea of 'core identity' is widely applicable. Many of my scientist friends say: "I cannot imagine myself doing anything else." Poets tend to say that they write poetry not by choice but by necessity, and photographers sometimes make the same type of affirmation. Climbing may be compared to a religious vocation. At Marpha in the Kali Gandaki Valley a proud layperson at a Buddhist festival I attended pointed out the small retreat cell on a cliff face that had recently been vacated by a local Lama after a year of meditation. If as a 'way of life' you choose to enter a Tibetan Buddhist monastery and, after staying the course for some years, retire to a cell or hermitage for a customary year of solitary meditation, there are many that would question your sanity. As a Buddhist devoted to the buddhisatva ideal you would understand your retreat as an act of compassion towards the whole community.

When faced by such strange behavior we may invoke a basic right to cultural autonomy and personal autonomy. The right applies to the mountaineering culture and to the Tibetan Buddhist culture. Such a right is not absolute; it does not preclude moral criticism or legislative control, but it may be presumed, much like the presumption of innocence. It is particularly difficult to accept for parents with respect to their children. We have an obligation to suspend judgement. But why speak of obligations; let us celebrate way-of-life choices as an essential part of human diversity, just as Kipling celebrated the procession of life along the Great Trunk Road. We see life from our own accidental corner. The elite climber and the Lama challenge us to accept new perspectives and to consider radical departures from our status quo.

6:2) The Interior Dialog and the Mountain Sublime

The 'Way of Life' definition assumes an interior dialog in which the climber examines the choices made. I spent an evening some years ago in New Hampshire talking with a physician who was there to practice ice climbing in preparation for a Himalayan trip. He was asking many questions: I know the statistics; why am I driven to take these risks? I am no sportsman out to win a competition. What do I, in fact, achieve? What is my moral justification?

Any discussion of such matters is difficult because the climber must often cite unique experiences that have few analogies to normal life. For example, Doug Scott, with reference to the 1975 first ascent of the South-

West face of Everest with Dougal Haston, writes about a curious out of body sensation where part of his mind gave him advice over his left shoulder. They observed the sunset from the summit for nearly an hour before making a snow-hole bivouac. Scott writes about "the calm prescience that all will be well; climbing up beyond suffering, fear and ego." Climbers often cite the simplicity and integrity of the world that has been entered. Anatoli Boukreev wrote in 1995 after climbing Everest: "Earthly compassion, / Conscious comprehending / Strength overcoming / Mindfulness discerning good and evil. / Live fully life at one with the earth."[147]

The above examples are both like and unlike Wordsworth's Snowden experience. It therefore seems worthwhile to reexamine Wordsworth's general affirmative approach that relates adult responses to Nature to the experiences of infancy. Wordsworth saw the "first-born affinities," the basic-trust relationship of infancy, as underlying his fuller understanding of his role as a poet and his relationship to Nature. The process of establishing the self begins in the mother's arms.[148] In addition to basic trust there is astonishment. Astonishment is part of the primal relationship; it is part of the bond between life and joy, and it becomes a part of the response to the Mountain Sublime. Wordsworth's short lyric that contains the line: "The child is father of the man" begins "My heart leaps up when I / Behold a rainbow in the sky: / So it was when life began." His hope is that this experience will continue until old age and death. Astonishment is part of the joy of being a scientist or a photographer. It is the experience of the mathematician in encountering an original proof. It is also the encounter of Dante with Beatrice. It is more basic than Burke's curiosity, and yet it is linked to curiosity and the desire to reach out in search of the unknown. It is part of the process by which the child begins to establish its own identity apart from its mother.[149] When I photographed the Snow Lake I kept saying to myself, I cannot believe I am seeing this. The climber, or photographer, who frames his activities in terms of astonishment is engaged in a dialog with the self as both child and adult.

But infancy passes through stages, and Wordsworth may have only partially grasped the process. Can his basic idea be extended? Some years ago I was discussing with a psychotherapist friend a photograph I had taken of a dramatic rock wall—Clyde Peak in the Minarets Range of the California Sierra. In trying to indicate the emotions I thought the photograph should convey I noted that the climber, on the one hand, knows that protection has been placed and that his body is secure against the wall, on the other, feels the sheer terror of the void beneath. My friend responded: It seems to me you are describing the emotions every baby feels, clinging to its mother, positioned between absolute trust and a fall into abandonment and isolation.

(Babies are born with an astonishing reflex to cling for sheer life to anything they can grasp and an instinct to cry if abandoned.) Of course, I have no memory of such infant emotions, but I do have a grasping response to rock walls that urges me to take their photographs. Again, the climber's, or photographer's, dialog with the self involves both the child and the adult. It is a reasonable hypothesis that the sense of the Mountain Sublime, in which beauty and absolute trust shades into fear, is rooted in such childhood experience. Wordsworth's descent from the Simplon Pass and ascent of Snowdon seem to draw on terror, astonishment and finally basic trust. All of these are grounded in experiences of the first three years of life.

The experiences cited by Doug Scott as making the "most profound impression" include astonishment at the view from the summit and a sense of basic trust. There is much in common between Scott's account and the response of Tenzing Norgay on climbing Everest cited above. Tenzing's Buddhist culture led him to explicitly relate his Everest experience to the security of his childhood relationship to his mother by reference to the goddess of the mountain.

6:3) The Centrality of Risk

The Wordsworth derived theory, which attempts to ground the inner dialog of mountaineers (and mountain photographers) in terms of infancy, is partially successful. It has some empirical justification. Provided we keep to the Well-Known Rules the theory seems to work. In the older mountaineering literature there is a shifting balance between awe, astonishment and joy. But we are concerned with elite Himalayan climbers—not just awe, but violent death must be considered. The encounter with death is central to elite mountaineering. Although the Terror of the French Revolution was part of Wordsworth's narrative and he was concerned with the death of friends, he does not claim to have taken deliberate risks. Should his theory be extended to pay attention to stages beyond early infancy in order to consider more fully the conflicts inherent in the taking of major risks?

Mountaineers frequently write of discovering or defining the self in the face of great hazards. Their quest seems to imply a stage of psychological development in which the establishment of a full adult identity involves isolation and a violent struggle before selfhood is reached. A model is provided by Greek tragedy in which struggles take place between parents, children and siblings. Maynard Solomon in his biography of Beethoven links this conflict model to Beethoven's preoccupation with the heroic.[150] A mountaineer's

attempt to deal with symbolic transgressions could account for the death risks taken—ascent leads to absolution. It is worthwhile to look again at the struggle to achieve full autonomy in the context of the Mountain Sublime in which beauty and terror coexist. If a search for catharsis were driving extreme mountaineering, one would expect to find in the literature encoded references to separation and release from guilt, although the code might be hard break. There is, of course, a serious danger in following this psychoanalytic line that the result will be pure fiction, but the issue of risk taking by elite mountaineers remains a problem, whether we follow this approach or not.

In examining the centrality of risk I will cite two climbers: Reinhold Messner and Joe Simpson. Reinhold Messner's brother Gunther was swept away by an avalanche in 1970 while they were descending the Damier flank of Nanga Parbat.[151] Messner described the event as being his own death, but he continued to climb. Later he described his sense of loss when his wife left him; a sense of "Black Loneliness." "It came to me that....life in high places was an end in itself. I thought of the soothing White Loneliness of the Big Walls, and I didn't just find consolation, I found a door to freedom." In much of his climbing it is as if he deliberately set out to discard the Well-Known Rules, and yet he has vigorously rejected the triumph-of-the-will attitude of the Munich climbers. In his ascent of the Eiger North Face and his solo ascent without oxygen of Everest by the Great Couloir there was a conscious throwing away of security. The last part of the Everest climb was made with the absolute minimum of equipment (as was Buhl's ascent of Nanga Parbat). This increased the chance of success, but also increased the vulnerability. By the rules of this game neither retreat nor error is allowed. Terror is not so much overcome as ignored.

Joe Simpson has perceptively discussed his survival experiences in *This Game of Ghosts,* an autobiography that is, in part, reflections upon the events described in *Touching the Void* (now a documentary-style movie).[152] Joe Simpson and Simon Yeats climbed the Siula Grande in Peru. The ascent itself had involved going beyond the point at which retreat was possible. (When a route offers no retreat the term used is 'commitment.' Elsewhere Simpson quotes Caesar's remark on crossing the Rubicon: *Alea jacta est.* The die is cast.) On the descent Simpson's knee and ankle were shattered in a fall. He had to be lowered by his climbing partner, rope length by rope length. Eventually Yeats' stance while lowering began to give way and he was forced to cut the rope, thus breaking a basic taboo of climbing—being roped together is an umbilical chord of ultimate commitment. Simpson was given up for lost, but, remarkably, he escaped from the crevasse into which he fell

and by sheer dogged persistence crawled down the glacier and stony moraine to the camp. Again and again he set himself a distance to be covered, however painful the progress and however hopeless it seemed. Of his slow recovery he wrote: "Even when I persuaded myself I would never climb again, I couldn't get rid of the feeling that I had once been somewhere ethereally beautiful, seen an intangible world I wanted to see again." This beauty is in some way connected to living in the pure existential moment of total responsibility and total freedom. "As the climber edges along the fragile line between the world of life and death, peering cautiously into the other side, it is as if he were immortal, neither alive nor actually dead." Maximum risk can lead to maximum gain.

In these examples the inner dialog of the climbers is set out with remarkable honesty. Simpson's writing is exceptional in a tradition that has generated many fine writers. These words by elite climbers are not translatable into Wordsworth's Snowdon experience. There may be more resonance with the Sinai narrative where sacrifice, the possibility of death and the overcoming of death are integral to the story and the unknowable unapproachable parental god is implied. Messner and Simpson seem to be constructing an "imaginative form" of the elite climber, not in terms of one who seeks the Sublime, although ethereal beauty is mentioned, but in terms of one who achieves existential freedom and thereby encounters a new form of the Sublime. In this freedom the bonds not only of childhood dependence, but also of societal dependence have been fully broken. If I understand Joe Simpson correctly, he claims that there is congruence between the language of elite climbing and the existential language of moral discourse. This is an entirely new argument and it has importance beyond the interests of a few climbers. Simpson quotes Jean-Paul Sartre to the effect that existentialism is an "ethic of action and self commitment." The individual poised between life and death echo's Sartre's edge between Being and Nothingness. Simpson writes about the climber taking the entire responsibility for his own existence.

Existential Choice

This is as far as I am able to extend Wordsworth's argument and link childhood with adult autonomy and the Mountain Sublime. I wish, however, to explore further the idea of existential responsibility. For me such language echoes back to my university years after World War II when the nuclear threat was just beginning to be recognized and the Cold War doctrine of Mutual Assured Destruction (MAD) was on the horizon. *Dr. Strangelove* was still in the future (1964). Existentialism had tried to redefine the self as a moral agent. It evolved as a way to handle the problem

of action in a chaotic world. A major context for this thinking had been the rise of Hitler when the State demanded obedience and religion acquiesced or spoke with a divided voice. How should one act when the action considered is in opposition to both parental precepts and the norms of society?

The United States faced an issue of existential responsibility in December 1955 when Rosa Parks was arrested in Montgomery Alabama for defying the law by sitting in the whites-only part of a bus. Thus began the Montgomery bus boycott—the Greensboro, North Carolina, sit-ins started in 1960, the freedom rides in 1961. In December of 1959 a college friend of my wife phoned us in New York to say that he and several students from the Boston Seminary were on the way South for Christmas and would visit Martin Luther King's church in Montgomery on the way. Would we like to join them? Being young and radically inclined we at once said yes. It was a long drive. As we had a black student with us, stopping for food was a problem once we got to the segregated South. After the Sunday Service in Montgomery we were entertained to dinner by Dr King and his wife. I was sitting next to him at dinner and thus I was able to ask the question: How do you decide to act in the face of uncertainty about the consequences and when the act may not only endanger your life and that of your family, but that of many young people with less experience and more to loose? It was not a hypothetical question—there were bullet holes in the house. Most people spend much of their lives trying to avoid having to make choices that probe the boundary between life and death.[153]

The concept of the existential moment of complete responsibility is usually traced back to the Danish philosopher Søren Kierkegaard (1813-1855), though other authors could be cited. He was concerned with actions and choices made by individuals, not collectives. The really important choices in life are made for complex reasons with moral rules only part of the picture. Immanuel Kant (1724-1804) had argued that the individual acts morally if he or she can will that the maxim followed should become a universal moral law. Emphasis is placed on the responsibility of the individual to make this choice, to discern the 'categorical imperative'. Kantian derived arguments continue to be very influential in discussing human rights, toleration and cultural pluralism, but these are matters for rational discussion and the law. How do we act when flags are being waved and when the cry of the family and tribe is revenge, honor, faith, glory, loyalty, freedom?

An alternative to systematic ethics is systematic indirection using stories and parables. Their function is to awaken the reader, not to find immutable principles. (The same could be said of many New Testament parables.) Kierkegaard's essay *Fear and Trembling* (1843) is an entry into the sacred and forbidden territory that defines matters of life and death.[154, 155] He borrows a story of intensely conflicting family duties and obligations from the Bible that is of the same realm as Greek tragedy; for example Agamemnon's sacrifice of Iphigenia. The story concerns Abraham, a journey and a mountain and it is told not by Kierkegaard, but through a fictional writer Johannes de Silentio who claims not to understand the story and therefore tries retelling it in multiple ways. My concern here is to use the story, not analyze the alternative arguments given by Johannes. My approach is one part Kierkegaard, one part Dostoevsky and one part Game Theory.[156]

Abraham, the God-driven Aramean, the hero of faith who had, at God's command, left his Chaldean homeland and tribe and journeyed to Palestine, sets out on a second journey. To God he owes allegiance as to a senior tribal member. He sets out to sacrifice, at God's command, his son Isaac—to offer him as a burnt offering on a mountain in the land of Moriah. He journeys for three days to this barren mountain in the wilderness to the east of the Jordan River. He set out to transgress the self-evident moral order in which a father protects his child—to destroy the child of promise given as an unbelievable joke to his wife Sarah in her old age. To slaughter Isaac would be to destroy his very self as father of a nation—to deny as progenitor of the tribe the commitment to the tribe that underlies the moral order. To slaughter Isaac, whose name signifies 'he laughs', would be to assume God has chosen to destroy the very possibility of laughter. Before the slaughter of Isaac he must first be bound, hence the story in the Jewish liturgy is known as the binding, *Akedah*. Abraham set out without telling Sarah or Isaac of his intention. He acted in the name of some undefendable belief without any explanation from God as to why the sacrifice was required. Like Oedipus, he was caught in a tragic drama not of his own making.

Johannes de Silentio declares Abraham to be a figure of horror: we should approach him "with the *horror religiosus*, as Israel approached Mount Sinai." Knowing that an angel provided a ram caught in a thicket as a substitute offering does not diminish the horror of Abraham's potential act. In this story is presented the ancient fear that if there is purpose and a moral order in the universe, it may not be perceptible to human understanding. In this place of radical uncertainty, how should Abraham have acted, indeed, how exactly did he act? What action is possible that goes not depend on tribal obligation? He acted in faith, but a faith, in Kierkegaard's words, that accepts 'objective uncertainty' and "remains out upon the deep over seventy thousand fathoms of water."[157] The prelude to sacrifice is part of our visual heritage: Rembrandt portrayed the anguished Abraham, who is shielding the

eyes of Isaac with his left hand, at the moment when the angel's right hand seizes Abraham's right hand. This is intervention, not a request. The knife is released. The light falls, as if through mountain clouds, upon the raised hand of the angel, the joined hands of the angel and Abraham, the face of Abraham and the prostrate body of the bound Isaac.

The story has a certain resonance with our previous discussion: *Horror religiosus* more or less describes the reaction of Winthrop-Young and Mason to the Munich climbers. Can the Akedah story be retold in the mountaineering context? The story sets Abraham between two absolute loyalties: loyalty to God versus loyalty to the moral law of the tribe against filicide. Both are categorical imperatives. If Abraham decides that loyalty to God overrides his ethical feelings, his love for Isaac, he looses Isaac and probably destroys himself by guilt. We know only too well that this type of absolute duty can leads to suicide bombers and, if we equate God with the State, to Nuremberg rallies. In the process Abraham sacrifices both his moral sense and his intellect. If he refuses pointblank, he looses God, who so far has been trustworthy; Isaac's future as the patriarch of a nation is placed in question. In the aftermath the isolation and guilt may consume both Abraham and Isaac.

Must Abraham choose between obedience and blank refusal? Let us postulate he chooses to shame God by walking silently day after day towards Mt Moria, as instructed, until he makes the final ascent in fear and trembling knowing that there must be a final confrontation, a final refusal. Alternatively, as implied by a commentary in the third century Mishna, he argues with God, day after day, mile after mile, appealing to God's true compassion and righteousness.[158] In either case Abraham accepts that the family relationship with God is one of *mutual responsibility*. The outcome is not clear. Abraham is no longer bound by the old obligation to the tribal god. He choses a strategy of maximum risk for maximum gain. His intentions could go terribly wrong; he could loose the sense of his own autonomy along the way and simply follow the supposed divine will. One of the poems written by Wilfred Owen before he was killed on the Western Front in The First World War retells the story. In *The Parable of the Old Man and the Young* the angel calls Abraham to spare his son and "Offer the Ram of Pride instead. // But the old man would not so, but slew his son, / And half the seed of Europe, one by one."

What then could have been God's intention? Was it indeed a test of Abraham's faith? Let us postulate that God's greatest desire is for Abraham to understand his adulthood and differentiation from the tribe—his total

freedom and total responsibility. But this autonomy must be experienced, it *cannot* be implanted by moral exhortation. Saying "Stand up, accept responsibility" does not suffice. In order to learn, like Petrarch, he must climb the mountain: Abraham must come to the boundary between life and death in the context of a real struggle and real uncertainty. In this reading, elite mountaineering, by following a strategy of maximum risk for maximum gain, becomes a parable about our moral existence.

The Voices Never Heard

By rights this should be the end of the story. The claim that elite mountaineering serves as a parable about moral choice can be allowed to interact with the other interpretations that argue that mountaineering is not just a matter of personal gratification or military conquest, but a way of life that confers benefits on society at large. The photographer who chooses to record the great Himalayan peaks provides a route by which others may enter into this dialog about the Mountain Sublime.

There remains, however, a major disjunction in the interpretation of mountaineering that I have presented. On the one hand there is the basic trust of our first–born affinities, and on the other the emphasis on an encounter in which the father may play a secret role. It is the difference between Snowden and either Sinai or Turner's vortex. The photographer stands with the shepherd as a free man living with Nature, though still exposed to the season's hazards, or with the elite mountaineer engaged in a moral struggle to which the entire person is committed. In our Western culture childhood nurturing may have led us to place emphasis, not on basic trust, but on the juxtaposition of beauty and terror that generates awe. The terrible danger of this is that in the struggle towards adulthood, the later layer of development will lead to a rejection—a blindness towards our first-born affinities that are "the bond of union between life and joy." Can the Mountain Sublime, through shock of circumstance, enable us to reexamine our core identity? In brooding about this rejection, I returned to the story of Abraham and Isaac that is so deeply imbedded in our Western culture and listened for the voices that are never heard. I shall not retell the story, but I shall make a small addition to what has already been said.

Had not Sarah laughed at God? Had she not laughed in joy as she held Isaac and marveled at his beauty? Had she not rejoiced in astonishment at this new world of possibilities? The God of the great deserts, struggling with the will of Abraham, had not been looking or hearing. Abraham intent on understanding his duty towards God and to Isaac had not been looking or hearing. In the intensity of their confrontation they had not looked to see

the ripples in the sand or the movement in the dry grass of the wilderness and had not heard the sound of the laughter of Sarah that carried from the snows of the mountains of Lebanon to the emptiness of salt. In the place of radical uncertainty, the end of the journey, shall we find the freedom and compassion to hear this laughter?

This essay has been concerned with a journey of the imagination; a meta-journey that draws together the experiences of many Himalayan trails. It is a necessary journey rooted in a childhood desire to reach beyond constraints, to cross boundaries and see the land beyond the horizon. But this land, these mountains, cannot be possessed—the solitary wanderer is scarcely given tolerance. Both beauty and the finality of death are together confronted.

7) THE CAMERA & THE JOURNEY

What of the camera? Does the view camera constrain or reveal? The photographer encountering the Himalayas finds that the subject matter is bafflingly different, the light is too intense, no clouds relieve the harshness of the sky; the equipment is heavy, the toes hurt, acclimatization is slow, the risks are significant and dust gets in the film holders. Such challenges serve to remind the photographer that the camera is an instrument dedicated to that which is seen—not that which one would like to see or that which is relayed by authority. In this it is linked to a scientific tradition of precision, actuality and the primacy of experiment that led the Royal Society to adopt as its motto words derived from the Latin poet Horace: "I am not bound to swear allegiance to any master...."[159] This affirmation of the observed, the actual, this affirmation of quiddity, is echoed in Mallory's oft-quoted reason for climbing Everest: "Because it is there."[160] Part of what is there is an emotional reality. The combination of fact and emotion is fundamental to Ruskin's experience in Fontainebleau that I related under the heading *The Geologist Eye*: "At last the tree was there, and everything that I had thought before about trees, nowhere."

But, as we explore the actuality of the journey, there comes the slow understanding that not only things matter (rocks, leaves, mountains), but individuals matter—their endurance matters. The Pakistani girl in a remote Karakoram village who seeks knowledge, though no school is available, matters, not just to Greg Mortenson, but in a fundamental way to us all. Individuals matter—*in all their peculiarity*. This is a principle repeatedly denied in the real world. In the real world we shun autonomy and appeal to the Sovereign to define individual identity and grant individual rights. The Sovereign may be the State, the Tribe, the God, History, or the Cause. The principle that individuals matter, their autonomy matters, is not in itself an ethical system, but it is a chord thrown across the chasm to which the stronger cables of love and compassion may be attached.

The actuality recorded in the photographs has led me to explore a number of diverse yet entangled themes that include science, history, poetry and faith. Part of this exploration has been the encounter with another culture, that of Himalayan Buddhism. To try and understand a remote pre-scientific culture requires cutting away the assured base from which the traveler views the world. I have tried to suspend questions of truth and belief and simply to look—as if I were focusing the camera—asking only how things fit together. Occasionally there are small openings and connections that form an entrance to this invisible world of custom and commitments. I think often of the occasion in 1986 when my wife and I were taken by our Sherpa guide to a house in Manang where a group of mothers were sitting around singing and clapping their hands while a little girl in a long traditional dress danced by making hand gestures. I remember the smiles on the mother's faces and the seriousness of the girl. Some years later I followed a small boy walking along the trail making the same sort of gestures and realized he also was dancing as he sang to himself.

The life of the Himalayan villager, as encountered by the photographer, is linked to the idea of the sacred mountain and thus to the Mountain Sublime that is also an integral part of the mountaineering tradition. The linkage is through the village chorten and through the monasteries—Shey in Inner Dolpo that faces the Crystal Mountain, Braga from where one can hear the rumble of avalanches on the Manang glacier, Tyangboche below the austere pinnacle of Ama Dablam, and the Rongbuck Monastery in Tibet that guards access to Everest.

Exploring ideas of the Mountain Sublime, lead to Sinai, and from there to a confrontation with the language of science (Sections 3:5). Poets and prophets have identified God as the maker of landscapes. They have claimed to find in the wilderness a Divine Presence, have spoken of the

encounter with the Sublime, with God, with Presences of Nature and with the Spirit of the Mountains. And yet, from the time of Samuel Bourne onwards, the Himalayan photographer has been in an ambiguous position— there is both a representation of the Sublime and exact documentation. The scientifically observed universe, by the consistency of its structure, appears to provide no room for language about the forbidden sacred or divine intervention as traditionally understood (i.e., as actuality, not metaphor.)

If divine intervention is scientifically problematical, what can be said about the conviction that there is a link between the structure of the natural world and the existence of a universal moral order? Philosophers, theologians and poets have argued for such a linkage, but the actuality encountered by the Himalayan photographer includes not only the magnificence of the scenery, but the geological record. The vast span of geological time revealed and the understanding of the evolutionary record, initiated by the study of fossils and developed by a vast array of genetic evidence, have undermined such notions. There was not much acceptable morality to be abstracted in the nineteenth century from the Malthusian struggle termed Natural Selection—no clearly discernable moral signature. That difficulty has not changed.

Faced with these shards of broken pottery, what validity has our experience of the Mountain Sublime? It is intrinsic to our world of finite human relationships that we live with myths, symbols, emblems and memory. For the photographer, as distinct from the scientist or theologian, the encounter is with the *symbolic actuality* of our human response to the mountains. The response is, in itself, a complex narrative. The photographer, as he or she composes the photograph on the ground glass screen or struggles to print the image, may experiences awe, terror or transcendent beauty. Alternatively there may be an overwhelming sense of abandonment, the conviction that the world is without assured moral values. To proceed furtherwe must consider again our basic human condition.

I have turned to Wordsworth as a guide because he grounds his experience of Nature in the basic trust that is our first-born joy and wisdom. It is established by face-to-face encounter. It creates our childhood sense of identity and is the ground of empathy, compassion and forgiveness. To recognize this trust is an irreducible human need. Trust implies the existence of at least one other being—a 'thou' who cannot be manipulated as an object amongst objects. When individual trust is destroyed, as for Lear in the death of Ophelia, we can only howl. When the bonds of society are systematically destroyed we can only cry: How can this be? As at the beginning of the Book of Lamentations: "How lonely sits the city that once was full of people." How can this be?

But our primate origins confine trust and empathy to the family and the tribe. If we accept this heritage we are forever lost. Wordsworth transcended the conflicts of sects and factions in the drama of Snowdon, but let us consider also the steady gaze of the view camera. A photograph hangs on my wall of a dock worker in Havana, taken by Walker Evans in 1936. The face looks back at me as if I were looking into a mirror. Identification takes place, though neither head shape nor skin color resembles mine. The basic trust of infancy and the mystery of adoption is transiently recreated across the boundary of race and culture.

Such experiences of trust and identity can be our guide when we approach stories about the Sacred and Divine. For the Tibetan Buddhist the fundamental dialog of infancy extends to the Guru and then to the tutelary deity, and from that encounter to a higher existence; in the Judeo-Christian tradition it can lead to a passionate dialog with God, as with Saint Augustine. But sadly, each of us can enumerate a long catalog of terrible actions against clan outsiders by the devout. The Dalai Lama has spoken against devotion to the Tantric clan guardian Shugden, even though devotion may leads to convincing visions, because it does not lead to compassion. In a familiar parable the Good Samaritan—an outsider, a schismatic—shows compassion towards a man, of no known religious affiliation, who has been attacked by thieves. A priest and a Levite, concerned with ritual purity, pass by. They fail the test.[161]

The experience of Wordsworth that our first-borne affinities are linked to the Mountain Sublime closely parallels that of Tenzing Norgay, a Tibetan Buddhist, on Everest. But for this photographer, as for most mountaineers, the Himalayan encounter is more complex. Himalayan photographs derive much of their emotional power from the specific dramas associated with the challenges of exploration and the dangers of the great peaks. Elite climbers, alone or in small mutually-committed groups, have risked and lost their lives in order to find new routes of ascent or stand where no person has stood before. The levels of risk imply a moral calculus peculiar to mountaineers: their choices are linked to the claim that mountains provide a unique experience—call it beauty, joy, terror, awe—that points beyond our reasonable world and takes us to the boundary between life and death.

In considering the risks taken by elite climbers, we must consider the further process of separation and individuation, which echoes the challenges

of infancy, but leads to adult autonomy. The relationship to the parents is challenged; there may be violent opposition or affirmation. The conflict can be seen as the underlying theme of the heroic quest. Mountaineers have spoken of realizing their true identity in the quest to discover the unknown. These symbolic dramas have meaning for the greater society. The conflict leading to adulthood, however, can be linked to the symbolic recreation of hidden violence implied in sacrificial rituals. In discussing the father/son encounter of the Abraham-Isaac story, I suggested the silence about the mother implied a cultural repression of our first-born joy and wisdom. I do not find this repression in the mountaineering tradition which places emphasis on the absolute trust implied in the use of the climbing rope. At its best, elite mountaineering presents an integration of both child and adult.

Elite mountaineering provide us with a second symbolic drama. It defines our moral autonomy in terms of existential commitment. I understand this existential freedom as primarily a willingness to exist apart from the tribe, even though it is the tribe that, to a major extent, creates and defines our lives. There are times when society desperately needs people who will stand alone, who will say in the public forum, regardless of the potential cost, that certain actions are morally unacceptable. (I note particularly the use of torture in the name of security and freedom.) Mountaineering is about making such gut-wrenching commitments.[162]

But such analyses must not replace experience by theory—they must not cut down the Mountain Sublime to manageable proportions and thus deny its most important characteristic, namely that it is absolute and irreducible. In the mountaineering quest we cross the uncertain boundary between emblem and actuality. For the photographer to represent the irreducible nature of the experience is an almost unbridgeable challenge.

Let us return to our quest narrative. There are trials of fear and abandonment, but there are often loyal companions and sustaining gifts. The camera, like music, is such a sustaining gift. It can carry us forward when the way seems uncertain and words about belief are entangled briers that choke the path of progress. The camera can help us face the condition of radical uncertainty that is a necessary condition of adulthood. Above all, it allows for astonishment. If we in the journey can recover our first-born astonishment, much else can follow. Here is an admonition from a Lake District gravestone:

> The wonder of the world,
> The beauty and power,
> The shape of things,
> Their colors, lights and shades,
> These I saw,
> Look ye also while life lasts.

NOTES

1. John Bunyan, *The Pilgrim's Progress* (Final eleventh edition, London, 1688, See www.books.google.com: (New York: Harvard Classics 15, Collier, 1909) 22.

2. Sir Thomas Malory, *Morte D' Arthur* (Caxton version, 1485). Edited by Ernest Rhys (London: Mudie's Select Library. ca 1900). Ch XVI. *The Book of the Achievement of the Holy Grail*. Section XIII.

3. Maxwell, J.C., Editor, *William Wordsworth, The Prelude, a Parallel Text* (New Haven, CT: Yale University Press, 1971). Jonathan Wordsworth, Meyer Howard Abrams and Stephen Charles Gill, Editors, *William Wordsworth, The Prelude, 1799, 1805, 1850; A Norton Critical Edition* (New York and London: Norton, l979). *The Prelude* exists only as a work in progress with a final version (completed in 1839) published just after Wordsworth's death in1850. The earliest two-part version of 1799 is concerned with childhood and youth. A five part version of 1804, which contains the Simplon Pass and the Snowdon units, was expanded into the full version of 1805. As the 1850 version tends to be most readily available, I cite that version rather than the 1805 version. In these paragraphs the line citations are Part VI, 635-6; VII, 628; X, 631-3 and X, 13-15. In presenting the Snowdon unit, discussed in Section 3.3, Wordsworth has taken poetic liberties with chronology. Snowden was climbed in the summer of 1793; *before* he encountered the Terror in Paris in early October of 1793 not after, as its place in the poem seems to imply. It would appear, that, as with the Simplon Pass episode, the poetic understanding of the Snowdon ascent came later than the event itself. For chronology and the circumstances of composition see Adam Sisman, *The Friendship; Wordsworth and Coleridge* (New York: Viking Penguin, 2007).

4. Peter Matthiessen, *The Snow Leopard* (New York: Viking Penguin, 1978).

5. The Sherpas have been the subject of many ethnographic studies, e.g., Sherry Ortner, *High Religion, A Cultural and Political History of Sherpa Buddhism* (Princeton NJ: Princeton Univ. Press, 1989). Christof Von Furer-Haimensdorf, *Himalayan Traders* (London: Murray, 1975). James F.Fischer, *Sherpas: Reflections on Change in Himalayan Nepal* (Berkley CA: Univ. California Press, 1990). Barbara Brower, *Sherpas of Khumbu: People, Livestock and Landscape* (Oxford: Oxford Univ. Press, 1991).

6. David Snellgrove and Hugh Richardson, *A Cultural History of Tibet* (First edition, 1957). Reprint (Boston MA: Shambhala, 1997). David Snellgrove, *Buddhist Himalaya* (First edition: Oxford: Cassirer,1957). Reprint (Katmandu, Nepal, Himalayan Booksellers, 1995.) David Snellgrove, *Himalayan Pilgrimage* (Boston: Shambhala, 1989). David Snellgrove, *Four Lamas of Dolpo* (London: Bruno Cassirer, 1967). Reprint (Kathmandu: Himalayan Booksellers, 1992).

7. There is an enormous literature on the history of Buddhism; for a short summary see: Roy C. Amore and Julia Ching. *Buddhism* in *World Religions; Eastern Traditions.* Ed. Willard G. Oxtoby (Toronto: Oxford Univ. Press, 1997), Ch. 4.

8. In historical and religious studies it is now customary to write BCE in stead of BC and CE in place of AD: respectively, Before the Common Era and Common Era.

9. From the reign of Ashoka (273-232 BCE) to the 9th century CE Buddhism prospered in India, but the changing fortunes of the merchant class and the emergence of various Hindu movements led to a decline in which popular Buddhism became just another Hindu sect. Successive Muslim invasions destroyed Buddhist centers. In 1193 the Turkish Muslim invader Qutb-ud-Din captured Delhi and one of his generals went on to destroy the large Buddhist university and library at Nalanda in Bihar. Further destruction extended into Bengal. Hinduism proved to be more resilient.

10. James Hilton, *Lost Horizon* (London: Gross and Dunlop, 1933).

11. Edwin Bernbaum, *The Way of Shambhala* (Boston & London: Shambhala, 2001). The idea of Shambhala is found in the teachings of the Theosophy movement invented by Madam Helena Petrovna Blavatski (1831-1891). She was much given to creative autobiography and claimed to be in astral contact with a secret brotherhood of Tibetan masters that live in Shambhala. Followers of Blavatski have had a considerable influence in presenting Tibetan Buddhism to the West. Donald S.Lopez, Jr. *Prisoners of Shangri La, Tibetan Buddhism and the West* (Chicago, IL: Univ. Chicago Press, 1998), Ch 7. Peter Washington, *Madam Blavatski's Baboon* (First edition 1993). Reprint (New York: Schocken books, 1995).

12. Eric Valli and Diane Sommers, *Dolpo, Hidden Land of the Himalayas* (New York: Aperture, 1987).

13. The different sects reflect the fact that Buddhism entered Tibet by four main routes. The sect names end with –pa which means 'people of' or 'person of'. 1) The origin of the *Nyingma-pa* is given in the main text. 2) The *Kagyu-pa* derive from Naropa of Nepal who instructed Marpa (1012-1096) the famous translator of Sanskrit texts into Tibetan. Naropa and Marpa are two of the 84 great yogins associated with the Indian Tantric tradition. Marpa's disciple was the ascetic song writer Milarepa (1040-1123). The Kagyu sect split into the *Karma-pa,* the *Drug-pa* and two other sects, each following a different teacher. The Karma-pa were important at the Mongol court of Kublai Khan, the Drug-pa in Ladakh. 3) The *Sakya-pa* derive from the Tibetan Brog-mi (992-1074) who studied in Nepal with the magician Santipa in India. 4) The *Gelug-pa* derived from Atisa (982-1054) of Bengal, the most famous teacher of his time. There is much interdependence. The Dalai Lama in his teaching has drawn on all of these traditions, including *The Heart Essence of Great Perfection* of the Nyngma-pa, attributed to Padma-sambahva. *Dzogchen* (Ithaca, NY: Snow Lion, 2000).

14. Snellgrove, *Buddhist Himalaya,* 213. Lopez, *Prisoners,* Ch 4.

15. Snellgrove, *Himalayan Pilgrimage.* Snellgrove, *Four Lamas of Dolpo.*

16. Snellgrove, *Himalayan Pilgrimage,* 213. The local name is given as Drakar.

17. Lopez, *Prisoners,* Ch 7, 189-196.

18. Stan Mumford, *Himalayan Dialogue* (Madison WI: Univ. of Wisconsin Press, 1989). Reprint (Kathmandu: Tiwari's Pilgrims Book House, 1990). Mumford considers that the ethnology of religion is best understood as both a dialog between competing cultural traditions and a dialog within the self between different identities. Appendix B gives a Shugden blood-curdling Tantric text.

19. Mumford, *Himalayan Dialogue,* Ch 3. Contest, 52; Cave, 75.

20. Milarepa, *The Life of Milarepa.* Translation by Lobsang P. Lhalungpa of Tibetan original (New York: Arkana Penguin, 1977).

21. The demarcation of scientific knowledge is an important philosophical question. In the nineteen thirties Karl Popper defined such knowledge as a progression towards more inclusive theories. A theory must survive in a struggle to meet testable predictions. The prediction may be a simple yes or no, or statistical. Hypotheses that cannot be tested are not science, although they may sound like science, hence the exclusion of astrology. His views have been widely influential as they relate to the day to day experience of the research scientist who struggles to design experiments that will truly test a prediction. Karl Popper, *Unending Quest: An Intellectual Autobiography* (London: Routledge/Taylor & Francis, 2002), Ch 16: Theory of Knowledge.

22. The clinic at Khunde in the Khumbu region run by the *Himalayan Trust* demonstrates the enormous benefits derivable from a relatively modest expenditure.

23. Helena Norberg-Hodge, *Ancient Futures: Learning from Ladakh* (New Delhi, India: Oxford Univ. Press, 1991). The author is an advocate, in the Tolstoyan mold, of the virtues of traditional Tibetan society.

24. Ted Goebel, "The Missing Years for Modern Humans." *Science* 315 (2007): 194.

25. Robert Hewison, *John Ruskin, the Argument of the Eye* (Princeton NJ: Princeton Univ. Press, 1976). Fontainebleau experience (next par.), 41, my italics. Tim Hilton, *John Ruskin, The Early Years: 1819-1859* (New Haven CT: Yale Univ. Press, 1985), 53 (Newdigate prize).

26. John Ruskin, *Modern Painters.* Vol 1 (London: Smith Elder and Co., 1843). (Vol II, 1846; III, 1856; IV, ?; V, 1860). Second Edition, Reprint I-V (London: George Allen, 1906).

27. Ruskin, *Modern Painters,* V, Ch XIV, par 18.

28. William Wordsworth, *Lyrical Ballads.* Editions 1-4 (1798-1805). Preface to Second Edition (1800).

29. Quoted in Darwin's notebook 529. Sandra Herbert, *Charles Darwin, Geologist* (Ithaca, NY: Cornell Univ. Press, 2005), 136.

30. Wendy D. Watson, "Picturing the Sublime: the Photographs of Vittorio Sella," 125-140. In Paul Kallmes, Wendy D. Watson et al.. *Summit: Vittorio Sella; Mountaineer and Photographer; The Years 1879-1909* (New York: Aperture, 1999).

31. Douglas Freshfield, *Round Kangchenjunga* (London, 1903). Reprint (Kathmandu: Ratha Pustak Bhandar, 1979).

32. Edmund Burke, *A Philosophical Inquiry into the Origin of our Ideas of the Sublime and the Beautiful.* First published 1757. Ed. James T. Boulton. (South Bend, IN: Univ. of Notre Dame Press, 1958). The quoted passage is in Bk I, VII.

33. Andrew Wilton, *J. M. W. Turner, his Art and Life* (Seccacuse, NJ: Poplar Books, 1979). Slavers, 207; Snow Storm off Harwich, 228; Goldau, 241. James Hamilton, *Turner, The Late Seascapes* (New Haven, CT: Yale Univ. Press; and Willamstown, MA: Clark Institute, 2003). Ch2, 139-140. Rockets and Blue Light, Fig 27; Slave Ship, Fig 28; Goldau, Fig 43. Ruskin, *Modern Painters,* Vol. I, Pt. 2, Sec. 5, par. 39-40.

34. This is a theme taken up by the Jesuit poet Gerrard Manley Hopkins. In the poem "No worst, there is none." he writes: "O the mind has mountains; cliffs of fall / Frightful, sheer, no man fathomed. Hold them cheap / May who ne'er hung there."

35. Garry Wills, *Saint Augustine's Memory* (New York: Viking, 2002). The passage cited from the *Confessions* is in Book 10, III, 15. Augustine argues that the existence of the human self requires both consciousness and memory.

36. Jacob Burckhardt, *The Civilization of the Renaissance in Italy*. Translation by S. G. C. Middlemore of 1860 original. (London: Penguin Classics, 2004). Part IV, 194-5. Francis Petrarch, *The Ascent of Mount Ventoux.. Family Letters*. Book IV, letter 1 of 1336. (Tr. from Latin.) in: James Harvey Robinson, *Francis Petrarch, The First Modern Scholar and Man of Letters*. Ed. and Trans. (New York: Putnam, 1898). www.history.hanover.edu.

37. Wordsworth, *Prelude*. 1799/1850 versions. Was it for this: Part I, 1-5/ Part I, 269-275. Infant babe: Part II, 268-273/ Part II, 236-9. First-born affinities: Part I, 387-390/ Part I, 555-559. Spots of time: Part I, 288/ Part XII, 208. Auxiliary light.: Part II, 417-9, 422-3/ Part II, 360-370, 273-4. Ascent Snowdon: 1850 only: Part XIV,50-86. Shepherd: 1850 only: Part VIII, 223-285. Stolen boat: Part I, 81-129/ Part I, 357-400.

38. Richard E. Brantley, *Wordsworth's "Natural Methodism"* (New Haven, CT: Yale Univ. Press, 1975). John Newton, like William Cowper, the hymn writer, and William Wilberforce, the campaigner against slavery, were evangelical Anglicans whose outlook was similar to that of many Dissenters or semi-dissenters such as the Methodists. The most obvious common element between these groups and Wordsworth is the sense of being *called*. Prophet and poet had similar job descriptions.

39. Edward Rothestein, *Emblems of Mind* (New York: Random House, 1995). For the Coleridge influence on *Tinern Abbey* see Sissman, *The Friendship*, 218, 249

40. John Milton, *Paradise Lost* (1667) Book III.

41. Immanuel Kant, *The Critique of Judgement* (German Original, 1790). Translation with analytical index: James Creed Meredith (Oxford: Oxford Univ. Press, 1952), Section 25, Definition of the Term "Sublime." For the original definition of the Pathetic Fallacy, see Ruskin, *Modern Painters,* III, Ch XII, 161.

42. This and the following paragraph derive from: Paula Fredriksen, *Jesus of Nazareth, King of the Jews. A Jewish Life and the Emergence of Christianity* (New York: Knopf, 1999) and E. P. Sanders, *The Historical Figure of Jesus* (London: Allen Lane-Penguin, 1993). Fredricksen and Sanders are scholars who approach historical reconstruction as historians who have to rely on documents that often conflict (the Bible, Josephus, Philo).

43. Louis Jacobs, "The Problem of the Akedah in Jewish Thought" in *Kierkegaard's Fear and Trembling: Critical Appraisals,* Ed. Robert L. Perkins (Tuscaloosa, AL: Univ. Alabama Press, 1981), Ch 1, p 8.

44. In the gospel of John the crucifixion of Jesus coincides with the slaughter of the Passover lambs in the Temple. In the other three gospels it takes place on the day after the slaughter when the Passover meal occurs. (Sanders, *Figure of Jesus*, 312.) From the point of view of the Roman administration Jesus was not crucified for his ethical teaching, but as a revolutionary preaching a restoration of Israel in which all twelve tribes would be gathered (there were 12 disciples.) Pilate, for some reason, decided to kill only the leader and let the disciples escape. It seems highly probable that the Jesus community thought the blood of the sacrificed lambs was essential protection for the escape from bondage at the time of old Exodus and therefore that the same pattern applied to the death of Jesus and the new Exodus. Such typology is a basic thought process of the New Testament writers. The members of the Jesus movement seem to have believed they shared in the identity of Jesus and thus in the sacrificial death and the resurrection. The New Testament also presents other views of the death in terms of Temple worship, most notably the scapegoat ritual on the Day of Atonement. It is outside the scope of this essay, which is concerned with the Mountain Sublime, to discuss how the death of Jesus might be approached in terms that seem less archaic yet retain the idea of a transformation from a temple-centered ethic to a universal ethic. In twentieth century terms, *forsakenness* seems more relevant than animal sacrifice.

45. Mario Livio, *The Equation That Couldn't Be Solved. How Mathematical Genius Discovered the Language of Symmetry* (New York: Simon & Schuster, 2005), 198.

46. John Locke, *An Essay Concerning Human Understanding* (London, 1768.) See www.books.google.com: 29th Edition (London: Tegg, 1841) Bk 4, Ch 17 "Of Reason," para 24, p 508. Quoted by David A. Palin in "A Hermeneutical Problem before Kierkegaard" in *Kierkegaard* symposium, Ed Perkins (1981), Ch 2, 22.

47. Livio, p 198. The important Scottish-Enlightenment philosopher David Hume (1711-76) in the introduction to his 1757 skeptical "Enquiry" *The Natural History of Religion* wrote: "The whole frame of nature bespeaks an intelligent author." However, he did not argue that nature implies a *moral* intelligence. See www.books.google.com. *Four Dissertations* (London, Millar, 1757) p 1.

48. Beethoven's 1820 Conversation Book. Maynard Solomon, *Late Beethoven: Music, Thought, Imagination* (Berkley, CA: Univ. California Press, 2003).

49. Garry Wills, *Inventing America; Jefferson's Declaration of Independence* (New York: Haughton Mifflin, 1978). Freeman J. Dyson, "A New Newton". *New York Rev. Books,* 50 (July 3, 2003): 11. Jefferson's draft was even more radical: he *derives* the rights "inherent and unalienable" from the *truth* of man being created "equal & independent."

50. Martin J.S. Rudwick, *Bursting the Limits of Time: The Reconstruction of Geohistory in the Age of Reason* (Chicago, IL: Univ. Chicago Press, 2005).

51. Charles Lyell, *Principles of Geology* (London: 1830-33). Condensed and introduced by James A. Secord (London: Penguin, 1997). The quotations about Hutton are taken from Lyell. Rudwick in *Bursting the Limits* considers Lyell's view of Hutton with suspicion and emphasizes Hutton's Deism and commitment to large philosophical schemes.

52. Simon Winchester, *The Map that Changed the World; William Smith and the Birth of Modern Geology* (New York: Harper Collins, 2001). Stephen Jay Gould, "The Man Who Set the Clock Back," *New York Rev. Books,* 48 (Oct 4, 2001): 51.

53. Sandra Herbert, *Charles Darwin, Geologist* (Ithaca, NY: Cornell Univ. Press, 2005).

54. Voltaire in *Candide* had made the same point about the 1755 Lisbon earthquake.

55. Common ground was established between many geologists and scholars who studied the bible as a complex ancient text. Some geologists (the Catastrophists) clung to the idea of an ancient flood as an explanatory factor, but the case had to be made on the evidence, not by an appeal to the story of Noah. See Herbert, *Darwin, Geologist*, 192-6.

56. The ethical norm built into out primate nature by Natural Selection seems to be altruism within the clan group, especially towards immediate kin, and destruction of the males of rival groups. Robert Boyd, "The Puzzle of Human Sociality." *Science* 314 (2006): 1555. Caroline Ash, "Otherness—When Killing is Easy," *Science* 315 (2007): 601.

57. Studies of neural processing and biochemical intervention indicate that mental events are correlates of physical events. Moral decisions involve the interaction of distinct brain areas. We carry around with us empathetic neural constructs of close family and friends—the mirroring maintained by dialog. Dialog with others is an essential part of our sense of a narrative-based identity (see note 149.) The neurology of a subjective dialog with God concerning love and forgiveness would be expected to show a similar signature to that of a mental dialog with family and friends. But God is a secondary issue. The basic philosophical problem is to justify our common-sense view, the ground of all moral discourse, that subjective experience and personhood belong to a reality that is not reducible to biochemistry and neural codes.

58. John Sexton, *Quiet Light: Fifteen Years of Photographs* (Boston: Bullfinch Press; Little, Brown and Co., 1990).

59. Randal Keynes, *Darwin, His Daughter & Human Evolution* (NewYork: Riverhead/Penguine/Putnam, 2001), 309.

60. Hewison, *Argument of the Eye*, 122.

61. Arthur Ollman, *Samuel Bourne, Images of India* (Untitled 33) (Carmel, CA: Friends of Photography, 1983).

62. John Keay, *The Great Arc; The Dramatic Tale of How India was Mapped and Everest was Named* (New York: Harper Collins, 2000).

63. Kenneth Mason, *Abode of Snow; A History of Himalayan Exploration and Mountaineering* (New York: Dutton, 1955).

64. Bradford Washburn. Obituary. New York Times, Jan 16, 2007. Bradford Washburn, *Bradford Washburn: Mountain Photography,* Ed. Anthony Decanes (Seattle, WA: The Mountaineers, 1999).

65. Ian Cameron, *Mountains of the Gods: The Himalayas and the Mountains of Central Asia* (New York: Facts on File, 1984), Ch 6 (*The Scientists.*) See www. books google.com. Joseph Dalton Hooker, *Himalayan Journals*, Vol 1 (London, Murray, 1854) Ch. XI, 165.

66. Keynes, *Darwin, His Daughter*, 182.

67. Cameron, *Mountains*, Ch 4 (*The Explorers*): Moorcroft, 66-75. Jacquemont, 75-81; Vigne, 84-88. Mason, *Abode of Snow*, Ch 2.

68. Pankaj Mishra, "The Way to the Middle Way," *New York Review of Books* 50/10 (June 12,2003). Mishra discusses the linguist M. Alexander De Körös, also Jaquemont and the collector of manuscripts Brian Houghton Hodgson who from 1818 onwards brought Buddhism to European attention. De Körös was initially sponsored by Moorcroft.

69. Cameron, *Mountains*, Ch 4 (*The Explorers*), 120. Mason, *Abode of Snow,* Ch 4. Peter Hopkirk, *The Great Game: The Struggle for Empire in Central Asia* (London: Murray 1990). Reprint: (New York: Kodansha International, 1994), 329. Peter Hopkirk, *Trespassers on the Roof of the World: The Secret Exploration of Tibet* (London, Murray, 1982). Reprint: (New York: Kodansha International, 1995), Ch. 2 and 3.

70. Mason, *Abode of Snow*, Ch 3, 75. The link-up with the Russian survey is described in Ch 6.

71. Eric Shipton, *Blank on the Map* (London: Hodder and Stoughton, 1938). Reprint in *Eric Shipton: The Six Mountain-Travel Books* (Seattle, WA: The Mountaineers, 1985).

72. Karl E. Meyer and Shareen Blair Brysak, *Tournament of Shadows, The Great Game and the Race for Empire in Central Asia* (Washington DC: Counterpoint, 1999). Hopkirk, *The Great Game.*

73. Meyer and Brysac, *Tournament,* Ch 7, 187.

74. Raleigh Trevelyan, *The Golden Oriole: A 200 Year History of an English Family in India* (New York: Viking-Penguin, 1987). Reprint (New York: Touchstone/Simon and Schuster, 1988). The book provides a memoir of his Gilgit childhood—he left for school in England in 1931. His father was British military advisor to the Maharaja of Kashmir from 1929 to '33. His family played an important role in the development of Indian higher education and the legal system. Charles E. Trevelyan in his 1838 book *On the Education of the Peoples of India* viewed education as a way to peacefully move the country towards independence and avoid revolution. Lord William Bentinck, Governor General of Bengal, and a follower of Jeremy Bentham, was of the same opinion.

75. Patrick French, *Yonghusband: The Last Great Imperial Adventurer* (London: Harper-Collins, 1994). Kurt Meyer and Pamela Deuel Meyer, In the Shadow of the Himalayas...Photographic Record of John Claude White, 1883-1908. (Ahamabad, India, Mapin, 2005). Tibet expedition: 87-122.

76. Pankaj Mishra,"The First Citizen of India." *New York Rev. Books* 51/5 (March 2004): 25. Mason, *Abode of Snow,* 86.

77. For the intellectual and religious interactions between Buddhism, Hinduism and Islam see: Amartya Sen, *The Argumentative Indian: Writings on Indian History, Culture and Identity* (New York: Farrar, Strauss and Girou, 2005).

78. Mason, *Abode of Snow,* 151.

79. Isaiah Berlin, *The Roots of Romanticism* (Princeton, NJ: Princeton Univ. Press, 2001). Kenneth Clark, *The Romantic Rebellion: Romantic versus Classical Art* (New York: Harper and Row, 1973).

80. W. A. B. Cooledge, *The Alps in Nature and History* (London: Methune, 1908).

81. Edward Whymper, *Scrambles Amongst the Alps in the Years 1860-69* (London: Murray, 1871). Reprint Sixth Edition of 1936: *Scrambles Amongst the Alps* (Layton, UT: Peregrine Smith Books, 1986).

82. Molly Loomis: "A Woman's Place is on Top. Selected Highlights in Women's Alpinism," *Amer. Alpine J.* 47 (2005): 113-115. Molly Loomis: "Going Manless," Ibid. 99-112.

83. Jeffery Parrette, "100 Years of Death in High Places," *Appalachia* 210 (June 15, 2000): 38-63.

84. George D. Abraham, *The Complete Mountaineer* (London: Methune, 1907).

85. Mason, *Abode of Snow,* 93-94.

86. French, *Yonghusband.*

87. Francis Younghusband, *Everest the Challenge* (First published 1936). Reprint: (Kathmandu: Pilgrims Publishing, 2002), 4.

88. Mason, *Abode of Snow,* 105.

89. Cameron, *Mountains of the Gods*, Ch 5, *The Climbers*: Martin Conway, 132-139; Duke of Abruzzi, 155-158; The Workmans, 140-144.

90. Freshfield, *Round Kangchenjunga.*

91. Mason, *Abode of Snow,* 107-109.

92. Walt Unsworth, *Everest* (Oxford: Oxford Illustrated Press, 1989). Second Edition (New Delhi: Harper Collins, 1989), 13.

93. French, *Younghusband*, Ch 22.

94. Cameron, *Mountains of the Gods*, Ch 5, *The Climbers,* 161.

95. Sherry B. Ortner, *Life and Death on Mt. Everest*: Sherpas and Himalayan Mountaineering (Princeton, NJ: Princeton University Press, 1999). Ortner, *High Religion.*

96. H. W. Tillman, *The Ascent of Nanda Devi* (First published 1935). Reprint in *H. W. Tillman: The Seven Mountain-Travel Books* (Seattle, WA: The Mountaineers, 1983), 149-268.

97. Mason, *Abode of Snow,* 185.

98. Tenzing Norgay, *Man of Everest: The Autobiography of Tenzing.* Told to James Ramesy Ullman (London: The Reprint Society, 1956.), Ch 14. Unsworth, *Everest*, 315.

99. Unsworth, *Everest*, Ch 2.

100. Unsworth, *Everest*, 63.

101. Mason, *Abode of Snow*, 164.

102. For the Sherpa reaction to death see: Ortner, *High Religion* and Ortner, *Life and Death*. Another major accident involving Sherpas occurred in 1937 when nine Sherpas and seven German climbers died in the third German attempt on Nanga Parbat. I have encountered a number of Sherpa guides who, as the nearest family member, had taken responsibility for the children of a dead brother who had died in a mountaineering accident.

103. Conrad Ankers and David Roberts, *The Lost Explorer, Finding Mallory on Mount Everest* (New York: Simon and Schuster, 1999).

104. Mason, *Abode of Snow*, 175. Unsworth, *Everest*, 128, 177.

105. Parrette, *Death in High Places*. Unsworth, *Everest*, 103, 124.

106. Unsworth, *Everest*, 125.

107. Maurice Herzog, *Annapurna* (First published 1952). Reprint (New Delhi: Harper Collins, 1992), 206.

108. T. Howard Somervell, *After Everest: The Experiences of a Mountaineer and Medical Missionary* (London: Hodder and Staughton, 1936), 136.

109. Geoffrey Winthrop Young, *On The High Hills* (London: Methuen, 1927), 343.

110. Eric Shipton, *Blank on the Map* (London: Hodder and Stoughton, 1938). Reprint in: *Eric Shipton: The Six Mountain Travel Books* (Seattle, WA: The Mountaineers, 1985), 166.

111. Unsworth, *Everest*, 209.

112. Bunyan, *Pilgrim's Progress*. See www.books.google.com. (Harvard Classics 15) 163.

113a. Tsering Shakya. *The Dragon in the Land of Snows* (New York: Columbia Univ Press, 1999).

113. Tillman, *Ascent of Nanda Devi*. Mason, *Abode of Snow*, 207. Unsworth, *Everest*, 191.

114. Mason, *Abode of Snow*, Ch 5. Unsworth, *Everest*, Ch 14. Sir Edmund Hillary: Obituary, New York Times, Jan 11, 2008.

115. Norgay, *Man of Everest*, 21. Jamling Tensing Norgay, *Touching my Father's Soul: A Sherpa's Journey to the Top of Everest* (San Francisco, CA: Harper, 2001).

116. Mason, *Abode of Snow*, 306.

117. Parrette, *Death in High Places*, 38-63.

118. Yvon Chouinard, *Climbing Ice* (San Francisco, CA: Sierra Club, 1978).

119. Siegfried Kracauer, *From Caligari to Hitler; A Psychological History of the German Film* (Princeton, NJ: Princeton Univ. Press, 1947), 111.

120. Heinrich Harrer, *The White Spider* (London: Rupert Hart Davis, 1959). Revised (New York: Tarcher/Putnam, 1998). Douglas Martin, "Hienrich Harrer, 93, Explorer of Tibet, Dies." New York Times, (10 Jan, 2006): C17.

121. Parrette, *Death in High Places*.

122. Janet Maslin, Film Review: "Just What Did Leni Riefenstahl's Lens See." New York Times (13 March 1994): H16. (The NYT Archive text does not contain the sentence quoted.) Film: *The Wonderful, Horrible Life of Leni Riefenstahl*. Directed by Ray Muller.

123. Heinrich Harrer, *The White Spider*. Lionel Terray, *Conquistadors of the Useless*, first published,1961 (Seattle, WA: The Mountaineers, 2001). Chris Bonnington, *I Chose to Climb* (London: Gollancz, 1989). Joe Sympson, *The Beckoning Silence* (Seattle, WA: The Mountaineers, 2003).

124. Geoffry Winthrop Young; forward to Eric Shipton, *Upon That Mountain* (London: Hodder and Stoughton, 1943). Reprint: *Eric Shipton: The Six Mountain-Travel Books* (Seattle, WA, The Mountaineers, 1985), 311.

125. Harrer in *The White Spider* gives a list of all attempts up to 1981 on the Eiger North Face.

126. Unsworth, *Everest*, 468-476.

127. Unsworth, *Everest*, 480-4.

128. Molly Loomis: "A Woman's Place is on Top."

129. Chris Bonnington, *The Everest Years, A Climber's Life* (London: Hodder and Stoughton, 1986), Ch 4-6. Doug Scott, *Doug Scott, Himalayan Climber* (San Francisco, CA: Sierra Club, 1992), Ch 6.

130. Fiftieth anniversary volume: Simon Pierse, *Kangchenjunga, Imaging a Himalayan Mountain* (Aberystwyth: Univ. of Wales, 2005), Ch 7-8.

131. Joe Tasker, *The Savage Arena* (London: Methune, 1982), Ch 6. Peter Boardman, *Sacred Summits* (London: Hodder and Stoughton, 1982), Ch 7-14. Reprint of both: *The Boardman Tasker Omnibus* (London: Hodder and Stoughton, 1995; London: Bâton Wicks, 1996). Scott, *Himalayan Climber*, Ch 7.

132. Doug Chabot; "Alpine Style" *Amer. Alpine Journal* 47 (2005): 41-45. Steve House: "Karakoram Summer" Ibid, (2005): 33-40.

133. Anatoli Boukreev (1958-1997) provides an example of the athletic approach in which physi-ology is constantly monitored in order to push endurance and strength to new levels. He gained experience in Soviet competitive skiing and speed climbing; with the break up of the Soviet Union he entered the international arena. Anatoli Boukreev, *Above the Clouds: The Diaries of a High-Altitude Mountaineer* (New York: St Martin's Press, 2001).

134. W. H. Murray, *The Evidence of Things Not Seen, A Mountaineers Tale* (London: Bâton Wicks, 2002), 238.

135. Jon Krakauer, *Into Thin Air* (New York: Villard/ Random House, 1997).

136. Jim Curran, *K2, The Story of the Savage Mountain* (Seattle, WA: The Mountaineers, 1955). Parrette, *Death in High Places*. Lloyd Athearn, "Further Thoughts on Climbing Risks: Everest and the 8,000-Meter Peaks in Nepal." *The American Alpine News*. 12/251 (Autumn 2005): 10-12. Athearn reports that the rate of fatalities per climber attempt for Everest (excluding climbing Sherpas) has been varying from about 1.5% in the 1970s to over 2% in the 1980s and about 1% since 2000. The number of attempts per year has steadily increasing from about 50 to over 350.

137. Bonnington, *The Everest Years*, Ch 11.

138. C. S. Houston and Robert H. Bates, *K2 the Savage Mountain* (Seattle, WA: The Mountaineers, 1954). Robert H. Bates, *The Love of Mountains is Best* (Portsmouth, NH: Peter E. Randall, 1994). Curran, *K2-Savage Mountain*.

139. Maynard Solomon, *Beethoven* (New York: Simon & Schuster/Macmillan, 1977), Ch 12-14. Solomon defines the Heroic Decade as 1802-1813. At the beginning the Op 55 *Eroica* is bracketed by the *Waldstein* and *Apassionata* piano sonatas. The Op 106 *Hammerklavier* piano sonata falls within the late period, but retains the heroic style.

140. Roland Huntford, *Nansen: The Explorer as Hero* (London: Abacus/Little, Brown, 1997), 539, Ch 65.

141. Shipton, *Blank on the Map*, Ch 1.

142. Peter Bordman, *Sacred Summits* (London: Hodder and Stoughton, 1982). Reprinted in *The Bordman Tasker Omnibus* (London: Bâton Wicks, 1995); Quotation, 124.

143. *H. W. Tillman: The Seven Mountain-Travel Books.* (1983). Tillman quotation in the Introduction by Jim Perrin, 11.

144. Lito Tejada-Flores, reprint of 1967 *Ascent* article in *The Games Climbers Play,* Ed. Ken Wilson (San Francisco, CA: Sierra Club, 1978).

145. Maria Coffee, *Where the Mountain Casts its Shadow* (London: Hutchinson/Random House, 2003). The book derives from her personal loss (she was the companion of Joe Tasker) and from interviews with others who have had to face similar experiences. See also Linda Wylie's introduction in: Boukreev, *Above the Clouds.*

146. Bonnington, *The Everest Years*, 122.

147. Scott, *Himalayan Climber*, Postscript, 191. Boukreev, *Above the Clouds,* 232.

148. I have borrowed the term 'basic trust' from Erik Erikson. Erik H. Erikson, *Identity Youth and Crisis* (New York: Norton, 1968). The Child psychologist Donald Winnicott has written that the infant first begins to realize its true self as the mother's face mirrors the baby's emotions. Adam Phillips, *Winnicott* (Cambridge, MA: Harvard Univ. Press, 1988), 128. The validation of existence by mirroring protects the baby from "unthinkable anxiety." Maynard Solomon has examined the andante of Mozart's A-minor Piano Sonata K 310/300d in terms of Winnicott's mirroring theory. The sonata was written in Paris in 1778, when he was 22, at the time of his mother's death. The protected gentle space of the opening leads to a section with a chromatic pulsed series of descending discords that threaten annihilation before the movement finally returns to a transformed security. Having once recognized the pattern, Mozart was able to revisit and manipulate the archetype using it as a source of creative power. Maynard Solomon, *Mozart: A Life* (New York: Harper Collins, 1995) Ch 12, 195.

149. Margaret S. Mahler, *The Selected Papers of Margaret S. Mahler. Vol 2. Separation-Individuation* (New York: Aronson, 1979). Ch 1 and Ch 8 (from 1963-6). Following a period of symbiosis in which the baby is an integral part of the mother, a period of reaching out into the world starts between 7-10 months. In the process of individuation and separation the excitement at discovery alternates with a return to the mother for assurance. "Gradually the infant begins to express and thus to communicate, a wide range of affects: fear, pleasure, annoyance, affection, jubilation, distress, astonishment, and the rest." (p 11.) This stage has been called by Greenacre "a love affair with the world." (p 126.) Between 16-25 months the junior toddler becomes a senior toddler and, as the separateness of the mother and father becomes apparent to the infant, there is a fear of abandonment, the making of many conflicting demands and sometimes a struggle over toilet training. There is a longing for a return to the security of the symbiotic phase. Mahler terms this the *rapprochement crisis*. Although the issue of confronting danger and terror, that plays such an important role in mountaineering, is not stressed in Mahler's account, she does point to the emotional intensity of the infant experience.

150. Maynard Solomon in *Beethoven* notes Beethoven's delusions about his birth certificate, the notion that his real father was of royal status, the idealization of his maternal grandfather and his complete silence about the first ten years of his life. He links these to the Heiligenstadt crisis of 1802 and the subsequent burst of creativity that encodes the resolution of the crisis in terms of the heroic myth. He draws attention to the connection between heroic myths and the struggle over the father (the 'family romance') as discussed by Sigmund Freud and Otto Rank.

151. Reinhold Messner, *The Big Walls: History, Routes, Experiences* (New York: Oxford University Press, 1978) 101, 143.

152. Joe Simpson, *This Game of Ghosts* (New York: Vintage, 1994), 213, 277-8. Joe Simpson, *Touching the Void* (New York: Harper and Row, 1989). Simpson, *Beckoning Silence.*

153. Taylor Branch, *The Parting of the Waters: America in the King Years 1954-63* (New York: Simon and Schuster, 1988), Ch 6. King's *Letter from a Birmingham Jail* came in 1963.

154. Søren Kierkegaard, *Fear and Trembling.* Translation by Alastair Hanney (London: Penguin, 1985). Original Kierkegaard text in Danish, 1843.

155. Symposium: *Kierkegaard's Fear and Trembling: Critical Appraisals,* ed. Robert L. Perkins (Tuscaloosa, AL: Univ. Alabama Press, 1981). The literature on the attempt by Existentialism to redefine the concepts of human freedom and responsibility is diffuse and often polemical. Furthermore, there is disagreement as to what Kierkegaard was trying to say. The symposium covers the range of critical opinions about *Fear and Trembling* and the divergent interpretation of the Abraham and Isaac story (Gen. 22: 1-18) in Christian and Jewish literature and in philosophy. There is a short version of the story in the Qur'an, but there it is Abraham's first son Isma'il that is to be sacrificed and both Abraham and Isma'el willingly agree to the sacrifice (Qur'an, S35, 99-111.) The Eid al-Adha mid-winter festival following the time of pilgrimage to Mecca celebrates the sacrifice. For the appeal to God by Abraham to save the righteous living in Sodom, see Genesis 18:23-33. For the laughter of Sarah, see Genesis 17:17-18, 18:13 and 21:6.

156. There is a curious parallel between *The Brothers Karamazov* by Dostoevsky and *Fear and Trembling.* The former is concerned with parricide and the latter with filicide. Both use narrators and sub-narrators that are distinct from the author. Kierkegaard's author seems to accept that Abraham chooses absolute loyalty to God over the duty toward his son and talks about the "teleological suspension of the ethical" but it is by no means certain that this corresponds to Kierkegaard's position. Although Kierkegaard attacks Kant, both assume the complete ethical freedom and responsibility of the protagonist; the difference is in how the moral actor conceives the act. Kierkegaard seems to favor a dramatic resolution, much like Verdi. Kant favors universal principals and argues that as Abraham cannot know for certain that it is God's voice he hears he must stay with the duty to protect his son. It is possible that, had he thought of it, he would have extended this and rationally weighed obligations, as in Game Theory. The discussion of the encounter with God in terms of Game Theory can become quite technical. Steven J. Brams, *Superior Beings; If They Exist, How Would We Know?* (New York: Springer-Verlag, 1983).

157. Robert. L Perkins, "For Sanity's Sake: Kant, Kierkegaard, and Father Abraham," in *Kierkegaard,* Perkins, ed. symposium, Ch 3.

158. Louis Jacobs, "The Problem of the Akedah in Jewish Thought," in *Kierkegaard,* Perkins, ed. symposium, Ch 1.

159. The motto is the Latin tag *Nullius in verba.* Stephen J Gould, "Royal Shorthand," *Science* 251 (Jan. 1991): 142.

160. Mallory had probably read Ruskin. Unsworth, *Everest*, 100.

161. The parable occurs only in Luke: 10:38-42. The framing is a rabbinical style debate about Leviticus 19:18 which defines 'neighbor' as a fellow Israelite. T. W. Manson, *The Sayings of Jesus* (London SCM Press, 1948). Towards non-Israelites there may be little restraint: Samuel 15:3 and 33.

162. This topic is not beyond the reach of scrutiny. John Locke denounced choices based not on reason or revelation, but on Enthusiasm, i.e., on "whatever groundless opinion that comes to settle itself strongly upon the fancy." (*Human Understanding.* Part 4, Ch 19 "On Enthusiasm", p 515). But reason and revelation were once evoked to justify the separate water fountains of segregation and they can be evoked to oppose or justify the use of torture. The Lockean response (Jefferson, Kant, Rawles etc.) is to reason better or to better understand revelation. The third possibility raised in this Enquiry invokes the idea of a core identity that can be shaped by such anchoring experiences as the ascent of Snowdon. We do not torture because of who we are. To torture is to destroy ourselves, our core identity. Reasons are highly relevant, but they are not the ultimate check. But anchoring experiences may be challenged. In Dostoyevsky's 1883 novel *The Idiot*, Prince Myshkin, in the process of making an extraordinary commitment, struggles to analyze the sense "of completeness, of proportion, of reconciliation" that initiates his epileptic fits. "For this moment one might give the whole of life." Was this experience a disease, akin to opium hallucinations, or was it the highest form of existence? The novel turns the camera upon the self. (See www.books.google.com. Part 2, Ch.5. p225. Garnet translation.)

ON THE STRUCTURE OF MOUNTAINS

The photographer encounters the Himalaya as a physical reality. Churning streams and rivers have carved out steep valleys. Great ribbons of ice have gouged and smoothed rock surfaces. Icefalls, avalanches and landslides continue to abrade. It is this violent shaping of mountain structure that the photographer most obviously records, but another reality is hidden: the mountains encode the drama of their formation. A single mountain building process has given rise to three terrains: the *High Himalaya*, the *Kohistan-Ladakh Arc* and the *Karakoram*. Our understanding of this process has been transformed by the development in the last 50 years of the theory of plate tectonics and by recent major revisions in the theory of how the High Himalaya evolved. I write the following as a curious photographer, not as a qualified geologist.

Plate Tectonics: The globe is divided into about thirteen large semi-rigid plates that are slowly being formed and destroyed. They are generated as mid-ocean ridges are formed by molten rock from the earth's mantle. To compensate, these lithosphere plates, a few hundred kilometers thick, are elsewhere plunging downwards for hundreds of kilometers beneath other plates into the earth's mantle where ultimately they melt. The process is known as *subduction*. As a result of this continued creating and destroying ocean floors are no older than 200 million years. Continental masses are less dense than the lithosphere, having roughly the composition of granite, and, in effect, float on the viscous lithosphere rocks as a crust. Continental crusts on average are 35-40 km thick but increase to 80 km in the Himalayan-Tibetan region. Ocean crusts are only a few kilometers thick and have a denser basaltic composition. Mountain ranges float on the lithosphere like icebergs amidst pack ice, hence the highest mountains have the deepest crustal basements. Continents have one or more cores of great antiquity going back in places to 3,800 million years or more. These Precambrian shields are not substantially destroyed in the subduction process, but rearranged to make new assemblies. A continental mass may acquire exotic terrains: fragments of another continent or an island, as in the case of the Avalonia rocky coast of New England or the North Cascade Mountains of the northwestern USA.

If a plate with its thin ocean-floor crust sinks under the edge of a continental mass, subduction generates an offshore trench and a line of volcanoes that are driven by the explosive power of the water carried down in the ocean-floor rocks. Such chains can be seen in the Andes and the Pacific Northwest. If the subduction takes place away from a landmass, the chain of volcanoes forms an island arc, as exemplified by Japan. The remains of such an island arc, acquired as an exotic terrain, run from near the coast of

Connecticut northward through Massachusetts and New Hampshire. Within a landmass the heat generated as a plate sinks may also melt the overlying rock to form magma that may rise upwards and, on slowly cooling, create the large formations of igneous rock known as *batholiths* (typically granite). Several times in the course of the earth's history the upwelling of mantle rocks has pushed continents together to produce super continents, but these masses have been split apart again to create separate plates and new oceans. The East African rift system is an example of splitting in progress.

The Breakup of Pangaea: 200 million years ago, in the age of Dinosaurs near the beginning the Jurassic period, all of the earth's continents were gathered together in a single super continent known as *Pangaea,* but this ever-shifting assembly was now beginning to break apart. India was wedged in between Antarctica and eastern Africa with a continental shelf facing the ocean known as *Tethys.* This Precambrian shelf, destined to form the Himalayas, had been acquiring a changing mixture of sedimentary deposits for over 300 million years—limestone, shale, sandstone and mudstones. As Pangaea began to fracture it split into four main units: Laurasia, Gondwana, Antarctica plus Australia, and India. The split of Laurasia into North America and Eurasia was not completed until about 60 million years ago. An Andean-type mountain chain was created as the Indian plate began to thrust beneath the coast of Tibet and the area that later became the Karakoram. This process, together with a counter underthrusting of the Karakoram area by the ancient plate of the Tarim basin, subjected the layered sedimentary rocks of the region to heat and low-pressure metamorphism and also generated the highly metamorphic gneiss of

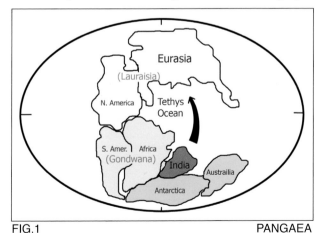

FIG.1 PANGAEA

K2, the Mustagh Tower and the Hushe region (Map page 9). (Gneiss is a catch-all German name for rocks, both sedimentary and granitic, that have been substantially recrystallized by heat and pressure).

Addition of the Island Arc: By 150 million years ago (late Jurassic) the subduction had changed and a volcanic island-arc (the Kohistan-Ladakh Arc-Batholith) had formed somewhere in the Tethys Ocean between India

and Laurasia. The island arc was added as an exotic terrain to the Karakoram coast about 70 million years ago (late Cretaceous). The Kohistan part of the arc extends northwestwards from the Indus near Chilas. The Ladakh part extends from east of Nanga Parbat to Skardu and the Ladakh Range. The Shyok River now marks the line where sediments from the sea between the approaching Ladakh Range and the mainland coast accumulated during the docking process (the *Shyok Suture Zone*). The arc region is over 800 km long and 30-60 km wide. A second smaller island arc may also have formed in the late Cretaceous that became the thin Ladakh Dras volcanic formation to the south of the Indus that border the Markha Valley (Map page 9).

The Closure of Tethys: Sixty five million years ago (the Cretaceous-Tertiary boundary) the world was a very inhospitable place. A meteor impact in Mexico had a major influence on the climate. A hot-spot mantle plume spewed out 200,000 square miles of dark basalt to create the Deccan traps in India. As a result the dinosaurs were extinguished, but the Indian plate continued relentlessly onwards. The shelf of the Indian subcontinent docked with Eurasia about 50 million years ago. The initial contact point was probably the Nanga Parbat region of Kashmir, with the rest of the closure taking place as the advancing Indian landmass slowly rotated in an anti-clockwise direction. Prior to closure some of the debris of the Tethys sea floor ("ophiolite" sediments) accumulated in the subduction trench. The Indian continental mass jammed these sediments against the coast and the narrow band so created became the *Indus-Tsangpo Suture Zone*. With the closure of the Tethys bay the eruption of the coastal volcanoes ceased, but at some point a long batholith was formed to the north of the suture zone from the Ladakh border to Arunachal Pradesh (the *Trans-Himalayan Batholith*). This explains why the Potala Palace and the houses in the older parts of Lhasa are built from granite.

Tethys Sedimentary Zone: This name is now applied to the region of sedimentary rocks to the south of the suture line that were deposited on the Precambrian crystalline rocks of the Indian continental shelf. On approaching Everest from the north the traveler crosses broad rolling hills suitable for yak and sheep grazing that are the folded remains of the coastal sediments. Similar sediments occur in Inner Dolpo (page 49) and to the north of a line from near Jomsom in the Kali Gandaki Valley to near Manang, including the Thorung La. According to the Nepal government geological map, they are of the Mesozoic period (250-65 million years ago; Triassic to lower Cretaceous). The Zanskar Mesozoic sediments to the south of the Indus in Ladakh are extensively folded. In the upper Kali Gandaki Valley to the north of Kagbeni the Lo-Mustang rift valley is filled with more recent sediments. The thick upper layers of limestone over the gneiss basement in the

Dhaulagiri and Annapurna region are of the earlier Paleozoic period, mainly Ordovician, i.e., about 450 million years old, and the main Himalayan chain in the Dolpo region is also composed of Paleozoic sediments. The full sedimentary sequence from the Cambrian to the Cretaceous in the Annapurna region adds up to some 10 km depth and has about 20 distinct layers.

Himalayan Formation: The Shingle-Stacking Model. The Indian plate continued to advance, thrusting beneath Tibet and also beneath the island-arc and the Karakoram. The pressure generated in the upper crust required that it fault, or fold and thicken, or both. As the upper sedimentary crust folded the lower continental crust moved northward with the Indian plate until faulting took place. Geological maps show a *Main Central Thrust* (MCT)—a fault that reaches from Ladakh to Arunachal Pradesh. According to the model, as the fault propagated west to east, a 2,000 km or more section of the continental crust was lifted up and an advancing section of continental rocks slid beneath this leading edge. This elevation created the *Greater Himalaya* (or *High Himalaya*). The region to the south of the fault is the *Lesser Himalaya*. The rock layers of the *Greater Himalayan Series* (and their sedimentary overlay) north of the MCT tend to slope downwards to the north. (The Series is sometimes labeled metamorphic and sometimes crystalline.)

Most of my wanderings have been to the north of the MCT in the High Himalaya and the Tethys Sedimentary Zone. The MCT runs a little to the north of Jumla in Western Nepal. It approximates the river between Dunai and Tarakot. (The children on the roof on page 48 are looking across the valley created by the fault.) In the Dhaulagiri-Annapurna region there is a double MCT fault to the north of Pokhara. The hot springs at Tatopani on the Myangdi River and Tatopani in the Kali Gandaki Valley mark the first and second sub-faults (tatopani is the Nepali term for hot water). The rocks associated with the Dhaulagiri waterfall (page 72) and the Marsyangdi Gorge (page 83) are part of the Greater Himalayan Series. In the Everest area the MCT fault is a few miles to the south of Lukla. In the Kangchenjunga area the fault makes a northward loop where the Tamur River has extensively eroded the rock overlying the Lesser Himalayan formation.

According to the stacking model, the crustal shortening allowed by the MCT fault provided only temporary relief. Continuing movement of the tectonic plate generated additional faults: the *Main Boundary Thrust* (MBT) and the *Himalayan Frontal Thrust* (HFT). Each underthrusting further elevated the High Himalaya. The faults fused into a single *Main Himalayan Thrust* (MHT, the Sole Thrust). Additional faults are developing below the Ganges plain. Earthquakes tend to originate near the

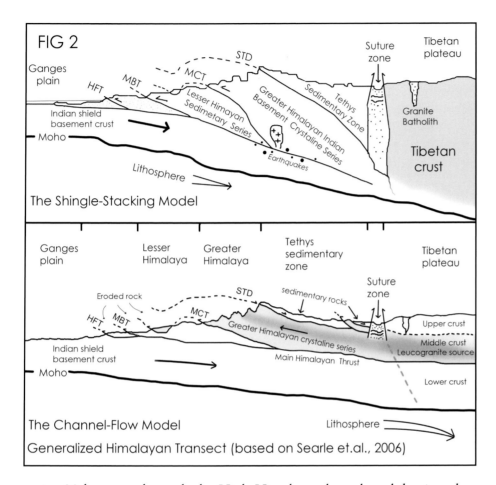

FIG 2

Ganges plain

HFT MBT MCT STD

Suture zone Tibetan plateau

Indian shield basement crust

Moho

Lesser Himayan Sedimetary Series

Greater Himalayan Indian Basement Crystaline Series

Tethys Sedimetary Zone

Granite Batholith

Tibetan crust

Earthquakes

Lithosphere

The Shingle-Stacking Model

Ganges plain

Lesser Himalaya

Greater Himalaya

Tethys sedimentary zone

Tibetan plateau

Eroded rock

STD

sedimentary rocks

Suture zone

HFT MBT MCT

Greater Himalayan crystaline series

Upper crust

Middle crust

Indian shield basement crust

Main Himalayan Thrust

Leucogranite source

Moho

Lower crust

The Channel-Flow Model

Lithosphere

Generalized Himalayan Transect (based on Searle et.al., 2006)

point 20 km or so beneath the High Himalaya where the subducting plate grinds past the junction of the MCT with the main fault. The impact of the earthquakes is usually propagated along the fault towards the Ganges plane. Elevation of the mountains into the jet stream created the monsoon system of South Asia and the monsoon rains eroded enormous quantities of rock from the front and top of the elevated ranges to create the Ganges plain.

Himalayan Formation: The Channel-Flow Model. The above picture has been steadily modified in the last seven years. It does not fit with measurements of metamorphism or explain the origin of the massive sills of leucogranite (white granite) that outcrop in the High Himalaya—the sills are seen on Cho Oyu, the Everest group and Makalu and, further south, on Ama Dablam. They can be found in the Greater Himalayan Series from Zanskar to Bhutan. The Lhotse granite layer is about 3.5 km thick, but elsewhere the granite intrusions may be only one meter thick. The stacking model assumed that Tibet is an unyielding block, but that is not the case. The continental crust of the Tibetan plateau is 80 km thick and there is evidence that its middle crustal layer between 10-28 km depth is extremely hot and subjected to enough pressure and heat, in part derived from radioactivity, to make it

relatively fluid (there are no earthquakes in this zone). The lower crust, under greater pressure, may have been transformed to give it less ductility. Tibet has been elevated because the Indian Plate has carried the Indian lower crust northward under Tibet for over 200 km at the same time that the Tarim Basin Plate is underthrusting from the north. The greater than 5 km elevation of Tibet relative to the Ganges plane establishes a lithostatic potential for the mass flow of ductile rock to the south even as the Indian Plate is moving north. This leads to a paradoxical theory known as the *Channel-Flow Model* which, with some trepidation, I will try to explain.

The first consideration is that the Tethys Sedimentary Layer is not firmly anchored to the underlying crystalline layer but is detached and free to fold separately. In the Dhaulagiri-Annapurna region the Ordovician limestone is folded above the lower layer of gneiss (see Tukuche Peak page 79). There is a fault line between the sedimentary and crystalline rocks known as the *South Tibetan Detachment* (STD) that runs from Zanskar in Ladakh to Arunachal Pradesh in India. In the Dhaulagiri area I crossed the SDT a little before reaching the gateway to the Chhonbardan Glacier (page 74). In the Everest area there are two high sub-detachments that join to the north. In 1993 the Main Central Thrust was immediately crossed on ascending from Dunai in Outer Dolpo towards Phoksumdo Lake. Here the Greater Himalayan Series is relatively brief and the STD was reached about halfway to the lake. From the SDT to the Kang La the territory belongs to the Paleozoic Tethys Sedimentary Zone, i.e., the older layers of sedimentary rock. Before the pass we camped near a cliff with evident folding. Beyond the pass the landscape of younger Mesozoic sedimentary rocks encountered on the steep decent was visually very different. Presumably the Paleozoic rocks in the region just traversed, themselves perhaps 4 km thick, had 5 km or more of softer Mesozoic rocks above them before they were eroded away. My amateur impression at the time was that at the pass a major fault line was being crossed—perhaps a detachment between the older and younger rocks.

The Channel. Measurements show that the SDT passes below the rocks of the Tethys Sedimentary Zone to reach the Tsangpo Suture Zone (Figure 2). There are thus two major parallel faults along the length of the Himalaya that define a channel with the SDT as the roof and the MCT as the floor. The layers of leuco-granite appear to be confined to this channel. Furthermore, when the metamorphism of the rocks above the SDT and below the MCT is examined, it appears that the greatest metamorphism took place *closest* to the faults. To change the adjacent rocks in this way the rocks of the Greater Himalayan Series must have reached a temperature of 600-700° C. The measurements also indicate the metamorphism took place between 32-17 million years ago.

To explain these observations it is postulated that the floor thrust made contact with the middle Tibetan crust at about 28 km depth and the roof detachment made contact at a lesser depth. By 32 million years ago rocks of the hot middle crust, under great pressure, had extruded to fill the channel between the roof and the floor. A pool of relatively fluid leuco-granite that happened to be available, intruded its way between the other rocks and formed layers that served as a lubricant for their motion. The leuco-granite outcrops in many places in the High Himalayas date from about 20 million years ago. The currently exposed Greater Himalayan Series thus derives from the Tibetan plateau, *not* the Indian crust.

The above surprising conclusion seems firm enough for the Zanskar/Nepal/Bhutan border region with Tibet, but how did the channel-flow process get started sometime between 50 and 32 million years ago? Did monsoon erosion of the southern face of the High Himalaya allow ductile Tibetan rock to forcibly extrude a wedge of continental rock initially present? Did monsoon erosion cause extrusion to continue even after the Greater Himalayan Series began to cool 16 million years ago? If erosion and extrusion kept pace with each other, the greater rainfall to the east would have promoted greater extrusion to the east. Does the channel-flow model apply in the west to the Nanga Parbat region? Is the source of this western Greater Himalayan Series the middle crust beneath the Karakoram? Much of this story remains to be written.

Everest Northern Aspect. The collection of rock specimens was a major activity of the early Everest mountaineering expeditions. Everest up to the detachment fault at about 24,500 ft is composed of highly metamorphic schist and gneiss that tilts downwards to the north. The leuco-granite intruded into this Greater Himalayan Series outcrops mainly to the south. Above the detachment is a Cambrian dark band, mainly shale and sandstone, and then at 27,500 ft there is a 500 ft Yellow Band consisting of greenschist and near-marble Ordovician limestone. At the top of this band is a second detachment fault. Above is younger dark-gray Silurian-Devonian limestone that forms a series of inclined steps.

The Karakoram: With the collision of India with Eurasia 50 million years ago the Karakoram was subjected to renewed pressure. From the south the Indian Plate undercut the Kohistan-Ladakh Arc and beyond that the Karakoram. Pressure also caused the Shyok suture zone to the north of the Arc to thrust beneath the Karakoram. This Main *Karakoram Thrust* (MKT) is indicated in the map on page 9 as a toothed line. The Tarim Plate was also underthrusting the Karakoram from the northeast. This underthrusting from both directions led to massive crustal thickening. The great pressure and heat generated 50 to 37 million years ago subjected the rocks to an extensive second metamorphism. Erosion of many kilometers of rock has resurrected these once deeply buried layers to yield the *Karakoram Metamorphic Complex* whose upended strata can be seen in the panorama on pages 19-22.

The *Karakoram Granite Batholith*, that extends across the whole width of the Karakoram and separates the metamorphic region into southern and northern parts, was generated between 25 and 21 million years ago when the temperature became locally high enough to cause extensive melting. (This is the same period associated with the leucogranite intrusions in the High Himalaya.) The boundaries of the batholith are indicated by dotted lines on the map on page 9. The heat from the batholith caused some metamorphism in adjacent rocks, for example, the black slate of Mitre Peak. The tectonic processes continue. A great deal of uplift has taken place in the last ten thousand years. The uplift in the K2 area continues to be exceptionally high.

The Continuing Drama. The mountain building process concerns forces and a time scale beyond our intuitive comprehension. That mountain building required great periods of time was first realized in the eighteenth century, and this was systematized in terms of geological periods in the nineteenth century. What is new is the precision of our measurements of time made possible by isotope and radioactivity determinations. In the nineteenth century the symbolic issue was the resetting of human existence in the framework of biological evolution. The geological process can be paced out against the evolutionary record. That issue is still relevant, but the problem of human vulnerability seems more significant. The photograph on page 10 shows the Indus Gorge where the river has cut through the northern finger of the Himalayan chain near Nanga Parbat. The road belongs to present day political realities, but this is the region where India first collided with Eurasia 50 million years ago. The process relentlessly continues with no possibility of influence by human action. The photographic record is bonded to the geological drama.

NOTE:

This outline of the Himalayan mountain-building process has been pasted together from numerous, sometimes inconsistent, sources at a time of changing ideas. The American Museum of Natural History in New York has a cross-sectional simulation of the shingle-stacking process made out of colored sand. A key source has been: M. P. Searle and R. Tirrul, "Structural and thermal evolution of the Karakoram crust." *Journal Geological Soc, London,* 148, 65-82 (1991). The paper was brought to my attention in 2001 by Andy Tuow, a graduate student from Oxford University, who was collecting rock samples at the junction of the Gondokoro and Charakusa valleys. The Channel-Flow Model is discussed in K. Hodges, "Climate and the Evolution of Mountains." *Scientific American,* August, 73 (2006). Also in M.P. Searle, R.D. Law and M. Jessup, "Crustal structure, restoration and evolution of the Great Himalaya in Nepal-South Tibet: implications for channel flow and ductile extrusion of the middle crust." *Geological Society, London, Special Publications,* 268, 355-378 (2006). The latter paper is part of a symposium on *Ductile Extrusion;* Ed: Law, Searle & Godin. Useful geological sketch maps of the Himalayas in general, of the Annapurna region and of the Annapurna stratigraphic sequence will be found in M. P. Searle and L. Godin, "The South Tibetan Detachment System....." *Journal of Geology,* 111, 505-523 (2003).

Geological Eras and Periods with Boundary Dates

Precambrian......first rocks to 543 ma (Archeozoic, 2,600 ma, Proterozoic, 543 ma).

Paleozoic...........543 to 251 ma (Cambrian, 505 ma, Ordovician, 435 ma, Silurian, 408 ma, Devonian, 360 ma, Carboniferous, 286 ma, Permian, 251 ma).

Mesozoic............251 to 65 ma (Triassic, 208 ma, Jurassic, 144 ma, Cretaceous, 65 ma).

Cenozoic............65 ma to present (Tertiary/Neogene, 2.6 ma, Quaternary, present).

Geologists present this list in two ways: as a *timeline*, with the oldest at the left, when discussing climate changes and mass extinctions; as *a column*, with the oldest at the bottom, when they are concerned with rock strata. ma = million years ago.

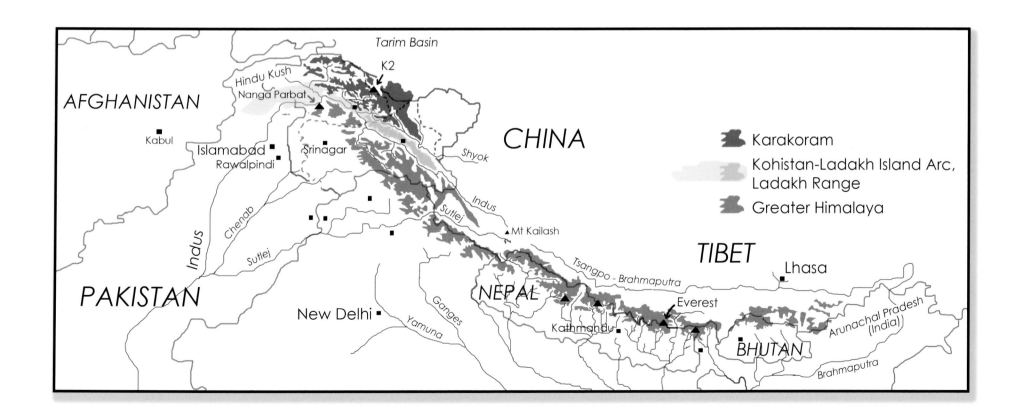

TECHNICAL INFORMATION

My camera equipment has been simplified and limited by the constraints of travel. Weight is a critical factor both on the trail and in coping with airport restrictions. The Toyo 4x5 Field Camera, acquired in 1978, has proved to be very rugged. (A lighter carbon fiber version is now available.) I have employed three Schneider lenses: 120 mm (Super Angulon), 210 mm (Symmar-S), and a 305 mm (G-Claron). This last was mounted with a custom-made tube extension as the camera bellows are too short for use with a 305 mm lens. The total weight of the camera bag, camera, three lenses with two lens hoods, a spot meter, dark cloth, loop, filters, plus notebook is 7.00 kg (15.45 lb). Two zippered bags each containing four film holders adds 1.58 kg (3.5 lb). Together with a point-and-shoot camera the total becomes 9.00 kg (20 lb). On promising days I added to my load a third bag of four film holders. All this fits in a frame rucksack which must also hold spare warm clothing and two bottles of water. In addition, there is a wooden tripod (shortened and with sander-trimmed legs) which, together with a tilt head, weighs 3.85 kg (8.5 lb). On my earliest trips I carried everything. On later trips I had help with the tripod and on the last three trips a staff member carried all the equipment. Staff members, however, have other duties and thus are not always available. In emergencies, such a sickness, they may have to help others. It was important to be able to carry the load myself.

The duffle bag carried by porters contained my boxes of film, plus a changing-bag-and-box combination. The 12 holders conveniently integrate with the use of 25-sheet boxes of 4x5 film. Nicks cut in the flap of the holders produced an identification pattern on the developed film corresponding to the number and side (A or B) of the holder. To avoid confusion I have used all 12 holders in sequence. Airport security has been an ever-changing uncertainty. I did not wish to consign my valuable camera to checked baggage and film had to be carried on. The film holders went in the duffle bag. My carry-on bag contained ten boxes of film wrapped in a lead cloth (total 250 sheets). This package was contained in a small sack that could be separately presented to security. I was sometimes able to avoid an X-ray of the film by politely explaining about the problem of cumulative exposure. The film together with the camera and lenses weighed 9.5 kg (21 lb).

In 1996 I switched from using Tri-X sheet film, developed with HC110 by a hand shuffle, to Ilford Delta-100 film developed with Kodak Xtol (2-fold dilution of stock) using a Jobo 3010 Expert Drum and a Bessler reversing motor. The Delta-100 gave smoother skies than Tri-X and the linearity of the film density/exposure relationship tolerated the errors in exposure that are frequently made under stressful conditions. (Tri-X has the advantage of stretching the middle tones.) My earlier printing was with a cold-light head, Brilliant paper and a two-bath combination of Selectol Soft and Zone VI developer. More recently I have used Brilliant VCIII paper and a Zone VI enlarger with a VC head (controls for green and blue light) and a 150 mm Schneider Componon-S lens usually set at f/9.5.

Training is necessary before a trek. Running improves stamina, but the muscles used in ascent and decent must be strengthened in order to protect the knees which are particularly vulnerable to long descents. Comfortable boots that provide ankle support are important. My practice has been to carry a pack up and down local hills on a regular basis before a trek. I increased the weight from week to week until I reached 50 lb about two weeks before the trip. Sherpas do not have to practice—they have been doing this since childhood.

ACKNOWLEDGEMENTS

This book would not have been completed without the help and influence of a many people. I am particularly grateful to Gail and Charles Fields for their early enthusiasm and their conviction that the impossible was possible. We are indebted to Steve Baron for giving us the benefit of his many years of experience in high quality photo book production. Steve was on the first Nepal trek my wife, Betty, and I took over twenty years ago. Several readers of my emerging essay have made important contributions. These include Virginia and Bob Hilton and Laura and Howard Reiter. Bob drew my attention to the child-development work of Donald Winnicott and Laura to that of Margaret Mahler—studies highly relevant to my Wordsworth theme. Brian Folker made valuable comments on my treatment of Wordsworth and the Mountain Sublime and chided me for neglecting Kant. My wife, in her academic incarnation as Elizabeth, has provided a running commentary on contemporary South Asian Politics. Tom Richardson, an ardent mountaineer, and Bart Jordans, both encountered as trek leaders, have examined the mountaineering aspects of the text. Greg Covington has provided material on Kangchenjunga. Doug Chabot communicated to me his enthusiasm for mountaineering by sending me headfirst downhill on my back at great speed in the hope that I would put into practice his instructions for making a self arrest. Conversations, over the years, with Kate Latimer and Wayne Meeks have influenced my treatment of various biblical passages in the essay. My brother Patrick has played a vital role by finding important mountaineering books and by demonstrating the relevance of geological maps. (His home on the edge of the Yorkshire Dales National Park looks out upon Carboniferous Limestone, but Silurian, Devonian and Permo-Triassic deposits are to hand.) As to the Himalayan journeys themselves: Dick Salisbury's determination to get into remote parts of Nepal made possible the Dolpo treks. Both of these were with *Journeys International* which was also responsible for the Dhaulagiri, Annapurna and Ladakh treks. The other treks were organized by *KE Adventure Travel* (formerly *Karakoram Experience*). I am indebted to many helpful and friendly leaders and staff members including Bart Jordans, Johnathan Hughes, Ghulam Nabi and Sher Ali in Pakistan; Sonam Phunchok and Tsering Norboo in Ladakh; and Babu Lama (on our first trek), Tom Richardson, Surgey Guiyev, Nawang Sherpa, Natang Sherpa, Pasang Sherpa and many others in Nepal and Tibet. I am also grateful to all the trek members who over the years have corresponded and sent photographs (typically, of me besieged by curious children) and to my fellow large-format photographers for their support and encouragement.

A major factor shaping this volume has been my father's Victorian enthusiasm for reading aloud all manner of books: from *The Pilgrims Progress,* to *Kim* and *Tom Sawyer*. At home were also books that later became important: Ruskin's *Modern Painters* and volumes with mountain photographs including George Abraham's *The Complete Mountaineer*. His love of books arose, in part, through the influence of Wesleyan Methodism; there was not much schooling as he had been the family breadwinner from an early age. I am still trying to decide if I was influenced by *Heroines: True Tales of Brave Women, A Book for British Girls* given to my Mother in Johannesburg in 1905. And yes, there are the memories of long walks taken and hills climbed with my father that function like Wordsworth's 'spots of time'. Also of significance were the books given to me about great inventors and scientists. These, and donated chemistry equipment, set my feet in the direction of science. (The explosion in the garden shed was an honest accident!) My approach to photography has been indirectly influenced by my scientific mentors and collaborators. In particular, Hans Hirschmann, who allowed me to share in his commitment to the precise description of chemical structure, in terms of symmetry theory, and Irwin Rose, who over many years has continuously challenged me with the rigor and tenacity of his analysis of the three-dimensional chemistry of enzymatic reactions. By their scientific commitments, both have influenced my thinking about the nature of all quests—scientific and otherwise.

DEDICATION

To my parents who first met in the highlands of Scotland,
To my brother who helped carry our tent to the Cuillin of Skye,
To my wife whose determination to cross cultural boundaries led to our first visit to the Himalayas,
To our children who continue to astonish us.

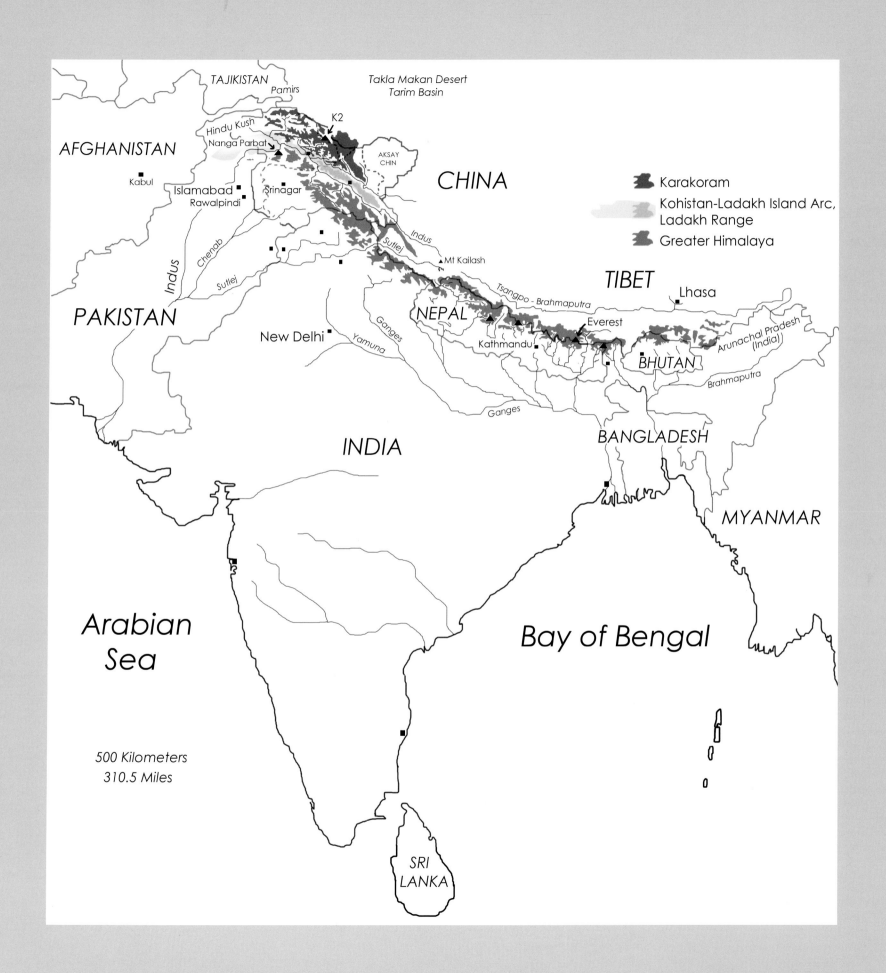

Copyright © 2008 Fields Publishing Photographs © 2007 Kenneth Hanson

Published by Fields Publishing, PO Box 564, North Truro, MA. 02652 508-487-5901 www.charlesfields.net

First Edition

Library of Congress Cataloging-in-Publication Data

Hanson, Kenneth.

Hanson, Himalayan Portfolios—Journeys of the Imagination; photography and commentary by Kenneth Hanson.

192 pages, 34.29cm x 27.94cm

ISBN 9780979059704

Library of Congress Control number 2007932640

1. Himalayan Mountains—Landscape Photography—Black and White Photography.

2. Mountaineering—Philosophy of Mountaineering—Intellectual History.

3. World Travel—Trekking—Tibetan Buddhism.

I. Title.

Cover photo: View from Muri Towards Dhaulagiri, Morning Clouds (1992)

Photo Editor Charles Fields

Book Design by Charles Fields and Gail Fields

Prepress Services Glen Bassett

Production Assistant Zheni Valcheva

∞ This book is printed on acid-free paper meeting the requirements of the American National Standard for Permanence of Paper for Printed Library Materials.

Printed in Korea

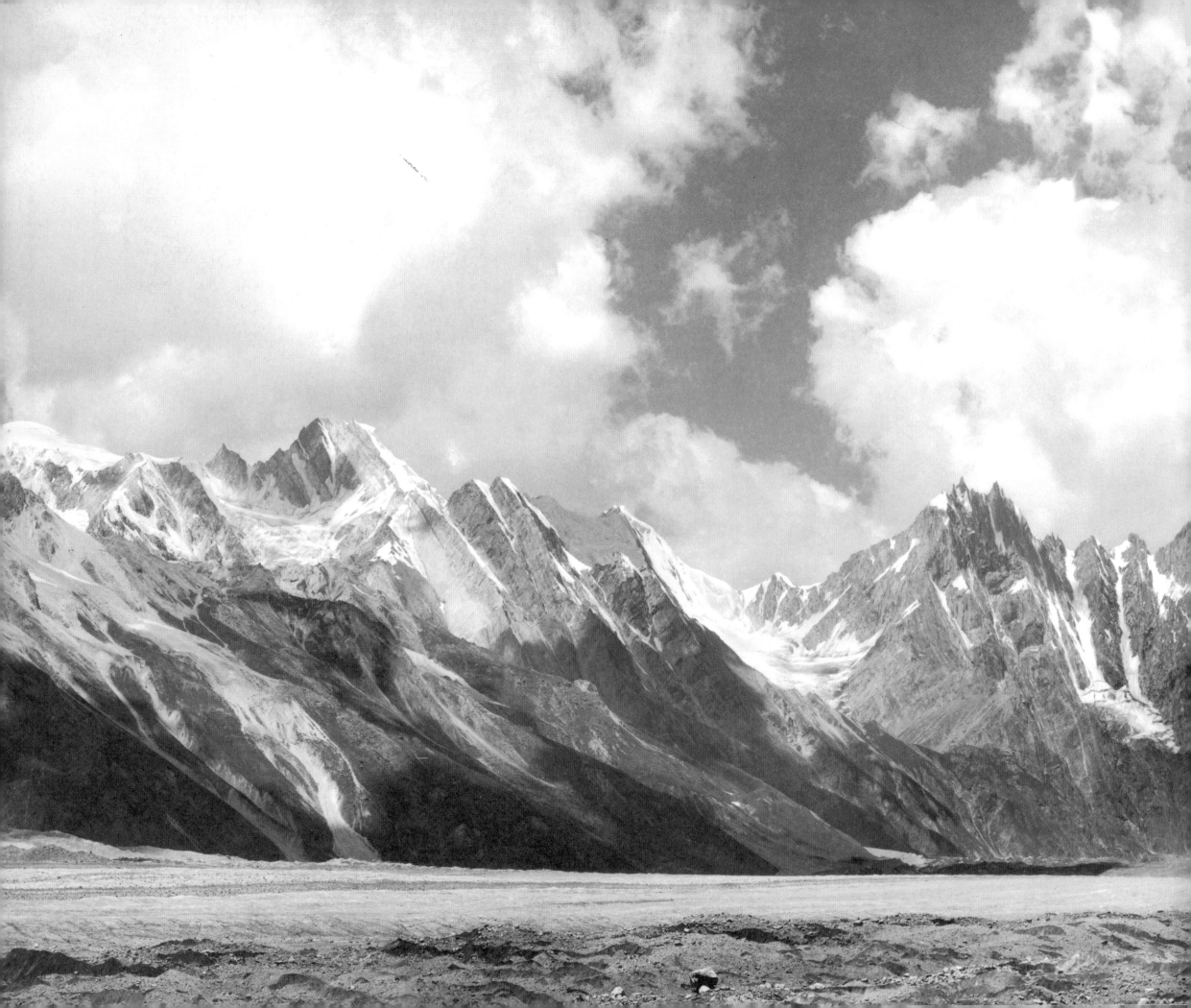